# CRAFT IN AMERICA

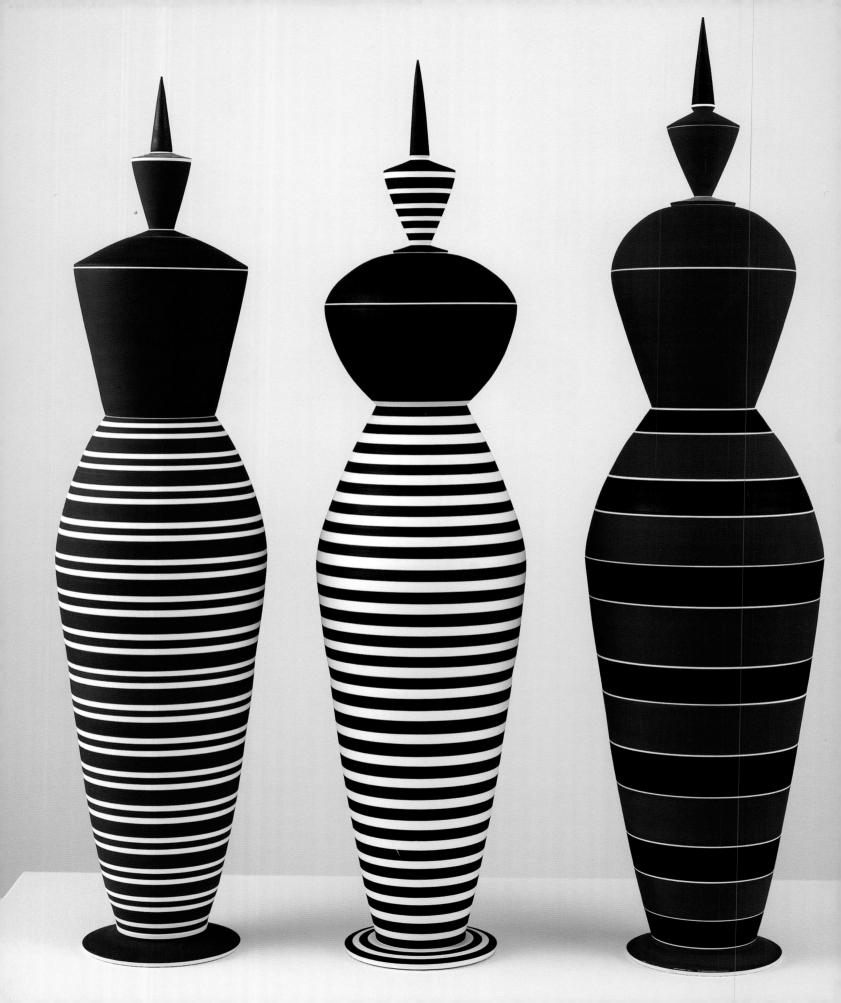

# CRAFT IN AMERICA

## CELEBRATING TWO CENTURIES OF ARTISTS AND OBJECTS

# JO LAURIA AND STEVE FENTON

CONSULTING ART HISTORIAN

**JONATHAN LEO FAIRBANKS**, Fellow AIC (Hon.)

The Katharine Lane Weems Curator of American Decorative Arts
and Sculpture Emeritus, Museum of Fine Arts, Boston

WITH CONTRIBUTIONS BY

MARK COIR ★ JONATHAN LEO FAIRBANKS ★ JEANNINE FALINO ★ STEVEN L. GRAFE

JILL BEUTE KOVERMAN ★ MAILE PINGEL ★ EMILY ZAIDEN

PROLOGUE BY **PRESIDENT JIMMY CARTER**

CLARKSON POTTER/PUBLISHERS
NEW YORK

Library of Congress
Cataloging-in-Publication Data
Lauria, Jo.
Craft in America : celebrating two centuries of
artists and objects / by Jo Lauria and Steve Fenton;
prologue by Jimmy Carter.
p.    cm.
1. Decorative arts—United States.    I. Fenton, Steve.
II. Title.
NK805 .L377
745.0973—dc22        2006034839

ISBN 978-0-307-34647-6

Printed in China

DESIGN BY MAGGIE HINDERS

10  9  8  7  6  5  4  3  2  1

First Edition

FRONTISPIECE **ROSALINE DELISLE, GROUP OF VESSELS, C. 1990, PORCELAIN**

**CRAFT IN AMERICA: EXPANDING TRADITIONS.** EXHIBITION TOUR SCHEDULE 2007–2009
ARKANSAS ARTS CENTER, Little Rock, Arkansas, April 13–June 24, 2007
MUSEUM OF CONTEMPORARY CRAFT, Portland, Oregon, July 22–September 23, 2007
MINGEI INTERNATIONAL MUSEUM, San Diego, California, October 20, 2007–January 27, 2008
HOUSTON CENTER FOR CONTEMPORARY CRAFT, Houston, Texas, February 22–May 4, 2008
CRANBROOK ART MUSEUM, Bloomfield Hills, Michigan, June 8–September 14, 2008
NATIONAL COWBOY & WESTERN HERITAGE MUSEUM, Oklahoma City, Oklahoma,
    October 11, 2008–January 18, 2009
FULLER CRAFT MUSEUM, Brockton, Massachusetts, June 27–September 27, 2009

CRAFT IN AMERICA: Expanding Traditions is organized by Craft in America, Inc., Los Angeles, chief
curator Jo Lauria; and Curatorial Assistance Traveling Exhibitions (CATE), Pasadena, California.
This exhibition tour is supported in part by an award from the National Endowment for the Arts,
American Masterpieces: Three Centuries of Artistic Genius.

# Contents

*Foreword* 7

CAROL SAUVION, EXECUTIVE DIRECTOR, CRAFT IN AMERICA

*Prologue:* Craft in *My* America 9

PRESIDENT JIMMY CARTER

*Introduction:* The Evolution of American Crafts 13

PART I: Communities of Culture 39

CHAPTER 1
Religious Communities and the Honoring of the Handmade 43

CHAPTER 2
The Arts and Crafts Movement in America, 1890–1930 79

CHAPTER 3
Native Communities—Indigenous Crafts by American Indians 103

CHAPTER 4
Communities of Heritage—Southern Contributions 121

PART II: Communities of Craft Teaching 141

CHAPTER 5
Rhode Island School of Design (RISD) 145

CHAPTER 6
California College of the Arts 153

CHAPTER 7
The Cranbrook Vision 163

CHAPTER 8
School for American Crafts, Rochester Institute of Technology 183

CHAPTER 9
Black Mountain College 189

CHAPTER 10
Craft Schools and Residency Programs 201

PART III: The Place of Craft in America 207

CHAPTER 11
The New Studio Crafts Movement 211

CHAPTER 12
Shaping Craft in an American Framework 269

BY JONATHAN LEO FAIRBANKS

*Epilogue:* A Past That Is a Prologue 277

*Notes* 286

*Selected Bibliography* 288

*Craft Centers and Schools* 292

*Museums That Show Crafts, Design, and Decorative Arts* 296

*Acknowledgments* 301

*Contributing Writers* 303

*Credits* 304

*Index* 313

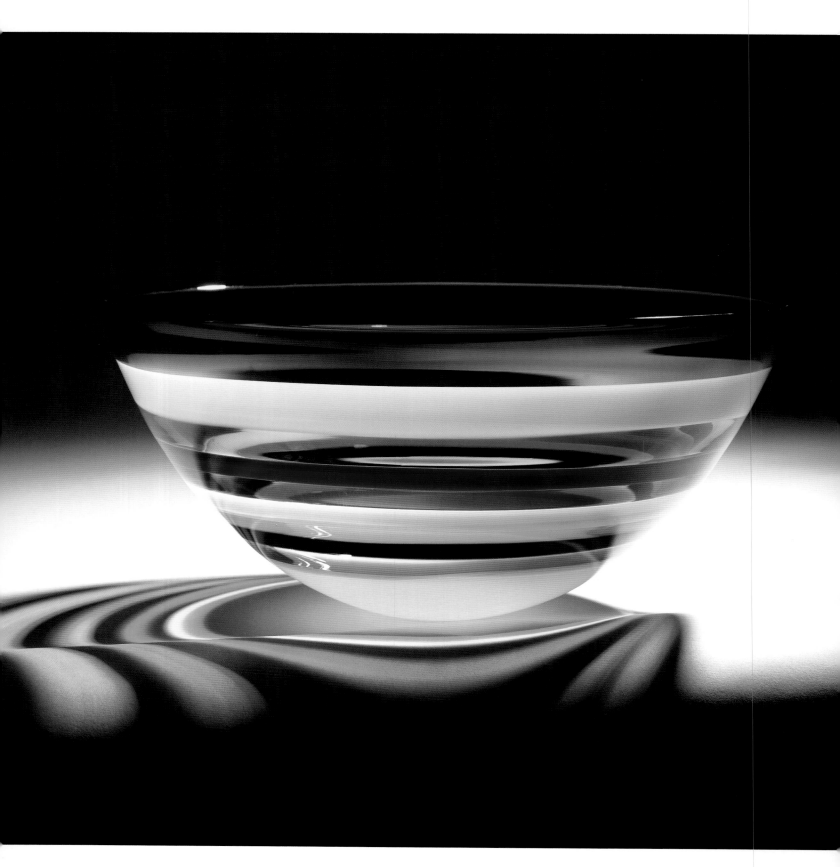

# Foreword

THE BOOK YOU ARE READING is a companion to the *Craft in America* PBS television series and to the traveling museum exhibition of the same name. All three are the outcome of a ten-year project designed to start a conversation about the crafts and to elucidate their importance to our twenty-first-century culture.

American craft, with a history that begins before the written word, continues to evolve. The past two centuries in particular have provided a stimulus for craft artists—artists who work with clay, fiber, metal, and wood, rather than paint or watercolor—who find a wide and varied audience and market for their creations. Our communities and schools, our ethnic and religious groups have all played a part in this ongoing story. Today we are a country rich in men and women who transform the ordinary object into the extraordinary.

This book will show that craft has never been just about pretty things. Or even just about useful things. It has always been about *our* things, our inheritance, our personal collections. It is about functionality, about identity, about conceptual thinking, about fun and experiment. *Craft in America* celebrates both men and women remembered by name and those who worked anonymously, country dwellers and city people, self-taught amateurs and university-trained professionals—artists all.

The story of craft in America is too big to be condensed into one television series, or one exhibition, or one book. Consider this book a starting place for your own route of discovery. We invite you to find out more about the crafts that attract you, to learn about the techniques involved in their creation, to meet the artists, and to enjoy the pleasures derived from your explorations.

CAROL SAUVION
Executive Director, *Craft in America*

OPPOSITE
CALEB SIEMON, *BANDED LOW BOWL*, 2006.

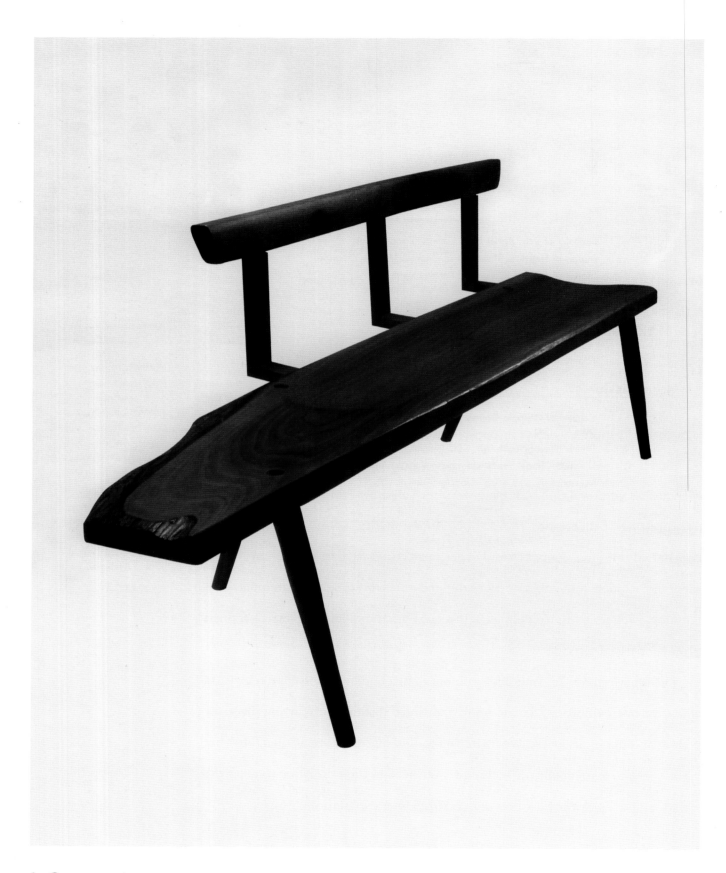

# Prologue: Craft in *My* America

AS A CHILD IN RURAL AMERICA, I grew up surrounded by family and friends who made things—women who came together in quilting bees; carpenters who built furniture, carved whirligigs, and made pull toys; blacksmiths who forged raw iron into objects of beauty and utility.

I watched over their shoulders and gained an early appreciation for anyone who created things with their hands. These were people who took pride in their work and signed what they made with their names or with their special look or design. The recipients knew they possessed something that was filled with love—worth more than money could buy.

It wasn't that we could not afford store-bought items, but using materials that were all around us—gifts of nature—was a way to be more in touch with ourselves and our talents. As I moved from Plains to Atlanta to Washington and back again, the value of the handmade has always had a special place in my heart.

During my presidency, I always had the desire to somehow recognize the skill and singularly American style that was present in handcrafted objects. I was fortunate that Joan Mondale, wife of my vice president, Walter Mondale, shared my love and interest in the expressions of our native artists. Few places in the world display the unbridled creativity exhibited by the tens of thousands of artists who make craft a unique part of the American experience.

Toiling individually, as part of craft circles, as full-time careers, or as escapes from their everyday jobs, these artists stand for everything that's good in our country. That is why we first established the White House Collection of American Crafts that continued through the Clinton Administration. For the first time, we recognized a medium that takes our ordinary, everyday objects like bowls, baskets,

OPPOSITE
**SHAKER STYLE BENCH**
This bench in black walnut by President Jimmy Carter was exhibited at the Museum of Design in Atlanta, Georgia, as part of *Talking Furniture Design: The Language of Contemporary Southeastern Artisans,* March 4– August 28, 2004.

As President Jimmy Carter describes: "I designed this bench to use a very large black walnut board that was hauled down from Ohio by a friend whom I have never met. He had it lashed on top of his station wagon, and left it at our front gate while we were not home. I thanked him, of course, and then decided to make something special."

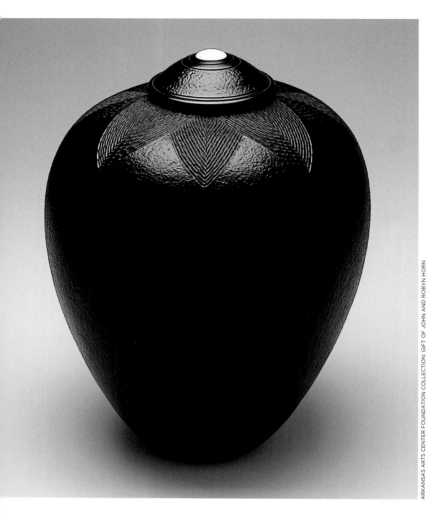

and quilts and elevates them to art forms that rival painting and sculpture in their impact. It shows that beauty can be found in the smallest things or in places we might overlook. Visitors to the White House, from ordinary citizens to foreign dignitaries, always were delighted by the colors and shapes of the pieces we displayed.

Craft, both historical and contemporary, is all around us, and it recognizes and communicates much about what we are as a country. It is our identity and our legacy. Handmade quilts and coverlets, pottery, furniture, glass, jewelry, and religious objects describe our society, as do the writings of our historians, poets, and statesmen. The things we hold most dear, often handmade, are a record of who we are as a nation. They stand for individualism and the satisfaction that comes from making something with one's own two hands. They appreciate the environment and the gifts the Creator has provided for use in our lives. They demonstrate the creative spirit within each of us.

One of the most satisfying things about American craft is its timelessness. Americans have a tradition of work, and the crafts are a continuous participant in that tradition. Manipulating clay, forming glass, shaping metal, weaving fiber, and working wood all require exertion that is strenuous, tactile, and satisfying for those who enjoy physical labor. There is a mind/body connection and collaboration that exists in few other activities.

Many objects used in our everyday lives become the subjects of museum exhibitions. The pieces in this book, and in the Public Television series and museum

ABOVE
JOHN JORDAN, BLACK
TEXTURED JAR, 1993, BOX
ELDER.

ARKANSAS ARTS CENTER FOUNDATION COLLECTION: GIFT OF JOHN AND ROBYN HORN

exhibition that it accompanies, are a chronicle of who we were and who we are: self-expression through homegrown skills that allows us to reflect on what generations of Americans have considered creative and important. In considering where we were, we can begin to get an idea of what we will become, and craft is the living link.

We could ask if drinking from a handcrafted goblet makes the wine taste any better, or eating from a crafted serving piece makes the food any more flavorful. Perhaps, or maybe not. But one thing is certain. Craft contributes to a life well lived in the same manner that paintings and photographs do. Without it, we would, as a people and a culture, be diminished as individuals and Americans.

Today I take pride in building homes for Habitat for Humanity, for the joy of both making something with my hands and bringing housing to those who need a place to call home. In my woodworking shop, I've made much of the furniture in Rosalynn's and my home and auction items for our annual Carter Center fundraiser. I find it rewarding on so many levels, much like any artist does with his or her chosen medium. The beauty of craftsmanship is that it has the capacity to engage each of us in activities that nurture our humanity, satisfy our need to express ourselves, and give us the opportunity to learn with our hands in ways that are not possible with our minds alone.

Those of you who have already experienced this feeling know what I mean beyond my words. If you haven't, I invite you to read this book, consider the outstanding objects these artists have imagined, and partake in what could well be one of the most satisfying times of your life.

—JIMMY CARTER
Plains, Georgia

# Introduction: The Evolution of American Crafts

## A CONVERSATION WITH RAW MATERIALS

★

To the casual observer, craft at its most elemental is simply taking a base material—metal or wood or fiber or glass or clay—and making something useful: a bowl, a vase, a quilt, a chair, a pot.

But it's also about making that base material into something more. This is what separates the utilitarian from art. It takes creative, thinking, caring human beings who see their creations as something more, imbuing their work with a message or simply a feeling—from deep within their souls.

Historians and cultural anthropologists have evidence of craft dating well back into prehistory. If we take an ordinary object, like a hand ax, and do nothing with it, it remains that, and nothing more: a strictly utilitarian tool that does not garner any further interest or attention. However, when we make one special, giving it an extraordinary quality for, let us say, ceremonies or rituals, it enters a transformative state. It becomes Art, with a capital *A*.

Starting off flat and almond shaped by design, symmetrical front to back and left to right, an ax undeniably fits comfortably in the hand and has sharp cutting edges. That makes it what it is. But many are attractive, with embedded, ornamental fossil shells. Some, under inspection by electron microscope, show no evidence of the wear and tear of use. Even a plain, well-worn hand ax seems to show the result of far more care by our *Homo erectus* ancestors than merely one capable of cutting.

The naturalist Loren Eiseley tells of his encounter with just such a tool:

> As I clasped and unclasped the stone, running my fingers down its edges, I began to perceive the ghostly emanations from a long-vanished mind, the kind of mind which, once having shaped an object of any sort, leaves an individual trace behind it which speaks to others across the barriers of time and language. It was not the practical experimental aspect of this mind that startled me, but rather that the fellow had wasted time. In an incalculably brutish and dangerous world he had both shaped an instrument of practical application and then, with a virtuoso's elegance, proceeded to embellish his product.

In a more contemporary example, a war mask used by Tlingit Indians (of the northwest coast, now part of Alaska) can be approached on several levels. As a piece of carved

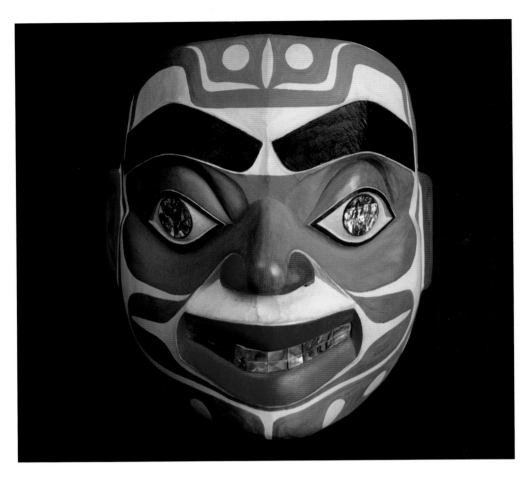

wood with abalone, hair, and feathers, it is a striking object, to be admired for its use of mythical imagery. As a functional mask, it provides protection for the wearer against enemy weapons.

But it goes even further, extending to the extraordinary. The designs and colors go beyond mere decoration or tribal identification. The mask co-opts another basic emotion, taking the fear-inducing glare of a predator's eyes and teeth, and turning it against the selfsame predator or enemy. It takes on magic, and by transferring power to the wearer, the warrior feels empowered and invincible in battle. A practical object? Certainly. An object whose beauty is seen in a whole different light, emerging from a whole way of life? Definitely.

Perhaps the ultimate connection lies in the anthropological scholar Ellen Dissanayake's description:

> *There is an inherent pleasure in making. We might call this* joie de faire *(like* joie de vivre*) to indicate that there is something important, even urgent, to be said about the sheer enjoyment of making something exist that didn't exist before, of using one's own agency, dexterity, feelings and judgment to mold, form, touch, hold and craft physical materials, apart from anticipating the fact of its eventual beauty, uniqueness or usefulness.*

# CREATIVITY AND THE RULES OF ENGAGEMENT

★

To all this, the arts professor Howard Risatti adds another crucial dimension. The craft artist must engage the materials with an extraordinary understanding of the science of the materials he or she works with—their physical strengths, weaknesses, and capabilities— or the piece is doomed to fail.

What are the properties of a specific wood, and how can it be formed, glued, jointed, or laminated so it maintains its form and function—as well as the artist's creativity? How thin can a pot or vase or bowl be thrown and still function as a vessel? Can wool be hand-felted without a comprehensive knowledge of the reaction of water temperature and hand pressure and of the physical properties of a myriad of wools from dozens of breeds of sheep? And what of the glassblower, who has to combine his creativity on the fly with more than a passing knowledge of glass solids and gases?

The probabilities of success in creating an object that is beautiful, functional, and, *above all, possible,* increase logarithmically with the artist's knowledge and experience in making the right choices. As the scientist Louis Pasteur so famously observed, "Chance favors the prepared mind."

Fact is, craft artists know that "making" is not the same as "manufacturing." And as if all that knowledge were not enough, they must bring to their work a requisite tactile feel and a sense they must experience before being comfortable and informed enough to turn it all into art.

ABOVE

**REHEATING GLASS AT THE GLORY HOLE, PILCHUCK GLASS SCHOOL.**

LEFT

**JOHN VAUGHN ECONOMAKI,** *VAUGHN STREET DESSERT CART,* 1985, WALNUT.
As a designer-craftsman, John Economaki stresses the true reason for being a woodworker is based on "an understanding of the principles that drive our perceptions of beauty: propor-tion, harmony, grace, eye flow, and texture." His *Cart* draws on the "bones" of old pushcarts and the handmade wheels reminiscent of horse-drawn wagons.

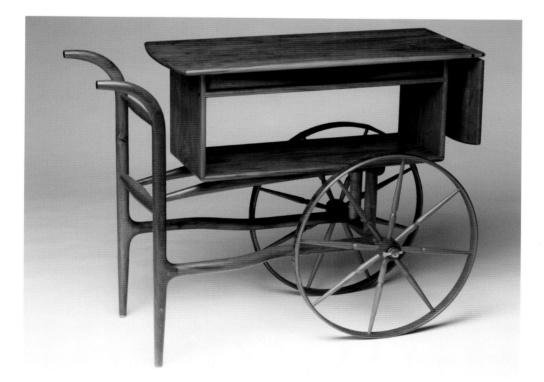

For any person who creates things, the most terrifying thing is the "blank page" that needs to be filled. For a writer, that "page" is quite literal. For the craft artist, it is a tabula rasa of raw material that must be addressed and worked to within an inch of its life (for the material does absorb life, after all, from the artist), and become something that talks to us, sings to us, stays with us.

When asked how they get there, craft artists may not even be aware of their internal processes. Many instinctively say it happens by "being one with" the medium. But it's much more—experiencing what professor Mihaly Csikszentmihalyi calls "flow." Metaphorically, it is a current carrying one along, an unconscious awareness of a conscious understanding—of what it takes to mold, meld, and fashion raw materials into something more. Among its components are concentration and focus; a loss of self-consciousness; merging action and awareness; losing track of subjective time; a sense of personal control over the activity; and an intrinsic reward by doing the activity, so there is an effortlessness of action.

"Flow" is not unlike the discipline honed by practitioners of Buddhism and Taoism. Indeed, this idea of overcoming the duality of self and object was earlier popularized by Robert Pirsig's 1974 cult classic *Zen and the Art of Motorcycle Maintenance.* There the author suggests, "When you're not dominated by feelings of separateness from what you're working on, then you can be said to 'care' about what you're doing. That is what caring really is: a feeling of identification with what one's doing."

Of course, because craft is art, and all art is in the eye of the beholder, it is not without its detractors. These are those who have no time for what they perceive as quaint efforts to recapture a time past, in their minds better left forgotten. For them, Ken Trapp, former curator-in-charge of the Renwick Gallery at the Smithsonian Institution, has an answer:

*Some may dismiss the handcrafted object as an anachronism, a nostalgic throwback to an earlier and supposedly simpler and happier time. But for many more, the handcrafted object is an authentic experience that is personalized, individualized and humanized.*

# CRAFT AND THE AMERICAN EXPERIENCE

★

We are the product of a vast and rich environment: an America blanketed by forests so dense we had to create legends like Paul Bunyan to explain how so much wood could be harvested; or like John Henry to build the railroads to transport it.

We are who we are as much because of rugged individualism as of rugged terrain. Our pluralism accounts for an America that is both the real and the ideal, a work in progress whose story has been written, rewritten, and will be rewritten again. The words and ideas are as old as the nation: individuality, democracy, diversity, equality, progress, and nationalism. They represent our dreams and ambitions, our successes and even our failures. And at the heart of this grand experiment are principles framed around the worth of its people and the value of their work.

## AMERICAN INDIVIDUALISM AND THE ENTREPRENEURIAL SPIRIT

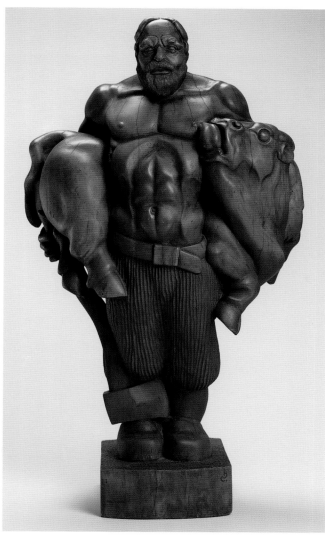

Coming to America, the artisans among the colonists, and later the foreign-born immigrants, discovered a remarkable entrepreneurial freedom that was outside their European experience. In a revelation that resonates to this very day, they were no longer restricted by the class and guild traditions of Europe: By working hard, they would succeed on their own terms, based on their own name, reputation, and quality of work.

This freedom was our country's signature as we progressed from thirteen colonies to a newly minted republic. For instance, in 1833, Christian Frederick Martin left Germany for lower Manhattan, combining his curiosity about what could be made and a continuous devotion to the handcrafted ethos to form a guitar workshop, the C. F. Martin Company, which has stood for almost two centuries. Now located in Nazareth, Pennsylvania, C. F. Martin makes, arguably, the best guitars, mandolins, and ukuleles. Even though most Martins are now factory made, their custom shop will create by hand a guitar to personal specifications.

Americans' asserted right to the "pursuit of happiness"—to be the masters of their own occupational destiny—is not something for just immigrants to enjoy. Ingrained in

ABOVE

**CARROLL BARNES, *PAUL BUNYAN*, 1938, CHERRY WOOD, 40$^{1}/_{4}$ x 24 x 12 INCHES.** It is appropriate that this image of the heroic lumberjack is sculpted in wood. Carroll, who was once a lumber-packer, went on to spend six years creating a mammoth, 16$^{1}/_{2}$-foot-tall version of the sculpture from a two-thousand-year-old redwood near Sequoia National Forest, begun in 1941. The world's largest wood carving, the piece rightly secured legendary status for the artist.

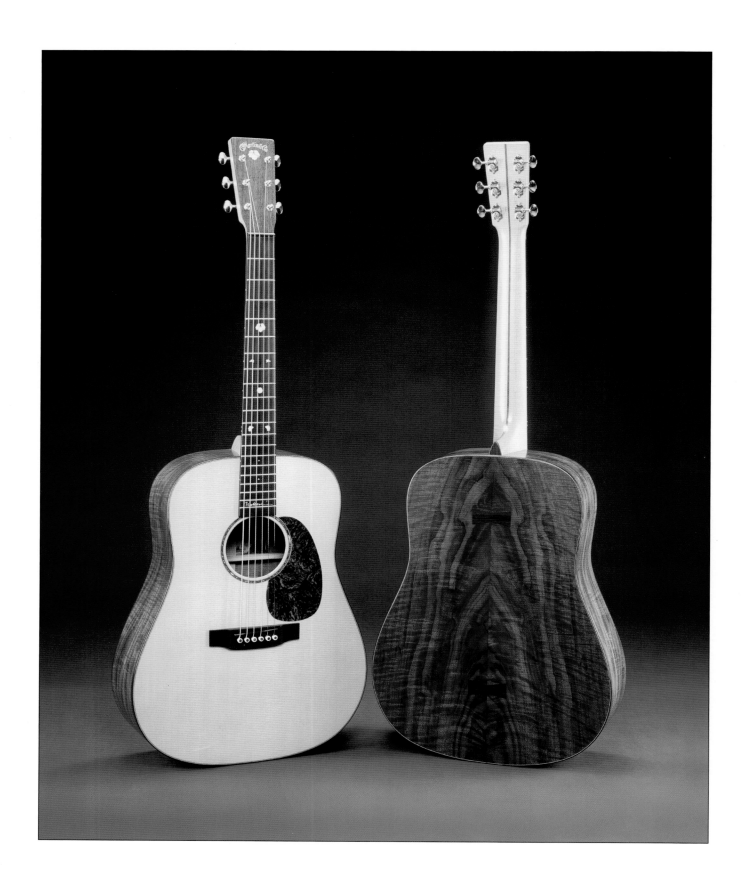

each of us from an early age, this goal is a cornerstone in choosing how we wish to live our lives. With so many crafts being individual endeavors, possessing that entrepreneurial streak is another dimension of the fully formed craft artist.

Following World War I, America turned inward, becoming insular and isolationist. Fortress America was more about building industrial capabilities and strengths. Then, when the Great Depression struck, and jobs were scarce, people turned to their hands and the skills of their forefathers as a source of sustenance. Domestic crafts, such as sewing, quilting, and needlework, were often taken up by those who needed money to support their families. In the mountains of southern Appalachia, in just one regional example, craft was often the only way a society could survive.

For the better part of two centuries, itinerant weavers traveled among small towns to weave coverlets. As today's artists carry their portfolios, the weavers, mostly men, would carry swatches and sample books, showing patterns with fanciful names that, like the constellations in the sky, often had no direct relationship to what they looked like, but captured imaginations nevertheless: Walls of Jericho, Sea Star, Lovers Knot, Philadelphia Pavement, among others. The men didn't merely take orders for future delivery, like traveling salesmen. They often stayed with the customer, weaved what was wanted, and then moved on to the next town and the next family.

The weaving tradition was exceptionally strong among the mountain people. With the turn of the century, settlement workers went to Tennessee, North Carolina, and Kentucky to start schools for needy communities. To improve their families' financial situations, the women took up the weaving of guest towels, baby blankets, and place mats, which found an easy market in the women's network of churches, arts organizations, and civic clubs.

The Fireside Industries of Berea College in Kentucky began with women weaving to pay for their children's school expenses. Berea later developed student labor programs allowing thousands of students to cover their tuition through a unique co-op system. Following the Berea model were Tennessee's Arrowmont School of Arts and Crafts and the Penland Weavers and Potters, begun at the Appalachian School at Penland, North Carolina. The idea was simple: Participants would take patterns and materials from the center, work the craft at home, and return with finished items to be sold. Soon, dozens of these weaving centers dotted mountain ridges.

OPPOSITE

**C. F. MARTIN & CO.®, NWG GEORGE NAKASHIMA CLARO WALNUT COMMEMORATIVE EDITION GUITAR, 1990, VARIOUS WOODS AND ABALONE.**

The guitar was made as a tribute to the great woodworker upon his death in 1990. It features his signature butterfly joinery, as well as a copy of his signature at the base of the fret board.

BELOW

**LUCY MORGAN IN THE WEAVING CABIN, EXAMINING HANDWOVEN GOODS MADE BY THE PENLAND WEAVERS, NORTH CAROLINA, C. 1930S.**

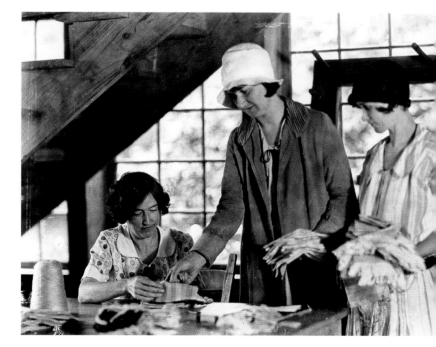

## THE GREAT LEVELING:
## THE CONTRIBUTION OF CRAFT TO EQUALITY AND DIVERSITY

Democracy in America is meaningless without the values of equality and diversity. The Declaration of Independence, in what is arguably the best-known and most important phrase in any American political document, posits and promises that "all men are created equal," and over the years, that status has spread to include women and minorities.

Sadly, the road to equality for our diverse populace has never been smooth and straight. The writing of our history has been witness to shameful episodes of societal schizophrenia marked by discrimination and worse. Yet, through it all, our history is also richer for recognizing their many contributions to our cultural lives. As they contributed to craft in America, they may also have contributed to their escape from prejudice.

### A TURNING POINT FOR WOMEN

Until the Arts and Crafts period, "proper" women were expected to be fluent in needle arts, making doilies and antimacassars. They learned their skills during breaks from often-busy schedules, creating complex samplers that featured a multitude of stitches used to create alphabets and religious sayings. But with the introduction of electricity and associated labor-saving devices, women found themselves with free time; many experienced a burgeoning commercial instinct that had become more socially acceptable, even if relatively few work opportunities were open to them.

In one such opportunity, young faculty members from New Orleans's H. Sophie Newcomb Memorial College Institute at Tulane University established a groundbreaking program of vocational training. Under the directorship of chief artist Mary Given Sheerer, they combined fine arts curricula with commercial enterprise. Newcomb Pottery became a studio business, with ninety women artists producing some seventy thousand pieces—no two exactly alike—between 1894 and 1940. No southern bride's gift list was complete without at least one piece.

Also part of this sea change for American women was Mary Chase Perry Stratton, an important figure in Detroit's artistic and cultural life who established Pewabic Pottery in 1903. On Jefferson Avenue, near the bank of the Detroit River, artists created art pottery that is now included in some of America's finest collections. Their tile work and ornaments became part of countless churches, schools, commercial buildings, and public facilities—even city subway systems. Stratton's vision clearly mirrored that of arts and crafts—and craft in general:

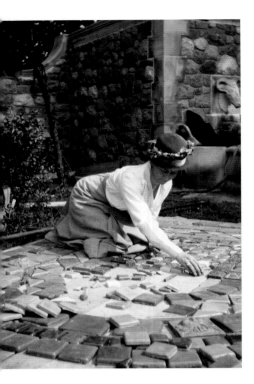

ABOVE

**MARY CHASE PERRY STRATTON LAYING OUT THE PEWABIC TILE BACKSPLASH OF THE RAINBOW FOUNTAIN ON THE CRANBROOK CAMPUS, 1916.**

Years before Henry Ford utilized the assembly line to mass-produce his cars, craft objects were often manufactured by assigning specific tasks to specific artists. This process, which many craft artists objected to, was replaced by the idea-to-completion concept of studio craft.

RIGHT

**NEWCOMB POTTERY VASE, DESIGNED BY JOSEPH MEYER AND DECORATED BY MARIE DE HOA LEBLANC, 1900–1910.**

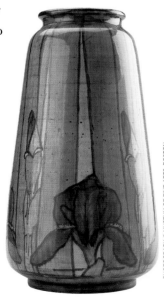

PHOTOGRAPH © MUSEUM OF FINE ARTS, BOSTON

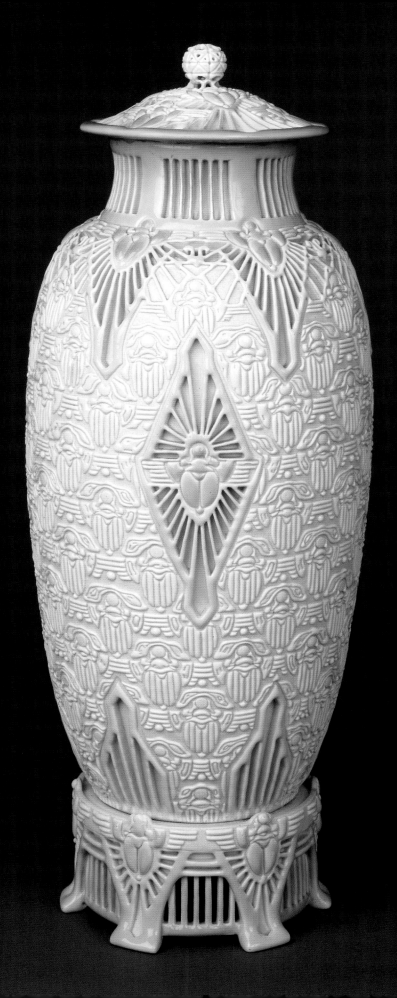

**ADELAIDE ALSOP ROBINEAU,**
*SCARAB VASE,* **1910,**
**PORCELAIN, 16⅝ x 6-INCH**
**DIAMETER.**
Made of high-fire porcelain, its
jewel-like richness comes from
alternating glazed and
unglazed areas. On its base,
Robineau inscribed the legend
*The Apotheosis of the Toiler,*
referring as much to the
purported thousand hours it
took her to complete the
carving as to the excised
scarab beetle, Egyptian symbol
of hard work, patience,
strength, and immortality.

*It is not the aim of the Pottery to become an enlarged, systematized commercial manufacturer in competition with others striving in the same way. Its idea has always been to solve progressively the various ceramic problems that arise in hope of working out the results and artistic effects which may happily remain as memorials . . . or at least stamp this generation as one which brought about a revival of the ceramic arts and prove an inspiration to those who come after us.*

Pewabic still conducts classes and workshops year round for children and adults at all levels of proficiency. The pottery also continues to produce tile that is handmade and hand glazed, often from original molds. These have been incorporated most recently in the new Northwest WorldGateway at Detroit Metro Airport and the Tigers' Comerica Park, one of the symbols of downtown Detroit's renaissance.

Another woman of note in furthering craft through this period was Adelaide Alsop Robineau. Considered perhaps the finest ceramist of her age, she expanded her influence to countless students as the editor of the monthly journal *Keramic Studio* and as a teacher at Syracuse University.

Her signature piece was *The Apotheosis of the Toiler* (also known as *Scarab Vase* because of its exceedingly complex design motif). In 1910, it won the grand prize in pottery at the Turin International Exhibition, serving notice on the world that American art pottery could now hold its own with the finest studio pieces created in Europe. In 2000, it was designated by *Art & Antiques Magazine* as the century's most important piece of American ceramics.

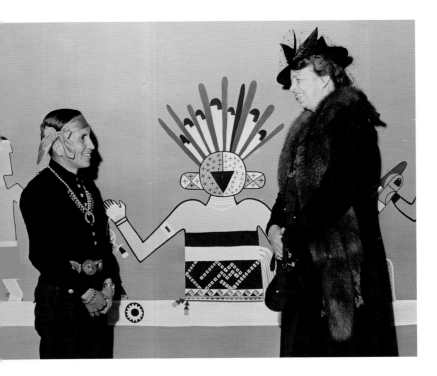

## AMERICAN INDIANS

When the first Europeans came ashore in the New World, they found a native population practicing a mystical interdependence between the people and the earth. American Indians borrowed from nature and translated creation legends and landscapes into designs that graced their pottery, basketry, jewelry, clothing, and blankets.

Over time, American Indians were forced by government fiat and missionary zeal to relinquish their culture and to be relegated to reservations. Not without irony, at the same time, they were being canonized by the movies and other forms of popular culture for their classic character and nobility.

With Franklin Delano Roosevelt's first administration, much (but certainly not all) of government's attitudes changed. Recognizing Indian culture, Congress

established in 1935 the Indian Arts and Crafts Board, which had the job of promoting "the economic welfare of the Indian tribes . . . through the development of Indian arts and crafts and the expansion of the market for the products of Indian art and craftsmanship." Under the leadership of Commissioner of Indian Affairs John Collier and Board general manager René d'Harnoncourt (who later became director of New York's Museum of Modern Art), they succeeded admirably, establishing standards for quality, reviving declining art forms, and even curating major exhibitions at the *Golden Gate International Exposition* in 1939, and at MoMA in 1941, to call national attention to the Indians' extensive and expressive talents.

In 2004, the new home of the National Museum of the American Indian, part of the Smithsonian Institution, opened its doors on the National Mall in Washington, D.C., alongside the capital's other great museums, allowing visitors to finally comprehend and appreciate the full breadth and depth of the many tribes' rich contributions to our craft tradition and heritage.

## JAPANESE-AMERICANS

Japan's December 7, 1941, Pearl Harbor attack had a traumatic impact on Americans as a whole, and in particular on 112,700 men, women, and children of Japanese ancestry, 70,000 of whom were U.S. citizens.

Urged on by irrational panic and war hysteria, President Roosevelt's Executive Order 9066 gave the military broad powers to ban *any citizen* (thus giving cover to the outward appearance of racism) from a fifty- to sixty-mile-wide coastal swath stretching from Washington State to California and extending inland to southern Arizona. Japanese-Americans were moved to military relocation centers in some of the most barren areas of

BELOW

**PHOTOGRAPH BY ANSEL ADAMS, *CATHOLIC CHURCH, MANZANAR RELOCATION CENTER*, 1943.**
Manzanar had a long history of forced relocation. In the 1860s the Paiute Indians were forced out of the area by white homesteaders. The Japanese-Americans were interned in a one-mile-square area, surrounded by barbed wire and machine-gun towers.

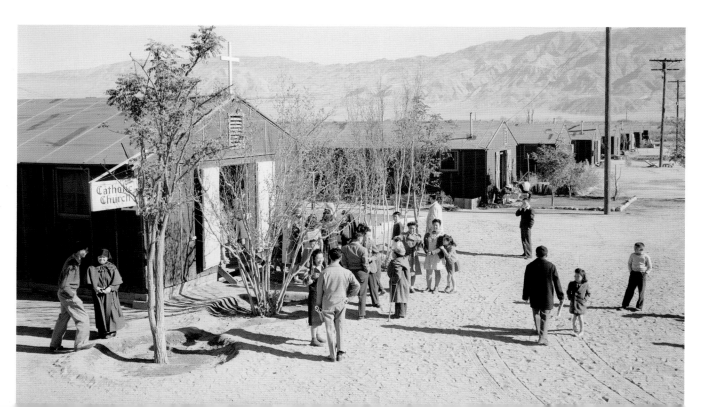

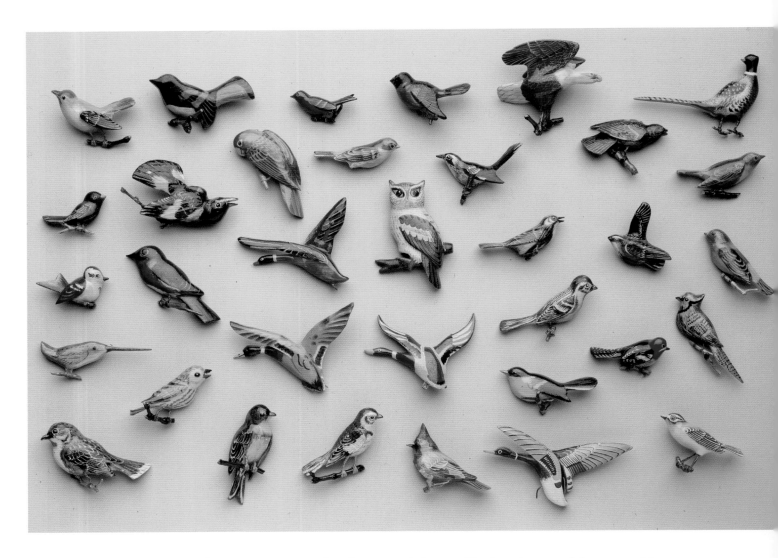

ABOVE

**BIRD PINS, RECYCLED MATERIALS, 1942–1945.** The desire to make things of beauty out of discarded materials was strong among the Japanese-Americans who found themselves in relocation camps like Manzanar. Tree twigs, burlap scraps, and glass from broken windowpanes were typical materials gathered to make other objects like birdhouses or picture frames.

the western states and as far east as Arkansas. The best known of the camps, Manzanar, sat at the foot of the Sierra Nevada in eastern California's Owens Valley.

Under orders, entire Japanese-American communities were given a week to settle their affairs and could bring with them only what they could carry. Everything else — sometimes including their homes — had to be abandoned or sold to often predatory merchants for pennies on the dollar.

Despite the grim surroundings, the internees were driven by the need to create. Forced behind barbed wire in whitewashed stables with only sleeping cots, their crafts were born of necessity, making rough-hewn furnishings and woodworking tools from whatever scrap or local raw materials they could find. As their confinement stretched from one year to four, their objects took on a startling elegance and irrepressible beauty. For these men, women, and children, pursuing their craft was the embodiment of *gaman,* the Japanese word for endurance with grace and dignity in the face of the unbearable.

## AFRICAN-AMERICANS

While most peoples came to America willingly, Africans and their craft cultures of basket making, beadwork, and kente cloth came here by force, making their experience as harsh an abuse as any in American history. Their struggles for the same rights their fellow citizens enjoy continue to this day.

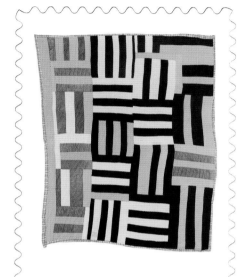

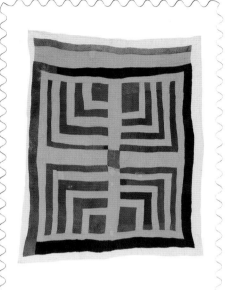

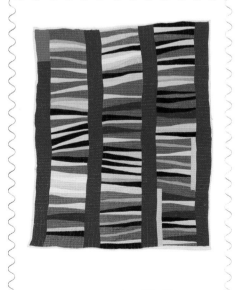

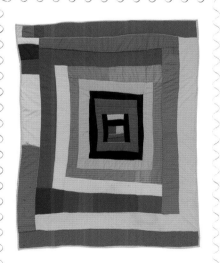

**FOUR STAMPS ISSUED BY THE UNITED STATES POSTAL SERVICE IN 2006, FEATURING REPRODUCTIONS OF GEE'S BEND QUILTS**
Clockwise from top left: Loretta Pettway, "Roman Stripes" variation (Crazy Quilt), 1970; Lottie Mooney, "Housetop" four-block "Half Log Cabin" variation, c. 1940; Minnie Sue Coleman, "Pig in a Pen" medallion, c. 1970, Jessie T. Pettway, "Bars and String-Pieced Columns," c. 1950.

One person in particular, known to us as Dave the Slave Potter, was an integral part of the nineteenth-century Edgefield, South Carolina, pottery community. (With emancipation in 1865, he took the name of his then-owner and called himself David Drake.) Dave was the first African-American to sign his ceramics. In addition to his proficiency and prolific output at some forty thousand pieces, they are often staggeringly huge. His smaller, ten-gallon pitchers would require moving 50 to 60 pounds of wet clay on and off his potter's wheel. Many of his other pieces were four times the size. (For more on Dave the Potter, see pages 124–125.)

In the 1930s, as crafts were revived, especially among the poor, some educated African-American leaders, particularly the Howard University philosopher Alain Locke, argued that this effort was counterproductive. His treatise, *The New Negro,* saw the avenue for black advancement tied to abandoning the folk culture of their slave days, with the exception of music, storytelling, and dance.

Ironically, while Locke was proposing this cultural amnesia, virtually all other ethnic groups were happily reinventing their craft traditions. And in spite of him, many African-American communities continued to prosper from their traditional crafts: quilting, basketry, ironworking, leatherworking, and pottery, practiced and perfected by black men and women in the eighteenth and nineteenth centuries.

In the South Carolina Low Country — Charleston, Mount Pleasant, and its environs — hundreds of women were daily fixtures in the central marketplace and along the Cooper River, coiling local sweetgrass and palmetto leaf into traditional baskets, trays, and hampers that were both artistic and commercial successes. The tradition continues to this day.

Being a port city, Charleston also had a great need for blacksmiths to make "boat iron" — chains, anchors, keels, and the like. Originally enslaved and forced to do this heavy labor, African-Americans excelled at this occupation. By the mid-1920s, horses and buggies were replaced by cars and trucks, and a committed preservation movement sought out blacksmiths to forge ornamental ironwork that would restore the architectural treasures of the city. The leading figure — the most talented in the area — was Philip Simmons. By designing and forging more than two hundred historically accurate gates, fences, grills, and more, Simmons has earned a most deserved reputation for preserving the image and soul of Charleston.

Among the quilters, crafts didn't have to be "revived"; they had never fallen out of use. Perhaps it was because quilting brought together a primal functionality ("good warm

cover") and social importance as an opportunity to communicate through quilting bees — or even entire communities such as the recently discovered and newly appreciated quilters of Gee's Bend, Alabama.

This community, hiding in plain sight thirty miles from Selma, was isolated by geography, poverty, and no small amount of government indifference. Perhaps because of this unique set of circumstances, generations of Gee's Bend women have turned out quilts of astonishing artistry from scraps of salvaged fabrics, like feed sacks and worn-out clothes. Their bold geometric shapes and off-handed construction result in abstract designs more akin to the rhythms of jazz and African art than to the geometric order and repetition of traditional American quilts. The *New York Times* has hailed them as "some of the most miraculous works of modern art America has produced."

## GREAT ART IS BORN OF GREAT OPPORTUNITY

Public education is perhaps the strongest evidence of a democracy, providing all citizens with the ways and means to secure equal opportunities and their place in the national economy. In the wake of World War II, with millions of returning veterans, the United States, as a matter of policy, determined that education was not only an individual right but also a public good, ensuring the future strength of the country. Many fields of study benefited from the fresh blood and new thinking these men and women offered. Few fields were changed as much, however, as craft.

After four long years on the world's battlefronts, American soldiers, men and women, officers and enlistees, returned battle scarred and often bearing terrible memories.

Humbled by their experiences and seeking direction, veterans were aided by the last piece of New Deal legislation, the Servicemen's Readjustment Act of 1944. Known familiarly as the GI Bill of Rights, it provided, among other things, for full coverage of college tuition. The prospect of having the service members' entire higher education paid for caused college and university enrollments to double or even triple.

Many veterans sought out colleges and schools where art departments, without much fanfare, had been establishing craft programs taught by émigré artists and craft artists who had escaped from the Fascist front in Europe. In America, hand and spirit came together in a chance to create, rather than destroy.

If you were so inclined, you didn't have to travel far. The first college-level craft program (founded at New York's Alfred University in 1900 as The New York State School of Clay-working and Ceramics) was now joined by programs at schools literally coast to coast and border to border, from Black Mountain College in North Carolina to California College of the Arts (formerly, California College of Arts and Crafts).

Americans saw an opportunity to look within, to the values and ideals that have

# JOHN TOWNSEND AND PAUL REVERE: REVOLUTIONARY CRAFTSMEN

**P**ERHAPS no one brought more praise to the American craftsman than the cabinetmaker and fifth-generation American John Townsend. His signature style was typically grand pieces capped by perfectly proportioned block-and-shell fronts and ball-and-claw curved cabriole legs possessed of both delicacy and power.

Assessing Townsend's place in craft's pantheon is the art critic Robert Hughes:

> *The strange and rather marvelous truth is that there was one area of the visual arts in which an American arguably was the best in the Western world, skilled and inventive to a degree that nobody else in Colonial America and very few in England or Europe could rival. This art was fine cabinetmaking; the place was Newport, R.I.; and the man was John Townsend. It was thanks to Townsend . . . and to his fellow craftsman John Goddard, that furniture became the first American art to attain complete maturity.*

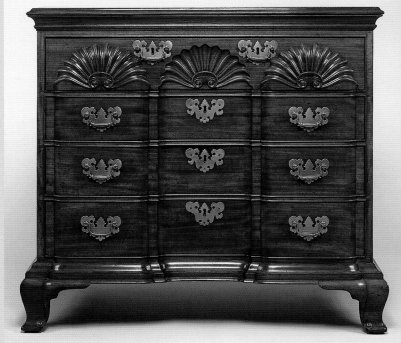

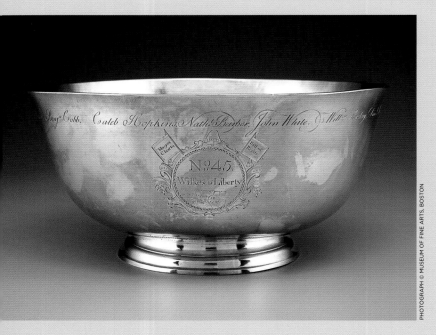

Perhaps the best remembered was the silversmith Paul Revere. Versatile and prolific, he produced more than five thousand silver pieces—much of it, like tableware or buckles, for citizens of middling means. In creating his classic "Sons of Liberty Bowl" he formed an icon celebrating resistance to the Royal Governor's demands in 1768. It also established a new American style of silver. In one piece, it may well be our history's most politically charged silver object; as the simple, classic "Revere Bowl," as it is often called, it is also our most enduring.

---

**ABOVE** John Townsend, chest of drawers, 1765, mahogany, white pine, chestnut, tulip poplar, 34$\frac{1}{2}$ x 37$\frac{1}{2}$ x 20$\frac{3}{4}$ inches.

**LEFT** Paul Revere, Sons of Lxrty bowl, 1768, silver, 5$\frac{1}{2}$ x 11 inches diameter.

always seemed an integral part of America's soul, and to spread the gospel of high craft art to others. A respite from noise, crowds, and pressure-packed nine-to-five days resided in the handmade, in a subdued, often solitary, environment. For many, it was just what the doctor ordered—often quite literally. It also allowed those who had gone through years of following orders in a rigid, compartmentalized military system to explore their creativity.

## THE BIRTH OF A NATIONAL CULTURE

In the Colonial era, craft was very much bound by regional characteristics. Each of the colonies, and later each of the states, took pride in its own distinguishing style and pedigree. While exotic woods like mahogany were imported for rich effect and show, most furniture was made from local woods and materials, such as walnut in Pennsylvania and cherry in Connecticut, with carved embellishments that reflected regional traditions or significance.

If you could hop into your time machine, you'd find craft everywhere you turned. Rather than announcing themselves with a simple line of emotionally cool Helvetica type, mercantiles and other establishments were marked by carved signs that exhibited skill and style in their typography, symbolism, and actual construction. Ships had ornately hand-carved figureheads to ward off the harpies that roamed the deep, while impressing viewers at dockside with the importance of their owners. Even the weathervanes on public buildings were as much works of art as indicators of changes in wind direction.

The handmade and handcrafted grew beyond utilitarian through the skill and energies of craftsmen up and down the Atlantic coast. Notable objects were created: In the metalwork of James Getty of Williamsburg, Virginia; the clockwork of Nathaniel Dominy, of East Hampton, New York, or Peter Stretch of Philadelphia, Pennsylvania; and the furniture of Duncan Phyfe of New York City—objects not just *needed* but also *desired* by those who could afford them.

Over a century and a half later, a nascent nationalism and resistance to waves of immigration would occur, during the period 1920–1945. Evidenced in legislation and newspaper editorials, this new perspective also impacted the arts, where it was known as the Craft Revival, expressed by a popular resurgence in colonial American (translated as "real American") furniture and craft. One company's advertising proudly stated that "the spirit of freedom" was inherent in all things colonial, conjuring up the Founding Fathers' ghosts (and their values) in every living room. Even Gustav Stickley, crusader against all things ornamental, got into the commercial act, producing a line of chairs and tables in the Windsor style—claiming he had always admired them.

And Val-Kill, a small shop producing quality furniture and other crafts, began under the sponsorship of Eleanor Roosevelt when FDR was governor of New York. Conceived as a way to provide supplemental income for the local Hyde Park farming families, who

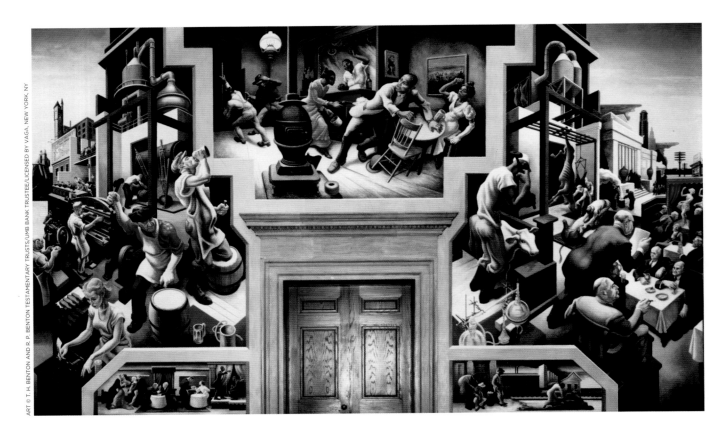

ABOVE

**THOMAS HART BENTON,
MURAL FOR THE MISSOURI
LEGISLATURE, C. 1930S.**
Paid for by the Missouri
legislature, in the spirit of the
WPA, Thomas Hart Benton took
two years to create a series of
murals depicting the state's
history. Painted in canvas with
egg tempera, the subjects in
Benton's signature style include
the Civil War, industrialization,
and folk legends like Frankie
and Johnny, and Jesse James.

would make furniture, pewter, and homespun cloth using traditional craft methods, the shop had principal craftsmen who, ironically, were the same immigrants to which the movement was a reaction.

Then, under the staggering impact of the Great Depression, a series of bold moves by the government kept the craft movement alive, providing a work base for artists of all media, including craftspeople, and, at the same time, celebrating and honoring American values and regional history. Starting with the Public Works of Art Project (1933–1934) and culminating with the Works Progress Administration's Federal Art Project (1935–1943), murals in public buildings, adornment on bridges, and programs designed to encourage, record, and perpetuate communities' heritages gave craft artists respect—and a paycheck—during the most trying of times.

Another WPA/FAP project, perhaps the most fascinating conceptually, was the *Index of American Design*. The idea was simple: Assemble a broad visual archive of our native folk and decorative art as seen in objects, drawing on the particular American idiom of design. What made it unusual was that the record was made up not of photographs but of watercolor paintings that were magical in their detail and could easily be confused for the former. Over six years, 18,257 items were ultimately included, created by approximately 1,000 artists.

The *Index* was motivated in large part by a 1918 article, "On Creating a Usable Past," by the literary critic Van Wyck Brooks. In it, Brooks pressed for the need to discover

# TIMBERLINE LODGE

**A** living reminder of the Depression era is the crown jewel of the WPA, which can be found midway to the summit of Mount Hood, outside Portland, Oregon: the Timberline Lodge. Film aficionados will recognize its exterior, at times haunting and brooding, as the fictional Overlook Hotel in Stanley Kubrick's epic horror movie *The Shining*. Inside and out, the lodge is an awe-inspiring place for all who visit and an homage to the crafts of the Pacific Northwest and the people who practiced them, from woodcarvers and stone masons to blacksmiths and needlecraft artists.

In a proposed report to Congress on the value of the WPA/FAP, aptly called *Art for the Millions,* one of the scores of anonymous writers from the Federal Writers' Project made clear Timberline's lasting legacy:

> *Like the mountain upon which it is built, Timberline Lodge is symbolic of many things not seen in the timber and stone which make it. . . . (T)he building exemplifies a progressive social program which has revived dormant arts and pointed the way for their perpetuation. It presents concretely the evidence that men still aspire to the dream, often secret but always universal, of becoming greater than themselves through association with others in a common purpose.*

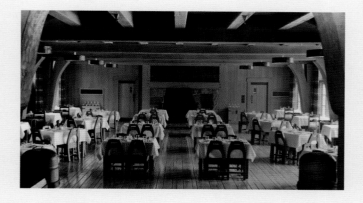

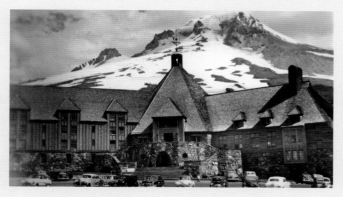

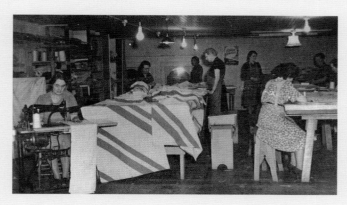

**ABOVE** Screen print by Sue Allen based on a design by Margery Hoffman Smith of a hand-hooked rug made for Timberline Lodge.

**TOP AND CENTER RIGHT** Exterior view of Timberline Lodge, c. 1940. Interior view of Cascade dining room, Timberline Lodge, c. 1940.
More than just a great structure, Timberline's building and all its furnishings were crafted by hand between 1936 and 1938 using wood, stone, flax, iron, and wool from Mount Hood and its environs.

**ABOVE** Period photograph of needleworkers at Timberline Lodge, c. 1937.
Needleworkers hired through the Works Progress Administration stitched bedspreads, curtains, and other fabrics, as well as hooked rugs, using native flowers and wildlife motifs in their patterns. Most popular was the blue gentian, a springtime mountain flower. The original designs are still featured in the lodge's guestrooms and public spaces.

what made America, America—and then to communicate its authentic, aesthetic self-identity. In other words, what was its "usable past"? Building an identity was, after all, something all nations and civilizations had done selectively (something akin to Winston Churchill's famous comment "History is written by the victors").

It was Constance Burke, the noted cultural historian and editor of the *Index,* who fully realized and stated the American character: an abundant folk tradition whose very existence was largely unknown and seriously unappreciated. With the *Index,* original Americana, ranging from quilts to carousel animals, weathervanes to stoneware, ships' figureheads to cigar-store Indians, all were recognized for their place in our collective spirit and native tradition.

An even more significant effort to inculcate this kind of recognition and appreciation of the craft artist and his or her work was the Museum of Contemporary Crafts, opened in September 1956 in New York City. The location was auspicious—on Manhattan's West Fifty-third Street, directly across from the city's more prominent resident, the Museum of Modern Art. This physical proximity implied, at least subconsciously, that modern American craft and modern international art were equals.

MCC (later the American Craft Museum, and now the Museum of Arts & Design) was founded by Aileen Osborn Webb, perhaps the single most committed person to American craft in the entire country. Her unwavering support and patronage since the

1920s did for craft financially what the *Index of American Design* had done intellectually: It made indisputable that craft was an integral component of American life and was something to be proud of. Her interests extended from educational programs and workshops to exhibits to the 1943 establishment of the American Craftsmen's Educational Council, which would become the American Craft Council. Going on seven decades, their mission reads, in part:

We value:

- *making* as fundamental to the human experience;
- *craft* as a means of learning and self-discovery—a way of unifying body, mind, and spirit;
- *makers* who work directly with materials, expressing their individual voice through objects that embody creativity and technical mastery;
- *craft traditions* and the role of makers in passing these on to future generations.

## TECHNOLOGY: PROGRESS AND PROWESS

As all things change over time, so, too, have our attitudes toward the objects integral to our lives, and the way they are made. Not surprisingly, the transitions have sometimes led to mixed results.

When America was going through its youth in the 1700s, objects were largely handmade. It was how things were done, because it was the only way things *could* be done. True, raw materials were often processed by water power, steam, or the like, but the assembling itself—*the making*—relied on hand tools, often the same kind used by craft artists today. Mass production—the producing of multiples quickly and cheaply—was not even a dream, let alone a reality, in the towns and cities across the heartland and in the vastness of unexplored America. There was no need to conserve; there were boundless natural resources that could be made into the objects we needed, when we wanted them.

By the mid-1800s—our country's adolescence—the wave of the Industrial Revolution that had already made its mark on these shores brought with it a flood of objects often decried by purists for their slipshod quality. But mass manufacturing equaled mass ownership, further evidence of a politically, economically, and socially democratic America. The idea that everybody could own a tea service, for example—and not just *any* tea service, but one that looked the *same*—was not conformity, but proof positive of a person's success and position in life. This phenomenon would predate the historian Daniel Boorstin's "consumption communities" formed not on the basis of common politics, religion, or stations in life, but on product ownership.

There has frequently been cross-pollination between industry and the world of craft, most notably in what is often viewed as the key process of production: the assembly line.

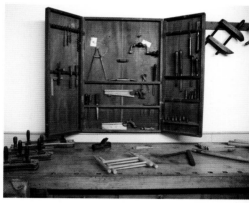

TOP

**AILEEN OSBORN WEBB, 1956.**
In addition to founding the Museum of Contemporary Crafts, Aileen Osborn Webb (1892–1979) also made craft objects available for sale through America House, a cooperative shop in New York. The shop provided a marketing outlet for the best work in virtually every medium.

ABOVE

**SHAKER CARPENTRY TOOLS, LATE 19TH CENTURY**
Sophisticated in its simplicity, Shaker furniture and objects have been made for more than two hundred years in the same functional, unadorned style.

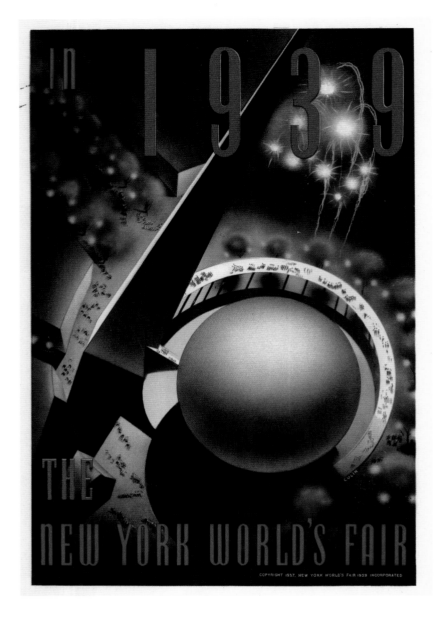

Although it was lauded as revolutionary in its approach, it was, essentially, an industrial take on the craft production line common at the time in craft workshops, when different artists were assigned tasks that complemented and maximized their particular skills.

By the early twentieth century, and the beginnings of our road to national maturity, the epitome of uniformity as a status symbol came with Henry Ford's Model T. Here was mass production for the purist, with every vehicle trundling down the line (and down the washboard roads) identical in every way, even to the point that Ford boasted, "You can have it in any color you want—as long as it's black."

The 1930s would begin as a decade of economic paralysis with people from virtually all tiers of society tired and worn down by daily struggles. But starting with FDR's first hundred days in the waning days of winter 1933, the decade and country's confidence would slowly build, culminating in the soaring symbolism of a 610-foot-tall Trylon and Perisphere at New York's 1939 World's Fair—heralding the "World of Tomorrow" and the riches it promised. The streamlined Machine Age, typified by Art Deco and Bauhaus, became the rage in everything from cigarette lighters to the massive Pennsylvania Railroad S1 locomotive of Raymond Loewy. The often-futuristic industrial look would maintain a hold on many people's imaginations.

In the 1950s, new technologies were adapted by multitalented practitioners such as the husband-wife team of Charles and Rae Eames, who drove their Cranbrook crafts background to, among other things, design a new range of furniture that took advantage of laminated woods. Extruded aluminum from aviation, advances in fabrics, and a new generation of colors and dyes would broaden horizons as well.

But this era also had its dark side. Advertising and mass branding created the consumerist society, and with it the infamy and waste of planned obsolescence. It was a

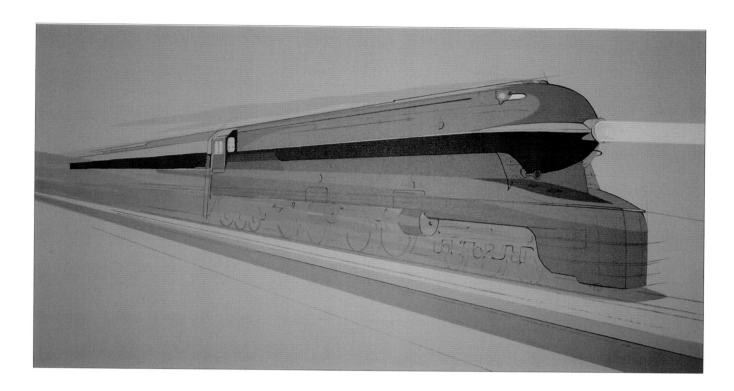

time, too often, of kitsch instead of class; *craft* became synonymous with *crafting*, a euphemism for home hobbies. Leather moccasins and mosaic-tile bowl kits, desk sets made from Popsicle sticks, and paint-by-number art held a prominent place in everyone's home. And while craft may have been introduced to an even larger audience, we must ask, at what price?

Craft as a noble pursuit by serious artists was debased in the public eye. Because something could be so easy and require no originality, it could be done by anyone—from school kids to grannies. No training. No skill. No experience. No commitment. And thus the very craft of craft was eliminated.

Today a new crafts paradigm, with its "truth to material" credo, extends to all disciplines. Studio craft presents an alternative to the factory as the locus where objects, by dint of big tools and complex processes, can be made. Its proponents have demonstrated that these could be modified to work in smaller environments. With it has come the single most important sea change in the way craft has been conceived and executed: one person making an entire object from conception to completion.

Here in the first decade of the twenty-first century, we find craft at a high-water mark. Perhaps it is a need to find and hold on to tradition and comfort and trust in a world turned upside down. Perhaps it is that many people today have the means to acquire the finest examples of the craft tradition. But whatever the cause, the effect is clear: Craft is recognized, perhaps as never before, as an important part of our national heritage and psyche.

# WOMEN AS LEADERS IN AMERICAN CRAFT

JUST as women have been at the forefront as artists and entrepreneurs, they have been pivotal in establishing and nurturing organizations that support craft artists and foster appreciation of their work. Over one hundred years ago the photographer Sarah Choate Sears and the designer Sarah Wyman Whitman were prominent Bostonians who supported the 1897 establishment of Boston's Society of Arts and Crafts, making it America's oldest nonprofit craft organization.

A common thread emerged in the 1920s and 1930s as craft was seen as an economic engine that could drive self-sufficiency among victims of hard times, led by the efforts of Lucy Morgan in Appalachia (discussed in Chapter 10).

Less well known was Mary Hill Coolidge, a Bostonian who summered in Sandwich, New Hampshire, and formed Sandwich Home Industries in 1926 as a means of encouraging rural handicrafts and helping their makers earn additional income. As the Depression deepened, and the need to support craft arts statewide became apparent, she founded the League of New Hampshire Craftsmen and served as its first president.

In Portland, Oregon, Lydia Herrick Hodge led a dynamic group of volunteers, including Katherine Macnab, in establishing the Oregon Ceramic Studio. A philanthropist, teacher, and activist, Hodge directed the studio from its inception in 1937 until her death in 1960. From the outset, its mission was to complement the education programs at institutions like the Portland Arts and Crafts Society. Here, artists would have

a venue to show their work for sale. At the studio's first exhibition in 1939, she purchased a yellow crackle-glaze bowl by the ceramist Glen Lukens that became the first piece in the collection of what has become Portland's Museum of Contemporary Crafts, a beacon of the Northwest aesthetic of natural materials.

The museum board voted to move from its original location to a 15,000-square-foot facility in Portland's art-centric Pearl District, reopening in 2007 as the Museum of Contemporary Craft.

More than merely a place to showcase established and emerging artists, the Museum of Contemporary Craft connects with the community to expand the audience for craft through workshops tailored to adults, children, and families.

But the grandest of the grand dames of craft was Aileen Osborn Webb. In just four decades she founded the largest craft organization in the nation; established the first museum dedicated to American craft; opened a retail shop—America House—offering artists' work; and edited a journal that continues today. Then, too, she helped establish the School of American Craftsmen, now at the Rochester Institute of Technology, and organized a 1957 international conference of craft artists at Asilomar, California, which announced the studio crafts movement to the world.

These three dynamic women put their substantial personal resources as well as their time into craft, and are largely responsible for today's acceptance—and accessibility—of craft. Our debt to them is far-reaching. Today's craft organizations—local, regional, national, even global through the Internet—owe their genesis to these Founding Mothers' foresight and passion.

Since then, women curators and show directors, like Eudorah Moore and her annual *California Design* exhibitions at the Pasadena Museum of Art in the 1960s and 1970s, have furthered their influence. By introducing a jury system, handsome catalogs, and promotional efforts that included coverage in national magazines—she heightened interest and raised the bar.

The importance of these shows cannot be underestimated; at the time, artists had few other ways to reach out to their fellow craftsmen or to find an appreciative audience for their work. As traveling exhibitions crisscrossed the country, they brought tangible evidence of advancements in the field and stimulated new bursts of creative activity wherever they appeared. The wealth of visual information and global networking that characterize the field today belies the fact that between the 1930s and 1950s books were chiefly limited to manuals, few periodicals existed aside from Aileen Osborn Webb's *Craft Horizons* (now *American Craft*), and few organi-

zations aside from her American Craft Council existed for the purpose of fostering a community of craftsmen.

Webb and her fellow craft advocates changed the landscape. They knew that if people could have a better understanding of handmade objects and more access to them, crafts could have an influence on mass-produced design. They also felt that craft could improve not only the lives of those who did the work but also the lives of those who enjoyed their products.

---

**OPPOSITE, TOP** *Paul Bunyan in Clay* was the title of the first in-house exhibition by what was then the Oregon Ceramic Studio. The exhibition, shown here, was an important step in the creation of the Studio's transformation into today's Museum of Contemporary Craft in Portland.

**OPPOSITE, BOTTOM** Edwin and Mary Goldsmith Scheier, *Bowl*, **13.5 in. diameter, 1951.**
Although they lived and worked in New Hampshire and were active participants in the League of New Hampshire Craftsmen, Edwin and Mary Scheier also traveled often to Puerto Rico and Mexico. As seen in this bowl, stylized Meso-American and African devices were often incorporated in their pottery, giving it a somewhat calligraphic character.

**ABOVE** Glen Lukens, yellow crackle-glaze bowl.

# CRAFT ISN'T HIS STORY OR HER STORY— IT'S OUR STORY

★

The story of craft in America is a journey of renewal and reinvention. We are a country people came to, rather than left from: a place big and brawny enough to accept and absorb the ebb and flow as well as the personalities, cultures, and skills immigrants brought with them. So, when scores of countries gave us their tired, their poor, and their huddled masses, well, they also gave us a rich tradition of craft that not only lives on in photographs and museums but also in today's homes, offices, and on our bodies. It is the output of a new generation, drawing on the skills of their ancestors.

The net result today is an amalgam of sources and resources unparalleled in history. With the breadth of our geography, the depth of our economy, and the openness of our society, things are tried here that might never be considered elsewhere in the world.

BELOW
**KATHERINE GRAY, *!*, 2001, HOT-WORKED GLASS, 12 x 3 x 3 INCHES.**

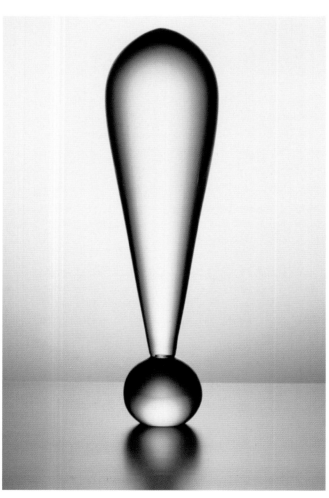

America offers an environment that makes possible an infinite number of "what-ifs" to develop new styles, new attitudes, new ways of doing things.

The architect Mies van der Rohe said, "God is in the details." To Mies's maxim, we can rightly add Ezra Pound's dictum to "make it new." Craft today is lush, rich, vibrant. It sings with renewed vitality like never before. It doesn't just stretch boundaries—it shatters them by ignoring perceived limitations and expectations. It would be a shame if we saw elegance without the exclamation point, design without the delight. We would be missing something, and it would be sad, indeed.

For F. Scott Fitzgerald there may have been no second acts in American life, but the genealogy of craft proves him wrong. Like a mighty chestnut, branches of this "family tree" spread thousands of miles, traversing bodies of water and spanning mighty mountains.

There is nothing like American craft as a powerful reflection of our history, our culture, our society, and our common purpose. It is as much a part of our collective DNA as our imagination. It is a by-product of all we were, all we are, and all we can become. In sum, craft is us.

• • •

# COMMUNITIES
# OF CULTURE

**THE SHAKERS AT A SPIRITUALIST CAMP MEETING, C. 1880.**

In their new home in America, the Shakers could freely practice their religious beliefs
and often took part in local revivals. During these religious revivals, they could voice their spiritual gifts,
or testimonies, and draw new converts to their community.

C RAFT AND COMMUNITY HAVE ALWAYS BEEN INSEPARA-
BLE. AMERICA IS A NATION OF DIVERSE CULTURES AND
EACH HAS GIVEN RISE TO DISTINCTIVE CRAFTS.
ALTHOUGH AMERICA HAS BEEN REFERRED TO AS A MELTING POT OF
CULTURES, IT MIGHT BE MORE VIVIDLY DESCRIBED AS A WOVEN
tapestry, the "threads [brought] from around the world. . . . Having these threads
come together, coalesce, [is] what has created the fabric of our nation, not a tra-
ditional fabric, but something different, something uniquely American."[1]

In America's past, the links between communities and the crafts they pro-
duced are not all the same: For some, crafts are part of religious practices or are
expressions of philosophical ideals; for others, crafts are rooted in heritage and
reverence for the handmade or, in the case of established craft communities, in
craft making itself. Members of religious communities such as the Shakers,
Quakers, Amish, and Mennonites have added their design aesthetic and hand-
work to the structure of American crafts. They have created craft traditions that
are strong, essential, elevating, and, by now, recognized as distinctly American.
The early-twentieth-century Arts and Crafts communities and related utopian

societies that championed the moral superiority of the handmade and the integration of art into daily life have also added to the American aesthetic landscape and have left their stylistic imprint on the crafts.

American Indians from the plains, the plateaus, and the pueblos have passed on their own creationist cultures through the oral tradition of storytelling, reflected in the symbolism and representation of their physical crafts, from pottery to painting to beadwork. In the twenty-first century, the legends, mysteries, and messages remain constant, interpreted anew by the latest generation of the same communities.

Countless immigrants, émigrés, and displaced African-Americans have given us a rich tradition of craft that lives on as decorative art in our homes and wearable art on our bodies. The work of furniture makers, carvers, glassblowers, and potters who evolved a very American style from their homeland heritages pays homage to the skills and styles of their forbearers.

The abundance of community is infinite and may also be found among teachers, students, and schools throughout the country, from the traditions of the Penland School of Crafts in North Carolina to the arts and crafts curricula developed at the California College of the Arts in northern California, from the Cranbrook Academy of Art in Michigan to Berea College in Kentucky, where the students work their way through college in the craft shops. This is craft as communal family tree: Skills take root in the rich soil of the campus and are carried out by each and every student who passes through its gates.

The exploration of the many communities of craft reveals the origins and substance of our artistic identity—elucidating who we are as a people and highlighting the objects we craft by hand to give meaning to our lives and experiences.

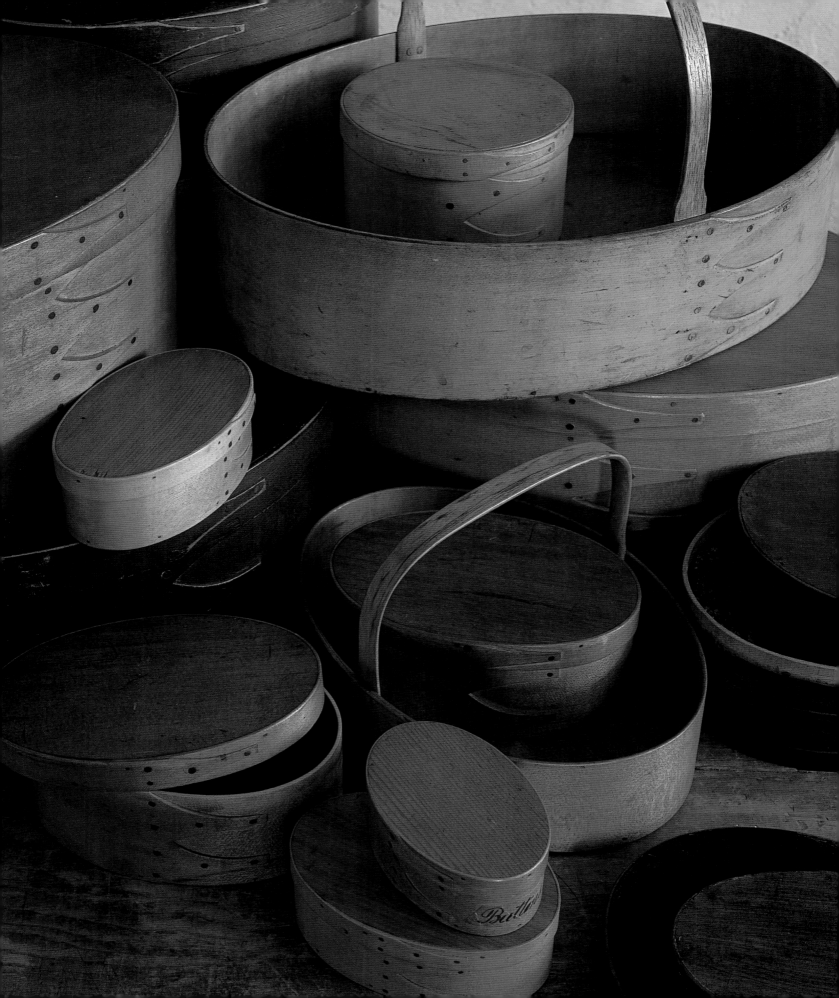

# Religious Communities and the Honoring of the Handmade

## THE SHAKER SETTLEMENTS IN AMERICA

★

SOMETIMES BEAUTIFUL HANDCRAFTED objects come from surprising, unexpected sources. This is certainly the case with the exemplary furnishings and household goods created by the skilled hands of Shakers. Although they were a religious community and not affiliated with any craft society or guild, the Shakers, believing in the inherent beauty, utility, and spiritual transcendence of objects made by hand, were inspired to create superbly designed and crafted items.

Formally named the United Society of Believers in Christ's Second Appearing, the Shakers were a religious sect founded in the eighteenth century by the mystic Ann Lee, a humble textile-mill worker from Manchester, England.[1] The "Shaking Quakers" were persecuted for their outspoken and demonstrative style of worship: Shaker Believers expressed their fervor at worship services through shouting, singing, and ecstatic dancing—agitated shaking, swirling, and leaping— practices that were regarded as acts of profanity by the leaders of traditional

OPPOSITE

**OVAL BOXES.**

Shakers became known for their production of oval boxes, which they made by the thousands in various sizes, in nesting combinations, and with "inserts" to fill specific needs such as holding spools of thread and sewing notions. The "finger" or "swallow-tail" joinery was a useful design feature as it allowed the wood to expand and contract across the grain in response to changes in humidity, thereby preventing warping and buckling. Although the Shakers did not invent this constructive feature, they certainly exploited its potential to create an appealing design.

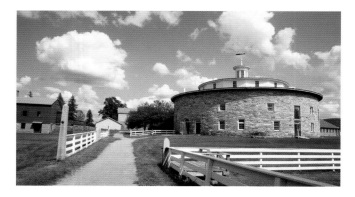

Anglican religions. "Mother Ann," as she was called by her
followers, received a vision from God instructing her to
lead a ministry of Believers into the New World—to
America—where they would be free from religious
persecution.

She and eight devoted followers emigrated to America
in 1774 and established the first Shaker settlement in
upstate New York, in Watervliet, on a piece of wilderness
land near Albany. By 1840, at the peak of their member-
ship, there were nearly six thousand Shaker Brothers and
Sisters living and working together in nineteen official
communities, scattered from Maine to Kentucky. The
furniture and products the Shakers created for their com-
munity needs were spare and beautiful, intelligently
designed, well constructed, and sturdy.

Although their communities were governed by
religious doctrines, not design principles, the Shakers
nevertheless created craft communities where useful,
high-quality goods with a sophisticated design sensibility
were made for their own consumption and for sale to others in "The World," that is,
beyond the borders of their own communities. Today, Shaker objects have become classic
examples of functionalist design and virtuosic craftsmanship, appreciated by collectors
for their honest, graceful style and superior workmanship. These inspired, handcrafted

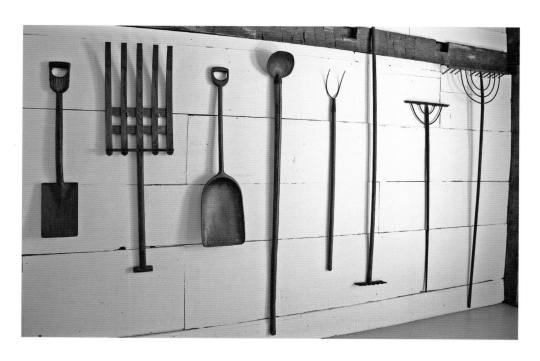

furnishings and commodities are one of the bequests of Shakerism and can be best understood in the context of this sect's history, framed by the religious beliefs and spirituality that motivated their production and shaped their aesthetics.

## ESSENTIAL SHAKER BELIEFS

The basic tenets that directed the Shakers' way of life were beliefs in communal living, celibacy, confession of sin, pacifism, gender equality, and hard labor. Their guiding principle was simplicity in all matters pertaining to material, temporal, and spiritual life. The "simple life," according to Mother Ann's teaching, meant giving up marriage, private property, and personal desire for the common welfare of the community. Believers would attain true selflessness and eternal redemption by following these Shaker doctrines.

As communitarians, the Shakers set themselves apart. They shunned extraneous ornament and adornment in their surroundings, furnishings, and personal dress; they required neatness, order, uniformity, and utility; and they upheld a strict work ethic that demanded industrious, conscientious effort. Laziness, slovenly behavior, and inferior work were not to be tolerated. Reflecting their belief that work was an act of worship, all forms of work, from the most menial and manual to the most skilled and sophisticated, were to be performed with care and a commitment to perfection. "Put your hands to work, and your hearts to God, and a blessing will attend you" was one of Mother Ann's "wisdoms" and was a bedrock principle of the sect. When Eldress Bertha Lindsay of Canterbury, New Hampshire, declared, "You don't have to get down on your knees to say a prayer," she was affirming the Shakers' beliefs that work and worship were inseparable

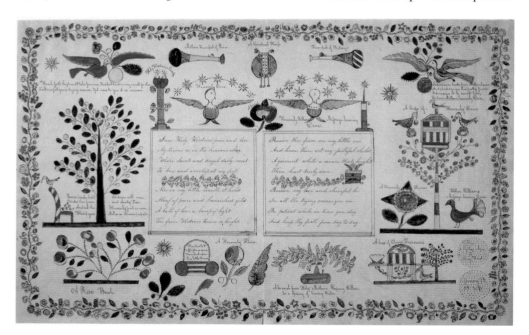

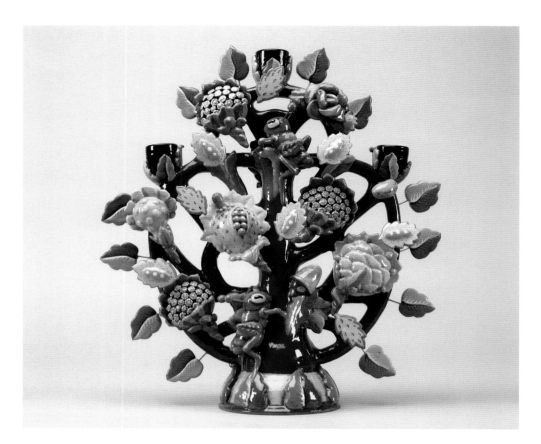

and that honest hard work, done well, was a spiritual offering.[2] In Mother Ann's own words: "Labor to Feel the Life of God in your soul; labor to make the way of God your own; let it be your inheritance, your treasure, your occupation, your daily calling. Labor to God for your own soul as though there were no other soul on earth."[3]

## THE END OF THE SHAKER FAMILY TREE

The Shakers' monastic and communitarian way of life has existed for more than two hundred years, but the number of Shaker Believers and their religious communities has been diminishing since the mid-nineteenth century. Community buildings that formerly comprised Shaker villages were sold or converted to historical properties after the last member living in the settlement died. Today only one Shaker community remains—a farm and village at Sabbathday Lake, Maine—and fewer than a handful of Believers are living there. However, the lure of the Shaker way of life still attracts "inquirers" at the Sabbathday Lake community where visitors numbering from thirty to fifty attend Shaker public meetings during the summer months.[4] It is unknown whether Shakerism as a theology will endure beyond the passing of the last Believer residing at the Maine community. What can be conjectured, with some certainty, is that the sensibility that was informed

by, and responsive to, their physical environment will live on. Shakerism resonates in contemporary culture through the recordings of their songs and hymns—the sacred hymn "The Gift to Be Simple" was popularized by celebrated composer Aaron Copland—through their colorful and compelling "gift" or "spirit" drawings, visions documented by Believers such as the well-known *Tree of Life* drawings, which have served as inspiration to generations of artists, and through their purposeful and beautiful crafts.

## SHAKER FURNITURE AS AN ENDURING LEGACY

The Shakers' legacy, their traditions and values, can be seen in the fine craftsmanship and the distinctive designs of their furniture, woodenware, baskets, and textiles. All their furnishings and household goods were made according to the Shaker precepts that governed every aspect of their lives: simplicity, utility, order, permanence, versatility, clean lines, and unadorned surfaces. Perhaps the most iconic Shaker objects are the slat-back or ladder-back chairs: the side chairs and rockers that were made by the thousands for Believers in every settlement and produced in great variety for sale in Shaker village stores and catalogs to this day.

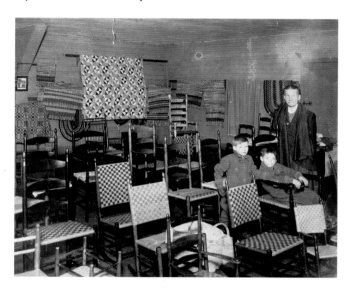

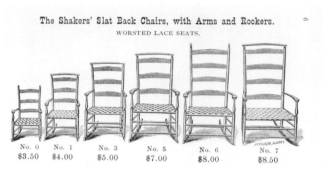

The Shakers' Slat Back Chairs, with Arms and Rockers.
WORSTED LACE SEATS.

No. 0 $3.50   No. 1 $4.00   No. 3 $5.00   No. 5 $7.00   No. 6 $8.00   No. 7 $8.50

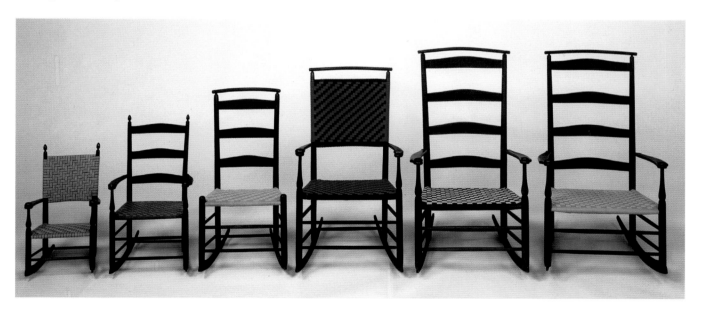

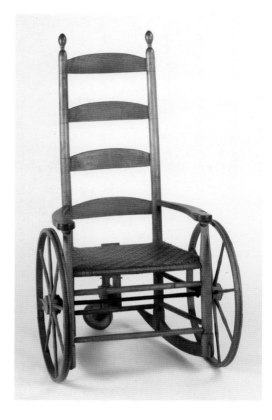

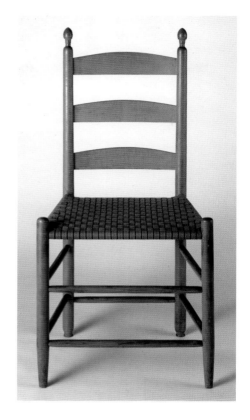

OPPOSITE

**SIDE CHAIR HUNG ON A PEG RAIL.**

Chairs were lifted and hooked on pegs to clear the floors for sweeping or to make space for community events.

FAR LEFT

**WHEELCHAIR, WATERVLIET, NEW YORK, C. 1820–1830.**

This early Watervleit rocking chair was converted into a wheelchair for an invalid.

LEFT

**CHAIR, MOUNT LEBANON, NEW YORK, 1830–1850.**

The iconic Shaker ladder-back side chair typifies Shaker furniture and their way of life: straightforward and unornamented, simple and refined.

Shaker craftsmen brought to their communities the skills they had acquired in The World before they converted, and they carried with them the knowledge of worldly styles. In general, Shaker furniture is remarkable not for its originality but for its elegance and refined simplicity.

Shaker ladder-back chairs are based on the vernacular New England side chairs and rockers that were popular in the early 1800s, but they reveal notable refinements of form—a composed, quiet grace in their straightforward design, balanced proportions, and delicate profiles—that set them apart from their lumbering ancestors. The chairs are angled back at a slant to provide greater support and comfortable seating; they are light and easily moved from room to room as necessitated by community activities; they can be hung on pegboards when not in use. Many were constructed with woven-tape seats, a Shaker advancement that made them more resilient, durable, and attractive, the tape offering a variety of colors and patterns—checkerboard, herringbone, and basket weave. Other materials used for seat construction included rush, splint, leather, plank, and cane. Entirely distinctive, and unique to the side chairs, were the "tilter" feet, attached to the back posts to allow the sitter to tilt back in the chair without toppling over and helped to prevent damage to the wood flooring.

The aesthetic impression of the Shaker ladder-back has strongly influenced chair design for the past two centuries. Its form and concept are continually being reworked and reinvented by modern furniture makers, who borrow from the store of Shaker style.

# NEW EXPRESSIONS, OLD FORMS: SHAKER CHAIRS ARE REINVENTED

**M**ANY contemporary furniture makers have been inspired to create new chair forms by recalling traditional Shaker ladder-backs in their designs. Leon Rasmeier's *Old Rocker* combines the essential style elements of the historic Shaker rocker it reflects, but the artist has made the chair a product of its time by using the contemporary materials of bent plywood for the frame and red-colored plastic for the runners.

The Shaker ladder-back was also used as source material and point of departure in the whimsical chairs designed by Jon Brooks and Garry Knox Bennett. Brooks amusingly elongates the back of his chair to an impossible length, and one wonders if his design is a playful reference to an actual Shaker ladder, such as the one shown here, used for apple picking. Bennett wittily constructs the ladder-back of his chair to mimic a modern-day ladder, although presented here in smaller scale. Bennett further complicates the chair by incorporating the seemingly real ladder of the ladder-back with a *Z* profile, the overall design of which mirrors the famous modernist *Zig Zag Chair* by Gerrit Rietveld—a clever combining of art historical references, indeed.

RIGHT Jon Brooks, Ladderback Chair, 1996.

OPPOSITE, LEFT Shaker ladder, Mount Lebanon, New York, 1875–1900.

OPPOSITE, TOP RIGHT Leon Rasmeier, *Old Rocker*, 2001.

OPPOSITE, BOTTOM RIGHT Garry Knox Bennett, Old Ladder Back #2 from Rietveld Series, 2002.

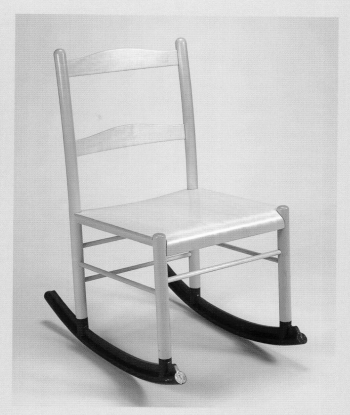

RIGHT
**DONA LOOK, *BASKET*, 2006.**
This birch-bark and waxed-silk thread basket constructed and sewn by contemporary artist Dona Look embodies many of the same qualities associated with Shaker crafts: the sensitivity to material and texture, the perceptible restraint of the design yet the generous touch of the hand, the fluency of the execution, and the uncompromised clarity of its utility.

BELOW
**PHARMACEUTICAL WORKSHOP, HANCOCK SHAKER VILLAGE.**
Intricately woven Shaker baskets of varying sizes and shapes were used for many purposes in the community household, workshop, and garden. Although used as common containers by the Shakers, these baskets today are treasured for their consummate beauty and refinement.

OPPOSITE
**COOPER-WARE FROM A VARIETY OF EASTERN SHAKER COMMUNITIES, 1830–1875.**
Fine pails, nicely painted, and some fitted with lids and handles, were intended for indoor use. This grouping of pails—each painted an aesthetically pleasing shade— demonstrates the importance of color in the Shaker world.

By merging key elements of Shaker design with their own vision, contemporary makers evoke the purity, simplicity, and utility of Shaker objects and reference the plain-living and spiritual lifestyle of the Shakers, while adding their personal stamp of creative expression and artistry. What results is not so much a hybrid as an adaptation: a new look at a timeless form that is inflected by history but succeeds in making a statement of its own time and place, often poignantly commenting on ideas that have currency in American contemporary culture.

## "THAT WHICH IN ITSELF HAS THE HIGHEST USE, POSSESSES THE GREATEST BEAUTY"

The most direct application of the Shaker conviction that "utility is beauty" is seen in the eminently rational designs of their everyday containers and utensils. Shaker baskets, wooden boxes, and buckets are ineffably simple and practical, yet they show a cultivated sensitivity to proportion, balance, line, color, texture, and volume—the formal qualities that generally define sculpture. These beautiful, useful, and bold objects own their beauty naturally, their decorative elements imbuing them with sensate qualities that are intrinsic

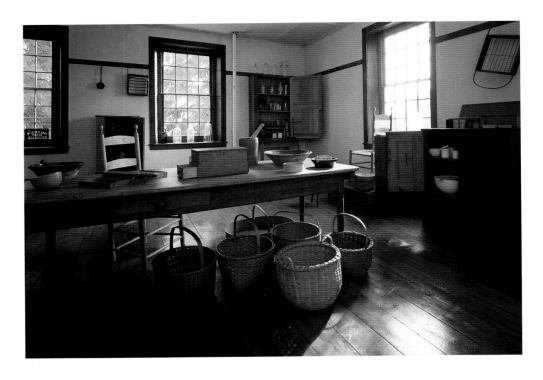

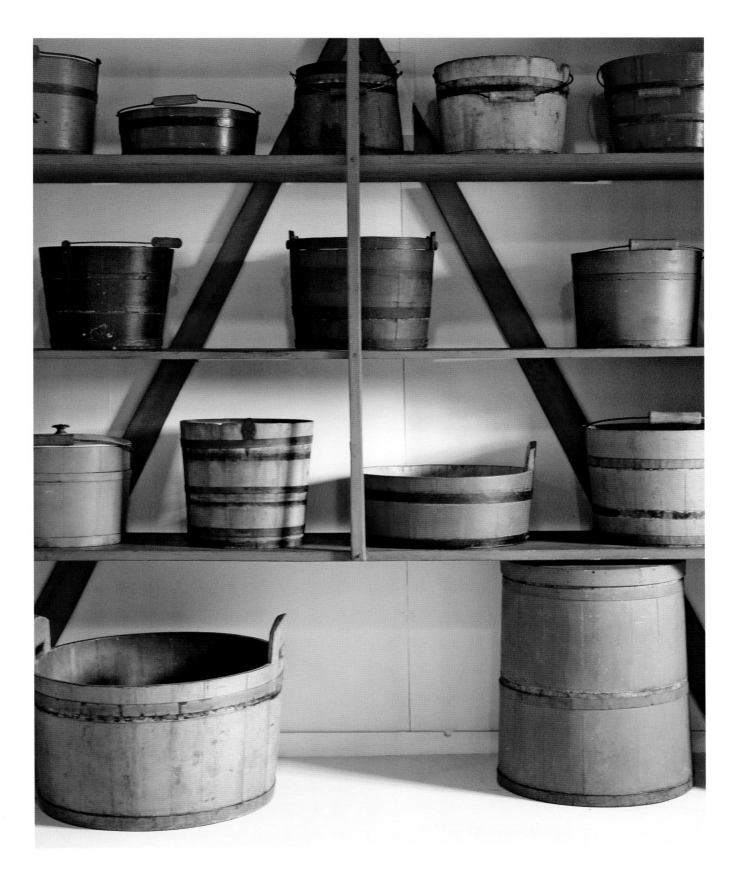

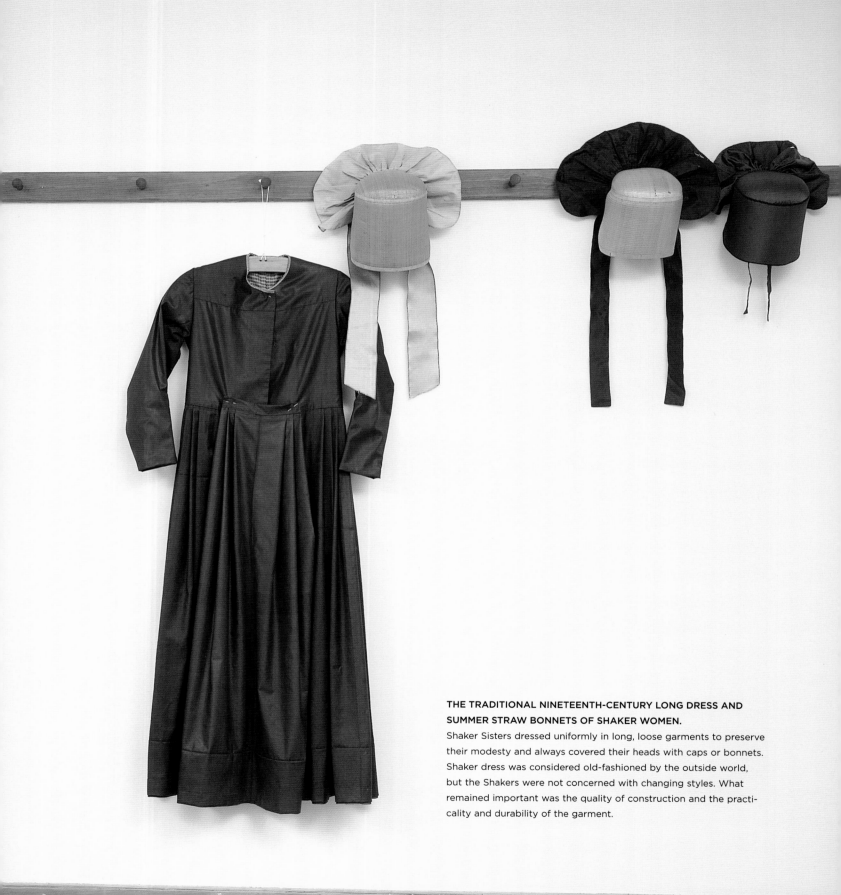

**THE TRADITIONAL NINETEENTH-CENTURY LONG DRESS AND SUMMER STRAW BONNETS OF SHAKER WOMEN.**

Shaker Sisters dressed uniformly in long, loose garments to preserve their modesty and always covered their heads with caps or bonnets. Shaker dress was considered old-fashioned by the outside world, but the Shakers were not concerned with changing styles. What remained important was the quality of construction and the practicality and durability of the garment.

to their design. Shaker baskets, woven in open or tight ornamental weaves depending on function, delight the eye that beholds them; oval boxes, with their repeating pattern of swallow-tail joints and perfectly aligned copper tacks, seduce the hand that holds them; and buckets, in a spectrum of colors and shapes, display precisionist attention to detail — the firm anchoring and proper arc of the handle, the exact fit of the lid, and the delicate banding. As the Shaker saying goes: "Trifles make perfection, but perfection is no trifle."[5]

## INTERWOVEN WITH THEIR BELIEFS: THE MAKING OF SHAKER TEXTILES

The Shakers' reverence for the integrity of craftsmanship, the value of the handmade, and the necessity for order and uniformity are demonstrated in the textiles they produced. Sisters in every settlement were occupied in making the vast array of textiles necessary to supply the community. They prepared home-dyed yarn and cloth; cut and constructed clothing; made textiles for domestic use such as coverlets, sheets, woolen blankets, linen towels, tapes for chair seats, and rugs — braided, hooked, crocheted, and knitted; they wove neckerchiefs of wool, cotton, and silk, bonnets of palm leaf and poplar cloth, and warm, woolen cloaks that were part of the Sisters' uniform ensembles and, when made more elaborately, sold to women "outside."

Shaker textiles are recognized today for their consummate refinement. The workmanship, from the homespun thread to the expert weaving and sewing, was exemplary. Although the Sisters used conventional loom patterns in their cloth — plain, "diaper," goose-eye, huckaback, M's and O's — they made subtle variations in the weave pattern and added sections of colors to the weft and warp threads, making their woven goods both distinctive and desirable. Characteristic of Shaker household textiles are their restrained, orderly patterns — delicate stripes and lattice designs — finely woven in two colors, most often white with blue.

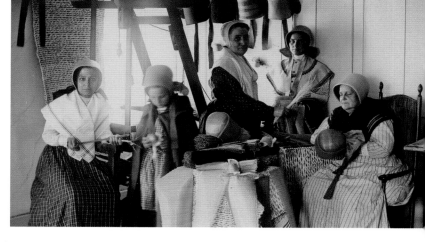

The common use of the color blue may have been as much practical as aesthetic: Blue was a regularly used dye at many of the Shaker Villages, and "thousands of yards of cloth" were dyed and woven annually by Sisters to supply the community and the marketplace. This nearly mass-production approach was economical and resulted in consistency and sameness—all attributes coveted by the Shakers.[6]

## STRIVING FOR THE HEAVENLY IDEAL

As many historians have noted, the Shakers were not as aesthetically severe as they are often portrayed, and their world was neither colorless nor completely stripped of decorative appeal. The handcrafting of beautiful objects and environments reaffirmed their deeply held conviction that heaven—a spiritual place of purity, simplicity, and intrinsic beauty—could be built on earth. This Shaker Hymn from Mount Lebanon, New York, written in 1884 well illustrates the concept:

*My heavenly home is here,*
*No longer need I wait*
*To cross the foaming river,*
*Or pass the pearly gate;*
*I've angels all around me,*
*With kindness they surround me,*
*To a glorious cause they've bound me,*
*And my heavenly home is here.*[7]

ABOVE
**CLOAK, LATE 19TH CENTURY.**
This rose-colored cloak was made by the Shaker Sisters at Mount Lebanon for sale to Mrs. William Bradford around the turn of the century, and is representative of the more elaborate and colorful cloaks sold to women "outside."
It bears the label of "E. J. Neale & Co."

OPPOSITE, BOTTOM
**EXHIBIT OF TYPICAL FURNISHINGS OF A POST–CIVIL WAR MOUNT LEBANON, NEW YORK, SHAKER "RETIRING ROOM."**
The consistent blue and blue/white fabrics the Shakers used for "comfortables," wall hangings, and other household textiles impart constancy, harmony, and order to their domestic settings.

ABOVE LEFT
**WOVEN SILK KERCHIEFS. SHAKER SISTERS OF SOUTH UNION SETTLEMENT, KENTUCKY, C. 1850.**
The stunning, vibrantly colored and patterned silk kerchiefs woven by the Sisters at South Union Settlement in Kentucky are emblematic of the Shaker design philosophy that advocated creating objects both beautiful and useful. Beauty was one of the many "heavenly ideals" that Shakers sought to attain in their daily lives.

LEFT
**DETAIL OF FIBER ARTIST RANDALL DARWALL'S HAND-DYED, HAND-WOVEN SILK SCARVES AND SHAWLS, 2006.**
Darwall's complex weave structures explore the reactive movement of color in dynamic proportions, and aesthetically share an uncanny kinship with Shaker silk scarves woven a century earlier.

# EAST MEETS WEST: THE JAPANESE-SHAKER FURNITURE OF GEORGE NAKASHIMA

IN his contemporary designs, George Nakashima, the Japanese-American architect, furniture maker, and master craftsman, embraced the Shaker aesthetic of simplicity, harmony, fitness for purpose, and reverence for the natural beauty of wood.

Nakashima often described his furniture as "Japanese-Shaker," and, referring to the deliberate reductivism, clarity of design, and emphasis on evident handwork, commented that, for him, "function and beauty and minimalism of line are the main goals in the construction of a chair." Moreover, Nakashima believed, like the Shakers, that a man's life and work should be integrated and not separated; he maintained the holistic view that living life through work was "a way of being" that nurtured the spirit.

Nakashima, trained as an architect and furniture designer, honed his woodworking skills while incarcerated in an internment camp in the Idaho desert during World War II. He produced many functional furniture forms, particularly benches, during his long life.

Stylistically, Nakashima's spindle-back bench (1960) is a direct descendant of the meetinghouse bench made by Shaker craftsmen more than a century earlier. Shakers produced these long spindle-back benches to be used in their meetinghouses, their places of worship, as pews, with the added requirements that the benches be light in weight and portable. The spindles are delicately hand turned and slightly canted back for comfort. The legs and stretchers are austerely slimmed to economize on material and underscore the minimalist profile. These features impart a regularity of line, rhythm, ethereal lightness, and natural grace to the design.

Nakashima's contemporary spindle-back bench mirrors all of these qualities and expresses his innovations: the width of the crest rail is thinner and more fluid; and the stretcher support is eliminated, resulting in a cleaner design with more physical and visual space beneath the seat.

In Nakashima's second-generation benches, the Conoid series, there is a perceptible change. Here one sees a deft blending of Shaker tradition with Nakashima's own signature. The conventional right-angled, modestly proportioned bench seat has been reconfigured as an organic, monolithic free-form plank of beautifully figured wood. Some seats retain natural edges; some retain inherent imperfections.

Nakashima carefully chose each slab of wood and precisely cut, sanded, and finished it by hand. This massive, freely contoured bench seat of polished walnut, from which the spindle-back lithely rises, exalts the raw beauty and physical power of the wood. Each Conoid Bench is a testament to the unique partnership between woodworker and tree, and underscores Nakashima's deep reverence for nature, as stated in his writings: "It is an art- and soul-satisfying adventure to walk the forests of the world, to commune with trees. . . . To bring this living material to the work bench, ultimately to give it a second life."

Mira Nakashima, who attended Harvard University and received a master's degree in architecture from Waseda University in Tokyo, worked for many years with her father as a colleague and designer in his workshop. Since his death in 1990, she has been the creative director of the Nakashima studio, where she continues to produce her father's classic furniture designs and to design and produce her own work as well.

---

OPPOSITE, TOP LEFT **Meeting House Bench, Church Family, Enfield, New Hampshire, c. 1845.**

OPPOSITE, TOP RIGHT **George Nakashima, Bench with Back, 1960.**

OPPOSITE, BOTTOM **George Nakashima, Conoid Bench, designed c. 1961.**

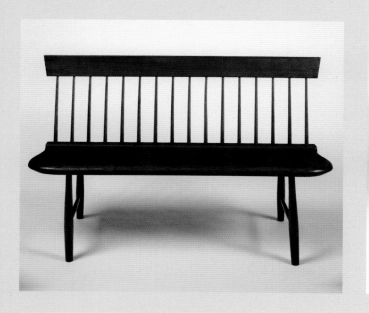

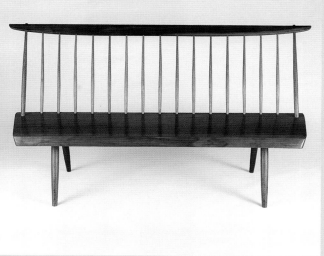

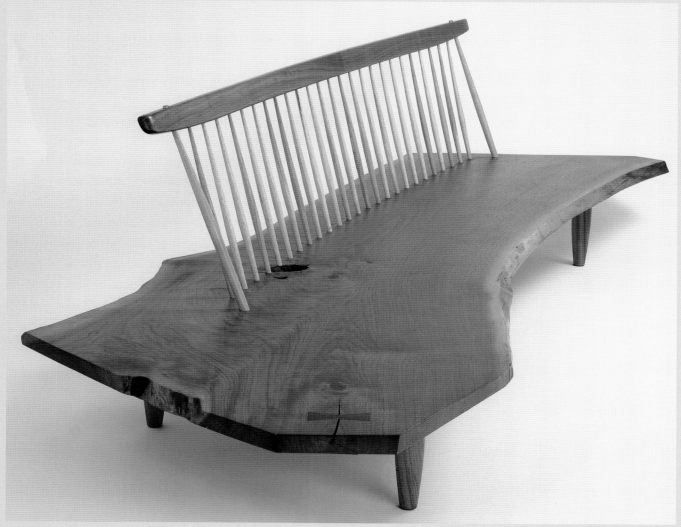

Beauty, too, was part of the "heavenly ideal" that the Believers sought in their villages through their architecture, gardens, interiors, handmade furnishings, and everyday objects. "Don't make something if it's not useful; but if it is both necessary and useful, don't hesitate to make it beautiful, as long as the decorative elements are an inherent part of the design and don't interfere with function."[8] This philosophy pervades all things Shaker and foreshadows the principle expressed as "Form follows function" advocated later by leaders of the Arts and Crafts Movement.

## CRAFTS AND SHARED BELIEFS: THE QUAKERS, ANABAPTISTS, AND INSPIRATIONISTS

★

Many of the cardinal principles upon which Shakerism was founded were shared by other religious sects that settled in America during the eighteenth and nineteenth centuries. Condemned at home as heretics for holding radical beliefs, the persecuted congregants began migrating from England and Continental Europe to America in the mid-1700s.

The constituents of the Religious Society of Friends (known informally as Quakers) and the disciples of the Amish (also known as Anabaptists, meaning "rebaptizers") made up the first wave of immigrants. Initially, they settled in and around Pennsylvania, the Quakers homesteading in the Delaware Valley and most of the Amish settling in Pennsylvania's Lancaster County — still one of the most notable Amish communities today. By the turn of the nineteenth century, large numbers of Quakers and Amish were moving westward to establish communities in Indiana, Iowa, and Ohio.

About one hundred years later, the Quaker and Amish were followed by the Mennonites and adherents of the Community of True Inspiration, the Inspirationists. The predominately Swiss-German Mennonites (a splinter group of Anabaptists known as "Plain People") first settled in Germantown, Pennsylvania, in 1863 and then moved as far west as the plains of Iowa and Illinois. The Inspirationists, also of Swiss-German origin, first settled in upstate New York, near Buffalo, in the early 1840s, and

BELOW

**QUAKER MEETING HOUSE, LOWER ALLOWAYS CREEK, NEW JERSEY, BUILT IN 1756.**
In keeping with their beliefs, the Society of Friends, or Quakers, held services in simple and austere meeting houses such as this one in Lower Alloways Creek in New Jersey. Built in 1756, this meeting house evolved from an original one-story building. Quakers believed in following personal conscience, and in traditional services, anyone could speak up when the spirit moved him or her.

then moved to the much less populated Iowa River Valley, where in 1855 they established the Amana Colonies, a collection of seven separate communalist villages.

For more than 150 years, members of the American Quaker, Amish, and Mennonite communities have variously built religious meetinghouses and community dwellings in the simple, unadorned style characteristic of Shaker settlements, and the women have woven fabric and constructed garments, handsome hand-embroidered samplers, and designed, pieced, and stitched remarkably fine quilts, for which they have become renowned. Committed to communal living and accomplished in the traditional arts of weaving and quilting, basket making, woodworking, and blacksmithing, the Inspirationists built their villages by hand on the rural Iowa land they purchased to accommodate their twelve hundred believers, each village comprising between forty and one hundred buildings.

## THE WORSHIPFUL WORK OF THE HAND: AMANA COMMUNITY CRAFTS

The Community of True Inspiration was a religious sect founded in Germany in 1714. Fleeing persecution, its members converged in the liberal province of Hesse.

By 1842, persecution had worsened, and the community's spiritual leader, Christian Metz, prophesied that the community should immigrate to North America. Metz said the Lord had told him, "Your goal and your way shall lead towards the west to the land which still is open to you and your faith."[9] Some sailed that fall and established two villages in Canada and four at Ebenezer, near Buffalo, New York, on a 5,000-acre tract of the former Seneca Indian Reservation.

Within a few years' time, the Inspirationists had outgrown the land, and Metz received a second message from the Lord, telling him to again move farther west. This

BELOW LEFT
**HANDCRAFTED OBJECTS AND HAND-SEWN CLOTHING ARE PART OF THE DAILY LIFE AT AMANA.**
Women and young girls contributed to the effort of the communal kitchens. Here they are shown on a kitchen porch, wearing traditional Amana calico dresses and aprons, sorting freshly picked greens using the wood trays and willow baskets that were handcrafted in the community.

BELOW RIGHT
**MEETING HOUSE, HOMESTEAD VILLAGE, AMANA.**
The church, or meetinghouse, at Homestead Village, is typical of all of the churches at Amana. A brick exterior with separate entrances for men and women leads to the main interior space with pale blue walls, plain pine benches and floors, with stripped rugs. Instead of an altar, there is a simple table covered in green baize, with a spindle-back chair for the elder leading the service.

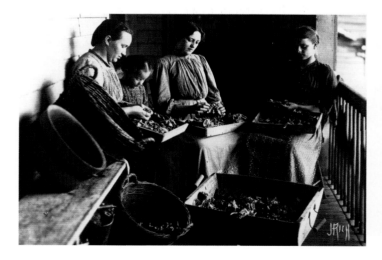

RIGHT

**KNITTING AND WEAVING SKILLS.**

Traditional crafts, such as knitting, were passed along from one generation to the next. Both the woman and child are wearing calico-print dresses produced in the Amana Colonies, and in the lower-left-hand corner is a traditional willow basket. Small, portable willow baskets were often used to hold sewing materials.

BELOW

**COMMUNION SUNDAY IN AMANA, 1894.**

This photograph, taken on Communion Day in the Amana Colonies, shows the well-organized structure of one of the seven villages, its clusters of buildings, roads, and fences constructed by the industrious members of the Community of True Inspiration.

time, members settled in Iowa's fertile River Valley in 1854 and built a larger community with seven villages on 26,000 acres.

Most of the Inspirationists who had come to America were of the artisan and peasant classes, which prepared them for the tremendous work of building entire villages from the ground up. The planning and architecture of their communities reflected their beliefs in simplicity, equality, and uniformity.[10] The new Iowa commune adopted the biblical name Amana, meaning "believe faithfully."[11]

In their new American community, domestic interiors were simple, although far more comfortable and colorful than those of other religious communities, such as the Shakers. The silhouettes were similar to their European counterparts but construction was simplified and with little ornament.

Although isolated in their community, the Amana did subscribe to several newspapers and trade journals, so contemporary design and ideas did, to a certain extent, enter their world. Church interiors, however, remained spartan, in a traditionally Germanic way. The plain pine benches, some over 20 feet long, were joined with wood pegs for easy disassembly.[12]

The Amana were able to produce nearly everything they needed. Cabinetmakers made not only furnishings but also wheelbarrows for the fields and spoons and other utensils for the communal kitchens. Blacksmiths made everything from machinery to crochet hooks.[13] Yet of the many crafts they produced, baskets and textiles especially embody the community's spirit.

Craftsmen made baskets of split oak and coiled grasses, but willow was the most common material, and each village planted its own willow crop with seedlings that had originated in Germany. The basket shapes were modified to suit their intended purpose: Apple-picking baskets had two handles on one side and were tied to the body, leaving both hands free; laundry baskets had hinged lids to secure the contents; and baskets used for gathering heavy crops had iron handles for extra strength. Each was given a 1-inch bottom rim that could be replaced when worn to extend the basket's life. Weavers created pattern, color, and texture with peeled and unpeeled branches.[14]

Amana's textile arts included knitting, quilting, tatting, or lace making, and crocheting as well as hand-woven rugs. The two most significant ventures were the production of woven woolens and the calico print. The Inspirationists first made woolen materials in one of the early Germany communes. The work was so successful (and necessary, as they used it for their own garments) that they brought the equipment to Ebenezer, and then to Iowa. The Amana villagers raised thousands of sheep but imported additional wool from places as far away as Australia to meet their needs. They produced a heavy wool flannel for work clothes and winter garments and later a more refined wool for men's suits — the latter was sold across the United States, especially to retailers in New York and Chicago.[15] That one Amana village had a railroad station made the sometimes necessary contact with the outside world possible, and it also made Amana's products more easily distributed, thus making the community financially sound.[16]

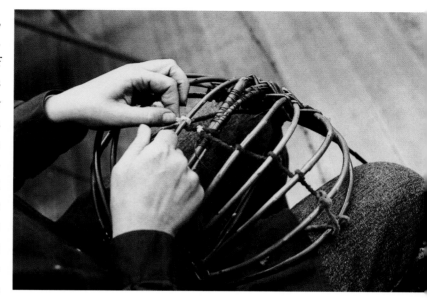

Amana's calico production began much as its woolen production did — in Germany, with the equipment moved from one location to the next. Calico, a printed or painted cotton muslin imported from Calcutta, was a popular textile in Europe from the seventeenth century.[17] It became a widely used textile in the United States from the early nineteenth century, when many mills were established on the East Coast.[18]

Unbleached cotton muslin and twill were imported to the Amana Colonies from southern and eastern states, then dyed and printed at the factories. Printing was done in several ways: by hand with carved blocks, by roller printing, by discharge (the pattern is bleached out of dyed fabric), or by resist (the pattern is drawn on with a dye-resistant paste that is then washed away to reveal the pattern after the fabric has been dyed). The patterns were usually white on a blue, brown, or black ground with a small geometric design, stylized flowers, or narrow stripes.

Thousands of designs were created, all of them by Amana members. Like the woolen flannel, the calico was first produced for their own use, as it was appropriate for their plain dress. Soon, however, they saw the opportunity to cultivate a larger market and produced sample catalogs and traveling salesmen who went from New York to California. At its height in the early 1890s, the Amana factory was producing 4,500 yards of material a day and grossing enough income to support all seven villages.[19]

In 1932, Amana society members voted to end communalism and establish a joint stock corporation to run the economic aspects of the villages, with a church society to oversee the spiritual components. The restructuring, coupled with the hardships of the Great Depression, forced the corporation to close many of the crafts shops to con-

centrate on the production of more profitable items, such as furniture and baked goods.

In 1934, a young Amana member named George Foerstner responded to an Iowa businessman's challenge to build a beverage cooler. Foerstner did just that, employing the talents of his community of craftsmen. This led to Amana Refrigeration, which grew into one of the largest appliance companies in America, with its humble beginnings in the former wool factory.[20]

By the mid-twentieth century the post–World War II studio crafts movement was gaining importance in the overall discussion of American art and beginning a reexamination of—and appreciation for—American crafts. In 1965, the Amana Colonies were designated a National Historic Landmark.

With a renewed sense of pride and industry—and tourism—many of the old Amana crafts were revived. In 1968, a group of Amana members established the Amana Heritage Society in order to preserve the history and experiences of the Community of True Inspiration.[21]

## CRAFTS AS COMMON THREAD

There are, of course, many differences in the doctrines and practices of the Quakers, Amish, Mennonites, and Inspirationists. A common thread, and one that ties these congregations to craft making, is their shared respect for hand work. The members of all these religious societies were instructed by canon to pursue the simple life, to search for a "certain kind of perfection" or spiritual self-fulfillment through honest, productive labor, to live close to the land and attain self-sufficiency, to maintain their distance from the "World" and its "Outsiders," and to follow rigorously a work code that mandated integrity and pride of workmanship.[22]

# QUILTING: THE FABRIC OF A CULTURE

★

The most enduring aesthetic legacy of the Quakers, Amish, and Mennonites has been their textile arts, particularly their quilts. This is a result, in part, of the long-standing tradition and continued development of quilt making among the women of these communities, where skills and advancements have passed from mother to daughter, carrying on their commitment to excellence and superior workmanship.

Like other pioneer women of the eighteenth and nineteenth centuries, the Quaker, Amish, and Mennonite women made quilts as part of their dowries and later to provide warm bedding for their families. But they devotedly made quilts to communicate their

beliefs and record family and community histories—commemorating significant religious events as well as births, weddings, departures, and deaths. They also made quilts for donation. Women cut, pieced, and expertly stitched outstanding quilts, which they gave to their community leaders to be sold or auctioned to Outsiders. The funds raised would be used to support the communities' relief efforts in foreign missions or to provide assistance to the poor and disadvantaged at home. This is still the practice in many communities, and the Mennonite Relief Auctions in Goshen, Indiana, are recognized as a source of exceptional quilts.[23]

## ORIGINS AND INNOVATIONS

The English brought their quilting skills to the colonies in the late 1700s and inspired their neighbors to become prolific quilters: "Soon quilting became a mix of influences: The Pennsylvania Germans, who originally would have made woven bedcovers (coverlets), became enamored of the craft, as did the Quakers and Scots-Irish Presbyterians, who were early settlers in the region. Along with the plain sects (the Amish, Mennonite, and Brethren, who adapted the techniques to their own use), other Pennsylvania German religious groups also make many quilts."[24] Making quilts from scraps and pieces of worn clothing would become an attractive activity among early settlers when resources were in short supply and the recycling of materials appealed to their cultural and religious values of frugality and thriftiness.

Innovation, resourcefulness, and imagination soon became part of the expressive vocabulary of pioneer quilters. "America's greatest contribution to quilting was developing the use of pieced work in creating quilt tops. . . . English quilters had employed piecing techniques as an element in their work, but Americans were the first to organize pieced tops into blocks."[25] The pieced quilt, assembled from many small pieces of material cut into geometric shapes and sewn together in blocks—which are often repeated— opened up new avenues for creative ingenu-

LEFT

**AN EXAMPLE OF QUAKER PLAIN DRESS, WINTERTHUR MUSEUM, DELAWARE.**
"Friends, keep out of the vain fashions of the world," George Fox, founder of the Society of Friends, or Quakers, exhorted his followers. Instead, they were to "mind that which is sober and modest, and keep to your plain fashions." The appearance of this Quaker plain dress from the 1840s reflects such fundamental values of austerity and humility—although the material is brown silk.

ity as it provided quilters with almost limitless choices for organizing patterns. Block construction also lent itself to quilting bees, as women could gather in "bees" to sew blocks together, the blocks having been made entirely by a single quilter or by many quilters responsible for one or more blocks of the design.

## QUILTS AS EXPRESSIONS OF CREATIVITY AND SPIRITUALITY

Quaker and Mennonite quilts, which share many characteristics derived from similar traditions, can be grouped together stylistically. Interestingly, and paradoxically, the decorative, colorful, and intricate patterns of their quilts are in marked contrast to the plainness of their households and their personal dress. Following religious guidelines, Quaker and Mennonite women avoided elaborate domestic furnishings and the wearing of "luxurious" clothing (fabricated of extravagant materials, in vibrant colors and prints, with cuffs and buttons and embellishments of any kind—including fancy topstitching, ribbons, and lace). Instead, they "showed an increased attention to God rather than to worldly fashions" by choosing to dress simply, which was interpreted as a modest full-length dress of plain cut, of subdued solid colors, and devoid of trimmings or finery.[26] A typical "plain dress" ensemble from the mid-eighteenth to the end of the nineteenth century included a fall-front floor-length gown (usually of a dark, somber color), a neckerchief, a light-colored shawl, a white cap, and a bonnet of dark cloth for outdoor wear. Thus clad, women identified their religious persuasion and affirmed their separateness from the outside world.

Although their religious convictions demanded austerity in their home, personal effects, and dress, the Quaker and Mennonite world was not without beauty, evidenced by their lush gardens and strikingly bold and multihued quilts. As among the Shakers, beauty was admired and cherished as one of God's gifts. Linda Boynton, an authority on Mennonite culture, explains this perceived contradiction:

> *There is no room for pride within the culture. Regulations on dress and lifestyle are in part to squelch temptations toward vanity. But the line here is delicate. In work, a job well done is imperative, yet pride in that job is not tolerated. There are few exceptions, but quilting is one of them. This is an avenue in which a woman may show off her skills unashamedly. Quilting allows her a vehicle for the expression of feelings otherwise restricted. The freedom of expression allows these women the opportunity for creativity in a world of limited options. Through quilting, utilitarian objects are elevated through imagination, enterprise and love to the status of an original art form.[27]*

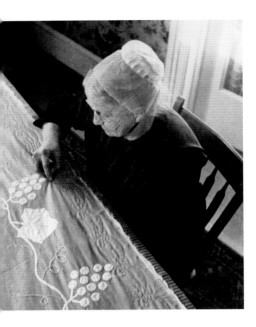

ABOVE

**MENNONITE WOMAN "EXPERT QUILTER."**
A Mennonite of Lancaster County, Pennsylvania, Anna (Huber) Good (1876-1969) was a devoted quilter throughout her long life. Even after raising eight children, she continued to quilt from dawn to dusk, pausing only to prepare meals and do necessary chores. Here she adds meticulous stitches to a Grape Vine appliqué quilt.

## DEFINING DIFFERENCES

Roderick Kiracofe, a quilt historian, identifies the years between 1875 and 1900 as "The Grand Epoch" of American quilt making, and notes that the emergence of the block style—from the 1840s through the 1860s—laid the foundation for this golden age. The best Quaker and Mennonite quilts are considered to be those made between 1840 and 1900.

It has been noted that Quaker and Mennonite quilts are difficult to identify by their appearance alone, partly because the women of these religious sects borrowed patterns from their "English" neighbors, and partly because the quilts were made of similar and limited materials. Close examination, however, reveals some distinctive traits: the excellence of the needlework, principally of the quilting stitches, which may amount to between eight and ten stitches per inch (rather than the five or six stitches sewn on quilts by other makers); the directness of the design and avoidance of the late-Victorian penchant for decorative excess and fussiness; the repeated use of Biblical names for patterns rather than the secular names in common use; and, unique to Quaker quilts, the incorporation in the quilt top of Chinese export and Quaker silks (somber-shaded silks the Quakers special-ordered for their "plain" dresses), and the unusual notation of the date in the sequence of day, month, and year.[28]

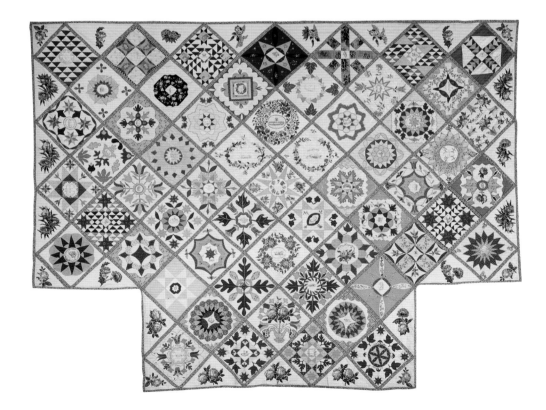

**ABOVE**

**EAGLE QUILT, PENNSYLVANIA, C. 1870–90; APPLIQUÉD BROADCLOTH AND MUSLIN**

Some quilts reflected a patriotic sensibility, such as this late-nineteenth-century "eagle" quilt from a Mennonite family.

**RIGHT**

**DETAIL OF MARY ALLEN'S QUILT, PENNSYLVANIA AND NEW JERSEY, MARKED 1847.**

Mary Pancoast Allen, a Quaker, made this stunning "signature" quilt, which is inscribed in ink in the central block with her name and the date, "10th Mo 1847." The white muslin strips running between the design patches are graced with written sentiments— mourning the passing of her parents, confirmations of friendship, and hopes for the life hereafter. Some excerpts include:

> *Wilt thou sweet mourner at my grave appear*
> *and soothe my spirit lingering near.*

> *When 'neath the quilt thy form reclines*
> *Please think of him who penned these lines.*

## STITCHES OF MEMORY

The album or autograph quilt (also known as the memory quilt) was the pattern type preferred by Quakers, and it enjoyed its greatest popularity in the 1840s and 1850s. The design was most frequently composed of pieced and/or appliquéd squares resembling the sheets of a scrapbook or family album, and the quilts were signed like the pages of an autograph book, inscribed with names of those who were near and dear, the names often accompanied by inked inscriptions of mournful and moralistic themes. These quilts provided Quaker women the means to express their hopes, beliefs, and individual stories—poignant documents of family and community histories that kept memories alive through a visual record long after they might otherwise have faded or been lost in the passage of time.

## BOLD GRAPHICS AND DARING VISUAL EFFECTS

The Mennonites were more daring and freewheeling in their adaptation of quilting patterns and techniques. Nineteenth-century Mennonite quilts are usually constructed of

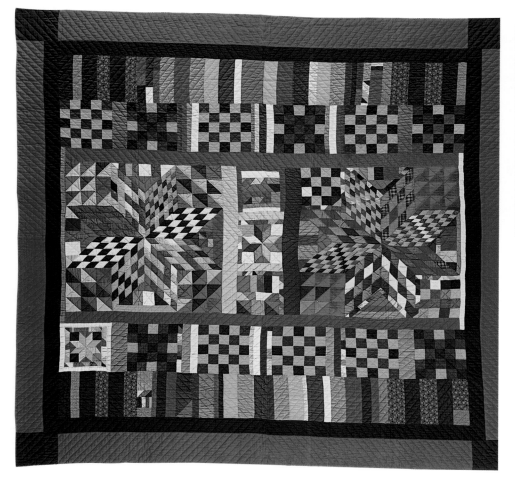

LEFT

**CRAZY STARS QUILT, LEBANON COUNTY, PENNSYLVANIA, C. 1890–1910.** This dazzling quilt made by Amy Bucher, a Mennonite, around 1900 is composed of scraps of solid-colored broadcloth and muslin pieced together in a "crazy stars" pattern. While their dress was somber, Mennonite women could express a love for color and decoration through these quilts, as well as put fabric scraps to use.

ABOVE

**LOG CABIN QUILT, LANCASTER COUNTY, PENNSYLVANIA, C. 1880–1900.** The "log cabin" motif is an exuberant celebration of the American frontier, and for some it is the quintessential American quilt. With strips of fabric—like logs—building up an outward expanding pattern, red is often found at the core of each block. It symbolizes the center of the home, the hearth.

wool or cotton fashioned into small strips, squares, or diamonds, cut primarily from recycled suiting or printed-clothing materials. Inexpensive calico prints purchased in local stores or by mail-order catalog often supplement the mix of reclaimed materials. Mennonite quilts are characterized by their dynamic interplay of multiple materials pieced together to create vibrant patterns emboldened by lively color combinations and contrasting textures. Above all, the quilts illustrate the Mennonites' "ability to be bold in color selection and pattern—not afraid to experiment—and [to] maintain a high quality of workmanship."[29] Moreover, Mennonite pieced quilts are recognized for the artistry of their rigorously geometric designs. Consisting of small squares or diamonds arranged in patterns such as Sunshine and Shadow (Trip Around the World), Log Cabin, Philadelphia Pavement, and a variety of Star compositions, these exuberant, multicolored, complex quilts make bold, graphic statements that are commendable for their technical virtuosity, fine stitchery, and compelling visual effects.

Hand-appliquéing techniques are also found in Mennonite quilts, and most appliqué designs follow a block format. Appliqué is a process by which the quilter applies and sews cut pieces of fabric to a plain white or solid-colored top to create an overall design

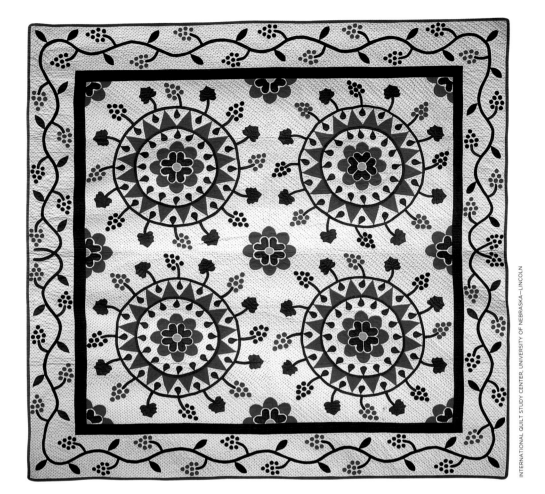

RIGHT

**FLOWERS AND GRAPES QUILT, PENNSYLVANIA, C. 1860–80.**

Dating between 1860 and 1880, this Mennonite quilt is hand appliquéd, using broadcloth and muslin formed into a "flower and grapes" pattern. Bunches of grapes sprout from undulating vines around the border of this 82-inch-square quilt, as well as from four circles inside the border. Abstract representations of flowers are inside the circles.

BELOW

**AMISH WOMEN AT AN AUCTION, ELKHART-LAGRANGE COUNTIES, INDIANA, 1981–84.**

To this day the Amish dutifully follow tenets of simplicity and humility in both clothing and furnishings. Here, two older Amish women wear basic black bonnets and cloaks as they stare out a window at a miscellany of people gathered at a yard sale.

scheme. This technique permitted more freedom in the design since the quilter was able to determine the placement of the cut-out appliqués and was not restricted by the rigorous geometry of pieced patterns. Mennonites favored the use of appliqués for designs based on patterns of repeating images that formed the central composition, and these designs were often bounded by decorative borders of scrolling floral motifs, some depicted quite abstractly.[30] Old Order Mennonites maintained that quilts constructed exclusively of intricate appliqué work were indications of undue pride and vanity; because the technique is purely decorative, the production of such quilts was regarded as a "frivolous endeavor." Nevertheless, Mennonite women were always able to justify the elaborate needlework designs they labored over on their quilt tops as necessary and purposeful because the quilting stitches joined together the three layers of the quilt and kept the batting secure.[31]

## THE AMISH REINVENT THE QUILT

Although the Amish came late to quilt making—the earliest examples of Amish quilts date from the 1860s, with very few known to have been made before the 1900s—cultural

historians view these quilts as significant in the development of American textile arts; they are wholly original in their palette and patterns and "represent what is arguably the single most impressive body of expression in American quilting."[32] Amish quilts made between 1880 and 1940 are considered to be the most desirable for their authentic patterns, distinctive color combinations, and meticulous needlework. Some historians conjecture that the quilts are so unusual because of the Amish's self-enforced isolation and their independence from the outside world. Effectively—until the mid-twentieth century—

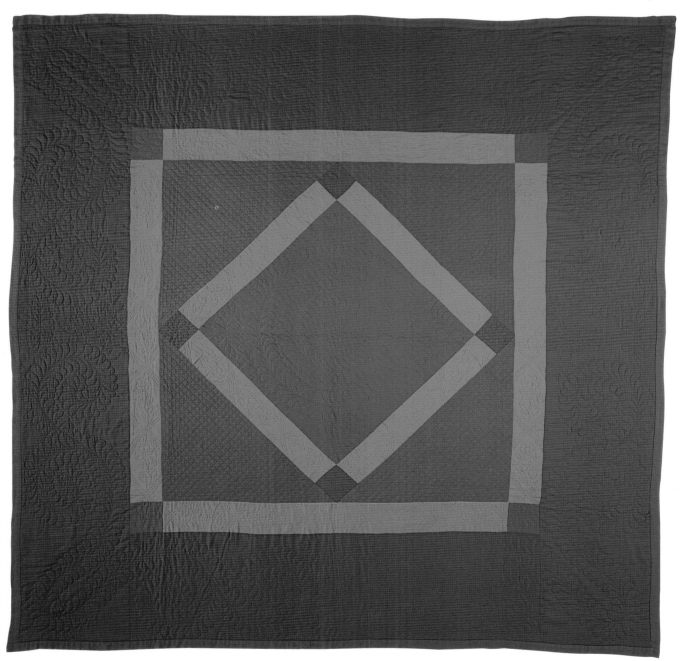

Amish women were unaware of established conventions; their quilts were made without the pressure or distraction of external opinion and custom.

Most Amish quilts were made from solid-color fabrics in basic, natural colors and earthy hues. The pieces of the quilt top were commonly sewn together by machine (foot powered, not electric), and were primarily fabricated of wool in the 1900s, of cotton in the 1920s, and of rayon and other synthetic materials in the 1940s. The quilts mirrored the colors and fabrics of their customary "plain" dress, as dictated by their *Ordnung,* the set of guidelines that govern Amish life, including personal dress and belongings. Like the Quakers and Mennonites, the Amish endeavor to live simply and humbly and to eschew frivolity, pretension, and excessiveness. Because patterned and printed materials were forbidden in Old Order Amish clothing—the sect viewed the wearing of printed-patterned fabrics as signs of vanity and pride—printed fabrics were not used for the quilt tops either. In the past, decorative printed fabrics, if used at all, have been limited to quilt backings.[33]

Yet Amish quilts are far from identical. Depending on the community's location, vernacular traditions, relative conservatism, and the availability and selection of materials, there is much diversity to be found among Amish quilts. The largest Amish settlements in North America today include the communities of Lancaster and Mifflin Counties, Pennsylvania, in the East; and Holmes County, Ohio, and Elkhart and LaGrange Counties, Indiana, in the Midwest. Each community has historically produced distinctive quilts that reflected the particular religious practices and regional preferences.

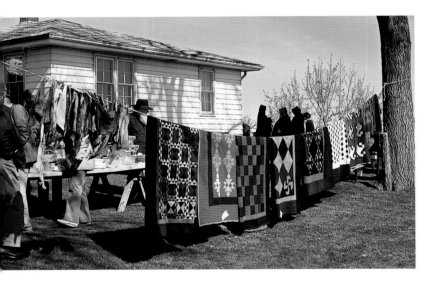

ABOVE

**AN AMISH PUBLIC AUCTION, ELKHART-LAGRANGE COUNTIES, INDIANA, 1981-84.**
Among the Amish, yard sales are popular events during spring and autumn weekends. Neighbors and tourists alike come to socialize and view baked goods, household furnishings, crockery, and tools for sale—with quilts occasionally among the offerings, as illustrated here, the quilts hung on the laundry line as a display strategy.

## AMISH QUILTS OF THE EASTERN AND MIDWESTERN COMMUNITIES

Traditionally, Amish women have been very skilled quilt makers, sewing between nine and eleven quilting stitches per inch rather than the average five to seven stitches per inch sewn by non-Amish quilters. The quilt makers of Lancaster County are "considered the most accomplished" among the Amish and their fine needlework can be seen in such quilting designs as feathered wreaths, diamonds, expansive eight-pointed stars, flower motifs, pinwheels, and hearts. The "classic" era of Lancaster County quilts spans the period from the late nineteenth century to World War II. The quilts made then are typically of wool and have large flat planes of rich colors juxtaposed to create striking designs, resulting in compositions that are often astonishing for their daring color contrasts, tonal variations, and graphic effects. These traits are visible in the patterns identified with Lancaster County: Center Diamond (which is exclusive to this community), Center

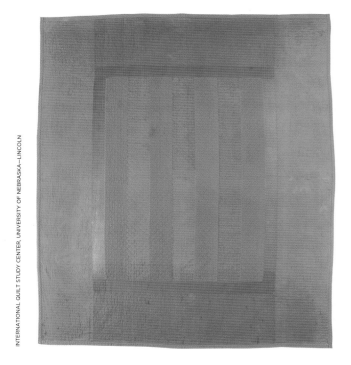

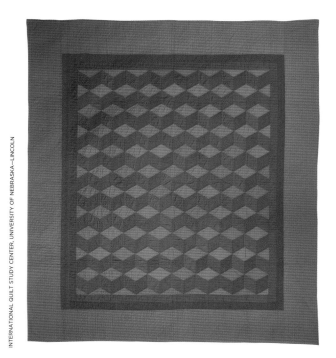

Square, Sunshine and Shadow, and Bars.[34] The large, uninterrupted areas of color, frequently framed by broad outside borders, and the overall geometric abstraction of the design, demonstrate that classic Amish quilts, particularly those from Lancaster County, share compositional qualities with twentieth-century painting. Jonathan Holstein, the curator of the landmark exhibition *Abstract Design in American Quilts,* at the Whitney Museum of American Art in New York in 1971, remarked that "the often startling resemblances between the total visual effects of some pieced quilts and some examples of modern painting are intriguing." This exhibition was the first in a major art museum to display, assess, and appreciate quilts on a purely aesthetic level and introduced the public to the beauty and inventiveness of Amish quilt designs.

The quilts emanating from Mifflin County—the other large Amish settlement in Pennsylvania—are the work of three different Amish communities, all named after important Amish leaders: the Nebraska Amish, who are the most conservative of the three; the Byler Amish; and the Renno or Peachey Amish. Cottons and rayons are the materials of choice for Mifflin County quilters, although wool and polyester are not uncommon. Quilts of the Nebraska Amish are generally dark and subtle in coloration, incorporating shades of brown, blue, purple, and gray in such designs as One Patch, Four Patch, Nine Patch, and Bars. These same patterns are found in the quilts of the Byler Amish, along with the Irish Chain, Jacob's Ladder, and Tumbling Blocks, designs favored for their optical effects and complex geometric framework. Byler quilts are further identifiable by the integration of dazzling, brilliant-colored fabrics in pinks, yellows, oranges, and blues.

The Renno or Peachey Amish also use vivid colors in their designs, including pieces of

ABOVE LEFT

**BARS QUILT, LANCASTER COUNTY, PENNSYLVANIA, C. 1890–1910.**

The sophisticated color palette in this Bars pattern quilt is so modern that it was included in the exhibition *Abstract Design in American Quilts* at the Whitney Museum of American Art in 1971.

ABOVE RIGHT

**TUMBLING BLOCKS QUILT, WAYNE COUNTY, OHIO, C. 1975.**

One of the most classic quilt patterns is "Tumbling Blocks," made with uniform diamonds of cloth to resemble a series of stacked square blocks. This modern Amish example thought to be from Ohio shows a bold use of eye-popping colors— bright orange, red, and blue.

**BASKETS, MIDWEST,
C. 1930–1950.**
A softer palette distinguishes
some of the Amish quilts found
in the Midwest. This crib quilt
dating 1930–50 measures
42 x 35 inches and constructs its
Baskets pattern from three
colors—an orange-yellow plus
pale shades of purple and
green—set against a cream-
colored background. These
joyful "sherbet" colors are an
excellent choice for an infant's
quilt.

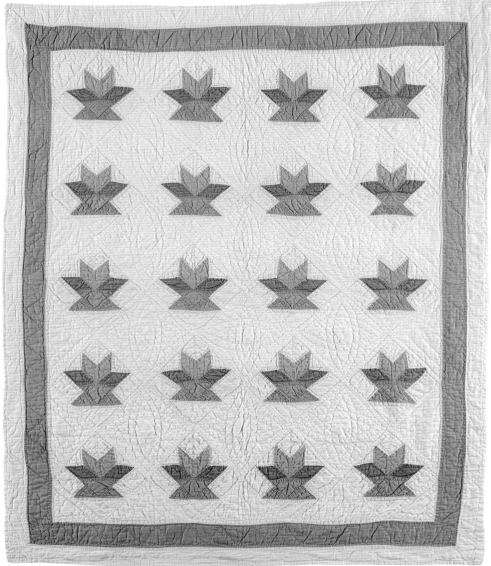

INTERNATIONAL QUILT STUDY CENTER, UNIVERSITY OF NEBRASKA–LINCOLN

bright yellow, blue, purple, and green. Their quilts are similar to midwestern Amish quilts in the use of repeating block patterns—Log Cabin, Shoofly, and Stars were apparently their favorites. Also similar are the placement of the blocks against a dark background and the frequent use of borders of black or dark blue.

Midwestern Amish quilts are much like those of their Renno or Peachey brethren, repeating block constructions used against dark, solid-colored, plain backgrounds. Constructed mostly of cotton fabrics, often from vividly colored polished cottons and sateens, they are easily recognizable within the Amish quilt group as their patterns are frequently the same as their non-Amish neighbors. Midwestern quilters often appropriated such mainstream patterns as Stars, Baskets, Bow Tie, and Log Cabin, and then modified them. Perhaps only in the Midwest can one find an Amish quilt with pastel colors. Occasionally, quilt makers of Ohio and Indiana used pastel fabrics in a repeating block

format, as on a Baskets crib quilt. The softer, quieter composition is markedly different from the boldness and exuberance of archetypal Amish designs.

## THE UNBROKEN CHAIN OF A TRADITION—QUILTING INTO THE TWENTY-FIRST CENTURY

Quilting has persisted and remained vital throughout the centuries. Remarking on the endurance of the quilt as an art form, culture historian Robert Shaw notes: "More than any other folk craft, it has weathered and absorbed changes in fashion and continued to attract attentive practitioners to the present day."[35] Quilts provide a compelling visual history for the last two hundred years of craft imbued with the indomitable spirit and creativity of America's diverse cultures. A handmade quilt unfolds its story: It communicates aesthetic diversity, complexity of workmanship, the traditions it engages and expands, and the blend of shared community values and individual artistry that has produced its design. These attributes are embedded in the quilts associated with various religious communities, and they have been carried forth into the present by those who continue the tradition, assuring that quilting retains its purpose and potency. Contemporary quilters and textile artists bring a current view to the art form and new technology, materials, and ways of thinking to the traditional techniques and perspectives of their ancestors.

### THE EMERGENCE OF THE FIBER ARTIST

After World War II, university and art school programs began to teach textile history and techniques, graduating what they designated "fiber artists," who infused quilt making

with new talent and experimental daring. In this new era, the "folk craft" of quilting was held to the same rigorous standards of design theory, mastery of technique, innovation, and application of artistic vision found in the fields of ceramics, glass, metalworking, and furniture making. Further, another shift occurred: As veterans returned and enrolled in college using the benefits of their GI Bill, male students began to attend textile classes. Quilt making as an art form was embraced by both men and women.

Michael James and Arturo Alonzo Sandoval are exemplary representatives of this first generation of male artists who reinterpret the quilt as a canvas for contemporary expression, and Wendy Huhn represents a new movement among younger women who become quilters to use the the quilt format as an interchange between material and meaning. Traditional and nontraditional fabrics and techniques of printing, cutting, piecing, layering, and stitching the quilt are used to create a "textile painting," a veritable pictographic wall hanging that is no longer tied to the customary functions of the quilt as only a warm and comfortable bed covering.

OPPOSITE

**ARTURO ALONZO SANDOVAL,**
*SKYSCAPE NO. 1,* 1979.
This large-scale machine-stitched and woven quilt—7 feet high by almost 11 feet wide—is one work in the SKY Series, a group of thematically related artworks the artist began in 1971. Inspired by the distant horizons and the "vast diaphanous cloud formations" of New Mexico, Sandoval set out to capture through this medium of interlaced and stitched fabric the "boundless dimension" of atmosphere and the effects of reflective and refractive light. The expanse of the interwoven blue field, punctuated by patches of white, and the shifting planes that move across the composition in this quilt all create the sensation of clouds moving across a plain and casting a fleeting shadow.

LEFT

**WENDY HUHN,** *EAT, SLEEP, WORK, PLAY,* 2005.
Artist Wendy Huhn uses the quilt format to convey gender politics and to underscore the role of women in contemporary society. Her ideas and process are revealed through the assembled quilt constructed of a collage of images. As explained by the artist, her iconography is "borrowed from eighteenth- and nineteenth-century women's magazines and books . . . to play historical images against modern-day culture."

Artists like them, and many others who have pushed the boundaries of this medium, are expanding the meaning and implication of "quilt." In their hands quilting has become an interwoven dialogue of folk, craft, and fine arts traditions, articulating a new language that will be learned, mastered, exploited, and expounded by successive generations of textile artists.

# The Arts and Crafts Movement in America, 1890–1930

THE ROOTS OF CONTEMPORARY CRAFT lie in the Arts and Crafts movement, which emerged as a social and artistic response to the dehumanizing effects of the Industrial Revolution. The first people to express these ideas lived in mid-nineteenth-century England — the most industrialized country in the modern world. Rapid, unregulated mechanization had forced workers into overcrowded, polluted cities, where many lived in squalor and were exploited in dangerous working conditions. Critics alleged that industrialization made workers into wage slaves and tenement dwellers, lowered the standards of design and workmanship, and diminished the quality of life by destroying human dignity and creativity.

Reformers, among them John Ruskin and William Morris, sought to revive a better, preindustrial world in which factories were banished and the necessities of the simple life were produced in conditions that would restore harmony and beauty to daily life.

OPPOSITE

**VASE WITH BLACK IRISES, ROOKWOOD POTTERY, DESIGNED BY CHARLES (CARL) SCHMIDT, 1911.**
Irises were a popular flower at Rookwood Pottery, and the decorator of this vase highlighted the delicate blossoms of the iris by placing the blooms of the flower against a background of saturated black glaze.

In their antipathy toward the factory, the proponents of the Arts and Crafts movement saw the arts and crafts as instruments for social change. The movement was based on the belief that a return to handmade objects and to "the simple life"—an emulation of the lifestyle of the craftsman—would provide an antidote to the ills inflicted on society by modern life. The movement took root both philosophically and aesthetically in England, spread through continental Europe, and crossed the Atlantic in the early 1890s. In America the movement permeated the visual arts and architecture and effected sweeping changes in domestic life. Its philosophy, ideals, and doctrines have left a stylistic imprint on the design and making of crafts and provided the standards against which the quality and worth of handcrafted objects are judged today.

AN ENDEAVOUR TOWARDS THE TEACHING OF JOHN RUSKIN AND WILLIAM MORRIS.

BEING A BRIEF ACCOUNT OF THE WORK, THE AIMS, AND THE PRINCIPLES OF THE GUILD OF HANDICRAFT IN EAST LONDON, WRITTEN BY C. R. ASHBEE, AND DEDICATED BY HIM LESS IN THE WRITING, THAN IN THE WORK THE WRITING SEEKS TO SET FORTH, TO THEIR MEMORY. AN. DOM. MDCCCCI.

## THE ARTS AND CRAFTS MANIFESTO

The essential tenets of the movement were conceived and developed as early as the 1850s by John Ruskin, an art critic and professor at Oxford University. Ruskin preached spiritual transcendence through harmony with nature and believed that the unity of heart, hand, and mind in the practice of traditional crafts was the best way in which to live a full and vital life. William Morris, a theology student at Oxford, became Ruskin's passionate disciple and, in essays on the virtues of crafts and the life of the craftsman, expanded on his precepts. Both men aspired to reform not only the appearance of useful art objects—those that were variously known as the decorative arts, the applied arts, and the crafts—but also the processes by which these objects were made, the environment of their making, and the way in which they were taught, thought about, exhibited, and discussed. The teaching of art, they felt, had been corrupted since the Renaissance by elitist academies that had created artificial, hierarchical distinctions between the high arts of painting and sculpture and the applied arts.

Further, they held that mechanized industry generated poorly designed objects of substandard workmanship

and in an environment that reduced the factory worker to a machine, thus debasing both product and maker. Factories adopted economies of scale that imposed an onerous division between intellectual and physical labor in the workforce. Assembly lines increased the speed of production and profits, but they also separated the craft from the craftsman: No longer did one individual control the making of an object from its inception to its realization.

Declaring that handmade objects were not only qualitatively better but also morally superior, the advocates of the Arts and Crafts movement promoted an ideal system in which designer and maker were one and the same. In 1882, in an impassioned address entitled "The Lesser Arts of Life," Morris stated that craft provided a crucial link to human creativity. He chastised English society for brutalizing the crafts and "cutting them off from the intellectual part of us . . . making us more dependent on one another, destroying individuality, which is the breath of life to art."[1]

## FERTILE GROUND FOR REFORM

As in England, industrialization had changed the face of late-nineteenth-century America:

> Urbanization, immigration, and the factory system seemed responsible to many for destroying community, undermining the work ethic, destabilizing the family, and replacing the purity and godliness of the past with greed and commercialism. The rise of giant corporations and the nationalization of business and intellectual life also seemed destined to crush the individual, leaving him or her a cog in the machine of progress.[2]

Following the example of Ruskin and Morris, American reformers supported the concept of the craftsman society—a place of "brotherhood and beauty"—and found models to emulate in Ruskin's utopian community, the Guild of St. George, and in Morris's eponymous and successful workshops.

## LABOR REFORM AND THE MORAL CODE

According to Arts and Crafts philosophy, the craftsman's workshop embodied the most humanistic alliance among workers, modes of production, and products. In the model workshop, individuality and creativity could be nurtured in a small, decentralized setting, close to nature and in a healthy environment, all conditions that were to be entirely different from the "factory system, surrounded with its filth, bad ventilation, and unwholesome influences."[3] Artists could control not only the design but also the methods of

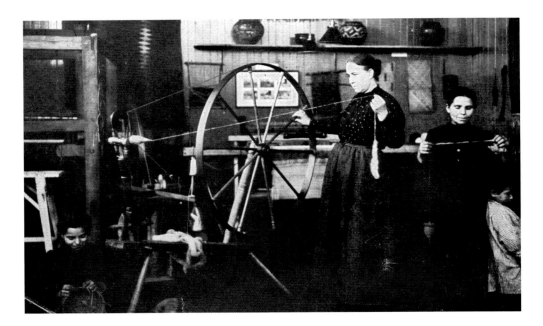

*A CORNER IN THE HULL HOUSE LABOR MUSEUM,* ILLUSTRATED IN *THE CHAUTAUQUAN,* MAY 1903. Commenting on one of the objectives of the Hull House Labor Museum in Chicago, John Dewey wrote in *The School as Social Center* (1902): "One of the chief motives in the development of the new labour museum at Hull House has been to show the younger generation something of the skill and art and historic meaning in the industrial habits of the older generations—modes of spinning, weaving, metal working, etc., discarded in this country because there was no place for them in our industrial system. Many a child has awakened to an appreciation of admirable qualities hitherto unknown in his father or mother for whom he had begun to entertain contempt. Many an association of local history and past national glory has been awakened to quicken and enrich the life of the family."

production and the aesthetic determination of the final product. Working cooperatively, they would enjoy the fruits of their labors equitably through profit sharing or communal land ownership. Morris's maxims, "Have nothing in your houses that you do not know to be useful or believe to be beautiful" and "Art is the expression of man's pleasure in labour," became the movement's touchstones.[4]

## MORRIS & CO.: ARTS AND CRAFTS AS BUSINESS

It was William Morris who most successfully applied the movement's theory of ethical art into business practice. In 1861, he established the firm of Morris, Marshall, Faulkner and Co. (restructured as Morris & Co. in 1875), organizing it as a collaborative enterprise of designers, craftsmen, painters, and architects who worked together on the design and making of furniture, textiles, stained glass, and tiles. Morris's workshop-based firm produced quality goods and offered a viable alternative to the factory production system. Furthermore, mingling the talents of fine and decorative artists raised the status of the applied arts.

## GUILD AND SCHOOL OF HANDICRAFT: A MEDIEVAL REVIVAL

Less practical but equally influential was the craft theorist Charles Robert Ashbee (1863–1942). Following his graduation from King's College in Cambridge, where he had read Ruskin and Morris, Ashbee moved to London to work as an architect. His evenings were

spent in the poor Whitechapel section of the city, where he worked at Toynbee Hall, the first university settlement in England, created for Oxford and Cambridge students to better understand and improve the lives of the poor. In 1886, Ashbee offered to teach a course on Ruskin's writings. A year later, after a class discussion about the dignity of manual work, the class decided to do something about it—and resolved to decorate the dining room of Toynbee Hall. The success of this enterprise gave Ashbee the idea of establishing a school for the settlement house, and in 1887 he founded the School and Guild of Handicraft with the intention of providing training and craft production side by side (the Guild of Handicraft was started a year later). In 1902, in an effort to distance the school from the pressures of London, Ashbee relocated it from the city to western England. In the Cotswolds, in the town of Chipping Campden, he formed eight separate workshops that specialized in wrought iron, silver, furniture, printed books, and other crafts.

Among the many Americans who were impressed by visits to Ashbee and his workshops in both locations were Jane Addams, the founder of Hull House in Chicago; Ernest A. Batchelder, an influential teacher, writer, and tile maker; and H. Langford Warren, a professor of architecture at Harvard University and a founder of the Society of Arts and Crafts in Boston. Financial difficulties forced the guild to close after about six years, but by this time it had received much good press, and Ashbee had made a few influential speaking trips to America, during which he spread the word about his activities.

## ARTS AND CRAFTS MOVEMENT COMES TO AMERICA

★

Americans who wanted to take part in the reforming efforts did so in a multitude of ways. Elbert Hubbard (1856–1915), a successful soap salesman, visited Morris's workshops, and Gustav Stickley furniture workshops, commercial ventures based on Arts and Crafts aesthetics and some of its principles. Two utopian communities, Byrdcliffe in New York and Rose Valley in Pennsylvania, attempted a more idealistic approach, with mixed results. In each case, the craftsman was allotted a lesser or greater degree of involvement, credit, and compensation, depending upon the goals of these enterprises. All, however, shared a commitment to good design and craftsmanship.

## ROYCROFT AND THE POPULARIZATION OF THE CRAFT IDEAL

While traveling abroad Elbert Hubbard was so inspired by Merton Abbey and the Kelmscott Press, where William Morris produced richly printed books using type of his own design, that he began a periodical, *The Philistine,* through which, with a mixture of humor and common sense, Hubbard popularized the craftsman ideal to a broad audience. With a never-ending stream of articles, books, and sayings that poked fun at the stuffy side of human nature, Hubbard adapted the ideas of Ruskin and Morris for the American middle class.

It was not long before Hubbard's operation expanded with the establishment of the Roycroft Community in East Aurora, New York, and the production of furniture, metalwork, and leather goods. An inn was built to receive celebrities and the many admirers of "Fra Elbertus," Hubbard's name for himself, an allusion to the ostensible medieval roots of his enterprise. This reference to brotherhood notwithstanding, Hubbard was above all a businessman, and he held the economic and social reins of his community firmly in hand while acting as a paternalistic and even enlightened employer. His commercial suc-

ABOVE
**PORTRAIT OF ELBERT HUBBARD, FOUNDER OF THE ROYCROFT COMMUNITY.**
Hubbard is seen here in characteristic "artistic" or "poetic" dress for men of the period that usually included a soft, broad-brimmed hat with indented crown, loosely tied silk cravats, and long hair.

RIGHT
**ROYCROFT FURNITURE SHOP, ARMCHAIR, C. 1910.**
This broad chair with its stamped leather seat was used by Elbert Hubbard when he gave lectures.

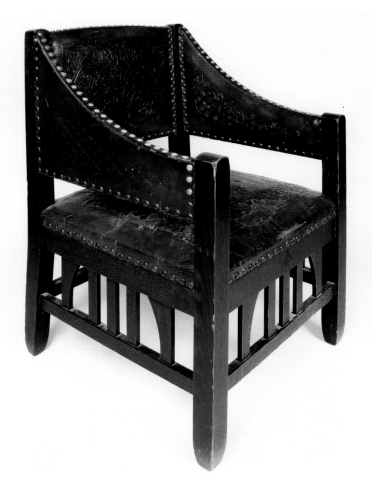

cess can be measured by the circulation figures for *The Philistine* — more than 100,000 copies were apparently sold each month — and by the size of his operation: Four hundred workers are said to have been in his employ by 1906.

The medievalism implied by some of Hubbard's rhetoric and his adoption of the Roycroft symbol was little more than symbolic. Working conditions at Roycroft were healthy but were marred by the intrusion of assembly-line work and mechanized operations. Hubbard offered a menu of cultural and sports activities to his staff but maintained a distance between workers and management. As a "social and industrial experiment," Roycroft fell short of the mark although it did continue until 1938, many years after the death of the founder in 1915.

## STICKLEY FURNITURE: ADAPTING THE IDEAL FOR COMMERCE

Another American proselytizer of the Arts and Crafts movement, Gustav Stickley, began as a furniture designer and maker. He and his younger brothers, Albert, Charles, Leopold, and John George, worked together and separately over the years in a variety of furniture-making partnerships.

In 1901, he founded a periodical, *The Craftsman,* which was a promotional vehicle for his company and a guide to developments in the Arts and Crafts field. His first issue was on the life and writings of Morris and the second was devoted to Ruskin. The magazine provided crafts projects for the aspiring artist and articles on craft workshops and communities, Native American crafts, and European folk art.

The next year, he began to produce unadorned, rectilinear furniture that constituted a radical break with the historicized Victorian furniture that he and most American manufacturers had produced. His furniture was admired for its materials and finish but criticized for being overly large and heavy. Stickley defended it, alluding to Ruskin when he wrote, "It is true that our severe and simple style now errs upon the side of crudeness. But it suggests vital force in progress."[5]

In 1902 and 1903, Stickley traveled to London to attend the seventh exhibition of the Arts and Crafts Exhibition Society, and there he met the English architect and designer C. F. A. Voysey, among others. In London he found works that echoed his own aesthetic and confirmed his belief that he was on the right path in making this new kind of plain, well-made furniture.

Beginning in 1904, Stickley began to produce furniture in a profit-sharing enterprise that he named United Crafts. However, rapid growth and poor bookkeeping led him to

abandon this approach and reorganize the company along more traditional business lines, as Craftsman Workshops.

His furniture was recognizable by its plain, sturdy shapes, exposed oak joinery, and unadorned leather upholstery. Although called Mission furniture, the association with the furnishings of early California churches built by the Spanish had more to do with nostalgia than with true precedent. In a significant break with Ruskin, Stickley advocated the use of power machinery, stating that "it should be the privilege of every worker to take advantage of all the improved methods . . . that relieve him from the tedium . . . of purely mechanical toil, for by this means, he gains leisure for . . . working out his designs, and for the finer touches that the hand alone can give."[6] Machines were also the pragmatic choice if the company were to turn a profit.

The year 1904 was also when Stickley began to promote Craftsman homes in his magazine. Intended for middle-class subscribers, he provided a full set of architectural plans for construction by local builders. Like his furniture, Stickley's houses included exposed structural elements and natural materials. Following the lead of English and European Arts and Crafts architects, he employed built-in elements such as benches or cabinets and considered all furnishings, including lighting fixtures, as part of the overall design concept.[7]

By 1908, encouraged by the success of his magazine and furniture company, Stickley began to assemble a large tract of land in Parsippany, New Jersey, for a farm school and

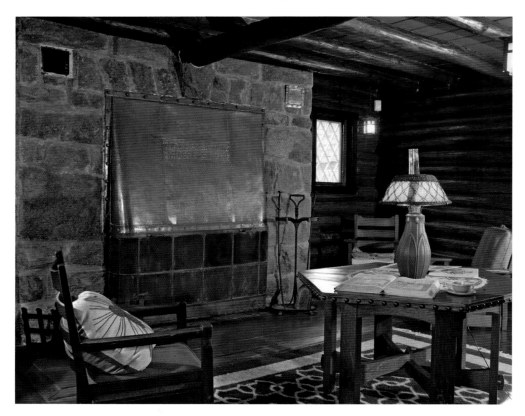

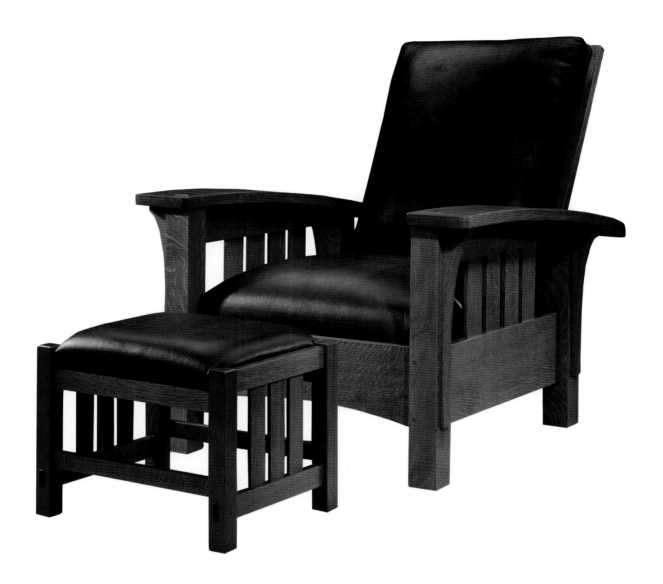

community that he called Craftsman Farms. The first and only building constructed was a magnificent log clubhouse, which he and his family eventually occupied. In 1913, he built a twelve-story building in New York City that included a showroom and offices for his publishing operation, a library, lecture hall, and restaurant.

Despite these prodigious efforts, his expansionist goals proved costly at a time when economic constraints caused by World War I were contributing to the demise of the Arts and Crafts movement. The company entered bankruptcy in 1915, and the magazine ceased publication in 1916. Meanwhile, his brothers Leopold and John George formed their own company, named L. and J. G. Stickley, which produced a more conservative version of Arts and Crafts furniture, among many other styles. They absorbed Craftsman Workshops in 1918. Today the firm is known as Stickley, Audi & Company, and sells high-quality Gustav Stickley's Craftsman furniture for the twenty-first-century consumer seeking a plain but handsome style that resonates with the ideals of the Arts and Crafts movement.

ABOVE

**BOW ARM MORRIS CHAIR, ORIGINAL DESIGN C. 1910, BY LEOPOLD STICKLEY.**
This armchair and ottoman is Leopold Stickley's finest tribute to William Morris's arts and crafts ideals, represented by its straightforward, rectilinear design of solid wood, exposed joinery, and unadorned leather upholstery. These qualities make Stickley furniture designs honest, functional, and sturdy, key characteristics of the Arts and Crafts movement.

Far smaller in scale than either Roycroft or Craftsman Workshops was the Byrdcliffe community in Woodstock, New York, which was founded in 1902 by two wealthy philanthropists, the English idealist Ralph Radcliffe Whitehead and his wife. Intended to be an artists' colony, school, and farm, the enterprise failed as a self-sustaining community, but it has provided a supportive environment for the arts and continues to flourish today.

The son of a wealthy industrialist, Whitehead became a student and soon a disciple of John Ruskin. He visited and may have briefly participated in Ruskin's Guild of St. George, and was inspired to apply his own wealth to a similar purpose. Under Ruskin's tutelage, Whitehead resolved to improve the lot of the workers in his family's felt-making business and to reduce the pollution created by the factory. His family, however, did not share these noble Ruskinian goals and presented considerable opposition.

In 1900, he married the American artist Jane Byrd McCall (1861–1955), and the couple moved to Woodstock to establish Byrdcliffe. Whitehead chose the location for its natural beauty and for its access to railroads, a necessity for reaching the markets that would enable the community to be self-sustaining. He and his wife engaged the artists who settled in Woodstock, and the couple spared little expense in providing them with comfortable and well-equipped studios. The Whiteheads themselves lived in a house called White Pines, for which a pottery run by Jane Byrd McCall was later named. The site was quickly dotted with many buildings, which survive today.

Despite Whitehead's efforts, and in part because of his autocratic style, the community that he had dreamt of did not last more than a year or so. Furniture was the chief

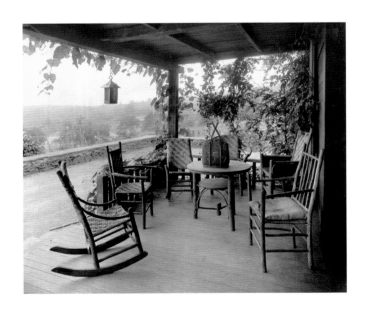

product, and the large cabinets that craftsmen fashioned, with delicately carved or painted panels, were competitively priced. But Whitehead had no taste for marketing or cultivating a brand identity, which had made Stickley and Hubbard successful.

Nevertheless, the colony survived in a manner that continues to attract visitors to the present day. While the couple made hand-built pottery and weavings when living in Byrdcliffe on and off for thirty years, dozens of professional artists in all media came intermittently to work, some of whom rented space to teach and create works of art. And the colony inspired the formation of other artistic groups, among them the Maverick colony, the summer school of the Art Students League, the Woodstock Artists Association, and the Woodstock Guild of Craftsmen.

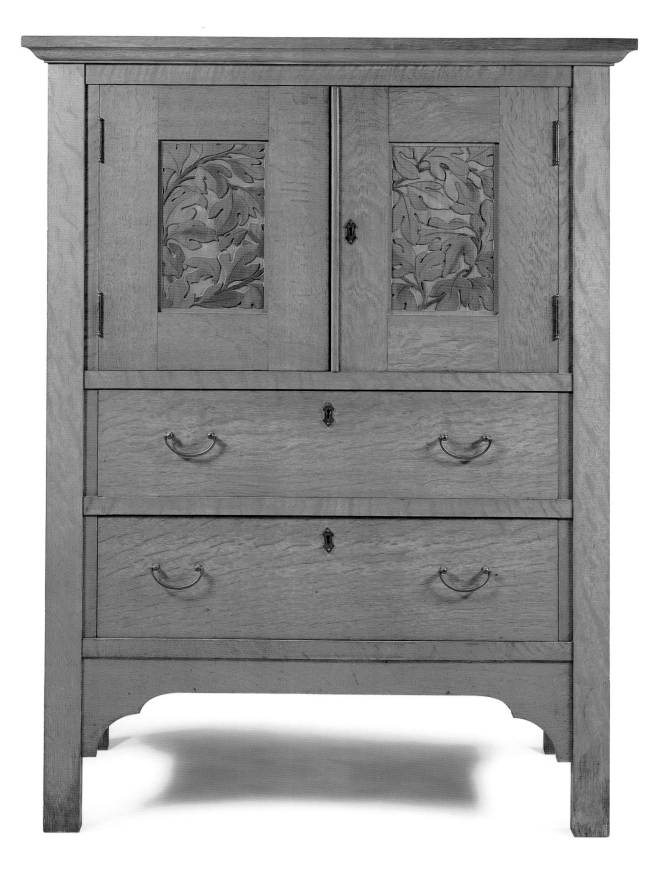

Today Byrdcliffe survives as the Woodstock Byrdcliffe Guild, which joins the Byrdcliffe Arts and Crafts Colony with the Woodstock Guild of Craftsmen.

## ROSE VALLEY: A COMMUNITY FOR ALL CLASSES

Best known for coining the phrase "the art that is life," Will Price (1861–1916) was an architect, furniture designer, and social reformer. In 1901, he established the Rose Valley Association on eighty acres of abandoned industrial land situated outside Philadelphia. Their plans for the industrial ruins included a library, theater, museum, and school. Surviving records document that association members regularly mounted plays, performed concerts, and invited lecturers to speak and that some worked privately as painters and illustrators. As an outlying village that was accessible to Philadelphia by train, the community thrived until 1909.

Furniture and pottery were the primary crafts produced for sale. Price designed the furniture, which was fabricated in a workshop in a former textile mill by immigrants with the requisite skills, which few Americans had, for carving, piercing, and shaping wood. His designs were in the Gothic, Renaissance, and colonial styles, and many were constructed with keyed tenons so that the furniture could be easily disassembled.

Like Stickley, Price was a publisher. In his writings he professed a desire to foster an environment where one's work and surroundings were in harmony. His woodworkers, however, could not have been satisfied with the arrangements. They had no say about the design of their furniture, and although they worked at Rose Valley, they were apparently not fully accepted as members of the association. Ironically, labor disputes may have led to the closure of the woodworking shop by 1906.

RIGHT

**ROSE VALLEY ARTS AND CRAFTS COLONY, 1906**

A photograph of the cottages for the "artisans" working at Rose Valley, 1906, shows the bucolic landscape and pleasing surroundings in which this arts and crafts community was built.

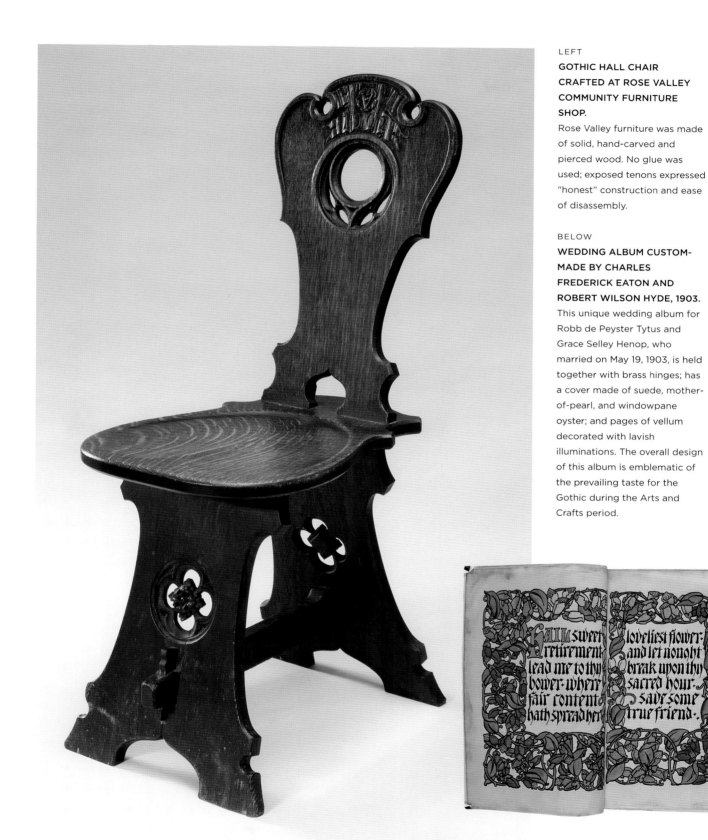

LEFT

**GOTHIC HALL CHAIR CRAFTED AT ROSE VALLEY COMMUNITY FURNITURE SHOP.**
Rose Valley furniture was made of solid, hand-carved and pierced wood. No glue was used; exposed tenons expressed "honest" construction and ease of disassembly.

BELOW

**WEDDING ALBUM CUSTOM-MADE BY CHARLES FREDERICK EATON AND ROBERT WILSON HYDE, 1903.**
This unique wedding album for Robb de Peyster Tytus and Grace Selley Henop, who married on May 19, 1903, is held together with brass hinges; has a cover made of suede, mother-of-pearl, and windowpane oyster; and pages of vellum decorated with lavish illuminations. The overall design of this album is emblematic of the prevailing taste for the Gothic during the Arts and Crafts period.

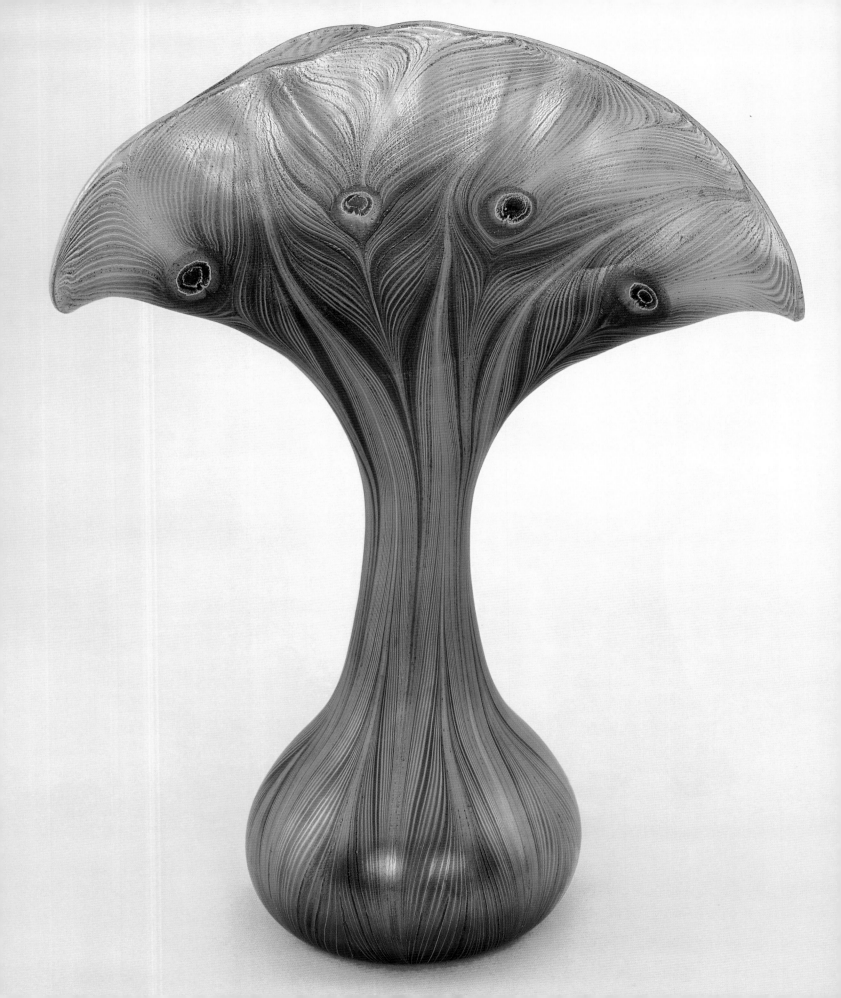

# SUCCESSFUL WORKSHOP MODELS

★

## TIFFANY: THE VALUE OF CREATIVE RISK TAKING

Although the utopian concept of an artistic community was beset with challenges and usually ended in failure, a more successful model was the workshop led by a gifted artist and a talented circle of associates: the glass, metal, wood, and clay workshops founded by Louis Comfort Tiffany (1848–1933). Because Tiffany's personal fortune permitted him to take risks in experimenting with new media and designs, his workshops, with their outpouring of lighting fixtures, furniture, pottery, metalwork, and jewelry, much of it in an art nouveau style, mark a high point in the history of American decorative art.

Louis, the son of Charles Lewis Tiffany, the founder of the luxury goods retailer Tiffany & Co., studied painting as a young man, traveled to Europe and to North Africa, and immersed himself in foreign and exotic cultures as he traveled. Upon his return, he and several others formed Associated Artists, an interior design firm patronized by many of New York's elite families.

Interested in colored flat glass that could be used for windows, Tiffany established the enterprise that would gain him the greatest acclaim, Tiffany Glass Company, in 1885. The company enjoyed numerous commissions from private individuals and churches for stained-glass windows and mosaics. Following a visit in 1889 to the *Exposition Universelle* in Paris, where he admired work by French glass artists, especially Émile Gallé, and where American artist John LaFarge received prizes for his stained glass, Tiffany began to experiment with blown-glass vessels. A year later, he invited the English glass specialist Arthur J. Nash to New York. Nash's considerable technical expertise encouraged Tiffany to envision new ways in which to create glass vessels. Their efforts soon led to what he would call favrile glass, a term based on the Latin *fabrilis,* meaning "handwrought."

By the late 1890s, the glass enterprise had grown to the extent that Tiffany was obliged to maintain between 200 and 300 tons of glass on hand and in more than five thousand colors and types in order to meet demand. Clearly a large staff was required to execute the commissions; the venture could hardly be called a workshop; it was, in fact, a firm with many dozens of employees. Tiffany exercised creative control over the whole, but he also enjoyed the assistance of talented designers and craftsmen, many of them female. At a time when women were beginning to enter the workplace, he hired graduates of New York's many art schools, employing about thirty women in the Women's Glass Cutting Department who worked with flat glass intended for stained glass windows and mosaics.[8]

The same was true, albeit on a smaller scale, in his jewelry and enameling work, which after about 1902 was located within Tiffany & Co., where he became artistic director. Tiffany functioned as both artist and entrepreneur. He worked with talented designers

OPPOSITE

**PEACOCK VASE DESIGNED BY LOUIS COMFORT TIFFANY, TIFFANY GLASS AND DECORATING COMPANY (1893–1902), CORONA, NEW YORK, C. 1893–1896. FAVRILE GLASS.**

Nature was a powerful influence on the forms created by Louis Comfort Tiffany, and the attenuated vases that he created based on flora and fauna motifs were made in abundance.

BELOW LEFT
**PORTRAIT OF MARIA LONGWORTH NICHOLS.**

Nichols was deeply impressed by the Japanese pottery exhibit at the 1876 Centennial Exhibition in Philadelphia. Within four years after her visit, she founded Rookwood Pottery in Cincinnati.

BELOW RIGHT
**ROOKWOOD DECORATORS, 1900.**

Both women and men worked as decorators in well-lit and ventilated rooms, underscoring the Arts and Crafts belief that the craftsperson deserved a good working environment, and so provided, would produce quality work.

and craftsmen for his most important creations, and delegated the fabrication of less demanding work and of multiples to other staff members. The uniformly fine quality of his production is proof of Tiffany's unwillingness to compromise his artistic vision, and was no doubt aided by his staff's efforts to meet his high standards of design and craftsmanship.

## RECOGNITION OF THE INDIVIDUAL CRAFTSMAN AT ROOKWOOD POTTERY AND AT THE SILVERSMITHING WORKSHOP OF ARTHUR STONE

Other crafts enterprises were the work of many identifiable hands. The Rookwood Pottery was established in 1880 by Maria Longworth Nichols in Cincinnati, Ohio, as a result of her early experiments with overglaze decoration. As the business expanded quickly, she added a decorating department and the Rookwood School for Pottery Decoration to train new designers and painters, many of whom were accomplished painters and sculptors in their own right. Some of the company's most memorable vessels are those painted with delicate floral motifs, for which they became known. Unlike Tiffany, who used the company name on all finished work and did not credit individuals, Nichols granted more autonomy to her artists, allowing them to sign their own work, a pattern followed by some other art potteries in this country.

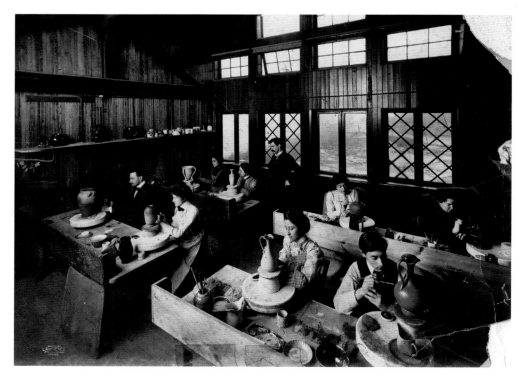

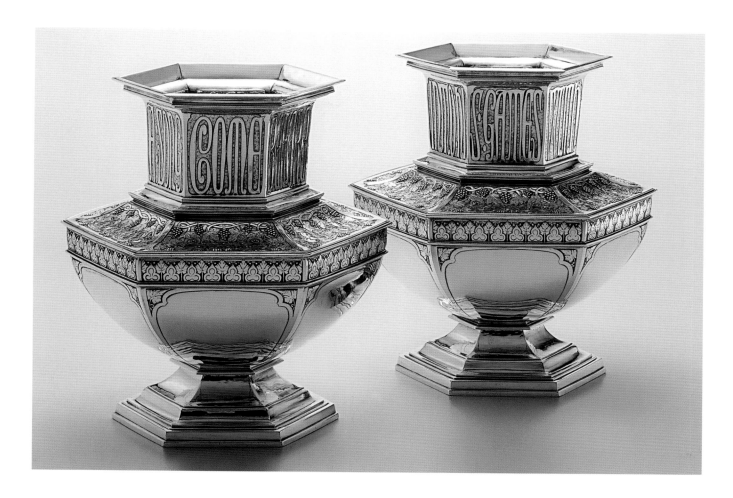

Similarly, the silversmiths employed by Arthur Stone (1847–1938) of Gardner, Massachusetts, enjoyed the privilege of having their work acknowledged. Stone himself designed nearly all of the objects produced by his workshop, but the silversmith who had the primary responsibility for making an object was permitted to add his own *touchmark* (an English term) to the studio mark that was struck on each vessel. Stone also divided the profits from earnings among the staff twice each year, which may have contributed to their long and faithful service to him. His workshop remained in business from 1901 until Stone retired at the age of ninety in 1937, after which it continued under new management until the 1950s.

## A THERAPEUTIC CALIFORNIA CRAFT COMMUNITY: AREQUIPA POTTERY

Vessels and tiles from Arequipa Pottery, in Marin County, California, embody progressive ideas about the dignity of work and the curative value of making craft. Founded in 1911 for tubercular working women who could not afford the cost of a sanatorium, the pottery enabled patients to earn a modest income while regaining their health. The name of the pottery, taken from a Peruvian city, means "place of peace" or "place of rest."

ABOVE

**PAIR OF ALTAR VASES BY ARTHUR STONE, 1915.**
These hexagonal vases, made for the chapel at Pomfret School, have been ornamented with a trefoil pattern below the shoulder and a grapevine below the neck. The text seen on the necks of these vases emulates Islamic lettering on religious objects. In slender lettering on one it reads: ENTER INTO HIS GATES WITH THANKSGIVING and on the other COME BEFORE HIS PRESENCE WITH A SONG.

**AREQUIPA POTTERY VASE,
C. 1912–13.**

Pink and white flowers sit amid
swirling green leaves on this
13-inch-tall Arequipa vase, with
inspiration from William Morris
wallpaper and textile. The
quality of the studio's output
was recognized by their
inclusion at the great Panama-
Pacific International Exposition
of 1915 in San Francisco.

**KAREN KOBLITZ, ARTS
AND CRAFTS STILL LIFE #2,
1994, GLAZED CERAMIC,
31 x 36 x 2 INCHES.**

This wall tableau comprised of
ceramic tiles and three vases
that rest on a shelf is Koblitz's
homage to the decorative style
of the Arts and Crafts
Movement. The surface textures,
colors, and patterns of the tiles
reference the work of Ernest
Batchelder, renowned California
tile designer, and the vessel
shapes and motifs are inspired
by the designs produced by
Rookwood Pottery.

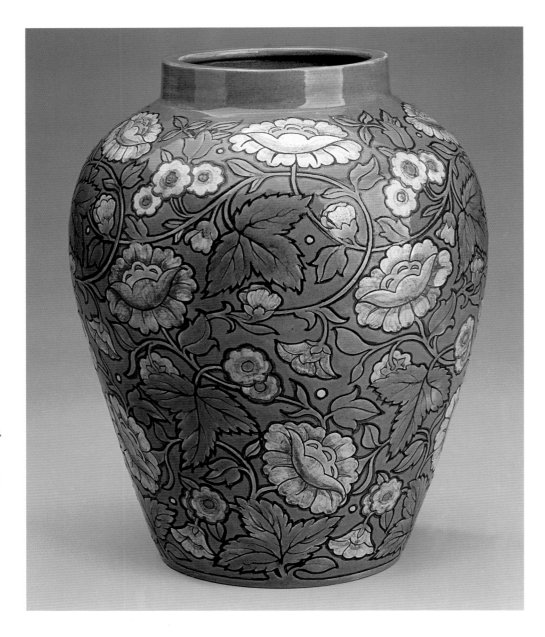

The English potter Frederick Hürton Rhead (1880–1942) was the director. He taught
the women to throw pots and decorate the vessels during the few hours each day that
they were allowed to work. He and other male assistants dug the clay, loaded the kiln, and
fired the finished pieces, but the creative aspects of making the forms were done exclu-
sively by the women.

Using slip-trail decoration, carving, and incising, the women ornamented the vessels
and tiles with designs drawn from the native plants of California. Manzanita, iris, poppy,
oranges, and eucalyptus were among their memorable subjects, and a trailing vine at the
shoulder of vessels was one of their most typical and pleasing patterns.

Arequipa participated in the Panama-Pacific International Exposition held in San
Francisco in 1915, exhibiting in the Palace of Education and Social Economy, where it

BELOW

**RANDY STROMSOE, SANTA ROSA, 2002, PEWTER AND EBONY, 15 x 11 x 13 INCHES.** Stromsoe, who as a young man apprenticed with Porter Blanchard, the illustrious Arts and Crafts metalsmith, carries on the movement's traditions in his silver and pewter hollowware pieces, which are entirely hand-formed and finished.

received the gold medal. Although the exposition brought significant attention to Arequipa, rising costs and the loss of manpower brought about by World War I caused the pottery to close in about 1918.

## THE LEGACY OF ARTS AND CRAFTS

★

The Arts and Crafts concepts of simplicity and usefulness were expressed in several key tenets: the application of form to function, the importance of hand workmanship and honest, evident construction methods, and the use of indigenous materials and vernacular motifs drawn from nature. These principles were translated into architecture, furniture, metalwork, textiles, glass, pottery, and books that form a beautiful and captivating visual record of the era. The force of the movement left a profound mark on the society and art of its day. Its legacy has been to validate the handmade object, the dignity of the worker, and the pure joy of creation.

• • •

# THE ALLURE OF JAPAN AND THE INFLUENCE OF THE EAST

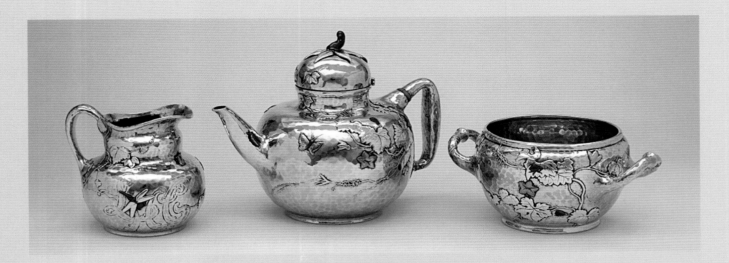

**E**VER since 1854, when Japan first opened its doors
to the West, the country has held a special fascina-
tion for European and American artists. Japan's allure,
whether real or perceived, lay in the apparent innocence of
its preindustrial society, a quality valued by the Arts and
Crafts movement, whether it was manifested in medieval
Europe, colonial America, or feudal Japan.

The arts of Japan captivated artists in all disciplines, and
many acquired examples for study from the quantities of
decorative arts and paintings that were shipped to the West
by the end of the nineteenth century. The unusual costumes
of the Japanese, the flat perspective of their landscapes,
and the sensuous approach to nature found an appreciative
audience in the West. Japanese pavilions, such as those
seen by Greene and Greene, were featured at the great
international exhibitions held in the United States and
abroad, and enchanted visitors with exotic materials and
subjects from a faraway land.

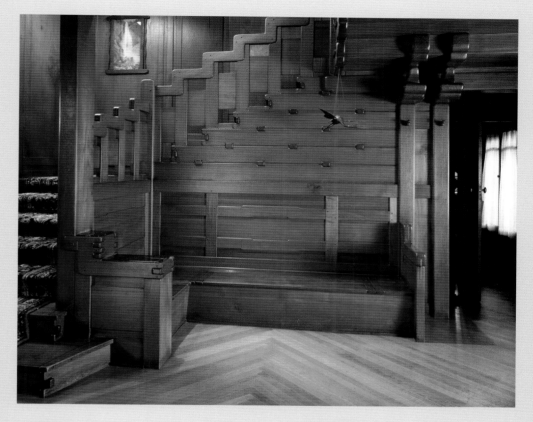

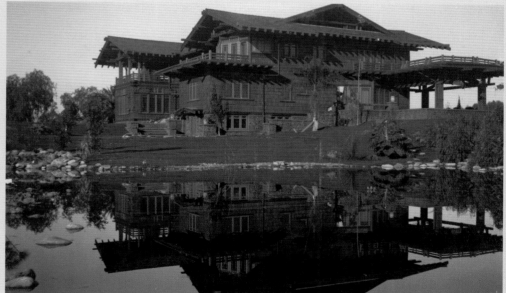

**OPPOSITE, TOP**
**TEA SET BY TIFFANY & CO., 1878.**
This silver, brass, copper, and gold tea set reflects that influence through its butterfly and dragon imagery, as well as its composition.

**OPPOSITE, CENTER**
*YOUTH,* **BY ARTHUR AND LUCIA MATHEWS, C. 1917.**
Arthur F. Mathews painted this romantic composition inspired by Greek mythology. He and his wife, Lucia, worked together on the elaborate Renaissance-style tabernacle frame. The carving on the frame features a pair of undulating dragons, which was a popular motif at the time, as the Mathewses, like other fellow artists of the era, were entranced by Asian art.

**ABOVE LEFT**
**DETAIL OF THE STAIRS IN THE DAVID B. GAMBLE HOUSE, PASADENA, CALIFORNIA, 1907–1909.**

**LEFT**
**ROBERT BLACKER HOUSE, PASADENA, CALIFORNIA, 1907, DESIGNED BY HENRY MATHER GREENE AND CHARLES SUMNER GREENE.** Projecting eaves with exposed timber and deep balconies created a dramatic effect. Meanwhile, interior furnishings, which they also designed, boasted more exotic woods, such as teak, ebony, and mahogany and were inflected with Asian references.

# HEART, HAND, AND MIND: THE CRAFTSMAN LIFESTYLE

WHERE *traditional craftsman was artisan because of material necessity, fashioning objects necessary to society, the new craftsman in the industrial society chooses the path of making the unessential necessity, fashioning his lifestyle to realize the creative impulse so vital to the whole person, providing those objects of the hand and mind so necessary to us all.*

EUDORAH M. MOORE
in *The Craftsman Lifestyle—The Gentle Revolution* (1978)

**A**RTS AND CRAFTS principles have endured into the twenty-first century through the creative voices and lifestyle choices of many craftspeople who have chosen to dedicate their life and work to handcraft and art. Internationally acclaimed woodworker Sam Maloof, now in his nineties, is the contemporary embodiment of the spirit and ideals of Arts and Crafts. He has captured the sense of mission that fueled the movement by continuing to work in time-honored craft traditions and creating a holistic living environment where the handmade is necessary, vital, and exalted. Like the founders of Arts and Crafts, his aim is the unity of art and life and Maloof's motto of "eye, hand, and heart" has been the guiding force in his life.[9]

## A TEMPLE OF CRAFTSMANSHIP

Maloof's handcrafted furniture and home—referred to as a "temple of craftsmanship" because his hands had created everything in the house—demonstrate his lifelong commitment to handiwork, as well as his heartfelt belief in the moral and spiritual benefits he derives from his work.

Maloof and his late wife, Alfreda, were inspired over a span of fifty years to transform the modest, low-cost house they had built in the late 1940s into a monument to their creative vision and craftsman values. More cottage than house, the 800-square-foot, flat-roofed structure was built from discarded wood and with borrowed tools, on land Maloof reclaimed from a citrus orchard in San Bernardino County, California. Maloof built their first household furnishings from "dunnage found along the railroad tracks."

Today, that same structure has been disassembled and moved to a new location in Alta Loma, and it has been absorbed into a greatly expanded house that has grown organically to encompass twenty-three rooms and cover 8,500 square feet, with every linear inch, every intricate architectural detail, every piece of exquisite oil-rubbed furniture designed and crafted by Maloof.

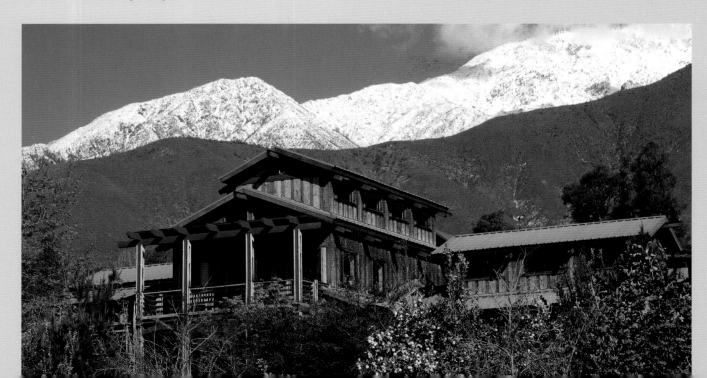

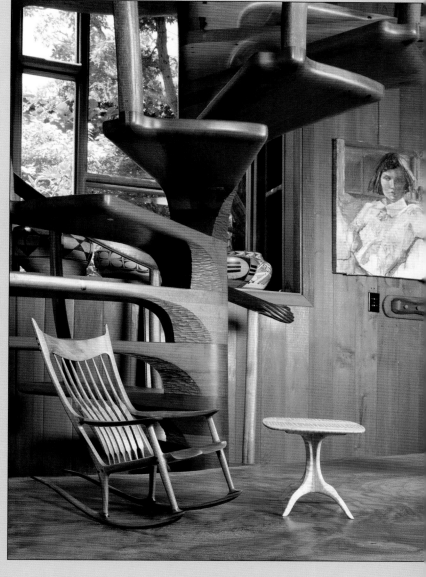

# THE "LINE OF BEAUTY" CAPTURED IN MALOOF FURNITURE

Maloof's first furniture pieces for his new home in the mid-twentieth century may have been improvised, and no doubt he had to make compromises because of a scarcity of means. But during the ensuing fifty years, Maloof's vision has evolved, and his work has matured into a sophisticated dialogue with material, form, and function, resulting in timeless designs that have become archetypes of the modern expression. Maloof's aesthetic, modeled after Arts and Crafts ideals of beauty, is characterized by the inherent splendor of the wood, careful attention to structural articulation, and polished simplicity. The form of his Double Rocker is a study of quiet grace, straightforward design, balanced proportions, and delicate profiles. Put into motion, it becomes a kinetic sculpture—line, mass, volume, and space engaged.

Maloof's furniture forms have become an emblem of elegant craftsmanship, and the Smithsonian Institution has called him "America's most renowned contemporary furniture craftsman." His mastery of the craft of woodworking and his classic furniture have also earned him celebrity status as furniture maker for the White House. His rocking chairs have seated presidents including Jimmy Carter, who visited Maloof's "temple of craftsmanship" to observe the master at work.

OPPOSITE MALOOF'S HOUSE, NOW A NATIONAL HISTORIC LANDMARK, SET AGAINST THE SNOW-CAPPED MOUNTAINS OF SAN BERNARDINO, CALIFORNIA.

ABOVE LEFT MALOOF'S DOUBLE ROCKER.

ABOVE RIGHT MALOOF'S TOUR DE FORCE SPIRAL STAIRCASE MADE FROM RECYCLED SHIPPING CRATES WITH MALOOF'S HANDCARVED FURNITURE "MINIATURES" IN THE FOREGROUND.

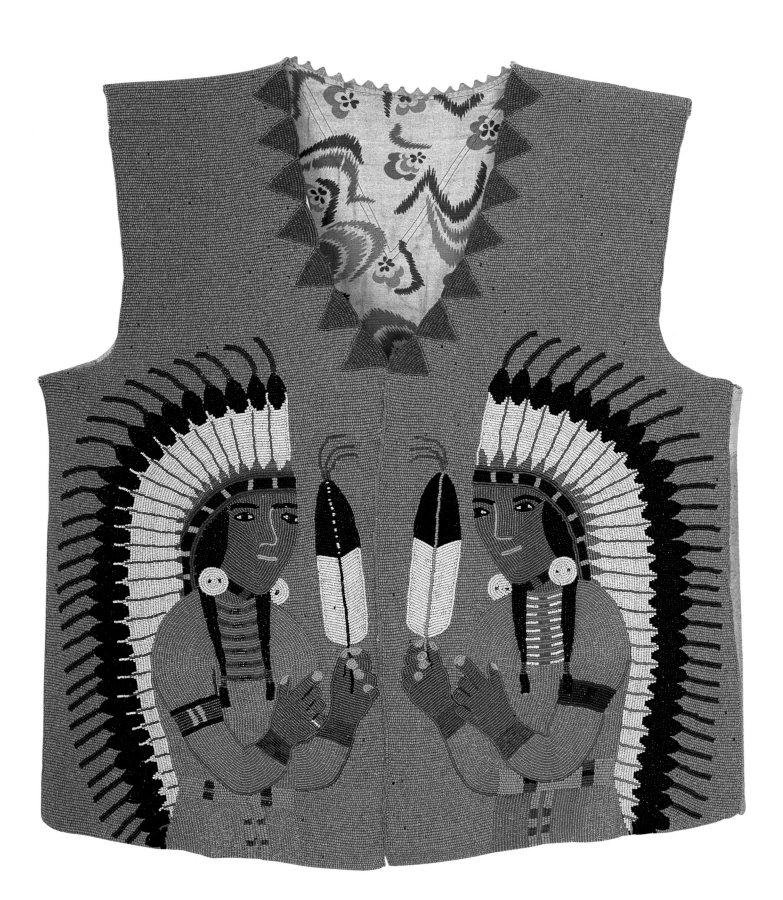

# Native Communities — Indigenous Crafts by American Indians

T HE OLDEST CRAFT TRADITIONS in the United States belong to its American Indian residents. For several millennia, artists working within diverse Native North American culture groups have used indigenous materials to produce functional and decorative works for personal, family, and community use. Ancient artistic traditions continue to inform the work of contemporary Indian artists and to impact modern Indian societies.

OPPOSITE

**SPOKANE, MAN'S BEADED VEST, C. 1920.** When seed beads arrived in the Pacific Northwest, two beadwork traditions developed, one geometric and one figurative. This vest is representative of the pictorial work that was popular in the Columbia River region during the late nineteenth and twentieth centuries.

## CRAFT, COMMUNITY, AND IDENTITY

★

Prior to the establishment of reservations during the mid-nineteenth century, all Indians were working craftspeople. Family and tribal economies required that everyone help produce the items needed for everyday life: clothing, pottery, basketry, tools. Artistic skill and creative drive prompted many artists to produce works that were finished beyond what was necessary for their basic function. The highest value of these works was nonetheless as utilitarian objects.

In the past, Native North Americans did not make a distinction between fine art and fine craft. Many Indian languages have no special word for *art,* and the

**ANCESTRAL PUEBLOAN MESA VERDE BLACK-ON-WHITE KIVA JAR, C. 1200–1300 C.E.**

Lidded vessels of this type are called kiva jars because they have often been recovered from prehistoric kivas (ceremonial chambers). The two holes that are drilled into the lid once took a rawhide tie that sealed the adjacent crack.

**WESTERN APACHE (ARIZONA), POLYCHROME BASKETRY OLLA, C. 1890S.**

Large coiled ollas of this type do not have historical antecedents in Apache culture. Smaller baskets with a similar form were used for water, seed, and grain storage. Finely worked baskets like this one were made for sale to outsiders. The Western Apache and the Yavapai lived near each other and intermarried, and their baskets share numerous traits. The human and animal figures on this basket are common Yavapai motifs.

making of beautiful objects was not considered a specialized occupation. Within Indian communities, however, the skills of some artists were recognized as being superlative. Their accomplishments were widely noted and appreciated. In addition to making fine things, these individuals influenced their social groups by sharing technical information, helping novices develop individual decorative vocabularies, and setting the standards of style. They were also frequently called upon to produce objects that had enough social and ceremonial importance to be seen as community property.

Like craftspeople in traditional societies throughout the world and like the artists who worked in the close ethnic, social, and religious communities that have existed throughout the United States, American Indian craft artists have at once been guided and constrained by the communities within which they lived. The forms and imagery used in their crafts historically served two essential purposes: to reinforce the identity of their own social group and to distinguish that same group from outsiders, whether allies or enemies.

Meyer Schapiro, a prominent art critic, has defined communal artistic style as being a "manifestation of the culture as a whole, the visible sign of its unity," and a reflection or projection of the "'inner form' of collective thinking and feeling." This definition is particularly appropriate to the understanding of traditional American Indian crafts. The vagaries of life and the necessity of community survival prompted artists to produce works using shared technologies, similar expressive styles, and common iconographic systems. Within these expressive parameters, however, individual artists could still be known through their use of specific motifs, the skill and methods they employed when fabricating and finishing items, and other identifying factors.

In some Indian communities, the creative expressions of men and women took divergent forms. Men's work often displayed representational imagery that described an individual's success in war or his encounters with the spirit world. Conversely, women's crafts were usually adorned with geometric motifs. The exemplary life of a woman was not revealed through unique behavior, but through her handiwork skill, her overall productivity, and her generosity.

Ancestral Puebloan (Anasazi) men attached figurative murals to kiva walls. They decorated rock outcroppings with pecked and painted human and animal figures. At the same time, Ancestral Puebloan women adorned their pottery and baskets with abstract geometric patterns. Plains Indian men kept calendars and winter counts and used figurative symbols and glyphs. They recorded the details of their lives by painting pictorial narratives on tipi exteriors, robes, and clothing. The women in their communities painted rawhide

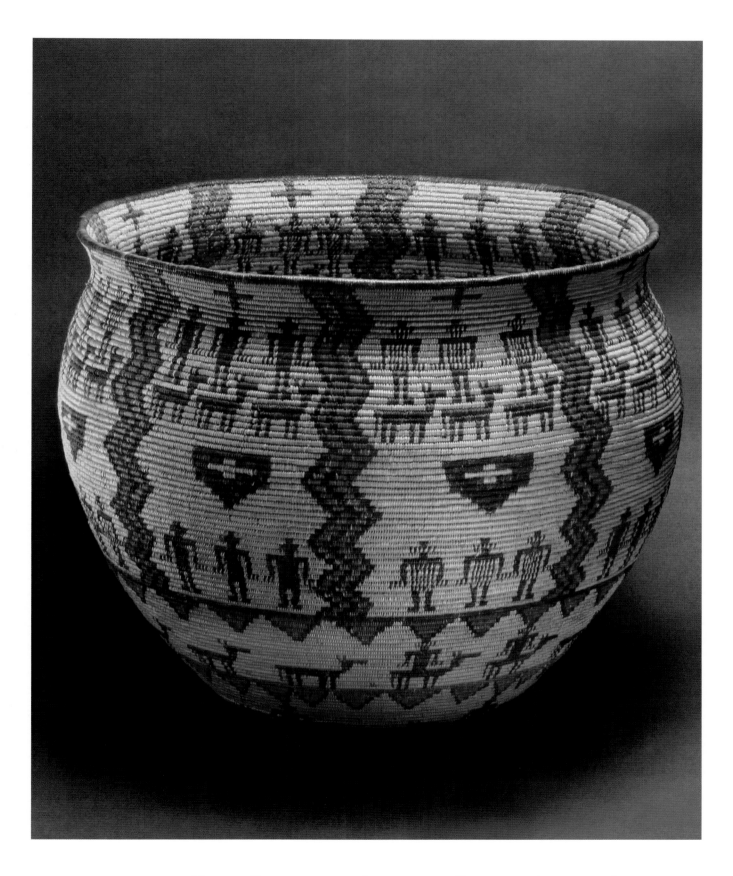

# WHERE THE BASKETS GOT THEIR DESIGNS: A KLIKITAT LEGEND

**A**LONG time ago in the animal world, before the Lataxat (Klikitat) people came, a young girl lived along the White Salmon River. She was Sinmi, the brown squirrel. Sinmi was slow and her fingers were clumsy. She did not know how to do things right. No one wanted to be near her or to help her. She lived all by herself.

Because she had nothing else to do, Sinmi would sit and dream in the shade of a huge cedar tree, Nank. The tree felt sorry for her, and one day he said, "My little sister, I cannot allow you to grow up like this. You must learn to do something to help yourself. I will teach you.

"First, go to the mountains and find a special grass. It is called *yaii,* bear grass. Pick it by pulling it out at the roots. Dry it in the sun and bundle it up neatly. Pick plants for coloring. Then come back here and dig up my straightest

roots. Split them into long thin pieces. Do as I say and someday you will be known for your basket work."

When Sinmi reached the mountains, she pulled up the grass and tied it into neat bundles. She searched for the plants for color. When she was finished, she returned to Nank. "I did as you asked," she told him.

Nank told her to dig his tender cedar roots, split them into long strips, and tie them into neat bundles by size. Then Nank showed her how to weave a basket with the materials she had gathered. She worked all day and far into the night. She was very tired but she kept on working until she finished one basket.

"I did this all by myself!" she told Nank, showing the basket to him.

"Don't brag," Nank said. "You still have to pass a test. Dip this basket in the river. If it does not leak, you have made a fine basket."

Sinmi dipped the basket into the river. The water ran right through it and onto the ground. She was very discouraged and she cried. Nank told her that she must make many baskets until she made a perfect one. "Soon you will be very talented," he said.

"Now you must find some designs to make your baskets beautiful," he told her. "Go out into the woods. Look at things of nature. Bring them back in your mind."

Sinmi set out again. She walked for many days, looking at everything. One day, Waxpush, the rattlesnake, crossed her path. He spoke to her. "See the designs on my back? Use them on your basket."

"Oh yes," she said, "those designs will be beautiful on my basket." Sinmi put the diamonds in her mind and was grateful to Waxpush.

She walked down the trail again until she saw Patu, the mountain. Patu spoke to her. "Look at me closely. I am like a design."

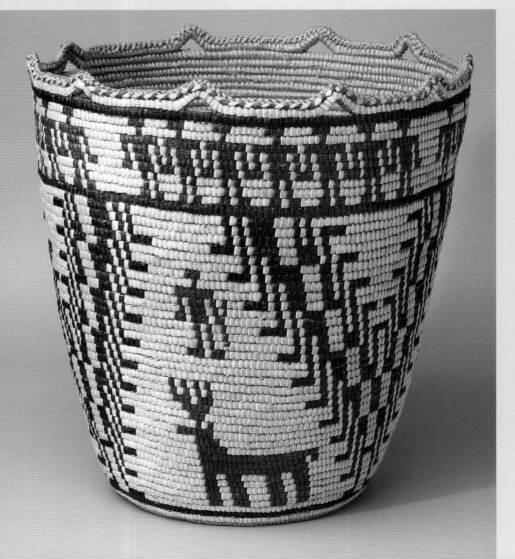

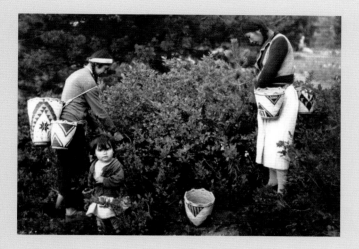

and he inspected her baskets. Spilyay said, "Soon there will be people coming to this part of the land. From today on this land called Lataxat will be known for cedar baskets."

And so it was. People came from all over to trade with the Klikitat people for their beautiful baskets that Nank taught Sinmi to make.

Adapted from Virginia Beavert, *The Way It Was* (Toppenish, Wash.: Consortium of Johnson O'Malley Committees, Region IV, 1974).

She thought, Yes, the peaks do look like designs. They would be beautiful on my basket. Sinmi put the mountains in her mind and she was grateful to Patu.

Farther down the trail, Pti the grouse ran across her path. Sinmi stopped and Pti spoke to her. "See my tracks? You may copy my footprints for your basket."

Sinmi said, "Yes, indeed, those tracks will look fine on my basket." And she put the tracks in her mind, grateful to Pti.

Several days later, as it was getting dark, Sinmi knelt down by Xowush, the brook, for a drink of water. The brook said, "Look at me. See the reflections."

"Yes," Sinmi said, "Xaslu, the evening star, reflected in the water, will be beautiful on my basket." So she put Xaslu in her mind, and was grateful to Xowush.

Sinmi was now ready to return to Nank and put the designs on her basket. She put the rattlesnake design around the edge. She put grouse tracks on the basket, then the mountain peaks, and she finished it with the evening star.

Nank reminded her of the test. Sinmi took the beautiful basket and dipped it in the Columbia River. It held water.

Nank was very proud of her. He told her to take away the basket and use it as a sacrificial offering, to teach her to be thankful that she had accepted the gift of basket making. "Next, you must make five small baskets to give to the *Watuyma tmama,* the oldest women, among your people."

But Sinmi wanted to keep her beautiful baskets. Nank told her she would never be a skilled basket weaver if she did not give away the first ones, and so she did. Sinmi made many more baskets, all of them beautiful and all with designs on them from the beautiful land around her.

It happened that Spilyay, the legendary coyote, was coming down the Columbia River. He learned about Sinmi

---

OPPOSITE **Nettie Jackson (Klikitat), Coiled Cedar Root Basket, 1984.** Coiled baskets like this are often called berry baskets because the Klikitats and their neighbors used them for temporary storage during berry harvests. The containers are pail shaped, and the loops around the rim may be used to tie down the foliage that protects the berries when the baskets are being moved. Few women now make baskets of this type, in part because Indian trade networks no longer flourish. Baskets like this were once traded for the necessities of life. To make a living, artists now depend on collectors and are subject to the vagaries of the market.

ABOVE **Huckleberry Picking Near Mount Adams, Washington, 1935.** In this photo, two Klikitat women, Minnie Marie Slockish (left) and her sister, Inez Slockish Jackson, are picking huckleberries into coiled cedar root baskets.

BELOW **Pat Courtney Gold (Wasco/Tlingit), Honoring the Wasco Weaver of the 1805 Basket Collected by Lewis and Clark, 2003.** In 1805, Lewis and Clark and the Corps of Discovery encountered

Chinookan-speaking people along the middle Columbia River. The explorers were given food in a twined Wasco-style basket that is now one of the few surviving expedition artifacts. It provides an ongoing inspiration for Gold and informs much of her work. Her 2003 basket contains personal elements and preserves the distinctive imagery of the 1805 prototype.

**ELIZABETH HICKOX (KARUK),
1913.**

Elizabeth Hickox and her
daughter, Louise, were skilled
and innovative weavers who
lived along northern California's
Lower Klamath River. Pasadena
curio dealer Grace Nicholson
promoted their work to collec-
tors throughout the United
States.

OPPOSITE
**LOUISA KEYSER (WASHOE),
"DEGIKUP" BASKET, C. 1918.**

Louisa Keyser (also known as
Dat So La Lee) became a full-
time basket maker when she
was in her mid-forties. In 1895,
she was employed by Carson
City, Nevada, business owners
Abe and Amy Cohn. The Cohns
provided Louisa and her
husband with room and board
in exchange for her completed
works. They promoted and sold
her vessels and over a period of
thirty years, she completed
more than one hundred baskets
for them. Keyser was thus one
of the first Indian craftspeople
to be sponsored by patrons.

containers and produced quill-and-bead embroidery by combining small abstracted designs into larger compositions. Apart from the changes wrought by outside patrons, Indian bas-ket makers—most of them women—usually worked within these same design parameters. As with all generalizations, there were exceptions to this rule and the late-nineteenth and twentieth centuries saw figurative imagery appearing in diverse women's arts.

Historically the specific motifs used by women—whether worked on baskets, pot-tery, beadwork, or rawhide—were often the property of individual artists. The designs were frequently inspired by the natural world or seen in dreams. Artists did not usually copy the work of others, although an artist might allow her close relatives to borrow or modify select motifs. As a result, observers could often identify which individuals or fam-ilies might have produced similar-appearing objects.

# CRAFT, GEOGRAPHY, AND ECONOMY

★

American Indian crafts reveal the creative thinking of artists as they were influenced by the material needs and cultural values of the societies within which they have lived. Regional differences in craft production were linked to the specific natural resources that were available within a given landscape, although long-established trade systems did pro-vide artists with small amounts of exotic raw materials for their work.

The relationship among local geography, tribal economic life, and individual craft production is significant. Plains Indian artists produced many functional items using the skins, bones, and horns of buffaloes. Because Plains people were generally mobile, the objects they made were necessarily lightweight and not prone to breakage. In contrast, the sedentary agricultural peoples who lived in the American Southwest and along the Mississippi and Missouri Rivers dug clay and made pottery. Artists who lived in the wooded regions of the Atlantic Northeast and Pacific Northwest became skilled wood-carvers. Residents of the Great Lakes region produced objects adorned with intricate moosehair embroidery. Skilled basketmakers lived throughout the continent, and their baskets were produced using many different plant materials and diverse weaving and twining techniques. These were occasionally adorned with additional materials, such as the shells and feathers favored by some California Indian people.

The people who lived in coastal areas and along major rivers made diverse items from carved shell and from shell beads. Southwestern Indian peoples, for example, mined turquoise and sometimes combined this stone with the shells that they had acquired through trade. Thousand-year-old shell-and-turquoise necklaces, pendants, and earrings have been recovered from locations in New Mexico and Arizona. Jewelry produced in this same tradition is still being made at places such as Santo Domingo Pueblo and Zuni Pueblo.

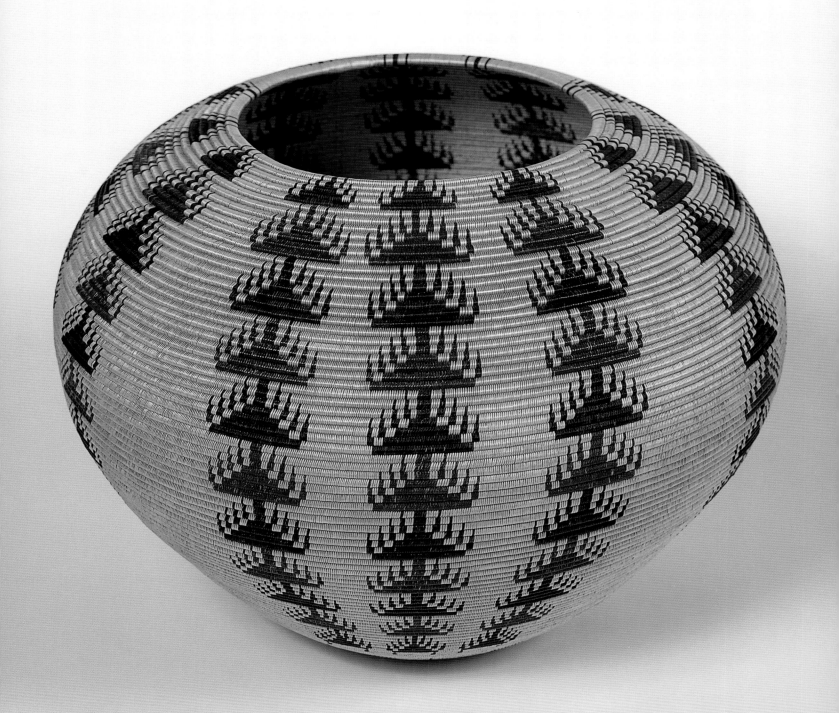

Other regional jewelry traditions are derived from materials and techniques that appeared after contact with Europeans. Silverwork is said to have become a part of the Navajo decorative vocabulary after 1850, when Navajo artists learned the craft from Hispanic silversmiths in the Rio Grande Valley. Within twenty years, Navajo artists had taught Zuni people to make their own silver jewelry. By 1900, silver production had spread from Zuni to the Hopi mesas. With these shared traditions, the earliest work by the artists in all of these communities combined hammered and cast metal with large turquoise and other stones.

The earliest known textiles from the American Southwest were made from fur, feathers, and wild plant fibers. Museum examples of this work date to 200–600 C.E. Before 500 C.E., cotton was introduced into southern Arizona and it reappeared in Ancestral Puebloan loom-woven fabrics a century or two later. When Spanish explorers first entered the Southwest during the sixteenth century, they found cotton being cultivated throughout the Rio Grande Valley and Pueblo houses, which were filled with cotton cloth. The Pueblo people they encountered were then wearing a sophisticated array of woven-cotton clothing and accessories that included painted and embroidered shirts, kilts, shawls, and sashes.

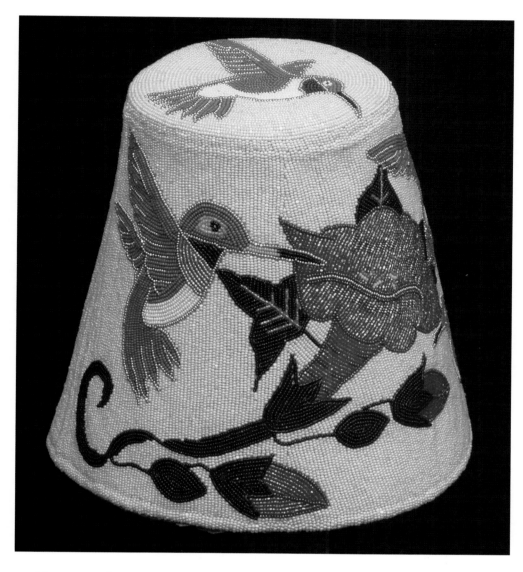

OPPOSITE, TOP LEFT

**HOHOKAM CULTURE (ARIZONA), MOSAIC OVERLAY FROG PENDANT, C. 1200–1450 C.E.**

This pendant combines turquoise and argillite on a *Glycymeris* shell. Expansive, sophisticated trade routes existed throughout the American Southwest during ancient times; prehistoric jewelry combining these and other materials are found throughout the region.

OPPOSITE, TOP RIGHT

**CARL CLARK (NAVAJO), BRACELET WITH DANCING *YEIS*, 2005.**

Carl Clark, who works with his wife, Irene, is a master of stone mosaic work. In this contemporary use of the ancient technique, Clark has used more than seven thousand stones.

OPPOSITE, BOTTOM

**MARTINE LOVATO (SANTO DOMINGO PUEBLO), *DOORWAY TO CHACO CANYON* NECKLACE AND EARRINGS, 2004.**

Martine Lovato's ten-strand necklace is a modern rendition of the Southwestern shell jewelry tradition that has its roots in the prehistoric past.

ABOVE LEFT

**DORIS SHIPPENTOWER (YAKAMA/UMATILLA/NAVAJO), WOMAN'S BEADED HAT, 1998.**

This hat replicates the traditional twined basketry hat form that was worn by women in the interior Pacific Northwest. Its beaded designs are a modern rendition of the region's pictorial beadwork tradition.

Navajo people moved into this same region only a few centuries before the Spanish arrived. Through warfare and trade, the Navajo acquired sheep and weaving technology. Their weaving tradition is thought to date to shortly before 1700. Written records from the eighteenth century describe Navajo cotton textiles, but that tradition was only short-lived and woven-wool blanket-dresses and wearing blankets were soon more commonly made. At the beginning of the twentieth century, the Navajos had replaced handmade woolen wearing blankets with Pendleton-style commercial trade blankets.

Traders and trading posts across the Navajo reservation were by then encouraging the production of rugs for sale to consumers in distant metropolitan areas. Many of the trading posts became hubs of surrounding style centers. Local styles and regional pattern preferences were influenced by the personal taste of the non-Indian traders who also served as textile brokers.

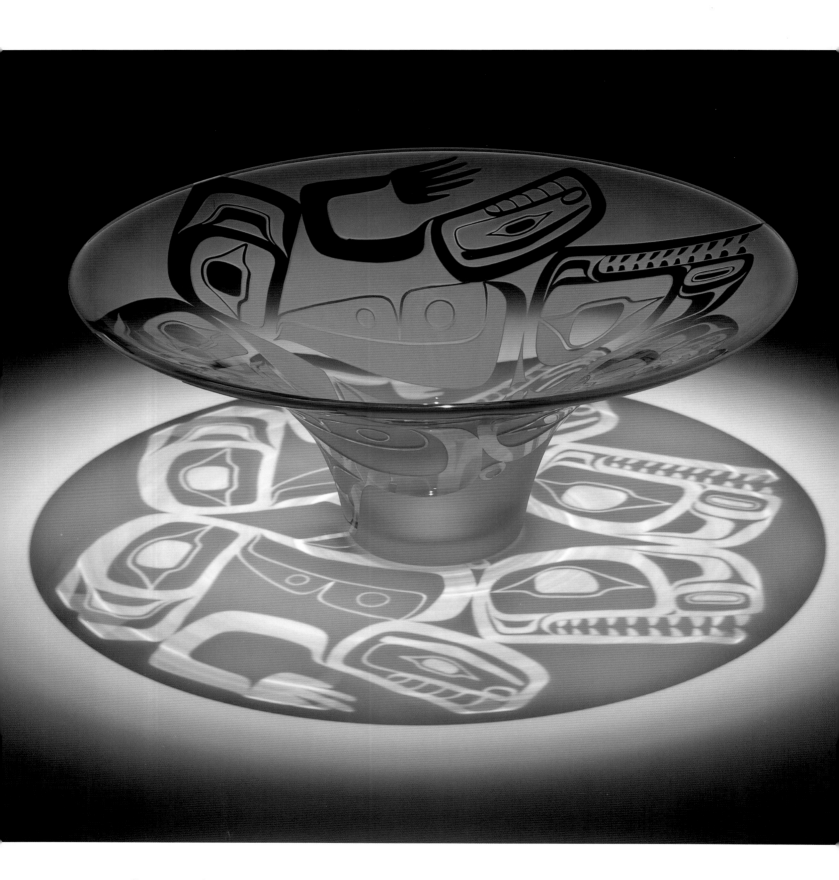

Before outsiders arrived in North America, Indian people routinely adorned their clothing and accessories with bird and porcupine quill embroidery, shell beads, pieces of bone, copper, stone, and other organic items. After contact with Europeans, glass beads became very popular trade items. These beads were made in a variety of locations, but most of them came from Venice, Bohemia, and China. Tiny glass seed beads are now popularly associated with many American Indian groups. These first appeared on the continent in great numbers during the middle of the nineteenth century. They were easily integrated into existing decorative traditions, and distinct regional styles soon developed. During the late nineteenth and early twentieth centuries, reservations isolated Indian communities and limited access to their usual and accustomed hunting and food-gathering lands. Despite this disruption of traditional economies and the resulting change of lifestyle, Indian women remained industrious and labored over their handiwork. Beadwork production flourished and the overall amount of ornament that was applied to diverse surfaces increased.

American Indian artists have worked with glass since glass beads first arrived in North America. And since the 1970s, a growing number of Indian artists have been crafting traditional forms and motifs in glass. Although historic bead embroidery and contemporary glasswork share a similar medium, they employ different techniques. New work with molten glass continues a centuries-old tradition in Indian country. In March 1805, Lewis and Clark recorded that Arikara (North Dakota) women were pulverizing trade beads, creating a glass paste, and shaping it into new bead and pendant forms, which they fired on copper plates. The process was one that was reportedly learned from the more western Shoshone. Other tribes in the interior of the continent may also have been practitioners of the technique.

## PATRONAGE AND PUEBLO POTTERY

★

As is true with every culturally vital tradition, American Indian artists have always been eager to embrace new mediums. Introduced materials encouraged, expanded, and modified prehistoric and historic artistic activities. Then evolving economies and the patronage of non-Indian collectors significantly impacted American Indian craft production during the late nineteenth and twentieth centuries.

Scientific interest in the Native peoples of the American Southwest grew dramatically after about 1880. The popular belief was that Indian people would either be assimilated into the mainstream or that they were doomed to extinction. As a result, many archaeologists and anthropologists—some in the employ of the U.S. government, others on the payroll of large eastern and European museums and universities—flooded the

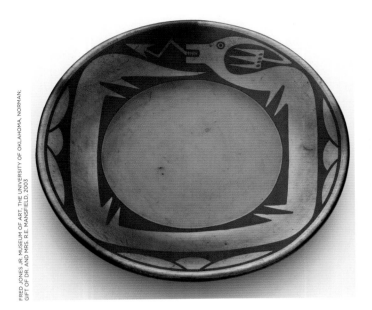

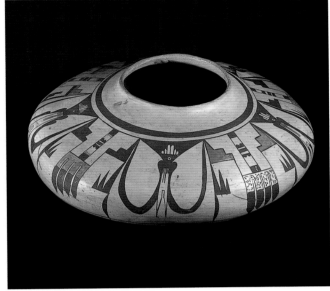

ABOVE LEFT

**MARIA MARTINEZ AND POPOVI DA (SAN ILDEFONSO PUEBLO), PLATE WITH** *AVANYU* **DESIGN, C. 1960.**

During her lifetime, Maria Martinez made pots with her husband, Julian, her daughter-in-law, Santana Roybal Martinez, and her son, Popovi Da. The iconography on Pueblo ceramics often references water. The Avanyu (Water Serpent) surrounding the center of this plate represents the first rush of water coming down an arroyo after a thunderstorm. It is a symbol of thanksgiving for water and rain.

ABOVE RIGHT

**NAMPEYO (HOPI-TEWA), SIKYATKI REVIVAL POLY-CHROME OLLA, 1903 OR 1904.**

Nampeyo was descended from Tewa Indians who moved from the Rio Grande Valley to the Hopi mesas about 1700. Her work drew its inspiration from pottery that was once produced at the ancient Hopi village of Sikyatki.

region. Their goal was to acquire as many objects as possible and to preserve them for future study.

Thomas Keam established in 1875 the first trading post among the Hopi, who were then being slowly forced away from their traditional economy and were entering a world where cash was necessary. Keam promoted the production and sale of Hopi-made items to aid them in their transition. The trader also encouraged local potters to make ceramics that bore the designs appearing on pottery recovered from nearby protohistoric (c. 1400–1600 C.E.) sites. That pottery production was the beginning of what became known as the Sikyatki Revival style. The Hopi-Tewa potter Nampeyo was the earliest and most celebrated practitioner of this style.

Nampeyo first began producing Sikyatki Revival wares in about 1880. It is often said, however, that she first became conscious of historic Hopi designs when her husband was working for Jesse Walter Fewkes during the 1895 excavation of Sikyatki. The story is apocryphal but it is similar to another relevant, and factual, narrative. In 1908 and 1909, archaeological excavations on northern New Mexico's Pajarito Plateau employed men from nearby San Ildefonso Pueblo. Julian Martinez, the husband of a young potter named Maria, was among the laborers. The scientific recovery of prehistoric pots and the discovery of kiva murals inspired Julian to incorporate ancient designs into his watercolor paintings and onto the pots that he decorated for his wife.

Among the archaeologists who were locally active was Edgar Lee Hewett, the director of the Museum of New Mexico. He asked Maria, who had a reputation as being a skilled potter, to reproduce some of the black ceramics that had been unearthed by his excavations, which she did in 1910. Maria and Julian's other contemporary works were, however, generally polychrome wares. The couple continued experimenting, and by 1918

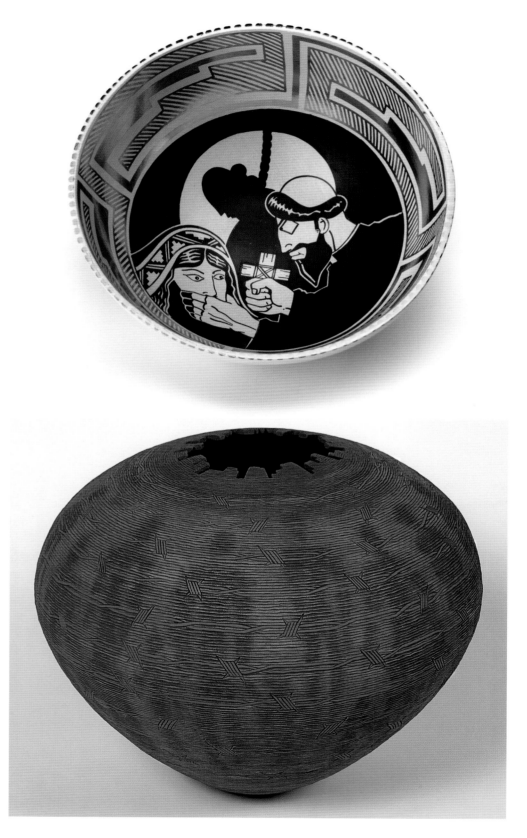

*LYNCHING*, 2004. 5 x 11"
DIAMETER

Diego Romero's family is from New Mexico's Cochiti Pueblo, but he was raised in California and received much of his art training there. Romero's work often combines contemporary urban themes with Pueblo pottery forms. His pottery also addresses the political concerns of New Mexico's American Indian population. This work recalls the oppression of the Pueblo peoples by Spanish settlers after 1598, and especially after the Pueblo Revolt of 1680. Missionary Franciscan friars frequently assisted the civilian government in perpetrating injustices.

BELOW LEFT

RICHARD ZANE SMITH
(WYANDOTTE), *BURY MY
HEART AT AUSCHWITZ*, 1995.

Richard Zane Smith is a descendant of Wyandotte people who were originally residents of the Great Lakes region and Ohio but who relocated to Indian Territory during the mid-nineteenth century. He works in the style of Ancestral Puebloan potters who produced "corrugated" wares using slightly overlapping hand-rolled coils of clay.

# SANTA FE INDIAN MARKET

**E**ACH YEAR in mid-August, Santa Fe, New Mexico, is home to Indian Market, the most important event on the American Indian art calendar. The event is the nation's oldest and largest juried Indian art show and it annually attracts as many as a hundred thousand visitors. During the two weeks preceding Indian Market weekend, the city also hosts dozens of gallery openings, auctions, sales of antique American Indian material, and related events.

Indian Market provides a forum for premier artists working in diverse mediums. A nonprofit organization, the Southwestern Association for Indian Arts (SWAIA), sponsors the event and scrutinizes exhibitors to see that standards of quality are maintained. The Indian Arts and Crafts Act of 1990 prohibits misrepresentation in the marketing of Indian arts and crafts products within the United States, and SWAIA also reviews background information to see that all participants are enrolled members of federally recognized American Indian communities.

The modern Indian Market has its roots in a variety of Indian arts events in Santa Fe. Between 1922 and 1962, Indian art sales were held in conjunction with the local Fiesta celebration. During the 1920s the Museum of New Mexico promoted an Indian art show as a way to preserve and encourage the production of distinct traditional crafts and provide a market and fair prices for Indian artists.

Between 1936 and 1939, the New Mexico Association on Indian Affairs sponsored a summer-long series of Saturday markets on the north side of Santa Fe's plaza. The association was also responsible for the Fiesta market and in 1959 changed its name to the Southwestern Association on Indian Affairs (it assumed its current moniker in 1993). Three years later the date of the Fiesta market was moved ahead one week and Indian Market became an independent event. Participation grew from 200 artists in 1970 to 330 a decade later. It now fills the streets surrounding Santa Fe's central plaza with 600 booths belonging to 1,200 artists representing 100 Native North American communities.

Artists covet the awards that are given at Indian Market because they boost an individual's reputation and career tremendously. Numerous distinguished judges review entries made in diverse categories. Recognition is given to those with skill in traditional materials and techniques as well as to those experimenting with new mediums and art forms.

Apart from Santa Fe, major Indian art sales are held annually at the Heard Museum in Phoenix, Arizona; at the Museum of Northern Arizona in Flagstaff; at the Eiteljorg Museum of American Indians and Western Art in Indianapolis; at the Gallup Intertribal Ceremonial in Gallup, New Mexico; and elsewhere. An important Spanish Market also occurs on the Santa Fe Plaza each summer. The event gathers together the finest Hispanic traditional artists from New Mexico and southern Colorado.

ABOVE **Jesse Monongya (Hopi/Navajo), bracelet with hummingbird, 2005.**
Jesse Monongya began his career by studying with his father, Preston, a renowned jeweler. Jesse is known as a master of inlay jewelry, and he frequently uses precious stones and gold. This work presents a somewhat different side of his work. In addition to receiving many other awards, Jesse's work won Best of Division at the 1992, 1993, and 1994 Santa Fe Indian Markets and Best of Jewelry at the 1995 event.

they were producing the pottery for which they are now famous: shiny black ceramics bearing matte black designs.

Maria and Julian were among the first Pueblo artists to sign their works. Through their close association with Hewett, the Museum of New Mexico, and the Santa Fe arts community, they became key figures in the production, promotion, and sale of fine twentieth-century American Indian crafts. The demand for their work was also heightened by the fact that their black-on-black pottery had visual appeal for the Art Deco enthusiasts of the 1920s and 1930s.

## EXPANDING MARKETS, NEW HORIZONS

★

When railroads were crossing the American Southwest during the 1880s, Indian artists gained new access to outside markets. The founding of informal artist colonies in Santa Fe and Taos, New Mexico, and elsewhere encouraged the acquisition of Indian-made crafts, as did the establishment and expansion of anthropology and art museums and the Arts and Crafts movement's demand for handmade household furnishings. The Fred Har-

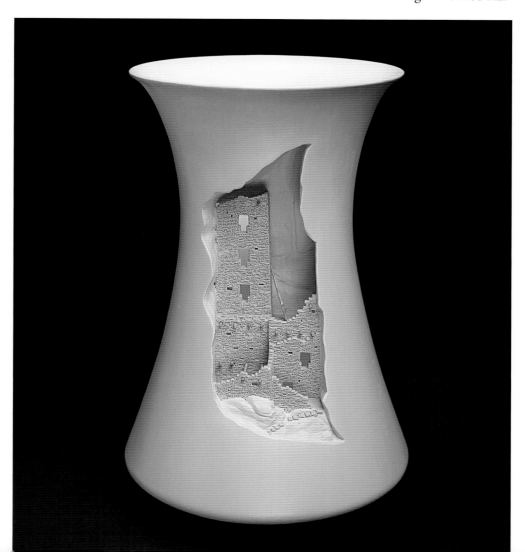

LEFT

**AL QÖYAWAYMA (HOPI),** *SQUARE TOWER,* **1998.** Al Qöyawayma is an accomplished engineer and a member of the Hopi Coyote Clan that once inhabited the ancient village of Sikyatki. He learned pottery techniques from his aunt, Polingaysi Qöyawayma (Elizabeth White). His father, Poliyumptewa, was a painter, and jeweler Charles Loloma was a relative. Al Qöyawayma says, "My clay creations reflect the aesthetic influences of the Southwest environment and values passed down through our family. . . . Oral history and research provide me with themes, continually emerging, which identify who we were and are; a profound pursuit."

117

**TERI GREEVES (KIOWA),**
*PRAYER BLANKET*, 2006. CUT
GLASS, BUGLE, AND SILVER
BEADS, HAWK BELLS, DEER
HIDE, COTTON AND WOOL
CLOTH, AND SILK RIBBON,
52 INCHES LONG x 51¹/₂
INCHES HIGH.

Greeves's *Prayer Blanket* joins
historic mediums and messages
in a work with contemporary
meanings. Her nontraditional
use of bead embroidery
acknowledges a longstanding
Plains Indian respect for military
service and skill. The artist says
this about her work: "This
blanket is my prayer—a prayer
for all the Kiowa men and
women serving in the Middle
East to take their rightful place
with the Kiowa warriors that
have come before them."
The female figure at upper right
center is a scalp-dancing Kiowa
woman. Below her is a Black
Leggings Society dancer, one of
many who served in the U.S.
military during the twentieth
century. To her left is a Kiowa
*Koitsenko*—an elite warrior who
fought against the U.S. Army
while staked in place. The
soldier in desert camouflage
stands in the middle of the
Milky Way—the place where
Kiowa people go after death.

vey Company stores and its Indian Detours promoted Southwest Indian art to a national
audience. The Harvey Company also hired first-rank academics to help them amass
Indian material from throughout the West, and they marketed items to major museums
and exhibited pieces at period expositions and world's fairs.

After 1921, the Santa Fe Indian Market provided a major venue for the sale of American
Indian traditional arts. The founding of the Santa Fe Indian School's art program a decade
later marked a watershed in governmental policy relative to Indian culture. Previously, the
national educational emphasis had sought to assimilate the American Indian population.
Afterward, art was among the skills taught at the nation's Indian vocational schools. The
Institute of American Indian Arts, also in Santa Fe, was established during the early 1960s
and continues to offer formal instruction in the diverse arts of Native North America.

For the last five hundred years, American Indian crafts have provided physical and
visual benefits to Indian and non-Indian people alike. They have inspired artists living

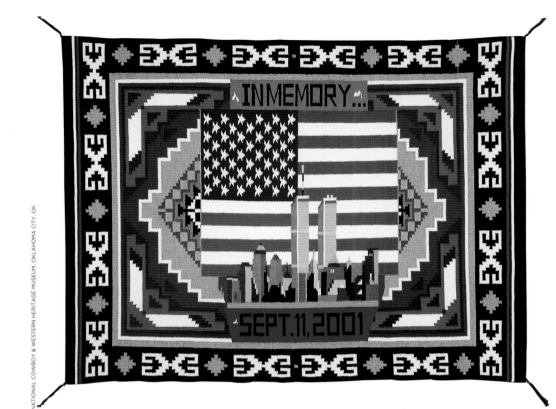

NATIONAL COWBOY & WESTERN HERITAGE MUSEUM, OKLAHOMA CITY, OK

LEFT

**ELLA HENDERSON (NAVAJO), WOVEN RUG, 2001.**

When Navajo women first began weaving wool, they produced a variety of tightly woven wearing blankets. They did not begin making rugs for sale to outsiders until the late nineteenth century. Navajo textiles have generally included geometric designs, but purely pictorial weavings have been popular since the mid-twentieth century. These often show reservation scenes, but dinosaurs, Santa Claus, rodeo contestants, and cartoon characters have also appeared. This pictorial rug commemorates the September 11 tragedy.

within and outside of Native communities. They have also embraced and incorporated new mediums, techniques, and foreign ideas.

Contemporary American Indian artists remain conscious of their ethnicity, cultural identity, and tribal traditions. Many continue to work with traditional materials and forms and they still make objects for traditional use. Although their crafts may no longer be solely about community and group survival, they maintain conceptual, technical, and stylistic links to the past. Indian craftspeople continue to produce works containing historic or symbolic links to a given cultural heritage, indigenous worldview, or traditional ceremonial structure. Some create objects containing commentary on American Indian history, the politics of Indian identity and survival, or events that impact the world at large.

American Indian communities remain vital and alive, and as a consequence Indian crafts continue to expand and evolve. Some observers may therefore fail to see the continuity that ties contemporary American Indian craftwork to the past, but Indian artists remain mindful of the cultural traditions that create the context for their work. They are aware of the body of material produced by their predecessors and of inherited traditions of technical knowledge and innovation. Many modern artists, especially those working in historic mediums, maintain a special relationship with the materials with which they work. They recognize these materials—whether clay, fiber, wood, metal, or stone—as being a living part of the world that they inhabit just as their ancestors did. To many contemporary Indian artists, the personalities of their chosen mediums remain living and active elements of their work.

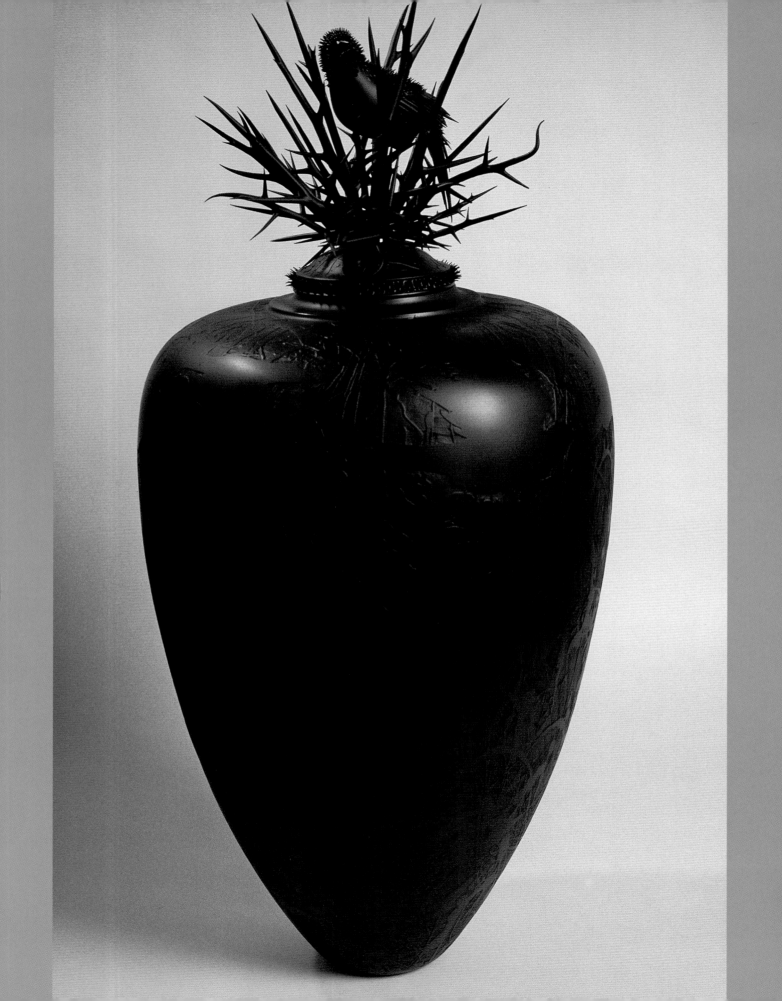

# Communities of Heritage—Southern Contributions

T HE DIVERSE PEOPLES OF THE SOUTH have contributed much to American culture. Oral traditions, stories, music, crafts, and cooking styles were brought over from Europe and Africa and often combined with Native American traditions. Crafts provide the most tangible evidence of early cultural exchanges and borrowings among these groups. For example, spread throughout the South are the coiled sea-grass baskets of the South Carolina and Georgia coasts, from Africa; Native American and European split-oak baskets in the Appalachians; and the alkaline-glazed stoneware tradition of Edgefield, South Carolina, from Asia.

The story of craft in the South begins with the physical landscape and the materials it provided to create utilitarian goods. The South encompasses the Appalachian mountain range, the fall-line regions with rich clay deposits and flowing streams, the wetlands and sea islands along the coast, and the cotton belt and rural communities in the Deep South. The forests provided a variety of woods for building houses, furniture, and musical instruments, along with wood for firing the pottery kiln. The hills provided kaolin and iron-rich clay and feldspar for pottery production. Oak, pine needles, river cane, willow bark, honeysuckle vine, rush, and sweet grasses were used for basket making. Also, the

OPPOSITE
**DAVID SENGAL, NIGHTBIRDS, 1996; RED MAPLE, BOX ELDER, ROSE AND LOCUST THORNS.**

land could be used to raise sheep for food and for wool and to grow crops such as cotton, flax, sorghum, corn, and other produce.

These resources were turned to good use. Food and syrups were preserved in stoneware vessels. Eggs were collected in handmade split-oak baskets. Rice was "fanned" (to separate the hull from the rice) in coiled sea-grass baskets. Coverlets and blankets were woven out of locally spun wool, cotton, and linen. Quilts were often made using strips and pieces of leftover store-bought or homespun cloth or worn-out clothes. Mothers taught daughters, and fathers taught sons these useful skills, with each adding his or her own individual style to the craft produced.

Many of these traditional crafts declined in use after the Civil War, with the change from an agrarian economy to an industrial one and the increased availability of mass-produced goods. In the early twentieth century, some crafts were revived as a source of income for the poor of Appalachia and the Sea Islands, who made woven coverlets and small handcrafted goods, some of which were sold locally while new markets began to develop in New York City and later across the nation, and catalogs were started for those interested in handcrafted items. For the first time, forces outside of the families and small communities—most of them religious missionaries or educators—began to have an important influence on the preservation not only of existing artifacts but also of the skills needed to make them. After World War II, interest in handmade arts and crafts declined again, but by the late 1960s, it was on the rise and it has been sustained ever since.

# SOUTHERN TRADITIONAL POTTERY

★

Earthenware and stoneware forms dominate traditional southern pottery. The earliest examples are earthenware vessels produced by Native Americans using the coiling method to make utilitarian and ceremonial pots, pipes, and figures. These pieces were fired in a pit and then burnished to a high gloss, a tradition the Catawba and Cherokee Indians have continued into the twenty-first century. The Qualla Arts and Crafts Mutual was established in 1949 on the Cherokee Indian Reservation as a retail outlet for their arts and crafts. The tourist trade also helped to support both the Cherokee tradition based around Asheville, North Carolina, and the Catawba group in York, South Carolina, on the border near Charlotte, North Carolina. The Catawba potters have a thriving tradition that has expanded to include male potters, many trained by the older matriarchs, who produce pots that are most stylized and individualized.

North of the Catawba reservation in Winston-Salem, North Carolina, is a settlement established by the Moravians, a religious sect that fled persecution in Europe in

the eighteenth century. Their European-style potteries, producing lead-glazed earthenware pieces, are also found in the Shenandoah Valley of Virginia and in Montgomery and Moore Counties in North Carolina. Because the Moravian earthenware was glazed with lead, which is both poisonous and expensive, its usefulness was restricted.

The southern market for pottery was more or less cornered by potteries located around Edgefield, South Carolina, home to one of the most significant American ceramic traditions. Before the Edgefield potteries were established, utilitarian wares had to be purchased from the northern states and from England or Europe. *Edgefield Pottery* refers to alkaline-glazed stoneware that was produced in the Edgefield district of South Carolina during the nineteenth century. This fall-line region along the Georgia border and the Savannah River is rich in clay deposits, hardwoods and pines, and rivers and streams.

Edgefield's alkaline-glazed stoneware is a unique blend of the ceramic traditions of England, Europe, Asia, and Africa. Many of the potters were English, Irish, and Germans who contributed forms and techniques from their homelands, while enslaved Africans and African-Americans performed most of the labor-intensive tasks of digging and refining the clay, chopping wood, bringing water, loading and unloading the kiln, and taking the wares by wagon to market. According to census and mortgage records, some slaves worked as turners before the Civil War, and after, several freed African-Americans operated their own potteries.

At its peak in the 1850s, Edgefield's five pottery factories made more than 50,000 gallons of pottery a year measured by the amount of food the vessels contained. Ovoid storage jars and jugs, straight-walled churns, pitchers, plates, and cups were produced in great quantities right through the Civil War. Transported by wagon and train, they were sold in South Carolina, Georgia, and North Carolina.

The Lewis Miles factory was the most lucrative of the Edgefield potteries in the 1850s. Miles married into the Landrum family and operated his pottery at several sites between 1840 and his death in 1867. Among the fifty enslaved African-American men and women who worked for Miles was a potter named Dave Drake, who made enormous jars — some large enough to hold 40 gallons. A literate slave who signed and dated many of his works and occasionally wrote a poem on the side, Drake was one of the best and most prolific turners.

Men who worked in the Edgefield potteries, both enslaved and free, took the alkaline-glaze tradition with them as they followed the clay veins and migrated north into Buncombe County, North Carolina, and westward into Georgia, Alabama, Mississippi,

ABOVE
**EDGEFIELD TOWN SQUARE, C. 1910.**
The Edgefield Town Square has not changed much since David Drake, known during the 1850s as Dave, lived and worked in the district. The poetic potter would have turned right at the courthouse and traveled approximately one mile to get to Pottersville, where he turned jugs, jars, pitchers, and churns for the Landrums and the Drakes.

# THE POETIC POTTER, DAVID DRAKE

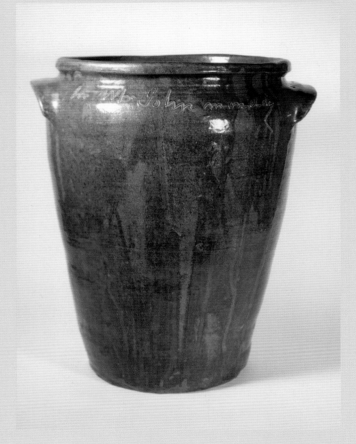

**D**URING his lifetime and afterward, David Drake was recognized for his magical skills as a potter and for an ability that was rare among slaves: He could read and write, allowing him to inscribe original poems, as well as his own name, on leather-hard clay before it was fired. As a result, the pottery he made must be viewed in terms of its artistic merits and its literary contribution.

Dave was born into slavery in 1800, most likely in the Edgefield district of South Carolina, where he spent more than seventy years of his life. All that is known about Dave is derived from his writing on the pots he made and from documents relating to those who owned him. For example, his name appears as collateral on a mortgage obtained in 1817 by Harvey Drake and his uncles, Amos and Abner Landrum. During this time, the Landrum family was establishing stoneware factories at Pottersville, a mile north of the Edgefield town square, and elsewhere in the area. By 1821, Dave was an established potter working for Drake.

Exactly how Dave learned to read and write is not known (it was illegal to teach slaves); he could have been taught by one of his owners or learned on his own by interacting with young white children or by teaching himself. In 1836, he wrote about other forms of chattel in the verse "Horses, mules and hogs, all our cows are in the bogs, there they shall ever stay, till the buzzards take them away."

By 1840, Dave was owned by and worked for Lewis Miles, a man ten years his junior who had married into the Landrum family and pottery dynasty. Many of the existing vessels attributed to Dave were made at the Lewis Miles factory, some bearing the initials *Lm*. One jar bears the verse "Dave belongs to Mr. Miles, where the oven bakes and the pots bile." This jar, dated 31 July 1840, is now in the collection of the Charleston Museum.

Of the thousands of jugs and jars that Dave made in the 1840s, several that survive bear poems he inscribed, including this one: "Give me silver or either gold, though they are dangerous to our soul." The pots indicate that Dave produced pottery during every month of the year, and he may have worked every day. The peak months of production were August and October.

By the 1850s, Dave was turning jars that could hold more than twenty gallons of foodstuff, a feat not accomplished by many American potters. Several of these enormous vessels had four handles, as two people would be required to lift the pot when it was filled. The largest jars made by Dave and his assistant, Baddler, have a capacity of forty gallons and have four handles. They stand over 2 feet tall and are more than 60 inches in circumference. When wet, they weighed between 200 and 300 pounds. Glaze was poured over the sides of the jars, because they were too heavy to dip into the glaze vat. After firing, they were significantly lighter but still required two people to move. These pots would have been used on a large plantation, as most farmers would not need to store that much meat, nor could they afford to purchase a pot that cost $4.

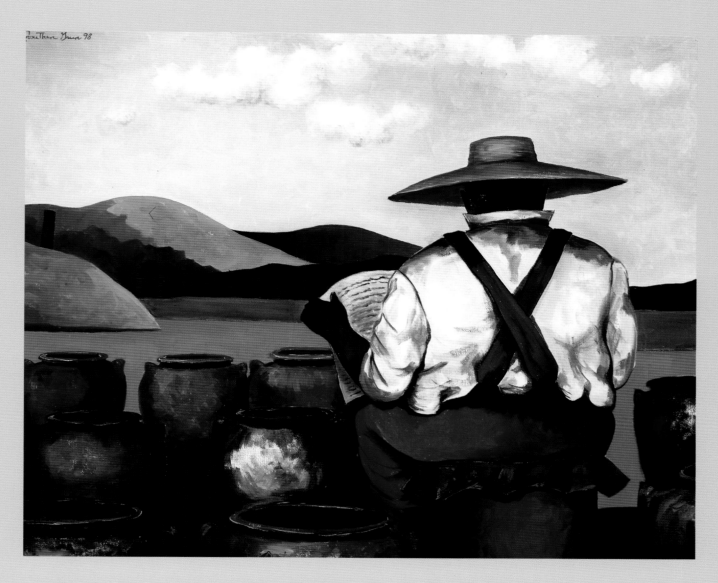

Edgefield pottery was distributed throughout the state via wagons and railroads, sold in small stores in Columbia and Charleston, and often ordered directly by the end user.

Dave worked through the Civil War producing jars as late as 1864. The last of his known poems is from 1862: "I—made this jar all of cross, if you don't repent you will be lost." The lack of signed works after Emancipation and the war's end in 1865 suggests that Dave was no longer producing pottery at the same volume, or perhaps at all. The 1870 federal census bears the listing: "David Drake–age 70–turner." The 1880 census contains no listing for David or Dave Drake, so it is surmised that he had died by that time, leaving behind a direct line of communication via his vessels to those who bought and used them—free or slave, white or black, past or present.

**OPPOSITE David Drake,** *Food Storage Jar,* **1856, stoneware.**
David Drake, a literate African-American potter working at the Lewis Miles pottery factory, turned this 2-foot-high food storage jar. It was made for Mr. John "Monday," who owned a nearby plantation. Because of the jar's size and weight, the alkaline glaze had to be poured over the vessel before it was fired.

**ABOVE Jonathan Green,** *Sir Dave,* **1998.**
As no photographic images of Dave are known to survive, artist Jonathan Green created a series of paintings inspired by Dave, his work, and the history of Edgefield pottery.

and Louisiana and as far as Texas. Many were related to the extended Landrum family, and new family-operated potteries emerged in other places.

By the end of the nineteenth century, the pottery factories in Edgefield had closed due to increasing competition from manufactured goods. However, traditional potters often became itinerant craftsmen in the early twentieth century, traveling throughout the Southeast to practice their trade.

In Cleveland, Georgia, Cheever Meaders and his children made utilitarian pots and jugs for the local community and a few for tourists traveling through the mountains. They were recognized in Allen Eaton's seminal work, *Handicrafts of the Southern Highlands,* first published in 1937. One of the Meaders children, Lanier, became one of the best-known folk potters in America. Lanier produced straight-sided churns and kraut jars, syrup jugs that tapered gently at the bottom, and pitchers with a sharply defined shoulder and a loop or strap handle. He was best known for his face jugs with eyes made of rock and teeth made of broken crockery. All his pottery had the "Shanghai" glaze, an alkaline glaze with high wood ash content that has a drippy look and texture.

Until Lanier Meaders's death in 1998, he continued the traditional way of making pots: digging the clay himself, using a mule-driven pug mill to grind it up, turning the pots on a treadle wheel, using an alkaline glaze, and firing the pots in a wood-burning ground-hog kiln. Lanier and his relatives, along with Burlon Craig in Vale, North Carolina, did much to sustain and then revitalize the alkaline-glazed stoneware tradition in the South. They influenced and inspired hundreds of contemporary potters, whose work shows reverence to the time-honored techniques of the traditional potters while adding their own style. Both Lanier Meaders and Burlon Craig were given the distinction of National Heritage Award winner by the National Endowment of the Arts, the equivalent of a national treasure designation for their work as traditional potters.

Today, the pottery capital of North Carolina is located in Moore County between Charlotte and Raleigh, a region rich in clay deposits and hardwoods. The landlocked community of Seagrove boasts about a hundred operating potteries. A variety of styles can be found, from utilitarian, salt-glazed stoneware that recalls the area's nineteenth-century pottery production to contemporary vessels with experimental glazes.

Jugtown Pottery is one of the oldest shops, established in 1921 by Jacques and Juliana Busbee to produce high-quality, handmade pottery similar to the wares made in North Carolina in the late nineteenth century. Among the original ten to fifteen people who operated the pottery were Henry Chrisco, Rufus Owen, James H. Owen, and J. W. Teague—potters whose forefathers were also

BELOW
**JACQUES AND JULIANA BUSBEE, DINING WITH BEN OWEN, C. 1940.**
Ben Owen was one of the young potters who was educated in his craft by the Busbees and then worked for them at Jugtown, where the candles, bowl, and dishes were all crafted.

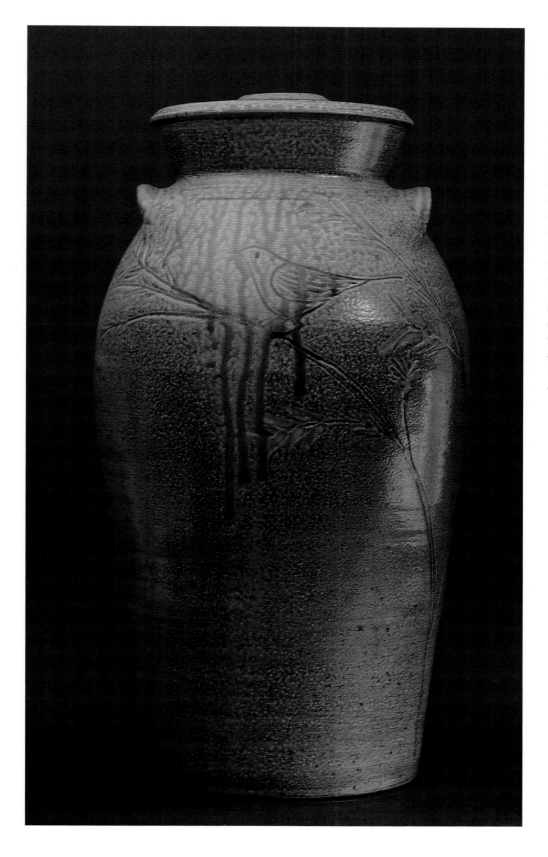

**SALT-GLAZED STONEWARE
CHURN, JUGTOWN, NORTH
CAROLINA, 2006.**
North Carolina potters such as
Pam and Vernon Owens at
Jugtown continue to turn large
salt-glazed stoneware churns
and storage jars, which have
been produced in North
Carolina since the eighteenth
century. The works are thrown
on a treadle wheel and fired in
a wood-burning kiln, which
brings out the deep red and
orange of the iron-rich local
clay. As the wood ash from the
kiln drops onto the churn
during the firing, it creates the
drippy appearance of the
finished piece, similar to the
alkaline-glazed tradition of
Edgefield and of Chinese and
Japanese wood-fired vessels.

# MAKING FACES: FACE JUGS IN THE SOUTH

FOR centuries, potters have been making usable ceramic vessels with anthropomorphic features. Besides expressing their creativity and emotion, the potters were often producing something they needed for everyday use, for ritual or ceremonial purposes, or just for the fun of creating. Among the ritual ceramics, for example, were Egyptian canopic jars, Nayarit figural vessels, and the German bellermine jugs. In other instances, such as Moche (Peru) and Mangbetu (Zaire) portrait vessels, the products were presented to the nobility and ruling classes. English Toby jugs were made as caricatures of the fictional town drunk, Toby Philpot. In the United States, the tradition of making jugs or pitchers with faces began around 1810 in the North with potters who were competing for a market that included English and European goods. The Remmeys of New York and Philadelphia made a small number of pitchers and jugs with applied faces for a short period of time between 1810 and 1858. After the Civil War, "face vessels" came out of Illinois, Ohio, and Kentucky. Many of these were related to the temperance movement and the evils of alcohol or "demon rum."

However, nowhere else in the world have potters been as prolific in making face vessels as in the American South. Since the 1840s, southern potters have produced thousands of "face jugs" of all sizes, shapes, and designs. Southern face vessels, along with the alkaline glaze that covers their surface, were born in Edgefield, South Carolina. The purpose of the earliest face jugs, aside from holding liquids, is still a mystery—were they made as protests or for ritual or for holding liquor? No one has been able to explain why this tradition became so popular.

Among its practitioners was Thomas Chandler, who made harvest or "monkey" jugs—so-called because of an African tradition associating thirst with monkeys—that had sculpted features and double spouts for keeping water cool. A surviving example, stamped "Chandler Maker," has carefully applied eyes and sophisticated African features, which leads us to believe that this was not the first time Chandler produced such a vessel. Some southern face vessels are bottles that could hold whiskey, syrup, or water while others are cups for drinking. It is thought that one particularly large vessel was used as an umbrella stand.

Edwin Atlee Barber, a ceramic historian from Philadelphia, wrote that many of these face vessels—or grotesque jugs, as he called them—were made by the slaves at Col. Thomas Davies's factory during the Civil War period, and some speculate that the work represents an African cultural contribution. The many surviving vessels are typically smaller than one gallon and bear crude, unrealistic features such as rolled kaolin eyes and rock teeth. One face jug is documented as decorating an African-American grave.

In the 1920s and 1930s, the Brown family of potters, which began in Georgia, was making these jugs, occasionally inscribing them with advertising messages. One member of the Brown family recalls that his father made a face jug as a joke for an Atlanta dentist in the 1940s. In the 1970s and 1980s, the popularity of face jugs among pottery collectors grew, due partly to North Georgia potter Lanier Meaders's artistry and his participation in the Smithsonian's Folklife Festival. Meaders continued to work in the old-time ways and was joined by other family members over the years. Today hundreds of southern potters create face jugs, popular as a traditional form.

---

**OPPOSITE, ABOVE Lanier Meaders's "Politician Jug," c. 1975–1980, and the Brown Family Potters' Devil Jug c. 1950s, probably made near Arden, North Carolina.**
Lanier Meaders was famous for his face jugs and wry sense of humor. Both characteristics are evident in this "Politician Jug" with its two faces. Devil jugs are also part of the face-jug genre. The potters truly had a sense of humor and showed off their creativity and ability to shock and delight with grotesque imagery.

**OPPOSITE, BELOW Unknown enslaved potter, stoneware face vessel, Edgefield District, South Carolina, c. 1860.**
This small alkaline-glazed face cup has kaolin eyes and jagged rock teeth and was most likely made by one of the enslaved potters working in Edgefield. Oral histories collected in the early twentieth century connect these vessels to those working at Thomas Davies Brickwork.

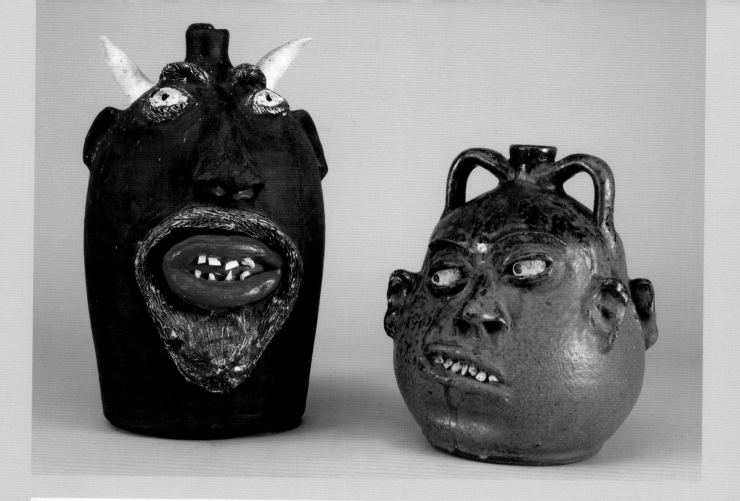
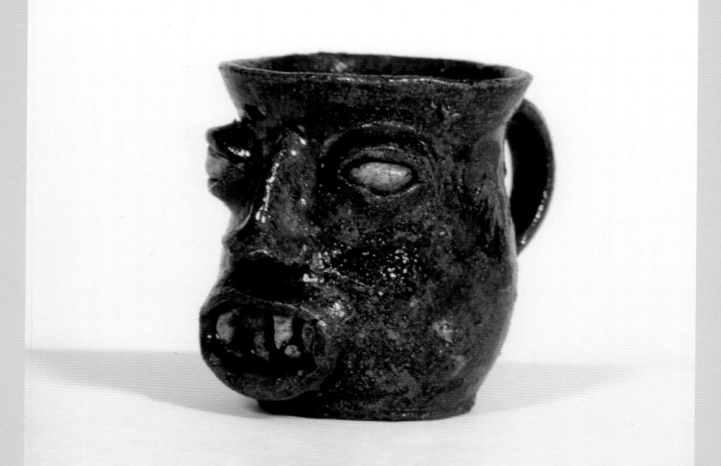

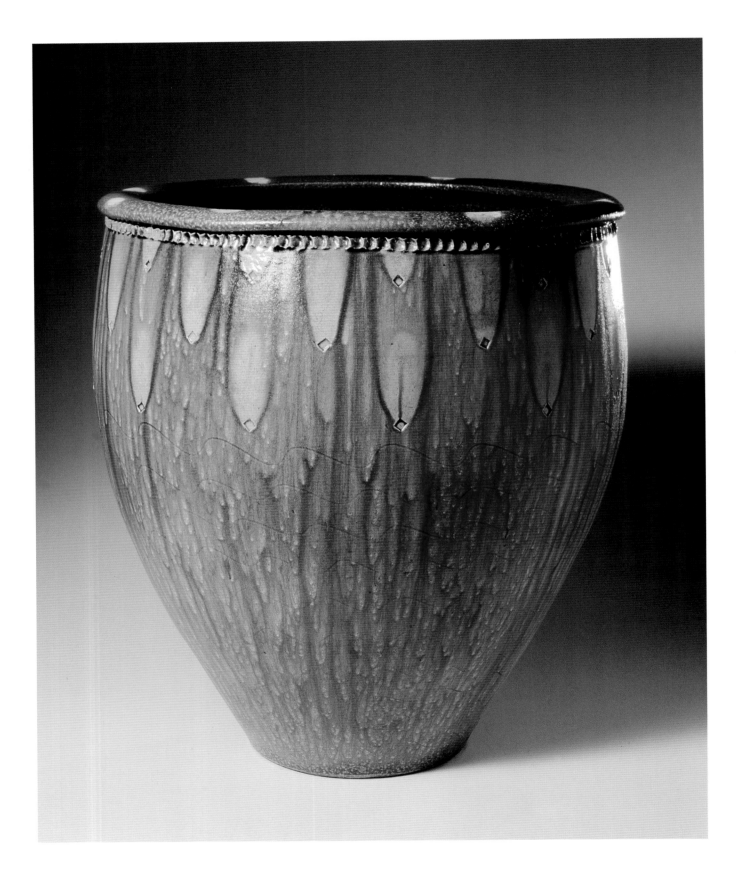

potters. The Busbees also hired Ben Owen and Charlie Teague as teenagers, then culti-
vated their artistic talents by sending them to visit museums throughout the United
States. Influenced by Chinese and Japanese ceramics, the potters at Jugtown developed
new forms such as the Persian Jar—a wide-mouthed jar that tapers to the shoulder and
then flares again, with a rope decoration at the shoulder. They also used glazes such as
Chinese Blue and Mirror Black that were patterned after the Asian ceramics. However,
they respected the traditional forms of bean pots and teapots and continued to produce
them. Ben Owen became the main potter at Jugtown, working there until 1952, when he
opened his own shop. His grandson, Ben Owen III, has become a master potter, too, and
continues the family tradition to this day.

Vernon Owens began working at Jugtown in 1959 under John Mare, then under Nancy
Sweezy, director of Country Roads, finally becoming the owner of Jugtown in 1983. Ver-
non's wife, Pam, is an accomplished potter herself, and their two children, Travis and
Bayle, "raised in clay," are also skilled potters.

Jugtown was not the only pottery operating during the second half of the twentieth
century. The Cole families operated numerous shops, producing earthenware pitchers,
bowls, Rebecca pitchers (cruses with elongated handles), and flowerpots, everything sold
both locally and regionally. People on their way to Florida would stop in and purchase
pieces as souvenirs. Other members of the Owen family operated potteries such as North
State Pottery and Rainbow Pottery, producing pieces for other markets. Numerous Cole,
Teague, Owen, and Owens potteries currently operate in the Seagrove area. By nurturing
and honoring its ceramic heritage, this community has become an epicenter for potters
in the United States and has attracted potters from all over the world. It is interesting to
note that in many southern states, numerous potteries are owned and/or operated by
multiple generations, similar to traditional potteries in England and Europe.

## SOUTHERN TEXTILES: WEAVING AND QUILTING

★

During the late nineteenth century, hand weaving was revived in the Appalachians as a
source of income for the greatly impoverished mountain people. The tradition of creat-
ing wool, cotton, and linsey-woolsey (made with linen and wool) coverlets was brought
over from Ireland, Scotland, and England. Many patterns had been passed down from
generation to generation on rolled-up drafts, often in enigmatic codes or series of num-
bers to signify the repetition. Without the handcraft revival, the South might have lost
this type of hand weaving.

Berea College, Kentucky, has one of the longest-operating weaving programs. When
its "Fireside Industries" were established in 1883, the purpose was to have the local people

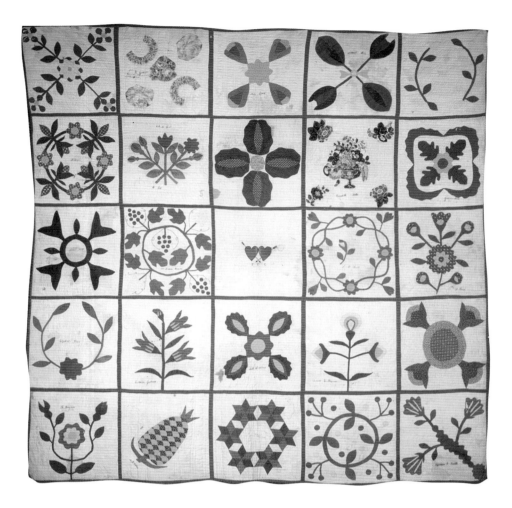

make coverlets and blankets, along with other crafts such as furniture and brooms, which would then be sold to benefit the weavers and improve the depressed economic situation. Looms were built for local women to reproduce *kiverlets* based on weaving drafts that had been passed down for several generations. All materials were produced locally, from sheep to shawl. Later, other crafts were added to the curriculum at Berea, where students are required to learn practical skills as part of their formal education. Today, visitors can still purchase finely woven products there, along with handmade brooms and other small pieces of furniture.

While other crafts waxed and waned, quilting never faltered. For centuries, women have quilted or made other bed coverings out of necessity and a desire to create something beautiful. Quilts covered family beds, made wedding presents as sons and daughters left home to start their own households, and marked the arrival of babies. Patterns have varied among cultural groups and during different centuries. During the late eighteenth and early nineteenth centuries, appliqué quilts and friendship quilts were fashionable, along with clearly defined patterns such as Whigs Defeat and Rose of Sharon. Crazy quilts emerged in popularity in the mid to late nineteenth century and were often sentimental, made by groups of women at quilting bees. Pieced quilts gained a stronger position in the quilters' domain as the economic situation changed. While some used high-quality store-bought fabrics, others made do with what they had on hand.

During the twentieth century and into the twenty-first, many community-based quilting groups have sold their works as a source of income. Quilting bees or circles are a way for women to work together for a common goal while enjoying a social outlet. These groups and the resulting quilts are a source of community pride.

In the 1970s the hoopla surrounding the bicentennial marked increased awareness of quilting traditions and the benefits of sewing skills. Hundreds of elementary school chil-

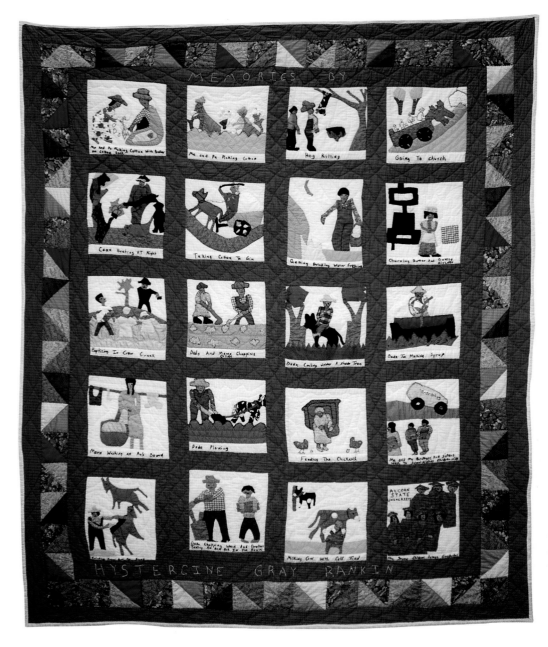

**HYSTERCINE RANKIN,**
*MEMORIES OF HYSTERCINE
RANKIN*, 1991, COTTON, WITH
SOME BLENDS, COLLECTION
OF MISSISSIPPI CULTURAL
CROSSROADS

In 1997 Hystercine Rankin
received a National Heritage
Award and Fellowship, and
Initiative of the National
Endowment of the Arts. She
was recognized for her master
quilting skills, especially as
demonstrated in her excep-
tional "story" or "memory"
quilts in which she depicts past
events in her life and those of
her family members. Several
quilting traditions and
techniques are used by Rankin
in this quilt. She recalls the
everyday activities of her child-
hood in rural Mississippi. She
helped around the farm and in
the fields, planting, chopping
and picking cotton. She also
highlights religion and the
importance of going to church
and being baptized. The last
square is a graduation
ceremony from Alcorn State
University. Each block has
appliquéd work and is joined by
strips with a square and trian-
gular border.

dren were taught to sew and created individual quilt squares that formed school quilts, an
activity that is still practiced today. By 1978, numerous quilt survey projects were under-
taken throughout the country, particularly in the southern states. The American Folklife
Center at the Smithsonian undertook surveys in North Carolina and West Virginia. In
Mississippi the Mississippi Cultural Crossroads was started with a two-pronged purpose:
to raise young people's awareness about their diverse cultural heritage and to involve
them with documenting their traditions, or "folk" culture, such as quilting. Local quilters
went into the schools and taught the young people. At the same time, these quilters—

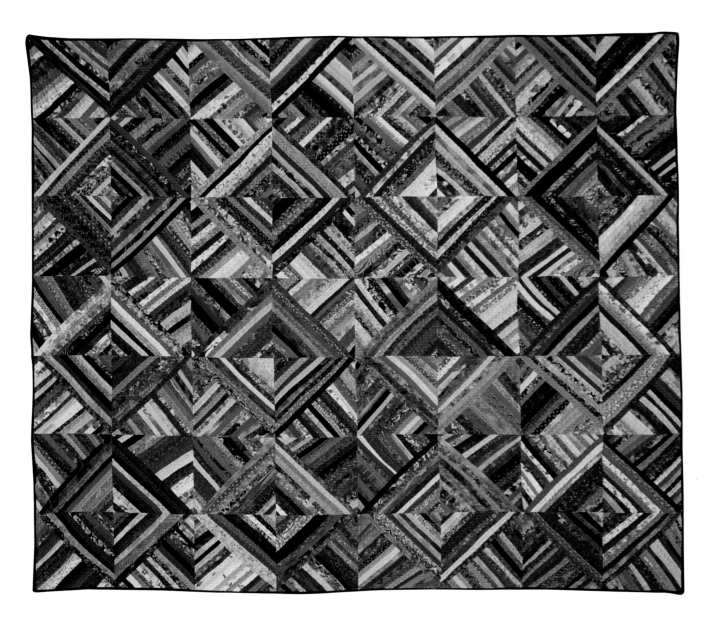

both black and white—were encouraged to share their knowledge outside the classroom at community centers. These women were not dissimilar from their contemporaries in Gee's Bend, Alabama and Johns and James Islands, South Carolina.

As their involvement in the community increased, Mississippi quilters such as Hystercine Rankin and Gustina Atlas in Claiborne County, Mississippi, were individually and collectively recognized by the Mississippi Arts Commission. Hystercine Rankin was given a National Heritage Award, an initiative of the National Endowment of the Arts, in 1997.

Many of the quilts made by the Mississippi Cultural Crossroads group reflect the technique favored by African-American quilters—that of the strip quilt—as opposed to

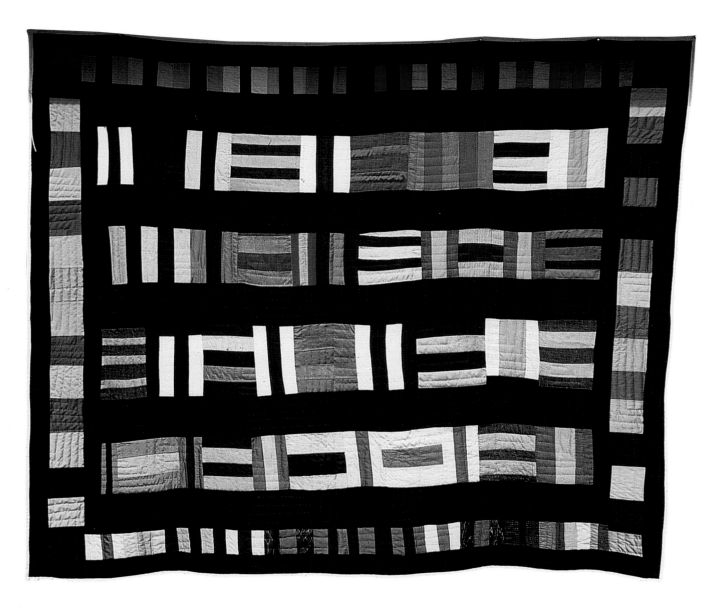

the symmetrical, patterned block quilts that come out of the European tradition. The strip technique allows a quilt to be made more quickly, not requiring the same level of fastidious and exacting measuring, cutting, and piecing of many shapes. Some relate the visual patterning of strip quilts to improvisation and the jazz aesthetic. Historically, the majority of African-American quilters in the South did not have the money to purchase fancy fabrics but used the materials they had on hand to make quilts used by their family to stay warm. Many of these quilts incorporate older quilts as the backing. Another quilt type that has emerged within the African-American quilting tradition is the story quilt, which has roots in the antebellum South and which is not too dissimilar from the album quilt.

Two historic examples of the story quilt were made in the 1880s by Harriet Powers, a

ABOVE
**GERALDINE NASH,**
*GERALDINE'S STRING,* **1999.**
OPPOSITE
**LORAINE HARRINGTON,**
*PANTS LEG,* **C. 1992**
Both pieces are characteristic examples of African-American quilts: considered "strip" quilts, the quilt-makers have chosen this technique to suggest geometric patterns and allow for interesting color placement, asymmetry, multiple patterns, and creative expression or improvisation.

woman who survived slavery in Georgia. One of her appliquéd quilts depicts fifteen individual scenes from the Bible, each block joined or bordered with a strip. Hystercine Rankin also made her own Memory quilts depicting past events in her life and those of her family members.

## BASKETRY

The coiled sea-grass baskets made along the South Carolina coast are an outcome of the transatlantic slave trade. Thousands of enslaved Africans from the rice-growing coast of Senegal, Congo, and Angola were brought into South Carolina as early as 1708 to work the rice plantations, bringing with them their skills in sewing coiled baskets.

Fanner baskets, large circular baskets with 2- to 3-inch sides, are used to sort the rice from hulls and chaff. Baskets were also needed to hold sewing tools, food, and other goods. The type of baskets people created changed along with the economy. By the late nineteenth century, for example, fanner baskets were no longer needed as rice cultivation in South Carolina diminished with the end of the plantation system after the Civil War.

During the early twentieth century, the Penn Normal, Industrial and Agricultural School (originally the Penn School) was established in Beaufort County, South Carolina, to teach the local African-American community skills such as basket making, iron working, and net making. These crafts were still economically useful, but they were no longer being handed down from person to person as they were during the days of slavery.

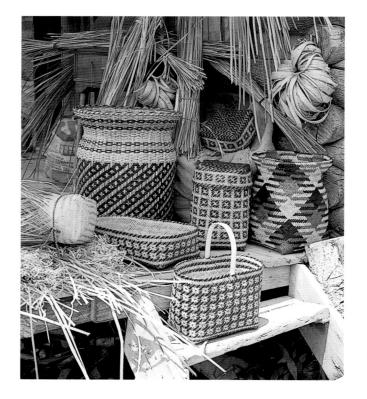

During the 1920s, markets for coiled baskets were found in Charleston and nearby Mount Pleasant as Charleston experienced a renaissance that made it a tourist destination. Stands selling baskets were set up along Highway 17, the major route linking Charleston to all points north and south. Baskets and flowers were also sold at the old market and at the "four corners of law," or Court House Square at Broad and Meeting Streets in downtown Charleston.

Essentially, tourists to the Charleston area who buy baskets have sustained the sewers who keep the tradition alive, although basket materials have fluctuated over the centuries. Bulrush, which was durable and good for fanning rice, has been largely replaced with sweetgrass, which is more aesthetically pleasing for decorative baskets. Pine needles, used in conjunction with the rush and sweetgrass,

are sewn using palmetto fronds. Recently, many sewers have been using rush again as condominiums and houses encroach on the marshlands where sweetgrass grows, reducing the supply. Along with their materials, the forms of baskets have evolved from utilitarian fanner and sewing baskets to highly stylized baskets made for decoration and adornment.

The craft of basketry is also prominent among Native Americans, particularly the Cherokee, who use local materials such as honeysuckle, river cane, and split oak. Different colors and textures are achieved through the use of natural dyes and physical manipulation of the materials. Thin splits are tightly woven to create beautiful and useful baskets of varying sizes and shapes.

The basket's end purpose influences the tightness of the weaving and the form. An egg basket has thinner and smoother splits than a large fish trap or cotton hamper, for example. The Cherokee tradition was buoyed when the Qualla Arts and Crafts Mutual was established in 1946 within the Qualla Boundary, the proper name of the Cherokee Indian Reservation and principal home of the Eastern Cherokee. Its goal was to promote the culture and sell the arts and crafts, including beadwork, pottery, and carving, produced by the tribe.

In the South, European settlers and enslaved Africans adapted Native American basket-making techniques. Baskets crafted today reflect the richness of these myriad traditions, as seen in the work of Billie Ruth Sudduth—a basket maker from the South renowned for her Fibonacci baskets, named after a thirteenth-century mathematician who was a proponent of the golden mean (see page 232). In her baskets, classical mathematics proportions are combined with Native American and Appalachian materials such as split oak and reeds dyed with henna, madder, and iron oxides.

# FURNITURE

★

Plain-style furniture produced in the South, including the iconic ladder-back chair from the Appalachians, was created for everyday use and with an eye for form and function. The beauty was often found in the aging of the wood, the weaving of the seat, and the graceful lines of the legs and rails. Much like Shaker furniture, this furniture was simplistic in form, and the maker or a family member was involved in all parts of the process: chopping down the tree, hewing away the bark, and splitting, planing, and shaving the wood to the appropriate size. Rather than fancy nails or glue blocks, chair construction depended on simple mortise-

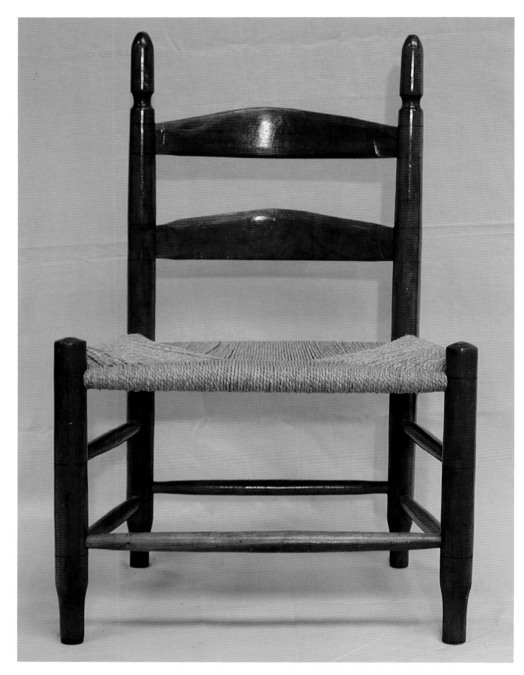

and-tendon joints, capitalizing on the different shrinking characteristics of the wood. The seats were often woven by the chair maker or someone local using split oak or rush. Other furniture pieces such as sideboards and cellarets (a kind of chest) were less fancy than their high-style counterparts made in Charleston or New York, and the wood was solid cherry, poplar, heart pine, or walnut—sometimes painted—instead of highly finished mahogany and satinwood veneers. Furniture was made in small quantities, not in the vast numbers required by retail shops in the cities.

By the turn of the twentieth century, mass-produced furniture was available in most southern communities through mail-order catalogs and traveling salesmen. However, many people in the South were poor, particularly in the Appalachians and remote areas such as the Sea Islands, and so they were not consumers of mass-produced furniture, relying instead on the woodworking skills of those in their community. By the middle of the twentieth century, just a few traditional furniture makers were working. By studying and writing about community—and culture-based traditions—folklorists and scholars fostered early interest in southern handcrafted furniture. At the same time, the artists themselves joined together in the Southern Highland Craft Guild to promote the sale of their handmade goods.

# SUSTAINABILITY OF CRAFT

★

While the making of pottery, textiles, baskets, and furniture met the everyday needs of southern communities in the eighteenth and nineteenth centuries, the twentieth century saw the arrival of social and missionary efforts to sustain these crafts in a world of machine-made goods. First, after the Civil War, poverty motivated some to recall the old crafts so they could make items to sell for extra income for the family. Then, schools and cooperative groups were established to teach and cultivate these skills and to provide a venue for the sale of crafts.

About the same time, proponents of the Arts and Crafts movement, along with others interested in cultural traditions among ordinary people, began to have an impact on the American South, particularly on those who lived in the Appalachian Mountains. Educators and missionaries took an interest in the people of these remote areas, surveying the land, collecting stories and songs and other aspects of the local culture. Inevitably, several schools were established throughout the South to cultivate these traditions.

These include Berea College (Kentucky), Crossnore School (North Carolina), John C. Campbell Folk School (North Carolina), Arrowmont School of Arts and Crafts (Tennessee), and Penland School (North Carolina).

Starting out as a weaving center, the Penland School of Crafts later expanded to include pottery. Today, it is a world-renowned center for craft art, where ten different disciplines are taught in a beautiful area of western North Carolina. Penland has embraced creative expression while fostering traditional values and provides a haven for teachers and students to immerse themselves in their art.

In addition, many traditional arts are brought to the national stage through the Smithsonian's Folklife Festival and documented through the national and statewide folklore and folklife programs created in the 1970s and 1980s. Continuing into the twenty-

OPPOSITE
**SHADRACK MACE, SLIPPER CHAIR, WESTERN NORTH CAROLINA, C. 1950.**
This slipper chair with its numerous slats looks like a ladder, hence the name, ladderback. Shadrack Mace was considered one of the finest chairmakers in western North Carolina. He used locally available woods such as hickory, poplar, ash, and oak. The chairs were often put together when the wood was still a little green so the joints would tighten up as the wood cured, thus decreasing the use of nails. This resulted in an extremely sturdy chair that would withstand heavy household use. The woven seat was made of rope, another choice of a durable material.

first century, these programs conduct research into past and present traditions while cultivating new and emerging ones. The National Endowment for the Arts has a Folk Arts component, and many state art agencies have similar programs designated to promote and preserve traditional arts and crafts museum exhibitions. Commercial outlets have also added to the awareness of our rich heritage.

Nurtured and sustained now by these institutions, the craft forms that took root in the South, blending the cultures of three continents, have an assured future. Their history will be preserved, and new generations will not only come to appreciate the arts of their ancestors but will also learn to employ the same techniques for their own pleasure. A dynamic new era is under way.

★ ★ ★

# COMMUNITIES OF CRAFT TEACHING

Artist and teacher Therman Statom demonstrating a painting technique to a student during a class at Penland School of Crafts, 1995.

Lacking the European craft guilds and apprentice-ships, modern America places the main responsibility of teaching and interpreting traditions on our established schools of craft, which supplement ethnic groups and societies in passing on skills and traditions. Ever since Alfred University opened the doors of its New York State School of Clay-working and Ceramics a century ago, craft schools—and craft departments within universities—have been the petri dishes of creativity, providing and sustaining an environment where method and imagination intersect and nurture each other.

Today's schools provide a craft continuum fostering an intrinsic knowledge, sense of aesthetics, and appreciation of the natural resources and materials integral to the creation of craft objects.

The curriculum of craft schools is a complex and deliberate blend of academic teaching and practical application. As the great academies of the Renaissance proved, applying thought to materials demands a thorough grounding in the science of the craft, learning and perfecting the ability to work in a chosen medium. Another element is obvious: the artist's ability to translate his or her creativity into objects that are beautiful, meaningful, and function in the real world.

Today's trained and talented craft artist is part scientist, part mathematician—as well as a creative person. Laws of physics, mathematical formulae, and chemical reactions must be considered, mastered, and applied. In the challenge to achieve his or her creative vision, the craft artist is often an inventor of process—a modern-day alchemist who transforms raw materials and imagination into tangible, spirited objects that sustain our culture, assuring its vitality and aesthetic edge.

Education should also be accessible to anyone. So, the best of these craft educational programs have a tradition of involving their communities in the appreciation of craft and the creative process as important parts in everyone's life. Further, they offer educational outreach programs and workshops to all who wish to discover their creative spark.

Focused exclusively on the teaching of crafts, these programs offer experienced and novice artists alike the opportunities to build on their skill sets or to immerse themselves in learning new ones. They range from the small, personalized places of learning that teach basket weaving and chair caning to larger centers that offer a more extensive experience, with one-, two-, and eight-week workshops in books and papermaking, clay, glass, blacksmithing, metals, printmaking, textiles, and wood. Schools like Haystack Mountain School of Crafts in Deer Isle, Maine; Arrowmont School of Arts and Crafts in Gatlinburg, Tennessee; and Anderson Ranch Arts Center in Snowmass Village, Colorado, are among notable schools whose mission is to make craft education accessible to all seeking to make crafts an important and integral part of their lives.

These places, and hundreds more like them, afford the opportunity—whether for four years, six weeks, or an intensive weekend—to learn from teachers who share their wealth of expertise, assuring that American craft traditions are alive, exciting, and progressive.

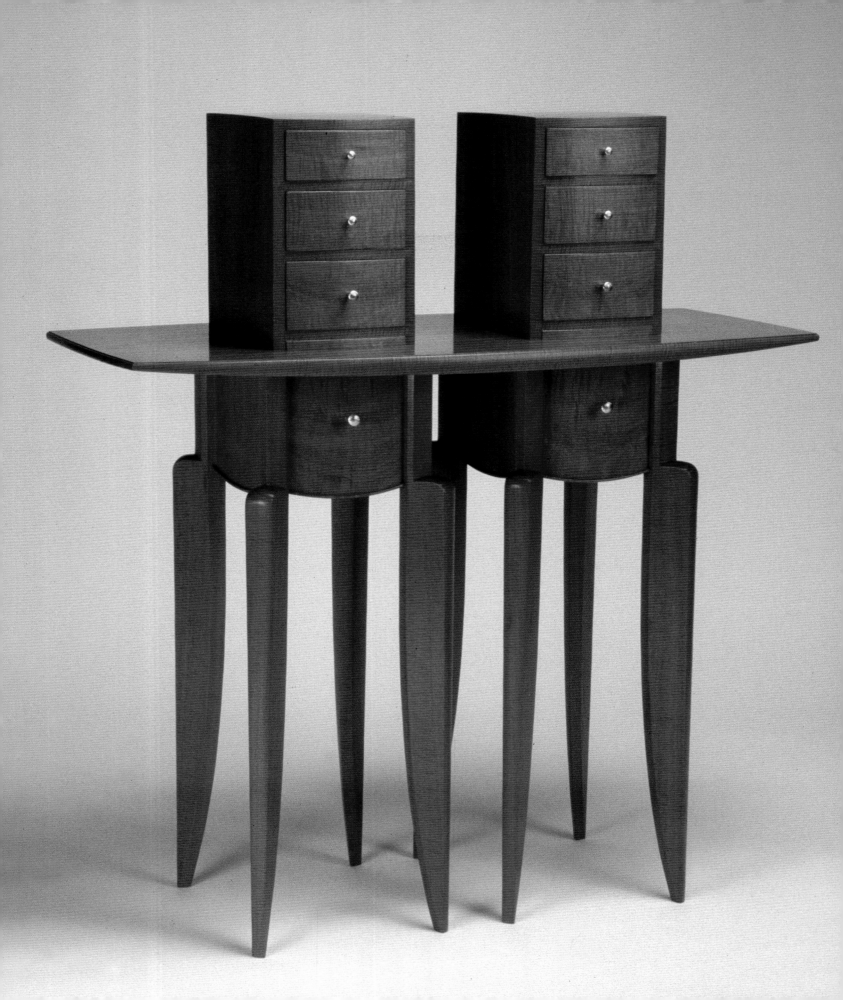

# Rhode Island School of Design (RISD)

CONSIDERED AMONG THE FIRST RANK of American art schools, the Rhode Island School of Design is respected for producing talented graduates with strong visual and technical skills along with an independent spirit. The school was created in 1877 by the Centennial Women of Rhode Island, whose members had funded the state's exhibit at the 1876 Centennial Exposition in Philadelphia. Inspired by the exhibits on design and decoration that they saw at the fair, the women, from leading Providence families, established a school in their own city for this purpose, using $1,675 in excess funds remaining from their exhibit.

From the beginning, RISD was known as both school and museum. By 1893, one floor of the school was devoted to a range of objects that included paintings, bronzes, pottery, embroidery, hollowware, and plaster casts. Today, the museum is nationally recognized for its collection of more than eighty thousand pieces that encompass Western and non-Western art. The curatorial staff works closely with faculty to ensure that students become familiar with the collection. In this manner, students learn to assess materials, design, manipulate, process, and resolve to a degree that few other schools can provide, and these experiences provide them with a competitive edge in visualizing and executing new work.

The school's alliance with industry was also apparent from the very beginning. C. B. Farnsworth, head of the school's Committee of Management, expressed the hope that graduates would "make their manufactures and handicraft productions more satisfactory to [specific] markets." The "cultivation of the arts of design" was the school's primary goal according to its articles of incorporation (1877), and its first objective was to create designers, or as originally written, to instruct "artisans in drawing, painting, modeling, and designing, that they may successfully apply the principles of Art to the requirements of trade and manufacture."

Such goals naturally led to the development of craft-specific classes in textiles (1882) and jewelry (1904), with ceramics (1947), furniture (1969), and glass (1972) developing over time. The school was also committed to the education of artists and teachers in the fine arts, a goal that was largely carried out through classes in painting (1878) and sculpture (1901). In time, these classes evolved into distinct departments with a dedicated faculty, along with many other departments, including architecture, graphic arts, illustration, and photography.

## TEXTILES

★

Textiles was the first of the craft-based courses, perhaps due to the prominence of New England's textile mills. A focus on technology and chemistry in the textiles department during the mid-twentieth century has given way to a more broad-based education in fabric, fiber, and pattern, with a detailed approach to the design process, structure, materials, and techniques of the medium. Costume classes first offered in 1933 are now part of the department of apparel design. Like all RISD programs, textiles and apparel design have successfully joined technical and design education, and they emphasize the holistic approach to teaching, where students are expected to learn and apply aesthetic theory. RISD believes that all these facets are essential in the education of successful artists such as Randall Darwall and John Eric Riis.

## METALSMITHING

★

One of the first influential metalsmithing teachers at RISD was Augustus Rose. An 1896 graduate of the Massachusetts Normal Art School, Rose taught drawing and manual arts at the Providence Manual Training High School and joined RISD in 1900. He traveled to London

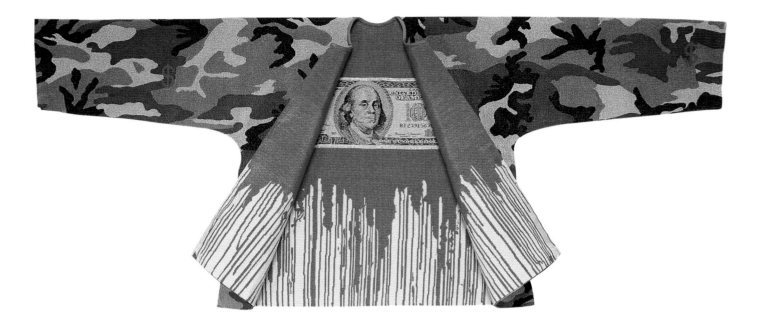

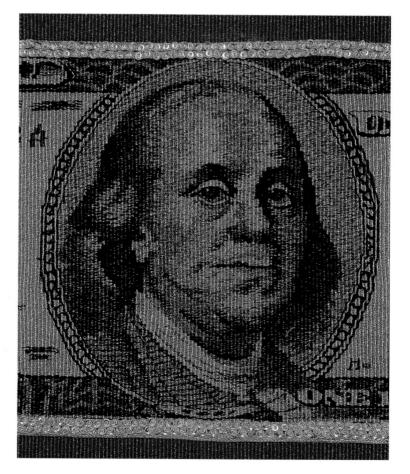

**JOHN ERIC RIIS, *"GREED" JACKET,* (WITH DETAIL) 2006, TAPESTRY WEAVE WITH JAPANESE METALLIC EMBROIDERY, METALLIC THREAD, AND SWAROVSKI CRYSTALS, 30 x 48 INCHES.**

A talented tapestry weaver, John Eric Riis creates rich, three-dimensional images that are also loaded with powerful social commentary. In the case of *Greed,* the artist has linked war with profit by creating a robe that is decorated with army camouflage on the exterior. Red dollar signs are the only indication that there is another message, which appears inside the robe, where a large dollar bill is adorned with metallic thread and Swarovski crystals. The currency floats in a red ground that, on close inspection, is depicted as blood that runs in rivulets to the garment edge.

BELOW

**LOUIS MUELLER, THE PRICE OF IMMORTALITY NECKLACE, 1989, STERLING SILVER, STAINLESS STEEL.**

Louis Mueller's rigorous training in metal has left him free to explore a literary form of expression: the hanging pendant on this necklace is an abstracted representation of Pinocchio's head, the long nose indicating that the boy/puppet has just been caught in a lie. Hence, this piece of jewelry becomes a wearable narrative and a morality tale.

BOTTOM

**JOHN (JACK) PRIP, DESIGNER "DIMENSION" TEA AND COFFEE SERVICE PRODUCED BY REED & BARTON MANUFACTURING, C. 1960, SILVER PLATE, VINYL, AND PLASTIC.**

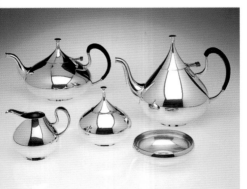

in 1902 to study metalsmithing, enameling, and pottery and, within a few years of his return, published *Copper Work* (1906), a classic text of the period that features an Arts and Crafts aesthetic. By 1910, Rose had become head of the Department of Normal Art (art education) and of the Department of Jewelry and Silversmithing at RISD. Rose was also involved in the rehabilitation of returning World War I veterans, an early example of adapting jewelry work for therapeutic purposes. In 1925, Rose became full-time director of the manual arts programs in the Providence public school system, which provided practical training in the crafts to high school students.

With the arrival in 1963 of John (Jack) Prip, the Department of Jewelry and Silversmithing took a turn toward Scandinavian design; Prip had been rigorously trained in Denmark. He had previously taught at the School for American Craftsmen at the Rochester Institute of Technology (RIT), New York (now called the School for American Crafts), and had worked as a designer-craftsman for silversmithing manufacturer Reed & Barton, designing prototypes for application in new product lines. Thus, when he came to RISD, Prip had already begun to explore silver and pewter for their expressive possibilities and led his students and the field into new territory.

Louis Mueller, Prip's student at RIT, followed him as department head at RISD, and his own playful experimentation with scale, perception, and language continued the exploratory trend. Mueller brought a number of foreign metalsmiths to the school as visiting professors, creating a new awareness of European aesthetic and technical developments among students. Current head of the renamed Jewelry + Metalsmithing Department, Robin Quigley pares down forms in nature and culture to iconic shapes that she ornaments with slate, wood, paint, and pearl.

Another key contributor in silversmithing was William Brigham, who graduated from RISD and quickly took up a teaching role there, later becoming head of the Department of Decorative Design. Brigham often included aged pieces of jade, glass, or other antiquities around which he created his own work of art. Brigham was ahead of the curve, experimenting with historical materials between the First and Second World Wars, when the country was adrift stylistically between the Arts and Crafts movement and Art Deco. During this period, furniture design briefly reverted to colonial and European antecedents. Other notable artists working in the metal arts, including Marie Zimmermann and Josephine Hartwell Shaw, also employed small antiquities to great effect, demonstrating that this aesthetic approach, made visible through the works of Brigham at RISD, was beginning to define the next wave in metalwork.

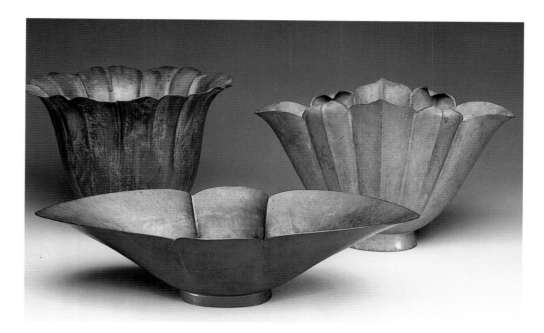

LEFT

**MARIE ZIMMERMANN, THREE VESSELS, C. EARLY 1920S, PATINATED COPPER.**

Called a modern Benvenuto Cellini, Marie Zimmermann maintained a studio at the National Arts Club in New York City from the 1920s to 1939, where she created jewelry with precious stones and metalwork in copper, silver, bronze, and wrought iron. Like William Brigham, Zimmermann enjoyed building works of art around historic or exotic elements that came her way. A special interest in patination led her to produce copper vessels in many colors, some of which are seen here.

## OTHER PROGRAMS

★

Danish-born woodworker Tage Frid arrived at RISD in 1962 and established the furniture program within the school's Department of Industrial Design (see figure on page 185). An influential teacher and writer, he wrote *Tage Frid Teaches Woodworking* (1979) and was both founder and editor of *Fine Woodworking Magazine,* which began publication in 1975. Frid's students John Dunnigan (MFA 1980) and Rosanne Somerson (BFA 1976,) teach at the school today in the Department of Furniture Design, established in 1996. Dunnigan is presently head of the department and works in a classical mode with elegant and often unexpected details. Somerson's rigorously executed furniture has an animated quality that she imbues with color and texture.

The ceramics department was begun in 1947 under Lyle Perkins, who served as head from 1947 to 1963, and his wife, Dorothy Wilson Perkins. Both were graduates of Alfred University, and their strong technical education provided a sound foundation for RISD's fledgling department. During Norman Schulman's tenure from 1965 to 1977, students were exposed to an emphasis on sculptural aspects of clay that reflected nationwide developments. With the arrival of Jacqueline Rice in 1977, a shift toward pattern emerged, as the notion of decoration began to achieve a new respect among ceramic artists. Rice hired Christina Bertoni and Jan Holcomb as faculty, and each artist brought a different perspective to students: Bertoni in her use of clay to invoke memory in domestic installations, and Holcomb in his narrative compositions, executed with figurative forms in the round and as bas reliefs. Lawrence Bush, now head of the program, continues to explore surface decoration, both painted and carved, of utilitarian objects.

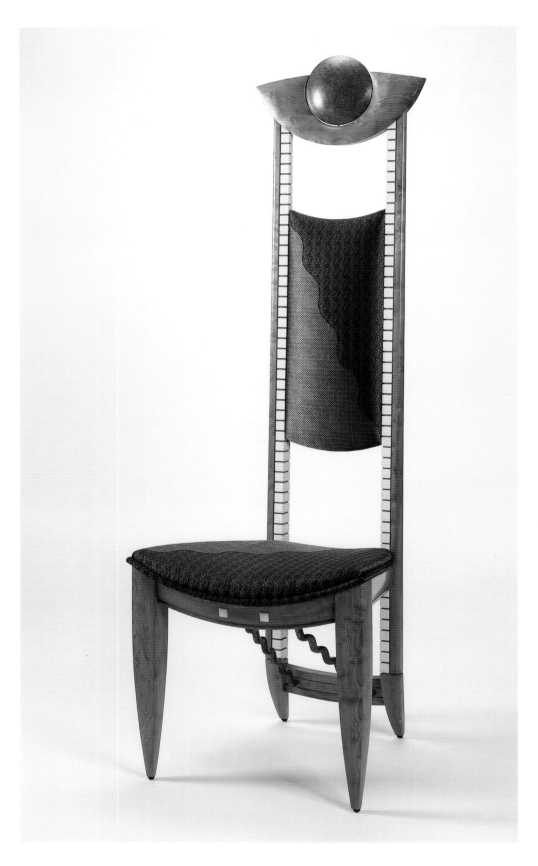

**ROSEANNE SOMMERSON** *TALL BLACK CHAIR,* 1990, POPLAR, HOLLY, AND BRONZE.

The Department of Glass, historically the last of the craft media to develop, was founded in 1969 by Dale Chihuly, who earned an MFA in ceramics at RISD in 1968. He then studied in Murano, an island off the coast of Venice where the once-secret art of glassmaking has been practiced since the thirteenth century—and for which it is internationally famous today. Upon his return in 1969, he established the glass program at RISD. Chihuly, arguably the best-known glass artist of our time, made his greatest contribution by creating assemblages of blown-glass elements that could embody such disparate concepts as seashells and chandeliers. The pieces have been used en masse to create landscape and museum installations.

As a cutting-edge art school, RISD's place in the educational community today is secure. Its unique mix of teaching in the studio and classroom and museum instruction through object assessment provides students with an excellent grasp of the complex interrelationship between craft, design, and culture that equips them for a successful career in the arts.

BELOW
**DALE CHIHULY, PILCHUCK BASKETS, 1980, BLOWN GLASS.**

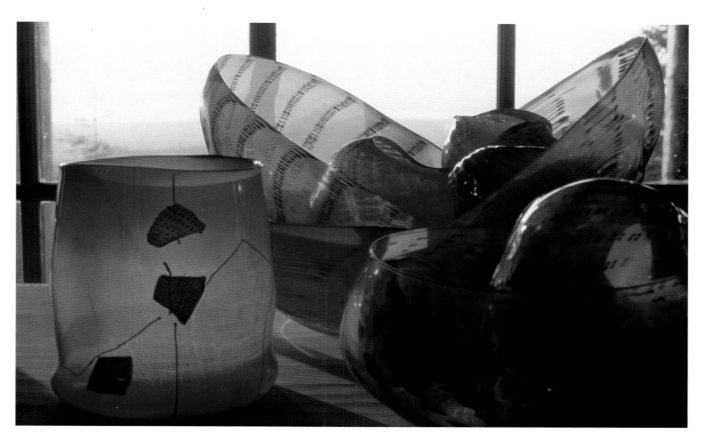

# California College of the Arts

FOUNDED IN THE AFTERMATH of the 1906 San Francisco earthquake by the broadly educated immigrant furniture maker Frederick Meyer, the California College of the Arts has been committed to education and innovation from its very beginning. While most art schools of the time taught students simply to imitate earlier works and styles, CCA showed them how to improve upon the materials of the past and develop their own artistic expression. By the end of the twentieth century, its cutting-edge faculty and alumni included such luminous figures as Bauhaus-trained weaver Trude Guermonprez; Marvin Lipofsky, who led the Bay Area's studio glass movement; and Peter Voulkos, a founder of the California art ceramics movement.

Meyer's founding philosophy was to teach crafts as a defined discipline, of equal importance to the fine arts. He also structured the college as an institution that would attract the best craft artists not so much to *train* as to *teach* them to be innovators. CCA, like California itself, has always been a place where anything goes. And it is this absence of self-consciousness plus the serious commitment to educate that made the college a place where creativity and innovation—however out there—were legitimized. It was the first college on the West Coast to truly join the contemporary, international community of arts educators, and to truly acknowledge the crafts as a formal discipline.

OPPOSITE
**LIA COOK, TRACES: INTENT, 2002, COTTON TAPESTRY.**
Lia Cook combines photography, computers, and weaving to produce a new genre, a hybrid of handcraft and technology.

## A PHOENIX FROM THE ASHES

★

When the earthquake struck on April 18, 1906, Frederick Meyer lost his home and studio, Craftsman's Shop, to the ensuing fires that swept through the city, destroying everything the trembling did not. Shortly afterward, at a Guild of Arts and Crafts dinner, he expressed his desire to build a "practical art school" that would train students in the fine arts of painting, drawing, and sculpture as well as crafts and the mechanical arts, and a school that would also train a new breed of arts teachers—teachers who would encourage individuality and self-expression in young artists, rather than train them to reproduce historical styles. Meyer, not knowing what those words would inspire, returned to Europe to see new Scandinavian designs and to buy studio materials for Arthur and Lucia Mathews, with whom he had begun working after the earthquake. When he returned to San Francisco in 1907, he found to his surprise that his remark had been incorrectly published in the *San Francisco Call* newspaper as a formalized plan.[1] The "plans" had caused considerable excitement among San Francisco citizens, eager to recover and redefine their city in a modern way—with new architecture, new materials, new designs, and new thought. Completely rebuilding a major city offered an unparalleled potential and the city's need for architects, artists, and craftspeople of all media inspired not only a tremendous influx of those anxious to contribute to the city's rebirth, but it also placed a definite spotlight on the arts and their critical relevance to everyday life. The city was ready for an arts school.

With students at the ready and the support of the guild, Meyer founded the School of the California Guild of Arts and Crafts in 1907.[2] Opening in a small studio in Berkeley with three classrooms, forty-three students, and four faculty, the school offered precisely what Meyer had dreamed of: courses in traditional crafts, the mechanic arts, and the fine arts, as well as a teacher-training program to prepare new arts educators.[3] In his new "practical art school," Meyer provided young artists not only with technical training but also with a framework in which to succeed as professional artists.

## FROM DESIGN TO REFORM

★

Displays of poorly designed and executed products at the 1851 Crystal Palace Exposition in England and the Philadelphia Centennial in 1876 caused reevaluations of teaching practices on both sides of the Atlantic and led to a wide-ranging reformation of arts schools curricula, paralleling the Arts and Crafts movement's call for design reform. Meyer's plan to open an arts school that gave crafts the same level of value as the fine arts

was part of an international push by educators and manufacturers to establish industrial arts schools.[4] A better-trained craftsman produced a better, more desirable (i.e., saleable) object and whichever country produced the best goods cornered the market. It was a simple case of economics.

This new style of training prepared American designers, artists, and craftsmen to compete on an international scale by producing goods of a higher quality than those items being imported from Europe. Meyer's students were offered an international stage by San Francisco's 1915 Panama-Pacific International Exposition.[5] That their furniture designs were displayed in the Palace of Education rather than the Palaces of Fine or Liberal Arts makes an interesting study. It was Meyer's college and students that were on display; they were exhibited as much as a model of educational reform as they were artisans creating new and important designs.

# FROM REFORM TO AVANT-GARDE

★

One of the earliest and most influential ceramics instructors on staff was Marguerite Wildenhain. Born in France but raised in Germany, she was forced to flee Nazi Europe and immigrated to the United States in 1940, where she landed at the college almost immediately. Her tenure was a brief but critical step in her career—and in the history of ceramics in America—because it led to the creation of the Pond Farm community and its distinctive philosophy and style.

Her two-year teaching experience provided her the momentum to establish the Pond Farm pottery studio and workshops in Guerneville, a rural community in northern California's Russian River Valley. While she brought additional faculty to the community in its early years, she was the only permanent faculty member, and she established a loyal following. Her Pond Farm "disciples," as they were called, learned the discipline of hand and mind required to achieve mastery of their craft, and they were inspired to seek perfection and attain consummate professionalism in their field—the same principles Wildenhain had been taught during her formative years at the Bauhaus. By the 1950s, her methods and techniques of

BELOW

**TRUDE GUERMONPREZ, UNTITLED SPACE HANGING, C. 1965, DOUBLE-WEAVE; MAGENTA AND LIME SILK, 60 x 24 x 24 INCHES (APPROX.).** Influential weaver Trude Guermonprez brought her Bauhaus training to the West Coast in 1949 and taught at the college from the early 1950s to the late 1970s.

working with clay had become the model associated with California. Through the 1970s, she taught students not simply about the medium but about the integration of life and art, about her philosophies on nature and its reflection in simple, honest, wheel-thrown forms.

Wildenhain's contributions occurred in a more roundabout way as well. She had invited friend and fellow émigré Trude Guermonprez to teach weaving workshops at Pond Farm and while doing so Guermonprez, from 1952 to 1954, taught additional summer-session weaving workshops. Although they were masters of different media, Wildenhain and Guermonprez bore a remarkable similarity in terms of their lifetime experiences: Both studied at the Bauhaus and the Halle-Saale School of Fine and Applied Arts in Germany, both had fled Nazi persecution via the Netherlands, and both had taught at Black Mountain College. From the late 1930s, the refugee population of artist-educators changed and enhanced the American educational system—most notably in the arts—not only by introducing modern European thought but by supporting each other in the way that Wildenhain did Guermonprez. Throughout the American arts colleges are stories of this overlapping, this interconnection, of lives and experiences, which broaden the notion of schools as communities of teaching to schools as communities of tolerance.

Guermonprez officially joined the faculty in 1954. She remained on staff until 1976, first in the Department of Crafts, later in the Department of Weaving. Already highly regarded for her textiles, which were exhibited nationally, she became equally known for her work as an educator and as a speaker. According to the Oakland Museum's 1982 exhibition catalog, *The Tapestries of Trude Guermonprez,* her legacy is the "return to the loom" by fiber artists and renewed interest in "combining graphic with woven construction." She is further credited with imparting "the ability to produce expressive work—which went beyond meticulous craftsmanship, mastery of means, and even personal imagery—to communicate to others, a wealth of human experience." It is an idea that encapsulates the very meaning of craft: that by making something with one's own hands, it is intrinsically imbued with all that those hands have touched. A personal experience can be expressed in three-dimensional form.

Viola Frey was a prolific and influential ceramist who graduated from the college in 1956 with a bachelor of fine arts and joined the teaching staff in 1965 and oversaw the establishment of the ceramic arts center. Her monumentally proportioned, largely figurative, painted sculptures were "brilliantly colored, gestural, animated . . . formed not only out of clay but of color, light and a lifetime of experiences."[6] Frey's work often dealt with political and gender issues, but also included irony, humor, and experiences with the mundane. Bold and groundbreaking monumental ceramic sculptures gained her international acclaim as an artist and teacher, and her growing fame attracted serious students, who enrolled to study with her. This, in turn, further enhanced the college's reputation as a

LEFT

**VIOLA FREY, WATERMAN**
A gallery installation depicting two of ceramist Viola Frey's monumental, brightly colored figural sculptures.

prestigious center of craft learning that not only valued the teaching of time-honored techniques but also encouraged risk taking and the application of conceptual modes of thought and practice.

Glass, too, became a major component of CCAC's programming. The department was founded in 1967 and directed for twenty years by artist-teacher Marvin Lipofsky, a former student of studio glass legend Harvey K. Littleton. Lipofsky's work from the 1960s and 1970s has come to represent the Bay Area's studio glass movement. From glass hamburger plays on pop culture, to his *California Loop Series,* sweeping curvatures of flocked and plated glass, Lipofsky turned a traditionally functional medium into a purely sculptural one, and placed the emphasis on unexpected forms and materials.

## CONTEMPORARY FACULTY: CONTINUING THE UNTRADITIONAL

★

The college's history of hiring avant-garde, artist-teacher faculty continues today with instructors such as internationally recognized fiber artist Lia Cook, who has taught at the college for more than thirty years. Cook's interest in photography, painting, weaving, and technology led her to the computerized Jacquard loom. In her 2002 work *Traces: Intent,* she constructed a woven interpretation of a photograph of herself as a child.[7] Her innovative technique exchanges fibers for pixels. The resulting tapestry is a hybrid of handcraft and technology: The digital loom weaves an image that is embedded in the very structure of cloth, which is constructed of thousands of threads in varying colors and textures. The large-format images at once reference contemporary photographic and looming techniques and the pointillist paintings of Neo-Impressionists like Georges Seurat.

Another member of the fiber faculty, Jean Williams Cacicedo, is a pioneer in the field of wearable art. Cacicedo is widely known for her elaborate "story coats." She was one of the first fiber artists to interpret clothing as more than functional adornment and simple fashion statement. Instead, she created imagery on her cloaks or coats to reveal the many inner and often intimate layers of emotion, memory, and personal stories. She wrote, "Combined with symbol and pattern, dyeing and piecing of fabrics, the garment becomes a narrative whose images embrace the wearer. I see the garment's shape, absent of body, as a canvas to color and sculpture to form."[8]

# ALUMNI: STUDENTS AS INNOVATORS

★

The college's history of iconic faculty is most directly reflected in the success of its students. Its broad range of programs has produced many groundbreaking artists.

Ceramist Peter Voulkos graduated with an MFA in 1952 and is credited with bringing the studio ceramics movement to Southern California—which had a long history of ceramics—in a commercial vein, as California was home to many commercial patteries such as Bauer Pottery Co. and Gladding, McBean & Co. Voulkos, who began teaching at Otis in 1954, pushed beyond function and created abstract, deconstructed vessels that were earthy and sensual and charged. His sculptures were vastly different from traditional wheel-thrown vessels and they revolutionized ceramics in the Los Angeles area. He was dynamic and young, and students were drawn to him.

Robert Arneson, who also attended CCAC in the early 1950s, became a leader of the Funk movement that developed out of the 1960s Bay Area counterculture. Arneson cre-

BELOW

**CANDACE KLING, CANDY SAMPLER: CRÈME DE LA CRÈME, 1998.**

An interest in historic dresses and trims, and an admitted even greater interest in candy, led Candace Kling to create whimsical boxes of sweets from ribbons. Each illusionistic piece of chocolate is created from folded and pleated silk.

ated large ceramic sculptures that confronted the New York gallery scene with their unexpected, arrogant, and often ugly nature. From vulgar representations of toilets to violently contorted self-portraits, his was "art that shouted—about politics, about sex, about everything not acceptable to polite society."[9]

More recent crafts alumni who have forged new territory and become innovators in their respective media include sculptor Robert Brady, known for his raw and powerful triballike figures and artifacts in clay and wood; fiber artist Candace Kling, who makes whimsical confections constructed of ribbon; and textile artist Joy Stocksdale (daughter of famed wood turner Robert Stocksdale and fabric artist Kay Sekimachi), who dyes, cuts, and pieces silk into gossamerlike wall murals of color and light.

## A CENTENARY FOR THE "PRACTICAL ART SCHOOL"

★

Throughout the twentieth century, the college has continued to grow, adding new buildings, classrooms, research facilities, exhibition spaces, and studios, as well as new undergraduate and graduate-degree programs. The mid-1990s also saw the addition of a San Francisco campus. In 1998, the Wattis Institute for Contemporary Arts was founded, establishing an international forum for arts discussion and incorporating the college's existing artists-in-residence program, the Capp Street Project. Two years later, the Center for Art and Public Life was created, using cross-disciplinary arts to address community issues via events, partnerships, academic programs, and grants.

With a broadening of its curriculum and outreach programs, the school that had been the California College of Arts and Crafts adopted a new all-encompassing name in 2003, California College of the Arts. By evolving constantly to maintain Frederick Meyer's mission of a "practical art school," it has remained one of the nation's finest for a century. No matter the media, its students create a kind of work that is independent of anyplace else. The pioneering, exploratory, and fearless spirit of their teachers, mixed with the relaxed, "laid-back" lifestyle that has come to define West Coast culture in the media, continues to be an important influence in the progressive arts produced at the college.

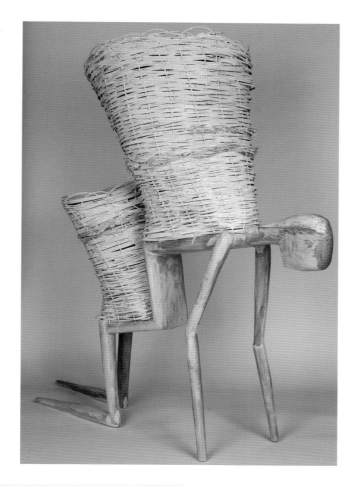

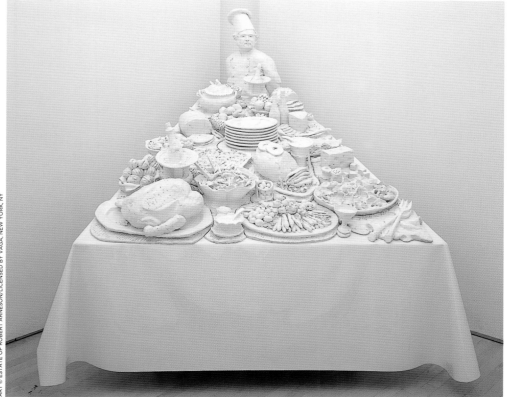

LEFT

**ROBERT BRADY STUDIED CERAMICS AT THE CALIFORNIA COLLEGE OF ARTS AND CRAFTS AND LATER WITH ROBERT ARNESON.**

He works primarily with figurative and spiritually driven sculptures in clay, wood, bronze, and mixed media.

BELOW LEFT

**ROBERT ARNESON, *SMORGIE-BOB, THE CHEF*, 1971, EARTHENWARE WITH VINYL TABLECLOTH AND WOOD TABLE.**

This impressive installation work is exemplary of Arneson's signature brash humor—the lip-licking chef is a self-portrait—combined with his significant knowledge and manipulation of art historical and popular culture references. Moreover, Arneson's formidable sculpting skills are showcased in the cornucopia of food cascading forth, in forced perspective, from the figure of the chef—creating a charged composition that activates the space that it occupies.

# The Cranbrook Vision

As the American Arts and Crafts movement burgeoned in the last years of the nineteenth century, the Detroit newspaper publisher George Gough Booth emerged as one of its most devoted followers. Born in Toronto in 1864 into a family of master craftsmen and designers, Booth had a natural personal affinity for the arts, especially the applied arts and architecture. As a child he heard stories about his father's ancestors, who had worked for generations as coppersmiths in the small village of Cranbrook, England, and he had the distinct pleasure of seeing his father, uncle, and grandfather—natives of Cranbrook and metalworkers all—plying their craft in the family shop in Toronto.

In the mid-1880s Booth purchased a half-interest in an ornamental ironworks in Windsor, Ontario, and began a lucrative business selling and manufacturing products of his own design. By the age of twenty-four, Booth was well established as the proprietor of one of Canada's foremost wrought-iron firms. His work graced many significant buildings in Quebec and Ontario, including the Bank of Montreal in Toronto, today housing the Hockey Hall of Fame.

OPPOSITE
JACK LENOR LARSEN,
*MAGNUM* (UPHOLSTERY AND
WALLCOVERING FABRIC),
DESIGNED 1970, MYLAR,
COTTON, VINYL, NYLON
AND POLYESTER, SHEER
POLYESTER, ORGANZA AND
WOOL, COTTON, SYNTHETIC
THREADS.

## THE INFLUENCE OF JAMES EDMUND SCRIPPS

Booth's fortunes improved considerably in 1887 when he wed Ellen Scripps, a daughter of James Edmund Scripps, publisher of the *Detroit Evening News* and a principal of the Scripps League, the nation's largest group of newspapers. At his father-in-law's urging, Booth sold his firm and embarked on a career as the business manager of the *Evening News*. Entrusted with ever increasing responsibility, Booth steadily rose through the company ranks and eventually succeeded Scripps as publisher in 1906. He oversaw the paper as it blossomed into a great metropolitan daily, following Detroit's unprecedented growth as America's largest center of manufacturing.

Booth's association with James Scripps, however, paid more than financial dividends. Booth learned about philanthropy as he helped his father-in-law, one of Detroit's towering cultural benefactors, plan and implement several initiatives, including the establishment of the Detroit Museum of Art (the precursor to the Detroit Institute of Arts), the building of Trinity Episcopal Church, and the beautification of Detroit's Belle Isle Park, one of Frederick Law Olmsted's largest commissions. Booth also benefited enormously from Scripps's connoisseurship, artistic connections, friendly collecting advice, and expansive collections of art and rare books as he began to develop his own collecting and patronage interests. For instance, an encounter with one of William Morris's Kelmscott Press books in the Scripps library inspired Booth to create his own Cranbrook Press, which between 1900 and 1902 produced a series of beautifully crafted hand-pressed books of Booth's own design.

## EMBRACING THE ARTS AND CRAFTS MOVEMENT

By the turn of the century, Booth was wholly engaged in the Arts and Crafts movement as a craftsman member of several societies, a patron, collector, exhibitor, and passionate advocate. Clearly, he felt driven to support the movement for personal reasons, for he always considered himself to be an artist and architect at heart, but he also believed strongly in the broader social, moral, educational, and aesthetic aims of the movement, especially in the regenerating or uplifting effects brought by aligning art with life. He corresponded with most of the major figures in the movement and was especially interested in the activities of individuals who sought to create model Arts and Crafts communities, for example, Elbert Hubbard of the Roycrofters.

Hence, though burdened by the demands of running his many businesses, Booth labored tirelessly in the first decades of the twentieth century to advance the Arts and Crafts movement in the United States. He served on the board of the American Federation of Arts, created training programs for industrial designers, underwrote a traveling

fellowship for architectural students at the University of Michigan, and eloquently promoted the ideals of the movement through articles and speeches. Gathering support from Detroit's architectural and artistic communities, he helped to organize the Detroit Society of Arts and Crafts in 1906 and served as its principal patron for several decades. With his backing, the society became one of the most active craft organizations in the country, serving up exhibitions, lectures, public theatrical performances, sales of crafted objects, studios for artistic production, and eventually a school.

## BOOTH EXTENDS HIS ART PATRONAGE

Believing that museums had a responsibility to keep the public abreast of developments in the decorative arts fields, Booth donated a remarkable array of about one hundred American and European sculptures, applied art, and decorative works to the Detroit Institute of Arts, forming one of the most significant collections of its kind in the country. Among its prized treasures was a wrought-iron gate designed by Thomas Hastings (of the prominent architectural firm Carrère and Hastings) and executed by the famed Edward F. Caldwell and Company of New York under Caldwell's personal direction. Depicting birds playing amid wisteria vines growing through a gate, the delicately wrought, polychromed copper-and-brass work required nearly a year's constant attention by half a dozen of Caldwell's most skilled metalworkers to produce.

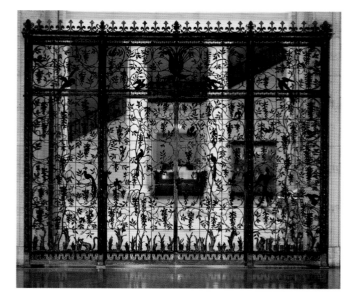

While amassing his collection at the museum, Booth also worked closely with Michigan's architectural and educational communities to enhance opportunities for architects, students, and artists involved in the building trades. "Builder Booth" was admired for his eagerness to build well and always appropriately, with expectations that his buildings would harmoniously blend art, craft, architecture, and landscape architecture and significantly contribute to the cultural foundations of their towns and cities.

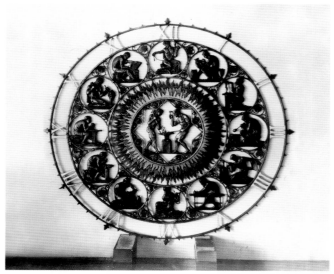

# CRANBROOK: A PATRON'S CANVAS

★

OPPOSITE

**EDWARD BURNE-JONES
(DESIGNER) AND WALTER
TAYLOR, JOHN MARTIN, AND
ROBERT ELLIS (WEAVERS),
*DAVID INSTRUCTING
SOLOMON IN THE BUILDING
OF THE TEMPLE*, 1902–1903.**
Wool, silk. 117 x 116 inches.
Originally produced as a
stained-glass window for the
baptistery of Trinity Church,
Boston, the design was later
woven at the Merton Abbey
looms for an Australian, George
Brookman. Booth purchased
the tapestry from Morris & Co.
in 1922, after Brookman resold
it to the firm. One of four
Merton Abbey tapestries that
Booth acquired, this is the only
one that he displayed in his
home. He later donated it to
Christ Church Cranbrook, where
it still hangs.

RIGHT

**HAND-COLORED IMAGE OF
THE WEST TERRACE AND
WEST WING OF CRANBROOK
HOUSE, C. 1920.**

As remarkable as these measures were, the crowning achievement of George Booth's life was the creation of Cranbrook, the renowned educational community that he and his wife developed in Bloomfield Hills, an outlying rural area near Detroit. Their venture began in 1904, when Booth purchased a rundown farm on gentle, rolling terrain and immediately began improving the property as a family retreat and working farm. From the outset, Booth anticipated that the land would eventually be given over to a higher, public purpose, and so he took extraordinary measures to ensure that he built well, with posterity in mind. He called the property Cranbrook, after his family's hometown in Cranbrook, England, which is a place of noted beauty filled with buildings inspired by Arts and Crafts ideals.

Booth's dreams for Cranbrook accelerated in the years after 1908, when he and his family took up residence at "Cranbrook House," which became a showcase for Booth's ever-growing collections of art, especially decorative objects. Booth surrounded the manor with formal gardens, statuary, and picturesque attendant buildings, including a Greek theater built for performances by the Detroit Society of Arts and Crafts. He frequently opened the house to visitors and arts organizations and encouraged the public to enjoy his estate's attractions.

As Booth approached his sixties, he gave increasing thought to the ultimate purpose of Cranbrook. Having no desire to squander his retirement in idle luxury, Booth felt compelled to use his wealth and talents to transform Cranbrook into an educational and cul-

tural center unlike any other, a place where the beauty of the setting would express the virtues of art in life and foster the creative growth of all who enrolled in its programs or visited its grounds. In doing so, he was fully prepared to divest himself of his life's fortune.

## ESTABLISHING THE CRANBROOK COMMUNITY

The first major institution to be established was Christ Church Cranbrook, an Episcopalian parish intended to serve as the moral center of the new Cranbrook community and a symbol of the melding of the spiritual and aesthetic impulses. Designed by Bertram Goodhue Associates and consecrated in 1928, the church incorporated hundreds of rare and commissioned works, many from prominent craft firms that were destined to be closed by the Great Depression within the decade. By virtue of its total embrace of the Arts and Crafts aesthetic, Christ Church Cranbrook stands as a monumental testament to the arts that flourished before the onset of modernism. Henry Booth, the founder's son and a graduate of the University of Michigan architectural program, designed a children's school, Brookside, which opened in 1929 in a fanciful but altogether charming building that trailed along a stretch of the Rouge River flowing through campus. For the

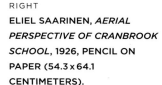

RIGHT
**ELIEL SAARINEN,** *AERIAL PERSPECTIVE OF CRANBROOK SCHOOL*, 1926, PENCIL ON PAPER (54.3 x 64.1 CENTIMETERS).
Eliel Saarinen responded to George Booth's suggestions for adapting a farm complex at the west end of the Cranbrook estate for educational purposes with this powerful perspective rendering that clearly indicates his architectural ambitions for Cranbrook School, the first of his many American buildings. Saarinen had a gift for conceptualizing projects with considerable clarity and detail, even in the earliest stages of design.

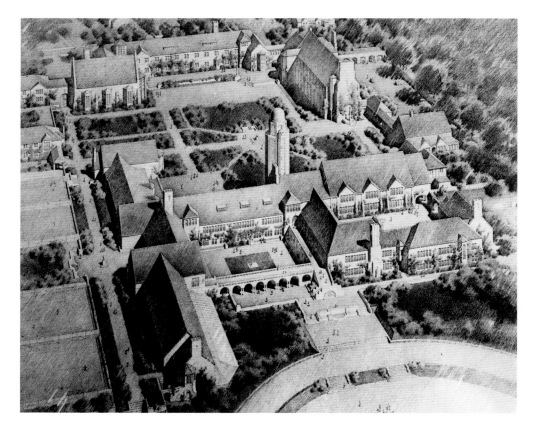

remaining institutions, Booth turned to Eliel Saarinen, the great Finnish master whose artistic roots lay in National Romanticism, the Finnish iteration of the international movement. Working closely with Booth, Saarinen executed four major building programs at Cranbrook: Cranbrook School for Boys, which opened in 1927; Kingswood School for Girls, 1931; Cranbrook Institute of Science, 1938; and Cranbrook Academy of Art, completed in 1942.

## BOOTH'S AIMS FOR CRANBROOK

Although each Cranbrook institution assumed a different architectural style, all reflected Booth's desire that they integrate interior and exterior elements in a pleasing composition that stressed craft and good design. All were set off by attractive landscapes and enhanced with statuary and water features, including reflecting pools and fountains. Knowing that Cranbrook was to be a community of artists, educators, students, and caretakers, Booth also constructed scores of homes, apartments, and dormitory rooms for their use. Such was the depth of his vision that Booth personally guided the development of Cranbrook's architecture and landscape, formulated the missions of the institutions, assembled their presiding boards, and commissioned or purchased much of the art that filled the buildings and grounds. In a fitting endgame, Booth donated the remainder of his life's riches to establish an endowment for Cranbrook. He would die in 1949 a "poor man," as he had hoped.

To nurture the creative abilities of younger Cranbrook students, Booth incorporated arts training into each of the schools' curricula and outfitted them with well-equipped facilities for craft and art production. Booth furnished Kingswood School, for instance, with the largest weaving studio in the United States. He also hoped that students would gain a greater appreciation of art by examining the holdings of the Academy's Art Museum and experiencing the many treasures that dotted the campus, from Samuel Yellin ironware and Carl Milles sculptures to Pewabic Pottery installations by Mary Chase Perry Stratton and tapestries from Merton Abbey. To influence Cranbrook students to become informed, engaged, and caring citizens, Booth and other community leaders stressed public service careers as highly as those in the professions and commerce. Cranbrook itself became a prime example of the model communities that students were expected to help build wherever they settled in life.

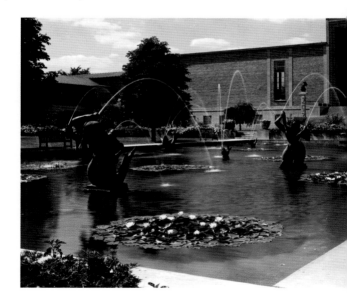

# ART EDUCATION AT THE
# CENTER OF THE COMMUNITY

★

Booth envisioned the Cranbrook Academy of Art as the community's educational center-piece, a place that would actively influence the creative aspirations of Cranbrook while assuming a major role within the nation's artistic life. Inspired by the American Academy in Rome, Booth sought to create a comparable institution at Cranbrook, a place where accomplished artists, well along in their professional careers, could pass a period of time working and living among peers in an atmosphere of creativity, interplay, and inward reflection. In the late 1920s, Booth took tentative steps toward realizing this dream by opening craft workshops, joining masters and students, to aid in the embellishment of the Cranbrook institutions and to promote artistic handwork to the general public. Among the craftsmen who came to Cranbrook under these auspices were Tor Berglund,

formerly a cabinetmaker to the Swedish royal family; John C. Burnett, a talented Scottish blacksmith; Jean Eschmann, a Swiss bookbinder; and Loja Saarinen, Eliel's wife, who established a fine handweaving firm, known as Studio Loja Saarinen, on the grounds in 1928.

Another early craftsman was Arthur Nevill Kirk, a superb English silversmith whom Booth recruited in London to craft crucifixes and altar plates for Christ Church Cranbrook. Kirk was a consummate designer-craftsman. He was a master of cloisonné enameling and preferred

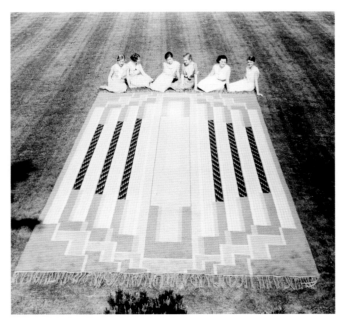

OPPOSITE, LEFT
**STUDIO LOJA SAARINEN
LOGO FROM THE COVER OF A
STUDIO BROCHURE, C. 1932.**
Loja Saarinen appears in silhou-
ette before a loom of her own
design.

OPPOSITE, RIGHT
**STUDIO LOJA SAARINEN
WEAVERS WITH A RUG
WOVEN FOR A KINGSWOOD
SCHOOL RECEPTION ROOM,
C. 1931.**

LEFT
**ARTHUR NEVILL KIRK,
*TRIPTYCH*, 1940 OR EARLIER.
SILVER AND ENAMEL
(9.6 x 6 x 3 INCHES).**
George Booth personally
invited Kirk to set up his studio
at Cranbrook. Gift of George
Gough Booth and Ellen Scripps
Booth through the Cranbrook
Foundation.

# WEAVING A HISTORY OF EXCELLENCE

CRANBROOK has been a center for fiber-arts production and education since the late 1920s, when Loja Saarinen established a commercial weaving studio on the grounds, Studio Loja Saarinen, and founded the Weaving and Textile Design Department—the forerunner of today's Fiber Department—at the Academy. In 1933, a high school weaving program was established at Kingswood School under the direction of Lillian Holm, one of Loja Saarinen's most talented employees.

With seventy looms in operation, the Kingswood weaving studio is today the largest in the country. Given such a heritage, it is not surprising that Cranbrook has turned out some of the most influential fiber artists of the past century.

What is surprising is that Loja Saarinen opted to open her studio in the first place, because she had actually spent little time exploring the fiber arts in her native Finland. The outstanding quality of Studio Loja Saarinen textiles quickly won the studio several significant commissions, from clients as diverse as George Booth, Frank Lloyd Wright, the Chrysler Corporation, and Richard Hudnut, the New York cosmetics magnate. Saarinen and her weavers, largely women of Swedish extraction, employed the Scandinavian *ryijy* technique in their rugs, which produced a deep nap formed by hand-knotting tufts of yarn onto the warp. The Cranbrook Loom, designed by Saarinen for her studio, is still widely used by weavers today.

Loja's successor, Marianne Strengell, revolutionized textile production at Cranbrook through her experimentation with synthetic, metallic, and natural materials on both hand and power looms. Her superbly crafted woven goods, popular designed fabrics, and industrial textiles secured her reputation as one of the most talented textile artists of the twentieth century. Strengell's success paved the way for those who studied under her.

Jack Lenor Larsen, her most famous student, emerged as America's leading fabric designer and fabricator in the late 1950s through his innovative use of technology, color, materials, and weaves. Larsen's products became strongly identified with modernist interiors. He was the first to create fabrics for jet aircraft, to print on velvet (in America), and to create stretch upholstery fabric. Yet another Strengell student, Charles (Ed) Rossbach, was a pioneer in the movement to create nonfunctional textiles and to employ fiber as a sculptural material.

As generations of teachers have left their mark on students, the torch is passed yet again, to Hiromi Oda, who studied under Jack Lenor Larsen. Trained in Japan in traditional weaving techniques, under Larsen's influence her work expanded to include more experimental approaches, such as off-the-loom weaving.

The Cranbrook Academy of Art's current director, Gerhardt Knodel, headed the Fiber Department for many years. Knodel specializes in producing monumental fiber

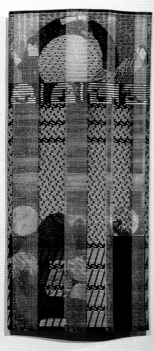

installations for architectural interiors. In *Guardians of the New Day,* Knodel blends photographic and weaving processes to create a four-panel woven wall hanging that unfolds the ecologically themed story of man's responsibility to nature: Each panel portrays a "guardian" protecting the elements of land, water, air, and light. Introducing figurative elements into contemporary weaving and "building light" into the textile through the use of layered transparent materials are the hallmarks of Knodel's innovative work, innovations for which he was honored in 1993 when elected an Honorary Fellow of the American Crafts Council.

---

**OPPOSITE A selection of woven textiles by Hiromi Oda.**
Oda displays her mastery of complex weaving techniques with her keen design sense of combining colors in her hand-loomed textiles.

**ABOVE** Gerhardt Knodel, *Guardians of the New Day,* 1987, cotton, linen, mylar
(42 x 93 x 6 inches).

working with traditional forms, but he always imbued his work with personalized twists that underscored his own contemporary impulses, as evidenced in his *Triptych* of about 1940. Whereas the beading and floral elements in the casing evoke Kirk's strong Arts and Crafts sensibilities, his treatment of the figures, support, and base indicates his willingness to extend his work with newer vocabularies.

Eliel Saarinen, heading a team of architects and draftsmen in the Cranbrook Architectural Office, made liberal use of the academy's workshops, churning out designs for

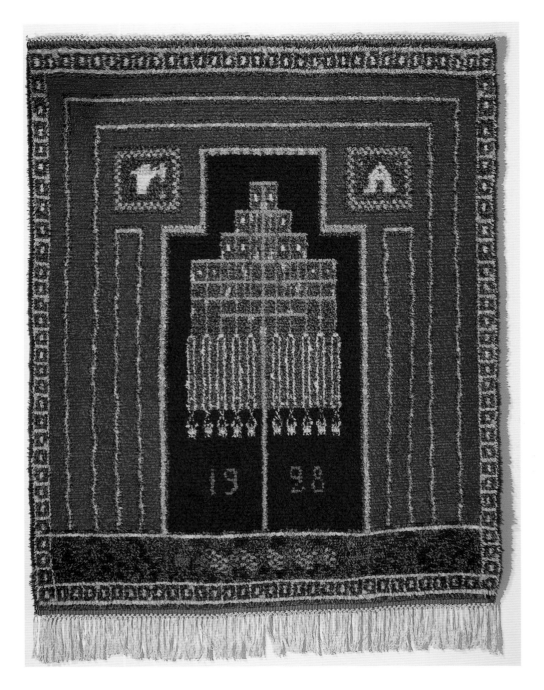

RIGHT
**LOJA SAARINEN (DESIGNER) AND VALBORG NORDQUIST SMALLEY (WEAVER), *RUG NO. 1*, 1928, COTTON WARP, LINEN WEFT WITH WOOL PILE (67 x 53 INCHES).**
This was the first rug created at Cranbrook by Studio Loja Saarinen.

textiles, andirons, gates, furniture, silver work, and more for Cranbrook's grounds. Most of the craftsmen willingly accepted these commissions, for it provided steady work under Booth's patronage.

BELOW

ELIEL AND LOJA SAARINEN (DESIGNERS) AND LOJA SAARINEN AND VALBORG NORDQUIST SMALLEY (WEAVERS), *RUG NO. 2*, 1928-29 COTTON WARP, WOOL PILE, PLAIN WEAVE WITH TEN PICKS OF WEFT BETWEEN EACH ROW OF KNOTS (110.5 x 39 INCHES). Eliel and Loja Saarinen often utilized a peacock theme in their work of the period.

## THE CRANBROOK ACADEMY OF ART AND CONTEMPORARY DESIGN

★

In 1933, as the Great Depression deepened and the building pace slowed at Cranbrook, Booth was forced to close the workshops, realizing that they could no longer be economically justified. However, unshaken in his belief that America still needed well-trained artists, designers, architects, and urban planners to give form to the towns and cities of the future as well as the product goods that would fill them, Booth seized the opportunity to reinvent the academy aong its current lines. He and Saarinen set the institution on a radically different path, one that emphasized contemporary design and a view toward machine production. This by no means signaled an end of handcraft at the academy, however. Rather, Booth and Saarinen hoped that the new approach would free artists to explore a range of materials, processes, and media that heretofore had been overlooked. The men hoped that the academy would remain small, affording continuing opportunities for faculty and students to live and interact in an intimate, creative setting. To ensure a high level of creativity, Saarinen decreed that the Academy be kept free of academic regimen, that it offer no formal classes or set curriculum. Students were expected to receive instruction in a variety of disciplines, to expand their understanding of materials and production techniques in order to be as inventive as possible. The Academy maintained ties with a number of manufacturers to permit students to professionally design for industry during their Cranbrook stay. Saarinen also encouraged students to enter competitions either collectively or individually and to accept private commissions as a means of furthering their professional careers.

At first, the Academy conferred no formal degrees. This changed during the Second World War, when the academy was formally spun off as a separate Cranbrook entity in order to take advantage of educational funding programs for veterans authorized under the GI Bill. From 1943 onward, the Academy has offered both undergraduate and graduate degrees, though its focus has been entirely at the graduate level in recent decades.

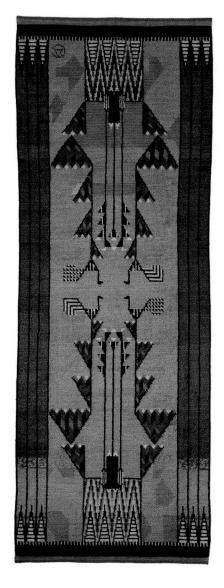

OPPOSITE
**ELIEL SAARINEN, *A ROOM FOR A LADY*, DESIGNED FOR THE 1934 INDUSTRIAL ART EXHIBITION AT THE METROPOLITAN MUSEUM OF ART, NEW YORK.**
Furniture by the Robert W. Irwin Company, Grand Rapids; textiles by Studio Loja Saarinen; gown by Pipsan Saarinen Swanson; lamp by the Frink Corporation, New York; and the tea urn and vases by the International Silver Company, Meriden, Connecticut.

RIGHT
**EERO SAARINEN AND CHARLES EAMES (DESIGNERS), *SIDE CHAIR*, 1940, FOR THE ORGANIC DESIGN IN HOME FURNISHINGS COMPETITION. THE MUSEUM OF MODERN ART, EXHIBITED 1941.**
Saarinen and Eames received help from several academy students as they worked out solutions for the design and manufacture of their famous bent-plywood furniture that won an influential Museum of Modern Art competition.

In spirit, the Cranbrook Academy of Art had much in common with the Staatliche Bauhaus, to which it has often been compared. Both institutions sought at a fundamental level to unify art, craft, and technology, but the Bauhaus' larger scale and adherence to established educational standards set it apart from the academy, where students were given much freer reign to develop their artistic temperament. Naturally, the Academy's forward-looking ethos at the time attracted individuals who were interested in modernism and mass production, as is evidenced by the careers of such Cranbrook luminaries as Charles and Ray Eames, Eero Saarinen, Florence Knoll Bassett, Harry Bertoia, Ben Baldwin, and Jack Lenor Larsen, among others. Nonetheless, many Academy students eschewed thoughts of designing for industry, preferring instead to concentrate on producing handcrafted or unique items, such as ceramic pieces, paintings, metal objects, and woven textiles.

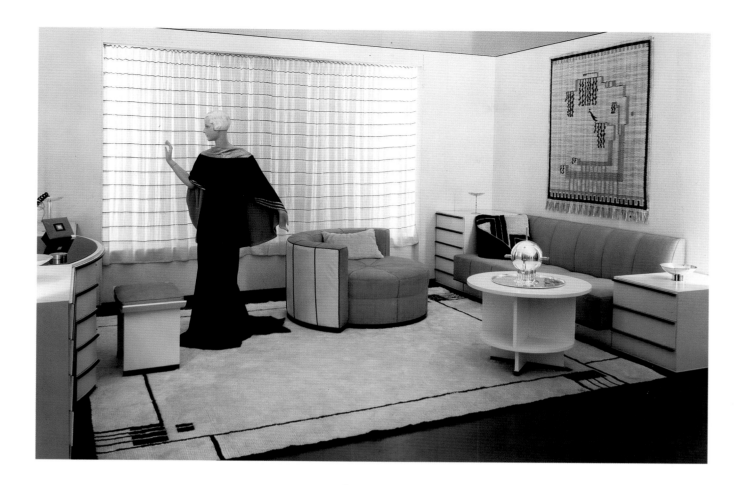

Saarinen and other faculty members led the way in the Academy's creative environment. In addition to monitoring and guiding students' professional growth, each was expected to sustain an active studio practice and maintain high visibility in his respective field. And many faculty members often invited students to help them out professionally on private commissions and competition entries. Charles Eames and Eero Saarinen, for instance, relied upon the skills of several students for assistance on their winning bent-plywood designs for the famous 1940 Organic Design in Home Furnishings competition for the Museum of Modern Art in New York City. Saarinen suggested the forms, but it took Eames, Harry Bertoia, Ray Kaiser, and others to work out fabricating techniques.

Eliel Saarinen's thriving private architectural practice, exhibition work, and designs for industry afforded him ample opportunity to apply his talents as one of the country's most eminent architects and designers. Paralleling his architectural work, which became increasingly spare and geometric as he grew older, Saarinen's designs for industry also assumed an increasingly unadorned elegance as the 1930s unfolded—his imposing *Tea Service,* for instance, designed as an accoutrement to his *Room for a Lady* at the 1934 *Contemporary Industrial Art* exhibition at New York City's Metropolitan Museum of Art, demonstrated Saarinen's mastery of form and proportion at any scale. The silverplated service, manufactured by International Silver Company, was never publicly marketed, but

ABOVE
**MAIJA GROTELL WITH ONE OF HER VASES, 1947.**

RIGHT
**MAIJA GROTELL, *VASE,* BEFORE 1943 (13.5 x 14 INCHES).**
Maija Grotell was among the first generation of ceramists who elevated pottery to a high art form. Her vessels are renowned for their subdued elegance, simple yet brimming with confidence.

BELOW RIGHT
**MARIANNE STRENGELL WITH ROBERT SAILORS AND OTHER STUDENTS IN THE CRANBROOK ACADEMY OF ART WEAVING STUDIO, 1944.**

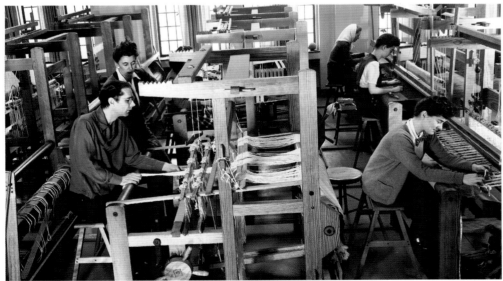

at least three variations of it were put into regular use at Cranbrook. One wonders whether academy ceramist Maija Grotell had Saarinen's spherical urn in mind when she produced a series of globular vessels featuring linked decorative surface elements in the 1940s, one of which, a stoneware vase from about 1943, is particularly striking for the way in which she raised check motifs in relief with slip above an otherwise unglazed striated surface.

Among the most innovative of all Cranbrook artists was Marianne Strengell, a family friend of the Saarinens who arrived as a weaving instructor in 1937. She pioneered the use of metallic and synthetic fibers in her handweavings and employed a power loom to teach her students how to design for industry. Throughout her twenty-five-year tenure, she produced fabrics for a wide range of industrial and commercial clients, including her old Cranbrook friends Eero Saarinen and Florence Knoll Bassett, and helped to create a cottage industry for handweavers in the Philippines to produce "transportation cloth" or automotive upholstery fabric.

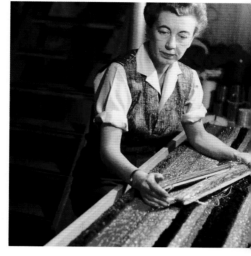

ABOVE

**MARIANNE STRENGELL IN HER STUDIO AT CRANBROOK, C. 1956.**

## SUSTAINING THE CREATIVE EDGE

Academy students, of course, have always responded well in this artistic milieu, often in ways that outpaced their teachers' efforts. Harry Bertoia, perhaps the most consummate of all Cranbrook artists because he excelled at several media, demonstrated such overwhelming talent that he was tapped to reopen the metalshop while still a student at the academy. The popular Bertoia designed and executed several notable items in the six years he spent at Cranbrook, including amusing jewelry pieces, a small plated tea service based on Eliel's famous urn, and other tea and coffee silver services that utilized forward-leaning forms with parabolic curves. Several of Strengell's protégés, including Jack Lenor Larsen and Robert Sailors, went on to influential careers in the fabrics industry. Similarly, Maija Grotell's three decades of teaching generated many prominent ceramists, including Toshiko Takaezu, Richard DeVore, and Harvey Littleton, one of the founders of the American art glass movement.

Most students look upon their Cranbrook years as the defining periods of their lives, and, true to form, most have continued to grow by delving into new media after they leave. Charles (Ed) Rossbach, for instance, who concentrated in ceramics and weaving at the academy, went on to establish himself as a top textile designer before experimenting with nontraditional material such as foil, twine, plastics, and twigs in his pieces. His *Ceremonial Vessel with Shells,* a late work from 1991, refers also to his fascination with basketry, the subject of two of his books. A few, like DeVore, returned to teach at the academy. Convinced that "pots" could convey ideas as powerful as any work of art, DeVore turned out enigmatic pieces with undulating surfaces, folds, lacerations, and recesses that challenged

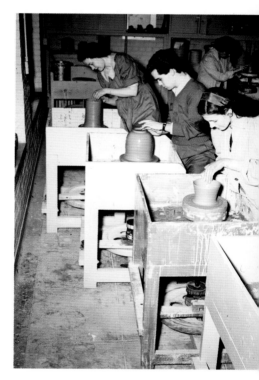

ABOVE

**STUDENTS WORKING IN THE CERAMICS STUDIO OF THE CRANBROOK ACADEMY OF ART, 1944.**

**HARRY BERTOIA, *COFFEE AND TEA SERVICE*, 1940, SILVER WITH CHERRY HANDLES.**

The parabolic curves and leaning forms in this tea service presage Harry Bertoia's later sculptural efforts.

**BELOW RIGHT**

**CHUNGHI CHOO, *DECANTER*, 1980.**

Born in Korea but trained at Cranbrook in the metals shop reestablished by Bertoia, Choo has advanced her skills to become a master metalsmith. The artist brings a minimalist sensibility to the form and structure of her metal objects—note how the need for handle and foot are eliminated by the artist's well-engineered design, but she does not strip them of their sensuality. The undulating, continuous curves of the profile; the reflective, smooth surface; and the sculptural roundness of the shape seductively draw the viewer's eye and beckon the hand to touch.

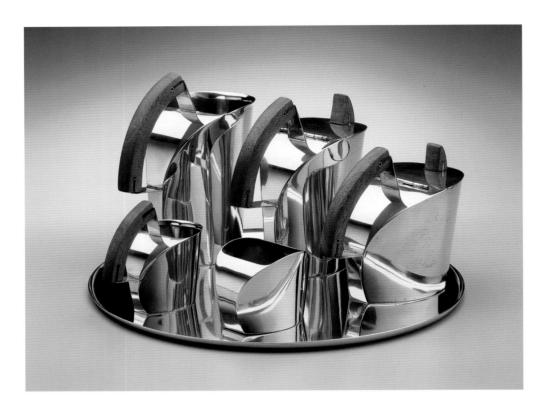

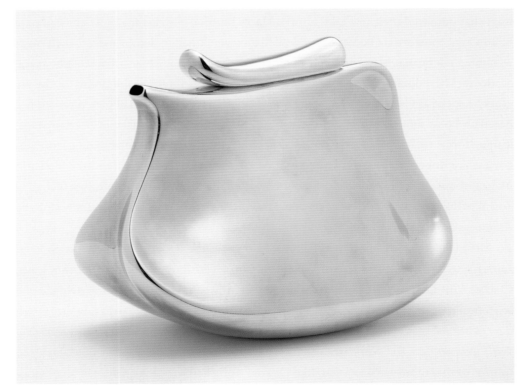

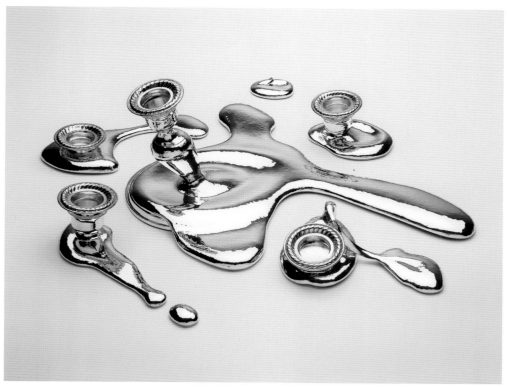

**GARY S. GRIFFIN,** *MODEL OF VEHICULAR GATE, LONE PINE ROAD ENTRANCE, CRANBROOK ACADEMY OF ART,* **2001, BASS-WOOD AND PAINTED BRASS.**

Griffin, head of Cranbrook's Metalworking Department (1984 to 2006), designed and fabricated this gate, continuing the Booth tradition of utilizing the talents of artists in residence. The design of the gate is inspired partially by tire treads.

**MYRA MIMILITSCH-GRAY,** *CANDELABRUM, SEVEN FRAGMENTS, 2002–2003* **(HEIGHT OF LARGEST PIECE: 6.25 INCHES).**

The seemingly melted silver sculpture was created by metal-smith Mimlitsch-Gray, who studied under Griffin at Cranbrook and combines demanding technical skills with conceptual abilities.

viewers to ponder the artist's intent and the meaning of the work. His ideas paved the way for later generations of Academy craft artists, who never questioned that they aimed for expression and not necessarily functionalism in their work. This freedom has led to an astonishing range of production. Myra Mimlitsch-Gray's *Candelabrum, Seven Fragments,* for example, a whimsical depiction of a melted candelabrum, actually calls into question more serious issues of materiality, impermanence, and artistic objective. Such a technically demanding piece would never have been created in the Saarinen era, for it boldly functions in the conceptual realms of aesthetics and theory, without concern for utility.

## AN ENVIABLE HERITAGE

★

By emphasizing the educational aims of the movement rather than the production of hand goods, George Booth set Cranbrook on a course that was to make it one of the few sustainable Arts and Crafts communities in the United States. In conception and realization, however, Booth ensured that Cranbrook would remain the most rarefied of all. No other crafts community offers as broad a range of educational programming or approaches its scale, which encompasses scores of architectural treasures on a 320-acre site. Perhaps most important, none matches its integration of art, design, craftsmanship, and natural beauty. All are found in abundance at Cranbrook, the last full flowering of the Arts and Crafts movement in America.

RIGHT

**CHARLES (ED) ROSSBACH,** *CEREMONIAL VESSEL WITH SHELLS,* **1991.**
Plaited ash splints and string with heat transfer and colored xerography. Trained as a weaver and ceramist at Cranbrook, Ed Rossbach later created works of art with nontraditional materials.

FAR RIGHT

**RICHARD DEVORE,** *VESSEL,* **1981, CERAMIC (15 x 13 x 8.6 INCHES).**
Richard DeVore's enigmatic "pots" transformed ceramics into an expressive medium layered with meaning.

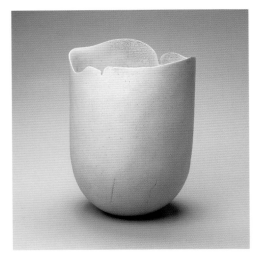

# School for American Crafts, Rochester Institute of Technology

T HE  S CHOOL  FOR  A MERICAN  C RAFTS  is a leader in producing artists, designers, and teachers in craft media. Merged with the Rochester Institute of Technology in 1950, the school today is a division of RIT's College of Imaging Arts and Sciences, which offers additional programs in art, design, photography, film, and print media. As such, it is at the center of a dynamic and lively environment for all of the arts.

But the school has an earlier, distinguished origin as the brainchild of Aileen Osborne Webb (Mrs. Vanderbilt Webb), who was responsible for organizing several national craft organizations during the late 1930s and early 1940s (see page 32). As a leader in the American Craftsman's Educational Council, Mrs. Webb wanted to offer a solid academic foundation for those who aspired to make a living as craftsmen. In 1944, she found a receptive base for her program, called the School for American Craftsmen, under the joint sponsorship of Dartmouth College in New Hampshire and the college's Student Workshop (founded in 1941). The training and rehabilitation of returning veterans was an early and integral part of the program since it was created during wartime, but within a few years, a diverse student body was in place.

**TAGE FRID, STOOL WITH
THREE LEGS, 1982, WALNUT
(30 x 19¾ INCHES).**

One of Tage Frid's most elegant
and economical designs was his
three-legged stool, seen here.
According to his obituary in the
Boston Globe on May 7, 2004,
he said, "I did some calculations
and studied fannies for a while,
and I found that a curved piece
[of wood] just 16 inches long
and 6 inches wide was all the
support you needed."

**WENDELL CASTLE, *MUSIC
STAND*, 1968, OAK, BRAZILIAN
ROSEWOOD (55½ x 25 x 20
INCHES).**

# THE DEVELOPMENT OF THE SCHOOL
## AND ACADEMIC CURRICULUM

★

A two-year program in the fields of textiles, ceramics, wood, and metal was planned, and the first classes took place in November of 1944. According to the school prospectus, training in specific craft disciplines and a practical education in the marketing and sale of goods would enable graduates to establish their own workshops, join others who were engaged in limited production, or execute specialized tasks for industry. Products made by individuals or workshops could be sold through America House, a retail shop on New York's Madison Avenue, created by the American Craftsman's Cooperative Council, and an excellent proving ground for an object's commercial appeal.[1] The writers of the prospectus also anticipated the potential for graduates to create new occupational fields, for in the postwar era, a new breed of designer-craftsmen emerged who worked with industry, created prototypes for production, and raised the level of design in manufactured goods. This development took place in the silversmithing industry, as Towle, Reed & Barton, and other manufacturers in the 1950s hired young, talented metalsmiths including John (Jack) Prip, Robert King, Ron Pearson, and Earl Pardon to develop prototypes for production.

The faculty was composed of experienced craftspeople, most of whom had previously operated their own shops or taught. Morning classes were devoted to design and the technical aspects of each discipline, while afternoons were focused on production. During the afternoon sessions, designs from various sources were considered on the basis of design, functionality, and marketability. Students then worked on approved examples, keeping track of their time, materials, and methods to determine the likely cost of the work.

Power and hand tools were available to students, who were encouraged to use the most efficient means to achieve their goals. The artistic nature of this work, however, was downplayed, unlike the approach taken during the Arts and Crafts period. The Dartmouth program was a practical one that had much in common with earlier manual training and later vocational schools. The use of power machinery did not mean, however, that hand tools gathered dust. The director of training, Virgil Poling, believed that handcraftsmanship was a creative activity that contributed to the quality of life in American culture:

> An educated person must understand at least the basic mechanical processes used in our industrialized society; that work with our hands is part of our tradition and thus a dignified procedure; that the ability and desire to invent or create are necessary and important steps toward the development of a national culture and the discovery and maintenance of human dignity.

In 1946, the School for American Craftsmen moved from Dartmouth College to Alfred University, in Alfred, New York, where students worked eleven months per year and forty hours per week, in emulation of the working world. Metalsmithing went forward at Alfred under Philip Morton, who had little formal education or apprenticeship experience but was open to explorations in design. His most important pupil was studio craftsman Ronald Hayes Pearson, who gave his mentor credit for focusing his attention on form and function. Morton later produced an influential book entitled *Contemporary Jewelry* (1970). The school was relocated for a second and final time in 1950 to its home at the Rochester Institute of Technology (RIT), in Rochester, New York. At RIT, the school settled into a larger cultural community that had the funding to support programming and could provide more space for classes.

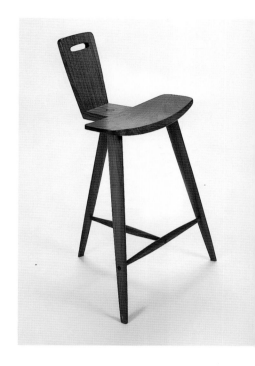

## DISTINGUISHED FACULTY IS DRAWN TO SAC

★

Key faculty members in the early years at Rochester were Danish furniture maker Tage Frid, German ceramist Frans Wildenhain, and American-born silversmith John (Jack) Prip, who had been raised in Denmark, followed by Danish-born Hans Christensen. In 1954, Frid, Prip, and Christensen provided a Scandinavian design aesthetic for which the school was known in its early years. Wildenhain, a talented painter and sculptor, was a free-spirited artist and graduate of the Bauhaus School, and he helped the school gradually move its focus from production to the pursuit of artistic achievement as a valid goal.

In 1952, Frid, Prip, and Wildenhain, along with former student Ronald Hayes Pearson, opened Shop 1, which was one of the first privately run galleries to sell midcentury crafts. Because of its close ties to the School for American Crafts (SAC), the gallery became an extension of the school, where students, customers, faculty, and other craftspeople could meet, exchange ideas, and see one another's work; it closed in 1977.

In the woodworking department, early graduates included William Keyser, Dan Jackson, and Jere Osgood. Keyser returned to teach in 1962, worked in a sculptural idiom, and during his thirty-five-year tenure emphasized for students the woodworking techniques he had learned with Frid. Wendell Castle taught with Keyser in the 1960s, and his experimentation with stack-laminated sculptural furniture had a significant impact on the field. Following his graduation, Osgood spent a year in Denmark, and briefly taught at the Philadelphia College of Art before returning to RIT in 1972. In 1975, he moved to Boston to teach at Boston University's Program in Artisanry. Modest and approachable, Osgood was able to impart his considerable skills to a number of students at several schools before returning to studio work around 1985. An impressive roster of RIT furniture graduates includes Jon Brooks, Richard Scott Newman, and Wendy Maruyama, who take

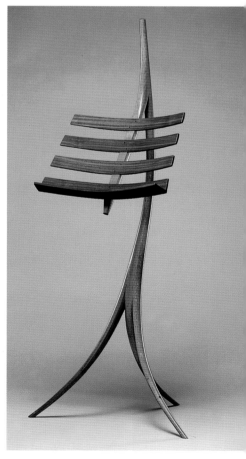

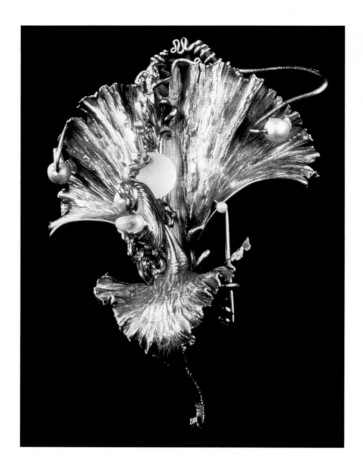

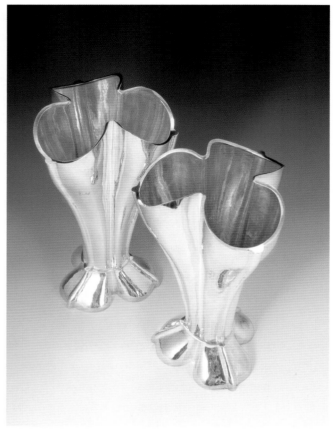

ABOVE LEFT
**ALBERT PALEY, *BROOCH* (#68-3), 1968; SILVER, GOLD, PEARLS, LABADORITE WITH AN OXIDIZED AND 24K GOLD PLATED FINISH. FORGED AND FABRICATED.**

ABOVE RIGHT
**WILLIAM FREDERICK, *PAIR OF VASES,* SILVER WITH GOLD PLATING ON INTERIOR OF VASES, 1994-95 (12 x 6 ½ INCHES).**
William Fredericks vividly recalls studying under Hans Christensen, who taught him to achieve a flawless surface by filing away his remaining hammer marks before polishing.

inspiration from natural, historic, and pop culture motifs. Leaders in the studio furniture field, professors Rich Tannen and Andy Buck continue a rigorous technical program and the exploration of style, content, and sculptural form.

Christensen had apprenticed with Georg Jensen Silversmithy before teaching for SAC. During his long tenure as silversmithing professor, from 1954 to his untimely death in a 1983 car accident, he carried the banner for Scandinavian design in his creation of elegant and inventive forms. However, with the arrival of Albert Paley in 1969 and Gary Griffin in 1972, it became clear that there were many avenues for personal expression, and these were explored by a new generation of students that included Claire Sanford, Sharon Church, and Susan Hamlet. Paley's fascination with the whiplash curve of art nouveau has been translated into delicate jewelry and monumental sculptural creations in wrought iron. He is artist-in-residence at RIT while continuing many public and private commissions. Sculptural work in metal has received a new emphasis under Leonard Urso and Juan Carlos Caballero-Perez.

Frans Wildenhain's student Richard Hirsch has been teaching at RIT since 1988. His tripod vessels and similar containers evoke the aura of ancient rituals with smoky raku firings. Since 1999, Julia Galloway has revived interest in functional vessels with her handsomely articulated forms and openly sensuous decoration.

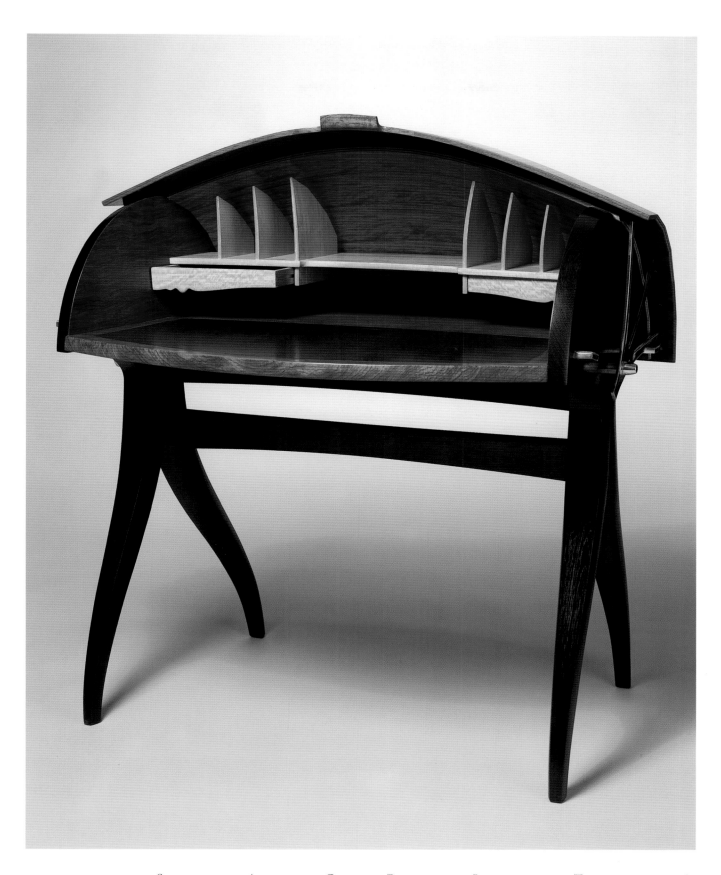

PREVIOUS PAGE
**JERE OSGOOD, *SUMMER '99 SHELL DESK,* 1999, BUBINGA, SATINWOOD, BRASS, WATER-BUFFALO SKIN.**

The graceful elliptical curves on Osgood's shell desk are made by laminating thin strips of wood in a mold; the elegant, tapering legs are made in a similar manner.

RIGHT

**JULIA GALLOWAY, *PITCHER.***

The decorative impulse in Julia Galloway's functional pottery is articulated in pattern and shape, and executed with richly colored glazes.

Today, as a division of the College of Imaging Arts and Science, the school includes glass among its craft disciplines under the direction of glass sculptor Michael Rogers, and students can work toward associate, bachelor, and master degree programs. Its graduates are equipped to work in their fields using traditional techniques and are conversant with the digital, aesthetic, and intellectual issues that are relevant to the twenty-first-century practice of their medium.

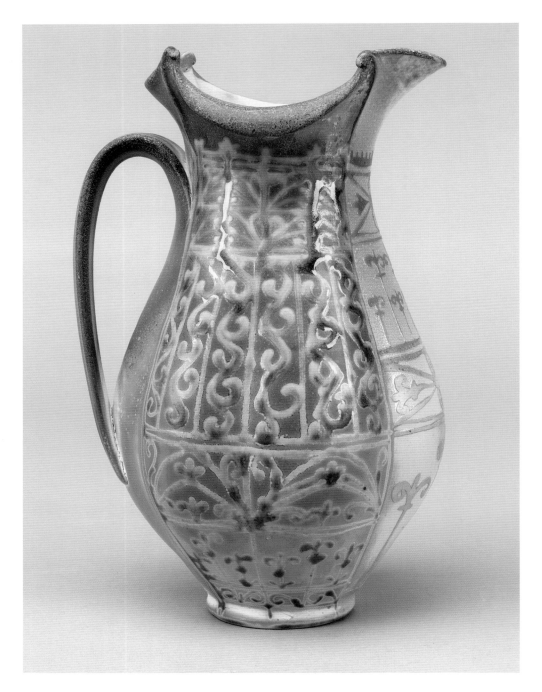

CHAPTER 9

# Black Mountain College

BLACK MOUNTAIN COLLEGE was a small, isolated, but international experiment in American education that attracted some of the greatest arts figures of the twentieth century. European émigré faculty brought a modernist spirit to the burgeoning progressive-education movement that took place during the 1930s. The result was to kick-start a wildly creative and deeply intellectual program, nestled quietly in the Blue Ridge Mountains of North Carolina.

The founder of Black Mountain College, John Andrew Rice, was dismissed from his position as a professor of classics at Rollins College, a small liberal arts school in Winter Park, Florida, in the spring of 1933. The cause was a dispute involving how students' days should be structured. Rollins College was known for its innovative approach to education and its eight-hour-day format of instruction (four two-hour blocks of conferences, as they were called). The administration, which was conservative despite the progressive temperament of the college, was moving toward a more flexible program, one that put more emphasis on the individual student and independent study. Taking students out of the group environment was precisely the opposite of what Rice believed to be the truest way of learning.

A committee was brought in to resolve the conflict, and it came down against Rice. He refused to resign and was forced out. That he had also offended colleagues and challenged the school's tradition of Greek societies and mandatory church attendance didn't help his case.[1]

By creating Black Mountain College the following fall—with the help of several fellow former Rollins professors who had been dismissed for not fitting the mold—he hoped to realize a kind of institution that did not yet exist in the country: an experimental liberal arts college that fully integrated life and education. For Rice, the best way to learn was by living.

## A SAFE HARBOR IN AN UNLIKELY PLACE

★

Rice's first challenge was to find a location for the school. The solution came in the Blue Ridge Assembly buildings in the small town of Black Mountain, about twenty miles east of Asheville, North Carolina. The buildings were used by the YMCA only during the summer months, so Rice was able to rent them during the school year.[2] With the location secured, the next issue was hiring—or finding—a faculty.

With little funding in place, a remote location, an uncertain future, and a communal environment, attracting established professors was difficult. Rice did recruit several young, forward-thinking Guggenheim fellows, Rhodes scholars, and others who had previously taught at experimental colleges, but for most professional educators, Black Mountain was not a particularly appealing opportunity.[3] For émigrés fleeing Nazi Europe, however, taking a position there meant getting a visa and a guaranteed two-year position. Hitler had been appointed chancellor of Germany, and his persecution of Jews, intellectuals, and artists—those who would eventually be labeled "degenerate"—was growing ever more threatening. They needed a safe harbor in which to land, and Black Mountain College welcomed them.

Many of the émigrés who came to America were distinguished and experienced professionals—artists, scholars, theorists, doctors, scientists—some of the greatest minds of their time. That Rice was able to bring many of them to Black Mountain greatly enhanced and enriched the college's curricula, as well as its reputation. Moreover, Rice added to the faculty of émigré artists acclaimed linguists, poets, mathematicians, performers, and historians, all chosen for their progressive ideologies and willingness to become wholly invested in the educational experiment. This faculty mix of European and American master artists and scholars created a dynamic, receptive environment, setting the stage for cross-pollination of ideas and a vanguard assault on conventional academia. Other "mountain" institutions that offered an arts curriculum, such as the Penland

School of Handicrafts and the Highlander Folk School, taught the traditional methods of various craft disciplines to local people and focused on preserving the indigenous culture.[4] Black Mountain, on the other hand, encouraged across-the-board newness in thought, approach, material, and process.

The hiring of highly acclaimed German artist and teacher Joseph Albers, negotiated by New York's Museum of Modern Art curator Philip Johnson, who was the Bauhaus's American representative, was a major coup for the school.[5] Moreover, the museum cleverly handled the publicity surrounding Albers's arrival in New York with wife Anni— an event that was covered by national papers. A prominent figure at the Bauhaus, which was forced to close over Hitler's demands, Albers was sought by the finest academic institutions in the United States. The potential and freedom offered at Black Mountain College, however, was more alluring; he and Anni became faculty in the school's founding year. Anni translated Josef's words to the reporters upon their arrival in New York (he spoke very little English): "He says that in this country at last he will find a free atmosphere . . . that art must have freedom in which to grow, and that is no longer possible in Germany."[6]

Albers came to Black Mountain with the hope of making it a major center for the arts, and he taught his students to "involve both intuition and the intellect in the search for form."[7] His classes brought not only modernist ideas but also Bauhaus-style teaching (the integration of "theoretical form teaching with practical workshop training")[8]. The visual arts curriculum he established, with a focus on design and color, would become a standard component of art education in America. Albers believed that one learned by doing; Rice believed that one learned by living. Their ideas meshed, at least initially.

Black Mountain College was a different kind of college from the others that existed at that time. It was owned and run by faculty members and was governed in a very liberal manner. Everyone played a role in the day-to-day operation of the campus, from kitchen duties to working the farms, and work was shared equally between the men and women. Mornings and evenings were devoted to classes and the afternoons to work. Classes were kept small, and there was a great deal of one-on-one time with tutors. Students and faculty lived together, worked together, and shared meals together, and students often said they learned as much at dinner as they did in class. The campus code was informal, but all were expected to dress for dinner, formally on Saturdays.

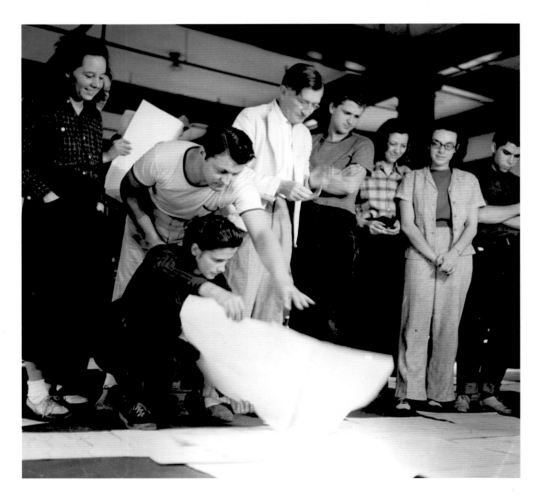

The college was a secluded place and virtually self-sufficient. There were few rules, no required courses, no grades, and no regular tests, but studying at Black Mountain was an absolutely demanding experience. Students were continually challenged by the high expectations of their teachers, and they were expected to offer original thought, to be vocal, and to be open-minded. A student could not advance from the lower division to the upper division without passing intense written and oral exams, and an even more rigorous set of examinations was required to graduate. That was something few students actually did.[9]

After about eight years, Black Mountain entered a phase of reevaluation and reconsideration of its mission and its faculty. Rice had felt an increasing loss of control and disenchantment with everything from the programs to the artists teaching them. There were tensions between him and Albers and tensions between him and faculty who felt the school was too much his own one-man show; his marriage, too, was falling apart. Several leaves of absence could not remedy the situation, and in the spring of 1940, Rice resigned, bringing to a close the first phase of Black Mountain's history.

## WAR, WORKSHOPS, AND WEAVING

★

In 1941, the perpetually unstable lease of the Blue Ridge Assembly buildings finally gave way and forced the college to relocate to a nearby property at Lake Eden, a former summer resort. The coming years were difficult as the Second World War took its toll. Plans for a new complex of buildings designed by Walter Gropius and Marcel Breuer were scrapped, and students were left to the task of renovating—and winterizing—the existing structures. In addition, most of the male students were drafted.

Despite the setbacks, progress continued, and by 1944, the college organized a summer program that offered classes with young, cutting-edge artists such as Willem de Kooning and Robert Motherwell. These leaders and their contemporaries in painting and craft were trying to change the definition of "good art" by breaking away from the overwhelming idealization of classical art, which was long regarded as having some sort of authoritative excellence. Their fearlessness and experimental drive was contagious, not to mention well timed.

The GI Bill of Rights provided funds that enabled the college to hire additional faculty members, and many returning soldiers sought the antithesis of military struc-

BELOW

THE DINING HALL, WHERE STUDENTS AND FACULTY SHARED MEALS, AND LODGES AT BLACK MOUNTAIN COLLEGE'S SECOND CAMPUS AT LAKE EDEN, CIRCA 1950.

ture and authority that was found in creative environments like Black Mountain College. By the late 1940s, the school had its largest student population — nearly one hundred — including artists Ruth Asawa, Kenneth Noland, and Robert Rauschenberg.[10]

The curriculum at Black Mountain included drama, psychology, languages, the visual arts, dance, writing, and music, as well as the lessons of physical labor, taught via constructing campus buildings and farming the land. Regular class work was supplemented over the years by the addition of workshops that provided a more in-depth study of a variety of subjects, from theater to art. With the college's applications for grants continually turned down, money was scarce; Josef Albers looked to the craft workshops with the hope that they would not only train students but bring in an income. At the least, he hoped they would be self-supporting and provide the college with necessary materials like furniture, tableware, fabrics, and printed items.

Albers wanted to establish a workshop system similar to that of the Bauhaus, which taught stone, wood, metal, clay, glass, color, and textiles. The Bauhaus saw craft as a preliminary study that would lead to designing for mass production and ultimately preparing a student to study architecture, which the school deemed the highest form of human expression. Craft served "solely to train the hand and to ensure technical proficiency," and workshops were essentially laboratories for industrial design.[11] Bauhaus students progressed from apprentice to journeyman to master over the course of their studies. It may seem incongruous to strive to become a master of a craft in an institution that heralded architecture as the supreme, but at the Bauhaus, crafts were such a critical component of the larger whole that they were not seen as less worthy. One did not exist without the other, and every medium, every form, was relevant. *Preliminary* did not mean *secondary*.

But the workshops that began at the Bauhaus in the early 1920s were not problem-free. It was hard to find enough qualified masters to lead the programs, money was limited, and equipment had been destroyed during the First World War. Workshops at Black Mountain proved equally challenging, as there was too little money to purchase equipment, and equipment made all the difference in production, the only means of a sure income.

The weaving workshop, headed by Anni Albers, was the only one that produced salable items and funded itself, though only on a small scale. It was also the most theory-based of the workshops, due to her Bauhaus training. Anni, like Josef, was firmly attached to the Bauhaus concept of using the crafts to establish a vocabulary of

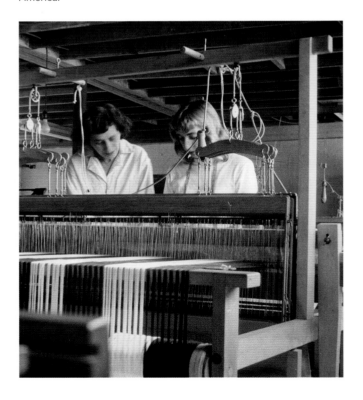

OPPOSITE

ANNI ALBERS, *ANCIENT WRITING,* 1936, WOVEN COTTON AND RAYON, 150.5 x 111.8 CENTIMETERS.

BELOW

ANNI ALBERS, AT THE LOOM WITH AN UNIDENTIFIED STUDENT CIRCA 1937.
Anni Albers was a Bauhaustrained weaver whose designs and techniques have greatly influenced the fiber arts in America.

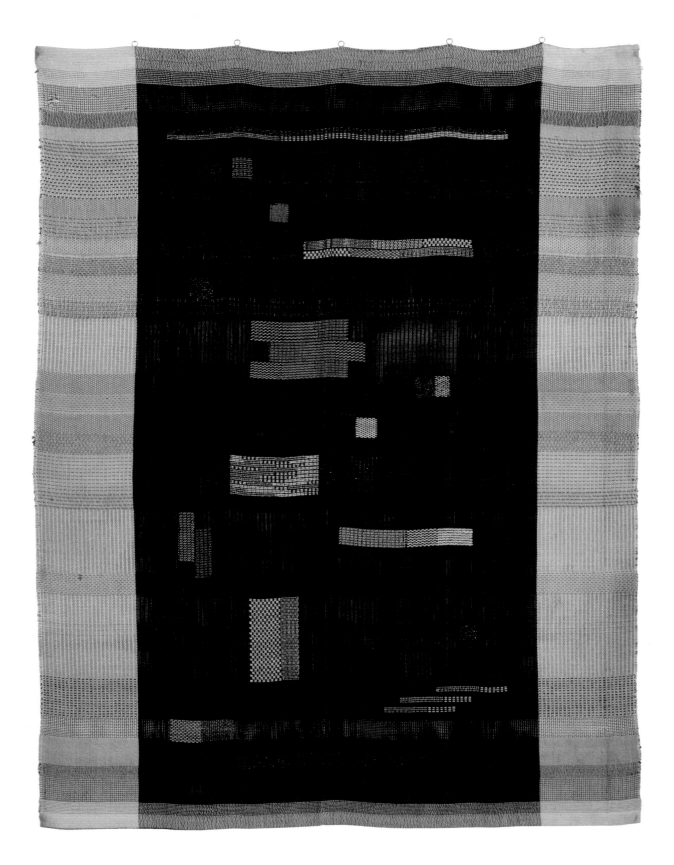

forms that could be translated into a design fit for production. She was keenly interested in the craft of hand weaving, but mainly as it related to design for public use.

To illustrate the history of production, she returned from a trip to Mexico with back-strap looms, which demonstrated how early cultures constructed highly advanced textiles as a precursor to mechanical production. She was also keenly aware of an industrial designer's role in society and accorded the designs of industrial products a high social and artistic responsibility because a single object reproduced many times would enter thousands of homes.[12]

Structure and tactile qualities guided Albers's designs, and she often incorporated unexpected materials, like plastics or metals. Albers's fascination for materials and the relevance of the mundane also manifested itself in her hardware jewelry, made of everyday items like pins and paper clips. In a groundbreaking achievement, she was the first weaver to be granted a solo exhibition at New York's Museum of Modern Art, a show that would travel to an unprecedented twenty-six venues across North America.[13] There were weaving programs at Cranbrook and the Art Institute of Chicago, but the program at Black Mountain differed in that it so strongly followed Albers's very defined aesthetic and her belief that textiles were "serving objects that should be modest in appearance and blend into the background."[14] Her and her students' textiles were exhibited throughout the United States, exporting the Albers style emphasizing thread rather than color or texture.

With her student Trude Guermonprez, a future Black Mountain weaving instructor, Anni established a small production-weaving program. Their intention was to make commercial textiles as well as custom designs. They received orders from New York, but the program could not sustain itself. Guermonprez later explained that the program was probably destined to fail, as the repetitive process of production was far too confining for Black Mountain students.[15] There didn't seem a way to focus their free-thinking, hyper-creative spirits into making someone else's work.

## A FINAL FLOURISH

★

Despite Josef Albers's apprehension about clay (he believed it was too easily manipulated and would be "abused by the beginning craftsman"), students wanted a ceramics program.[16] Albers acquiesced, and in 1949, the year he would resign from Black Mountain and take a teaching position in Yale's design department, he hired Robert Turner, a painter-turned-potter newly graduated from Alfred University's College of Ceramics, to build a studio and establish the program. Turner's forms have been likened to the gestural paintings of abstract expressionists: "the thickness of the stoneware and its coarse,

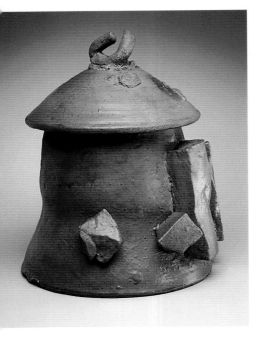

BELOW
**ROBERT TURNER,** *JAR,* **1997,
15 x 12½ INCHES DIAMETER,
STONEWARE.**
Robert Turner founded the pottery studio at Black Mountain in 1949, shortly after studying ceramics at Alfred University.

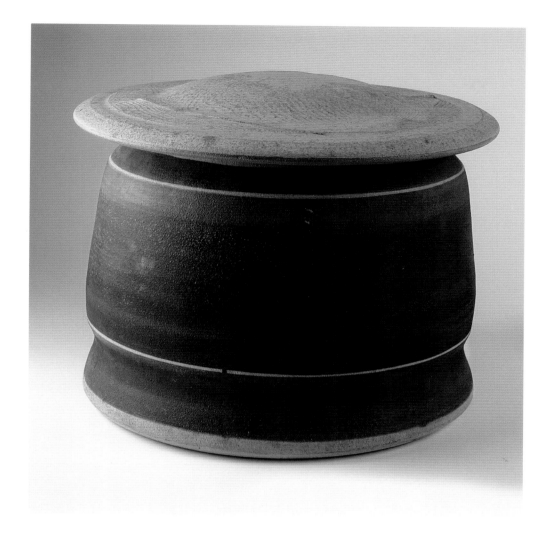

rough-hewn qualities communicate a sense of the gravity and physical presence of a de Kooning brushstroke."[17] Turner left Black Mountain after just two years and returned to New York to teach at Alfred. The pottery program was then taken up by fellow Alfred ceramics alumni Karen Karnes and David Weinrib, from 1952 to 1954. They produced mainly functional items that can be seen in context with the 1950s resurgence of the handcrafts in all media. Along with Turner, they were "among the first generation of postwar American craftsmen whose task it was to reassert and redefine the role of the unique or handmade object in industrial society, to establish high standards of craftsmanship, and to create a market for handcrafted products."[18]

During the 1952–53 academic year, the college organized a series of institutes, a final exhale of the Black Mountain spirit, as the coming years brought only increased struggle. The Crafts Institute, held in the fall, featured a special ceramics seminar organized by Karnes and Weinrib and led by former Bauhaus master potter Marguerite Wildenhain, whose studio at Pond Farm in northern California was widely known and respected. The

seminar included major figures in the field: potters Bernard Leach and Shoji Hamada, and Soetsu Yanagi, the founder of Japan's folk art movement and director of the National Folk Museum in Tokyo. Although it was intended for Black Mountain students, the daily programs of wheel demonstrations, films, and lectures on the history of ceramics in America brought back former students, as well as those from neighboring institutions, and attracted the local community. The school's ceramics program benefited from the success of the seminar and lured new faculty members including Warren Mackenzie and Peter Voulkos. For Voulkos, Black Mountain was a turning point in his artistic career as it provided "his first contact with a creative community" and one where "he first realized that skill could be the basis for invention as well as for a highly finished form."[19]

That the seminar featured Leach, Hamada, and Yanagi, as well as Wildenhain, signals the turning of American ceramics from West to East. Leach, who was raised in the Far East, brought Japanese pottery traditions to the United States, "awakening the Western potter to a Zen aesthetic that grew out of life and not out of design."[20] His first visit to the United States came in 1950; his second, two years later, was for the Black Mountain seminar. Leach offered an approach that was quite different from that of the Bauhaus-trained teachers whom students had come to know. His ideas and teaching methods—a blending of philosophical discussions with hands-on demonstrations—were fresh, challenging, and inspiring. Rather than craft as a means of study for something larger, he allowed craft to be . . . craft, and introduced the Japanese respect for and celebration of

BELOW
MARGUERITE WILDENHAIN,
*BOWL,* 1956, STONEWARE
(15 x 15¼ x 3½ INCHES).

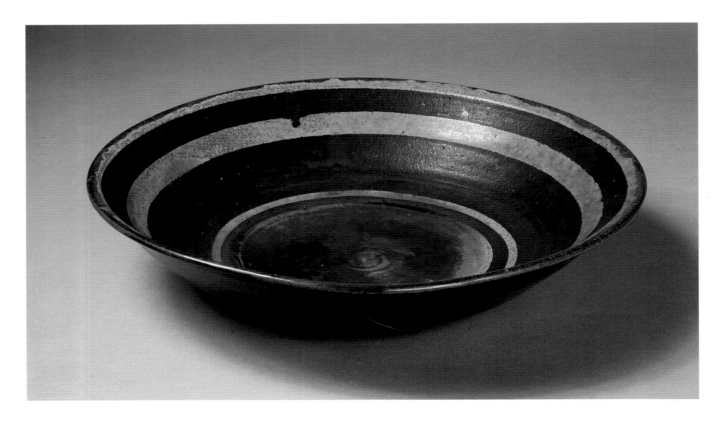

the potter. The Asian aesthetic "is that beauty derives not from the victory of science or art but from the sensitivity of every element of the process by which an object has been made. A pot is therefore a diary of a journey, and this is the root of its aesthetic worth, not the conscious striving for intellectually held visual principles."[21] The idea was revolutionary, and clay became one of the most aggressive champions of the studio art movement, especially on the West Coast. Peter Voulkos was a founder of the art ceramics movement that began in the mid-1950s — surely a spark that was ignited at the Black Mountain seminar.

## THE LAMP EXTINGUISHED, GLOWS STILL

★

In the 1993 catalog for London's Royal Academy exhibition *American Art in the Twentieth Century,* Mary Emma Harris, the premier researcher of Black Mountain's history, wrote that the college was "a unique combination of liberal arts school, summer camp, farm school, pioneer village, refugee centre and religious retreat . . . a catalyst for the emergence of the American avant-garde after the Second World War." Bucolic by outward appearances, the college was plagued with internal turmoil: financial troubles, disagreements, disappointments, and resignations from very early in its existence. It was never intended to be a utopia, but it simply proved too difficult to maintain a commune in which a dominant ego could force the redirection of the group, and in which artists were expected to be administrators and farmhands. It took them too far astray from their natural tendencies.

Yet despite its constant struggle, Black Mountain's history is of vital importance to the story of twentieth-century American education, art, and craft. In that small North Carolina town, Buckminster Fuller experimented with his first geodesic domes, and Robert Rauschenberg learned to look for found objects, producing reverberations that are still felt today. The college's contribution is all the more monumental considering that the campus closed in 1957, ending an astonishingly brief history of just twenty-four years.

Black Mountain is widely considered the "spiritual heir to the Bauhaus" and perhaps the truest representation of its ideas in America.[22] When Hitler handed the Bauhaus its new criteria in order to remain open, the remaining faculty faced the decision to accept it or to close the school. In a show of amazing fortitude, they chose the latter, a final expression of free will and artistic independence. The decision behind Black Mountain College's closure was not dissimilar. GI funds had all but gone, and raising money for an experimental art school during the political and social conservatism of the 1950s was near impossible. Faced with the decision to become a conventional college or close, the school chose closure over conformity, in a final expression of freedom of choice.

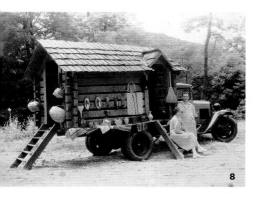

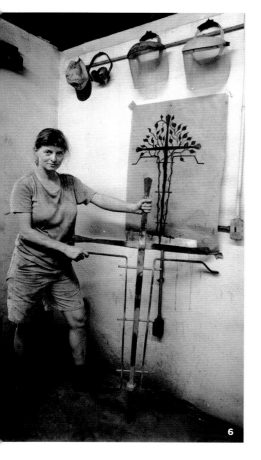

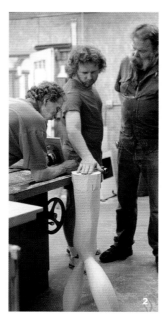

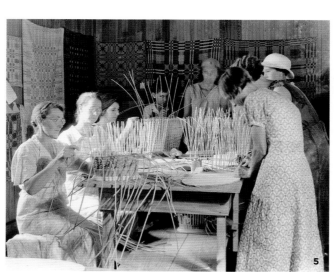

# Craft Schools and Residency Programs

## PENLAND SCHOOL OF CRAFTS

★

I F A N  A R E A ' S  E C O N O M Y was equal to the beauty of its environs, the Blue Ridge Mountains of western North Carolina would be wealthy beyond belief. The reality, though, is that lacking a strong industry or service sector like other parts of the country, rural mountain life has always been a challenge. In the years following the First World War, jobs were hard to come by, money was scarce, and the standard of living was marginal.

It was to this life that the Rev. Rufus Morgan, a native North Carolinian and seminary graduate, returned. In the small town of Penland, about an hour northeast of Asheville, he established in 1913, with the help and support of the Episcopal Church, the Appalachian Industrial School—intending to revive the nearly moribund craft of hand weaving and to provide a boost to the local economy.

In 1920, fascinated by crafts, his sister Lucy visited and took a nine-week weaving class. Dismayed that there were only a handful of women still practicing the craft, she took as her mission her brother's plans for a cottage industry built on the weaving arts.

OPPOSITE

1. A WOVEN TEXTILE "BANNER" DISPLAYING THE NAME OF PENLAND, SHOWN AT THE SOUTHERN HIGHLANDS CRAFTS GUILD, 2006.

2. ARTISTS/FURNITURE MAKERS WENDELL CASTLE AND GARRY KNOX BENNETT WITH STUDENT IN THE WOOD SHOP AT PENLAND, 1995.

3. CERAMIC ARTIST KURT WEISER WORKING ON ONE OF HIS "TORSO" VESSELS AT PENLAND, 1999.

4. WEAVER JIM BASSLER, PENLAND SCHOOL OF CRAFTS.

5. WOMEN LEARNING TO WEAVE BASKETS DURING A BASKET-MAKING CLASS AT PENLAND, C. 1930S.

6. PENLAND STUDENT GERTIE SCHRATTENTHALER WITH A PARTIALLY COMPLETED STEEL CROSS FOR HER FATHER'S GRAVE IN AUSTRIA. She made the piece during a Penland iron class in 2000. The drawing behind her shows the completed design for the cross.

7. ARTIST IN RESIDENCE, SHOKO TERUYAMA, CARVING A CLAY BOX, PENLAND SCHOOL OF CRAFTS, 2006.

8. LUCY MORGAN AND HOWARD "TONI" FORD WITH THE TRAVELOG, A TRUCK OUTFITTED WITH PENLAND CRAFTS, ON ITS WAY TO THE 1933 CHICAGO WORLD'S FAIR TO DISPLAY PENLAND GOODS.

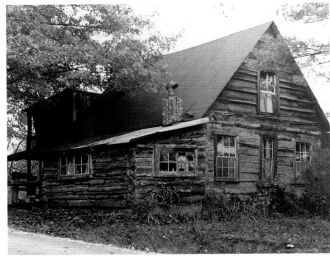

ABOVE LEFT

THE VIEW FROM THE PORCH
AT PENLAND SCHOOL OF
CRAFTS, SHOWING THE
BUCOLIC SURROUNDINGS.

ABOVE RIGHT

A MODEST PENLAND CABIN IN
WHICH RUFUS MORGAN, AND
THEN LATER LUCY MORGAN,
LIVED WHILE RESIDING AT
THE SCHOOL.
The cabin no longer exists, as it
was destroyed by a fire in 1937.

RIGHT

FOUNDER LUCY MORGAN
SPINNING CLOTH ON THE
PORCH OF MORGAN HALL,
PENLAND, AS WEAVING
INSTRUCTOR AND
COLLEAGUE EDWARD WORST
OBSERVES, C. 1934.

Something of a visionary, by 1924 Lucy Morgan had convinced forty or so local women to take up the craft. With local men building looms, women were weaving at home and the items were sold at fairs and mountain resorts.

It became clear that for her efforts to grow beyond a small scale, a central location had to be established that would allow for an easy exchange of ideas, patterns, and techniques among the women weavers. In a fateful decision, in 1926, Morgan added to the few structures already on the school property (still in use today) by building the Weaving Cabin, with summer programs that involved more and more local residents.

In 1928, the school was renamed the Penland School of Handicrafts (later, Penland School of Crafts), and took a bold step in inviting a renowned weaving expert from Chicago, Edward Worst, to work with the Penland Weavers.

Worst didn't come alone. He was accompanied by a journalist who wrote an article in a craft magazine about his having been here. Morgan then started to get inquiries from hobby weavers in other parts of the country who knew of Worst; could they come to Penland for his class. In 1929, the forty or fifty local women were joined by seven students from out of state. And with them, Penland School was born.

A natural marketer, Morgan immediately started to publicize the Summer Weaving Institute. Enrollment grew steadily each year. In the following decades, jewelry making, pottery, copper and pewterwork, bookbinding, and leather craft were added to a thriving summer session lasting several months.

By the time Lucy Morgan retired in 1962, Penland had acquired an impressive international reputation and had grown into a full-blown center for craft education.

# A UNIQUE APPROACH BRINGS
# UNCOMMON RESULTS

★

Although Penland was not alone in reviving mountain crafts (the Southern Highland Handcrafts Guild, the John C. Campbell Folk School, and Grove Wood Industries were just a few of the other schools), Penland was always distinctly different.

Lucy Morgan's brilliance was in inculcating an ethos of community derived from Arts and Crafts principles that determined Penland's purpose: that the effect on the maker was equal to what was being produced. Everything had a human value equal to a practical or economic value.

Her belief in the spiritual and therapeutic benefits of craft was manifest in the leadership of Bill Brown, her handpicked successor. With Brown, Morgan found someone who would contemporize Penland and bring in a new energy. As a working sculptor and Cranbrook graduate, Brown's network included many craft artists who had come through the university system, had apprenticed with great European craftspeople, or were themselves great European craftspeople who had come to America during and after the Second World War.

Today's atmosphere at Penland reflects Brown's belief that education should, simply stated, be the most exciting thing in the world. The school prides itself on selecting instructors particularly eager to engage with their students and to happily share everything

BELOW

*IRON STUDIO GATE,* 2000, MADE AS AN IRON-CLASS PROJECT WITH INSTRUCTORS JAPETH HOWARD AND ALICE JAMES.

The Penland gate, which is attached to the Penland iron studio, incorporates memorabilia, demonstration pieces, and other reclaimed debris from the school's first iron studio, as well as objects donated by instructors at Penland and individual pieces made for the gate by each member of the class.

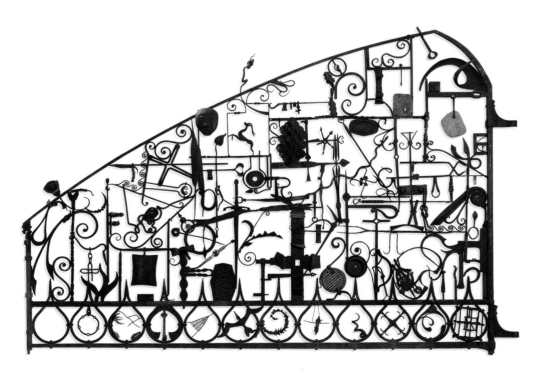

they know. And students come with the expectation that they will completely immerse themselves in their chosen subject over two-month sessions in the spring and fall.

Another significant difference is today's resident-artist program. Instead of the usual semester, or year, Penland's residency is for three years. Brown's rationale was that craft needed to be approached the same way people enter other professions, much like a medical residency or legal apprenticeship.

Brown also theorized that if he got people developing a career in craft to come and live there for a while and do their work, some would like the area enough to stick around.

And it's worked. There are currently about fifty working craft studios in the area, run by people who have been resident artists at the school, and dozens more studios with craft artists drawn to the area because of them. With a greater sense of community and continuity of craftspeople around the school, the students benefit as well. For those who appreciate discovering new work, it is an exceptional area for exploring.

As a center of craft learning, Penland has drawn tens of thousands of people to its campus by providing a thorough introduction to their chosen craft, regardless of previous experience. A place that welcomes discovery and self-examination, it has taken the essence of studio craft to heart in its respect for the individual and his or her relationship to the handmade.

In reflecting on Penland's place in the craft universe, Lucy Morgan wrote, "These are the Penland intangibles, the wondrous handicrafts of the spirit, things impossible to feel in your fingers or examine under a magnifying glass but real nevertheless and tremendously important and of value inestimable."

ABOVE LEFT
**ARTIST IN RESIDENCE VIVIAN BEER WITH THE CHAIR SHE DESIGNED WHILE AT PENLAND, 2006.**

ABOVE RIGHT
**DAVID CHATT WORKING ON A BEAD PROJECT AT THE PENLAND SCHOOL OF CRAFTS, 2006.**
Seattle artist David Chatt has been fascinated with beads and beading since his childhood, when he would accompany his jeweler father to craft shows. In the summer of 2006, he taught a class in beading at Penland School and instructed his students, who were at varying levels of proficiency, in the design and processes of beaded jewelry and sculpture. David was working on a beaded satin bustier entitled *Wardrobe Malfunction,* a commentary on the reaction to the Janet Jackson performance at the 2005 Super Bowl.

# ARCHIE BRAY FOUNDATION FOR THE CERAMIC ARTS

O NE institution that has maintained a particular influence is the Archie Bray Foundation for the Ceramic Arts near Helena, Montana. Established in 1951 by brickmaker and arts patron Archie Bray, its mission was modest: "To make available for all who are seriously and sincerely interested in any of the branches of the ceramic arts, a fine place to work." That it has succeeded beyond its expectations is due in large part to its stimulating environment as a gathering place for more than two hundred emerging and established ceramic artists at a time. It was at "the Bray" that such seminal artists as Rudy Autio and Peter Voulkos reimagined clay as a medium, setting the standard for innovation.

---

**ABOVE RIGHT PORTRAIT OF SARAH JAEGER IN HER MONTANA HOME HOLDING HER DOG, FRED, 2005.**

Sarah Jaeger is a prolific studio potter from Helena, Montana. She makes pots and bowls for everyday use, yet they have a luxurious look and feel. She proudly notes that her work is in many public and private collections and, most important, in many kitchens throughout the country.

**RIGHT Akio Takamori, Gemini Vases, 1990.**

**BELOW Brick arches with inset ceramic shards on the property of the Archie Bray Foundation.**

Known simply as "the Bray," the Archie Bray Foundation today welcomes—just as it did in the early 1950s—ceramic artists from across America and around the world.

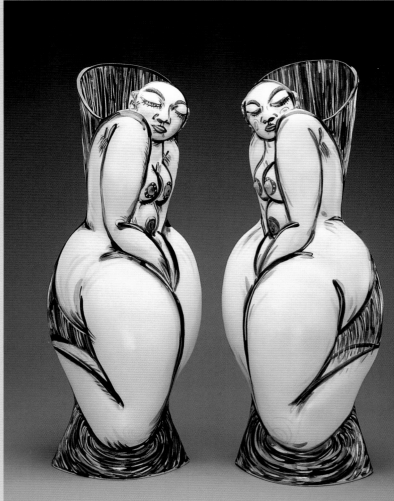

# THE PLACE OF CRAFT IN AMERICA

**RICHARD MARQUIS, *TEAPOT GOBLETS*, 1991–94, BLOWN GLASS.**

Along with Dale Chihuly, Richard Marquis is one of the forerunners of the studio glass movement and one of the first American artists to go to Italy to study ancient glass-forming techniques. The Italian millefiori and murrini techniques are used in these Teapot Goblets, producing the dynamic linear, spiral, and geometric patterns in the blown glass.

CRAFT TODAY IS COMPLEX AND IDIOSYNCRATIC. STUDIO-BASED, TRADITION-BASED, ETHNIC-BASED, AND HOME-BASED ARTISTS ARE ALL ENGAGED IN MAKING THINGS WITH THEIR HANDS. JUST AS THE OBJECTS FROM OUR PAST ARE ALL THAT REMAIN IN OUR PRESENT, TODAY'S OBJECTS WILL someday be the guideposts of the future. They continue to be the source of inspiration for all forms of art and design.

"The New Studio Crafts Movement" is truly a book unto itself: the story of a vibrant and relatively recent chapter of the craft continuum. The term "studio craft" refers to the work that was born after World War II when the very world was embarking on a new beginning, and individuality became a keyword for so many aspects of life. As represented by the work of contemporary artists, it continues to evolve and to produce the most conceptual and forward-thinking work being made today. The artists referenced are a sampling of the finest from the vast population of artists working in craft materials.

"Shaping Craft in an American Framework" is a discussion by Jonathan Fairbanks of craft's importance to us in this country, in this culture. As the

Katharine Lane Weems Curator of American Decorative Arts and Sculpture Emeritus, Museum of Fine Arts, Boston, his is a unique perspective of the importance of the handmade in our American history. He has spent a lifetime learning about and presenting handmade objects from every American tradition, including American Indian, early American Colonial, production, and studio craft. His scholarly consideration of craft across cultures and centuries gives him a singular ability to place craft in a context that increases our understanding.

Perhaps the most important aspect of craft is its constant presence at the heart of human creativity. It lives in us today. It will remain after we are gone. As eminent art historian Jules Prown has said, "objects are the only true events from history," and we tell our story through them. To bring the appreciation of craft into the twenty-first century, the epilogue helps us make sense of all that has been presented, considered, and discussed in this book and makes a case for the place of craft in the digital and virtual age. American craft is a vibrant, essential practice: It is encompassing and inclusive and stays current with technological advances while maintaining a focus on the handmade. Indeed, American craft is a "state of the art" member in good standing in the global craft community. In the words of artist and critic Bruce Metcalf, "a craftsperson's life is not a career, it's a calling." Every day, every week, their perpetuating commitment gives us a reflection of beauty previously unimagined.

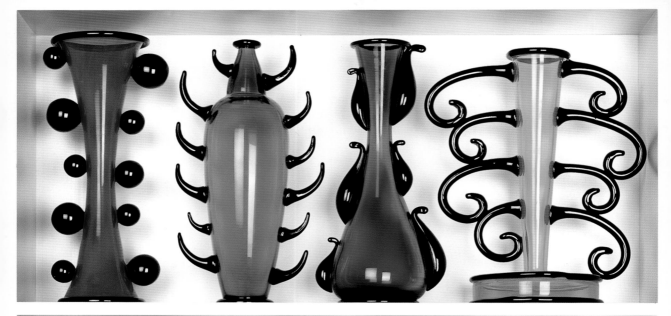
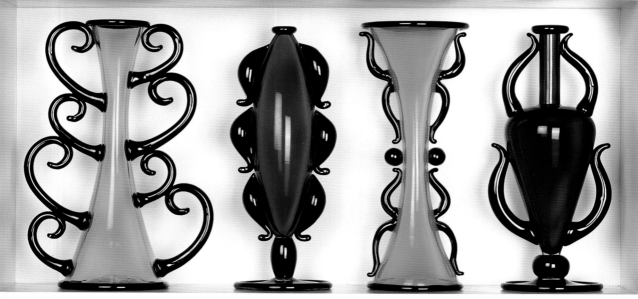
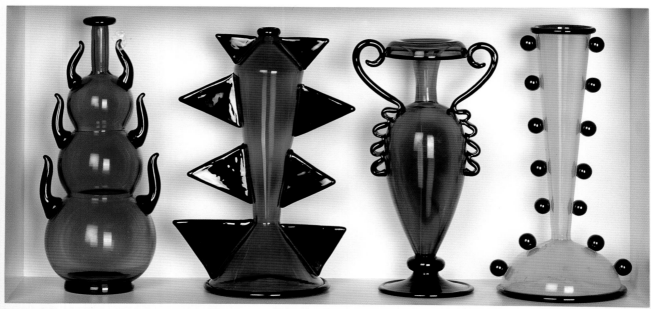

# The New Studio Crafts Movement

I N  T H E  1 9 6 0 S , craft witnessed nothing less than a perfect storm of creativity, technology, and process. The result was studio craft or studio art, one-of-a-kind pieces made by the artist from his or her original designs and expressing a strong idea or concept.

For craft artists the advent of studio craft meant they had the luxury and the liberty of controlling all aspects of their creativity and their product. It was a chance to *have* it all by *doing* it all.

Quality tools no longer had to be huge, commercial, and expensive. Technology could be embraced as a beneficial aid that could make a difference in a craft artist's output, without the fear of dehumanization. Miniaturization could make any space a craft studio, from garage or workshop to a table in the living room. And the precision of the new tools could make the process a pleasure.

More was at stake than just *how* objects were made. There was the underlying ethos of *why*. Just as with painters and other artists, a craft artist's vision didn't have to be subject to interpretation or compromise.

Virtually every craft medium found a place in the new ideals of the studio craft movement. As a result, more and more people who had wanted to pursue a craft experience, could. The number of Americans actively pursuing craft, either for fun or profit, increased dramatically.

Out of this new approach to craft came many who would make their mark on their medium. You'll find some of their names and stories in the pages that follow. Our sampling is limited by space, not by talent; there are so many who have made a difference.

Notably, craft and its practitioners aren't the only beneficiaries of the thinking behind, and implementation of, these innovations. As much as technology helped establish a new class of artists, studio craft has more than returned the favor. Its exponential growth has changed the face of publishing, broadcasting, retailing, and literally scores of other industries.

Glossy magazines like *American Craft, Ornament, Metalsmith, Fiberarts, Studio Potter,* and *Fine Woodworking* give inspiration, instruction, or affirmation to serious artists and do-it-yourselfers alike. Entering the word "craft" at amazon.com will bring up several hundred thousand titles, bolstering the work of publishing houses, their writers, designers, editors, and marketing specialists.

Whole cable networks exist to show craft-related programming. E-commerce outlets and retail stores offer professional-level craft supplies and tools, deliverable to studio door (or home workshop) by FedEx services. There are workshops to attend, videos to watch, websites to visit, galleries to exhibit in and buy from, and boutiques that feature work available nowhere else. Studio craft contributes mightily to our nation's commerce, as well as to our social discourse and spiritual well-being, making it much bigger, much more significant than just something people make in their spare time.

How far studio craft can advance is an unanswerable question. The same confluence that gave birth to the movement will continue to spark new ideas from the artists in the following pages. It is a world of promise—their world—which we can all look forward to with anticipation and confidence.

# GLASS: GOD'S OWN BRILLIANCE

★

For centuries, the making of art glass involved factories with hundreds of workers adhering to the typical industrial specialization of tasks. As a rule, each employee—designers, glass batchers, glassblowers, cutters, polishers, and others—played one part in a multi-stage process. Now, for the first time in more than 3,500 years, new techniques let artists make glass in nonfactory settings, either alone or aided with a "team" assembled to help with the process. They can merge art and craft in a room as small as a shed or garage, creating objects from concept through completion, from design through signature. The glass artist can finally look at a piece with a sense of total, personal accomplishment.

Studio glass's first advocate was Frederick C. Carder, in the 1930s through the 1950s. Founder of the Steuben Glass Works with Thomas J. Hawkes in 1903, Carder became de facto creative director of this division of Corning Glass Works in 1932 and experimented with a small kiln on the side. Edris Eckhardt was another early noted proponent of small-scale studio production. She was a sculptor who modified factory techniques involving very high temperatures so she could work in her basement, forming freestanding sculpture during the 1950s and 1960s. By 1953, she had mastered the lost methods of an ancient art form called gold glass, using it to make translucent shapes that she later combined with bonze.

BELOW LEFT
EDRIS ECKHARDT, *EVE,* 1975,
CAST GLASS.

BELOW
FREDERICK CARDER, *VASE WITH "M" HANDLES,* 1928,
FREE-BLOWN LEAD GLASS.

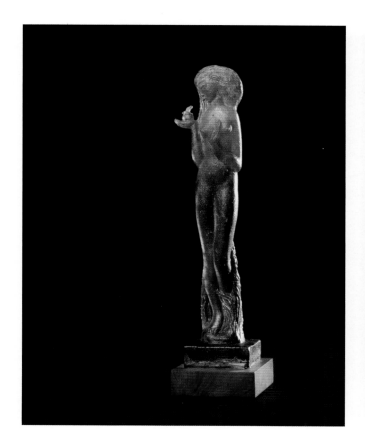

**JOEY KIRKPATRICK AND FLORA C. MACE,** *BY MEANS AND MEASURE,* **2002.** Artists Kirkpatrick and Mace learned glass processes at Pilchuck Glass School, where they worked with Dale Chihuly in the late 1970s, blowing and decorating vessels with "hot glass drawings," a technique they originated. Kirkpatrick and Mace have been collaborating for more than twenty-five years, and have evolved a signature style, very distinct from the work they did with Chihuly. They often work in series, and this sculpture is one of a group based on women's work and emblems of domesticity. These themes are expressed most directly by the depiction of the *Knitting Nancy*—a spool with embedded nails representing a tool/toy used by children to knit yarn—and the thick braid of woman's hair that has been "knitted," symbols of women's domestic roles and gender identity.

The most influential catalyst came in 1962 with Harvey K. Littleton, a ceramics professor at the University of Wisconsin. Some might say that Littleton was predestined to succeed. His father, Jesse Talbot Littleton, was the glass industry's first physicist, working at Corning Glass Works, and he had the idea of using glass as ovenware. To prove its feasibility, he sawed off the top of a glass battery jar and had his wife bake a cake in its bottom. The kitchen experiment changed the fortunes of Corning and the way twentieth-century families cooked. The scientists there call it low-expansion borosilicate glass.

We know it simply as Pyrex.

Littleton believed glass would become an accessible art medium if artists in small studios could perform the hot-glass technique of blowing. He and Dominick Labino, an

LEFT

**WILLIAM MORRIS,** *CANOPIC JAR DOE,* **1993.**
William Morris joined Dale Chihuly as a "gaffer" in his glass-blowing enterprise at Pilchuck Glass School in the late 1970s and soon became Chihuly's chief assistant. Morris's relationship with Pilchuck continues to this day. As Morris developed his most distinctive style, he began making works that evoke early earth history, mankind, and images that recall cave paintings. Anthropological or references to archaeological antiquity abound in his works of the 1990s, as seen in his *Canopic Jar*—a container used in ancient Egypt to store the organs of the deceased after the mummification process.

**SUSAN STINSMUEHLEN-
AMEND,** *WEDDING CHECKLIST,*
**2005. KILN-FIRED GLASS AND
ENAMEL PAINTS**

Similar to Kirkpatrick and Mace,
Stinsmuehlen-Amend is best
known for her edgy work in
glass. Here she details in
multiple panes of glass the
various duties a bride-to-be
needs to perform before her
wedding day—a wry comment
on gender identity and social
roles at play.

**ANNE GOULD HAUBERG,
WHO, WITH HER LATE
HUSBAND, JOHN, HELPED
FOUND AND FINANCE
PILCHUCK GLASS SCHOOL.**

industrial glass wizard and director of research at the Johns-Manville Fiberglass Corporation, presented glass workshops at the Toledo Museum of Art that involved building a small glass furnace and annealing oven and melting glass at a temperature suitable for blowing. The studio glass movement's flowering—and how it reached an apogee of extraordinary technical skill and high aesthetic quality—can be traced to these Toledo workshops and demonstrations. Littleton went on to create free-form, "slumped" (melted) art glass that, like all good executions, make us think differently. He later set up a pioneering program at the University of Wisconsin-Madison, which produced such artists as the prolific showman Dale Chihuly.

Chihuly's glass-making career has been and continues to be meteoric and phenomenal. It has touched everyone in the field of studio glass. In 1971, with the help and patronage of Anne Gould Hauberg and her husband, John, Chihuly cofounded the Pilchuck Glass School in Stanwood, Washington, an hour north of Seattle. Modeled after the prestigious Haystack Mountain School of Crafts on Deer Isle, Maine, Pilchuck's core curriculum concentrated on technical competence in glass, leaving artistic expression to the students. The Pilchuck school is so active that the glow of its furnaces' fires can be seen from orbiting spacecraft.

Littleton's influence continues to this day in the sheer number of university glass programs that provide a strong technical and artistic grounding. Within a decade of the

Littleton/Labino workshops, more than fifty American colleges and universities had glass programs, often founded by Littleton's students. Marvin Lipofsky, whose work is sensuous and fluid, is credited with being the father of California studio glass, and he started the glass program at California College of Arts and Crafts (now California College of Arts; see Chapter 6, page 000). Sam Herman extended Littleton's sphere of influence to London, becoming head of the glass department at the Royal Academy of Art. And the same tradition that influenced Chihuly, who studied at the renowned Venini glass factory in Murano near Venice, is also interpreted by artists like Dante Marioni and Caleb Siemon, whose works pay homage to Italian glass techniques and the multicolored Murano swirls. It doesn't stop—or even start—there.

At secondary schools, notably Punahou High School in Honolulu, glass programs have given youngsters a head start, much as music schools work to further their prodigies' talents. Glass centers such as Urban Glass in Brooklyn, New York, provide a place for artists, new or established, to rent space, blow glass, take lessons, or produce and sell lampwork beads. Urban Glass's Bead Project is a scholarship program for low-income women interested in acquiring a new skill to help provide supplementary income. Participants learn the art of glass-bead making and jewelry making as well as business skills needed to successfully market their work. In this way, the center perpetuates the cottage industry tradition of Appalachia, with craft as a vehicle for achieving a better life.

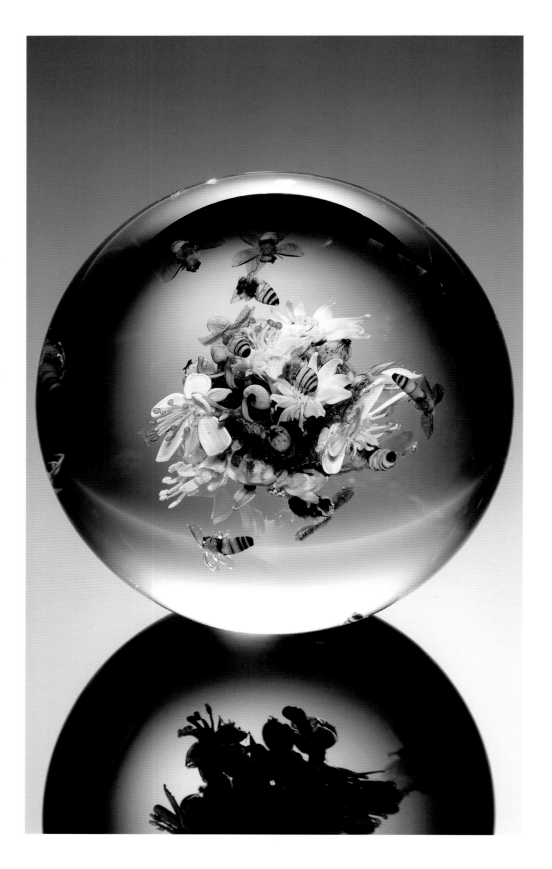

RIGHT
**PAUL STANKARD,** *SWARMING HONEYBEE ORB,* **2005.**
The artist explores supernaturalistic imagery with technical virtuosity in his miniature glass worlds of dream or fantasy.

OPPOSITE, TOP
**A SEQUENCE OF PHOTOGRAPHS SHOWING HARVEY LITTLETON AT PENLAND SCHOOL OF CRAFTS MANIPULATING ENCASED COLORED HOT GLASS FOR ONE OF HIS SIGNATURE "ARCED" SCULPTURES.**

OPPOSITE, BOTTOM
**MARK PEISER, MOON AND PALMS ON BONE, 1979. BLOWN AND TORCH-WORKED GLASS. 9$\frac{1}{2}$ x 6$\frac{3}{4}$" DIAMETER**

Will these artists ever reach the highest level of sophistication, like Paul Stankard and his amazing botanical paperweights? That's unknown, but it's not the point. The true legacy is in the number of artists and their extraordinary works, which have changed the way we look at glass.

Today, even the humble tumbler, because it touches thousands of lives, offers us a new appreciation for a material that, centuries ago, was seen as nothing less than a metaphor for God's own brilliance.

# POTTERY AND CERAMICS: THE LANGUAGE OF MOTHER EARTH

★

For American Indians, clay is substance taken from the body of Mother Earth. All matter contains spirit; hence all matter is sacred. On their earthenware pottery—which is coiled, raised, smoothed, and polished, slip-painted and/or carved, then fired under dried dung— are patterns that reference sky, rain, the river serpent, parrots, deer, and birds as well as flowers, seedpods, and other emblems of life and regeneration. Spirit resides in their pots. (See Chapter 3: Native Communities.)

In *Centering in Pottery, Poetry, and the Person* Mary Caroline Richards relates a story from ancient China about a noble who sees a potter at work. The noble admires the potter's work and asks how he is able to form vessels of such beauty. "Oh," answers the potter, "you are looking at the mere outward shape. What I am forming lies within. I am interested only in what remains after the pot has been broken." Richards goes on to say, "It is not the pots we are forming, but ourselves." She further recalls Robert Turner, who,

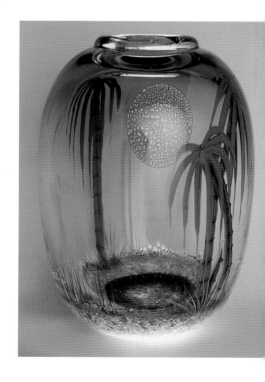

ABOVE
TOSHIKO TAKAEZU, *SAKURA I* AND *SAKURA II*, 2002, STONEWARE.

OPPOSITE, LEFT
RUDY AUTIO, *CHOCOLATE*, 2006, CERAMIC.

OPPOSITE, TOP
PETER VOULKOS, WORKING ON A MORE-THAN-3-FOOT "STACK," SO TITLED AS IT IS COMPRISED OF THROWN CYLINDER FORMS STACKED ONE ON TOP OF THE OTHER. Here Voulkos is demonstrating his throwing and assembling methods during a workshop demonstration in 1974.

OPPOSITE, BELOW
RUDY VOULKOS, *STACKED POT*, 1975, CERAMIC.

as he turned clay on the wheel at Black Mountain College, didn't look at the clay as the cylinder was drawn up on the spinning wheel. Rather, his ear was to the clay. "He was listening. 'It is breathing,' he said; and then he filled it with air."

This sense of the spirituality of pots and the creativity involved in their making is well suited to the new attitudes that developed in the 1960s.

The potter Toshiko Takaezu, a Hawaiian of Japanese descent who had studied at Cranbrook with Maija Grotell, began to close the tops of her vessels. This made them useless as containers. Thus altered, their purpose became that of contemplation. Before closing their tops, she also inserted ceramic pebbles within her vessels in order to create sound when the pottery was moved.

While Turner was making quiet, contemplative, and abstract ceramics, Peter Voulkos was revolutionizing the American ceramic movement with brashly abstract expressionistic stoneware of monumental and heroic vigor. Voulkos had worked at the Archie Bray Foundation in Helena, Montana, between 1952 and 1954. And, like Turner, he was part of the Black Mountain College Community in Asheville, North Carolina. This school was a flashpoint in the history of ceramics because of the confluence of artists and free spirits who shared the belief that everything was open to rethinking (see Chapter 9, page 189).

A ceramic artist who worked with Voulkos at the Bray was Rudy Autio, who beginning in the 1960s made spontaneous large-scale sculptural forms from slabs of clay. Autio's works are abstract in form but incised with gestural lines and colorful glazes, frequently depicting nude figures and horses floating on the surface. Viewing the drawings on Autio's vessels is similar to the dreamlike experience of a Chagall painting.

In California, the ceramic artist Robert Arneson dismissed any thought that he was a "potter," even though he was highly accomplished at the potter's wheel. In the 1960s, Arneson made a clay typewriter with fingers protruding instead of keys. He also combined pottery with ceramic images of human body parts in ways so witty, and often rude, that California critics were prompted to coin a new style, *funk art*. This was a short-lived term that Arneson dismissed—and soon outgrew. Yet in the 1960s, Arneson understood that the artist was expected to shock his or her audience. For the *Craftsman-Designer-Artist* exhibition at the Upton Gallery, State University College, Buffalo, in 1966, he provided a full-scale colorful toilet on ceramic floor tiles—all hand crafted—called *Polychromed Ceramic John*. A decade later he made a series of monumental self-portraits and other ceramic heads reflecting the irony, wit, pain, pathos, and horrors of war.

Viola Frey, another major figural artist from the San Francisco Bay area, was a pioneer in the development of monumental ceramic sculpture in America. Her larger-than-life human figures became increasingly abstract over the years (see page 000). She also incorporated in her works discarded debris from a nearby flea market, sensing in them special messages akin to the magic sensed by a shaman or poet.

On a parallel track with these sculptural works—liberating pottery from the need to be useful—was an expansion of ideas about functional ware.

In the 1950s, Midwesterners Byron Temple and Warren Mackenzie were among early disciples of the English potter Bernard Leach. Along with the Japanese potter Shoji Hamada, Leach was known for work of simplicity, directness, and humility, extracted from the value of Asian folk art. These artists combined personal expressions of their rural environment with a Bauhaus-Japanese emphasis on honest, warm, and inviting form (see page 298).

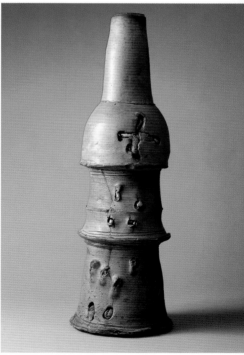

# PITCHER PERFECT: A SURVEY OF SERVING PIECES

**A**LTHOUGH mass-produced ceramics for practical use are abundantly available and affordable today, many contemporary potters still believe in handcrafting these functional forms. For them, it is a noble endeavor to make authentic, beautiful, and useful objects that can give meaning to the dinner table, the domestic environment, and their rituals.

Through this act of creation, potters bring together usefulness, beauty, and relevance. In the making of a pitcher, cup, plate, or serving bowl, these potters transfer a personal imprint to the object; the product of their imagination, skill, and passion often bears a recognizable signature technique or decorative style. When this functional object leaves the potter's studio to spend its life in service to someone's household, it brings along the memories, ideas, and individual marks of its maker, as well as a ceramic history that is rich in traditions.

These serving and display pieces—pitchers, teapots, ewers, and cups—range from functional to fantastical, a visual outpouring of ideas honed by artists' skills. Each seduces the eye as well as the hand. It beckons interaction, through its ergonomic construction, surface detailing and embellishment, tactility, and sensuous volumetric form.

Made to suit a purpose—a pitcher holds and pours liquid, and a cup receives and contains it—these objects also serve as documents, as metaphors, and as cultural indicators. They are commentaries on the artists' lives and the times in which they live. Besides the substances they are meant to contain, these vessels pour forth the elements that went into their making: the concentrated labor, technical agility, profound curiosity about the commonplace, and passion to connect with the user, whose hands, in the act of use, will complete the communion.

(Some of the ideas centering on the cultural meaning of "function" expressed by coauthor Jo Lauria in "Pitcher Perfect: A Survey of Serving Pieces" were first explored in an essay titled "Fill It to the Rim" commissioned by the John Michael Kohler Arts Center Sheboygan, Wisconsin, in 2005.)

---

1. Heidi Loewen, Pitcher, porcelain, smoke-fired, 2006.
2. Anna Silver, "Yellow Pitcher," glazed whitewall, 2006.
3. Cindy Kolodziejski, "String of Pearls," underglaze, on earthenware, 1999.
4. Cynthia Bringle, Pitcher, stoneware, 2006.
5. Kazuko Matthews, "Stacked Teapot," stoneware, 2006.
6. Marc Digeros, Pitcher, earthenware, 2006.
7. Tinya Seeger, Pitcher, stoneware, ash-glaze, 2005.
8. Bonnie Seeman, Teapot, porcelain, 2003.
9. Linda Sikora, Pitcher, salt-glazed porcelain, 2005.
10. Nikki Lewis, Pitcher and Washbasin, porcelain, 2006.
11. Phyllis Green, "Green Conversation," ceramic, 2005.
12. David Furman, "It's Knot For Me To Say," ceramic, 1980.
13. Jeff Oestreich, Pitcher, stoneware, 2006.
14. Patti Warashina, "Ka-Ching" Sake Set, porcelain and whiteware, 2004.
15. Michelle Erickson, "Timepeace," stoneware, 2005.

1

2

3

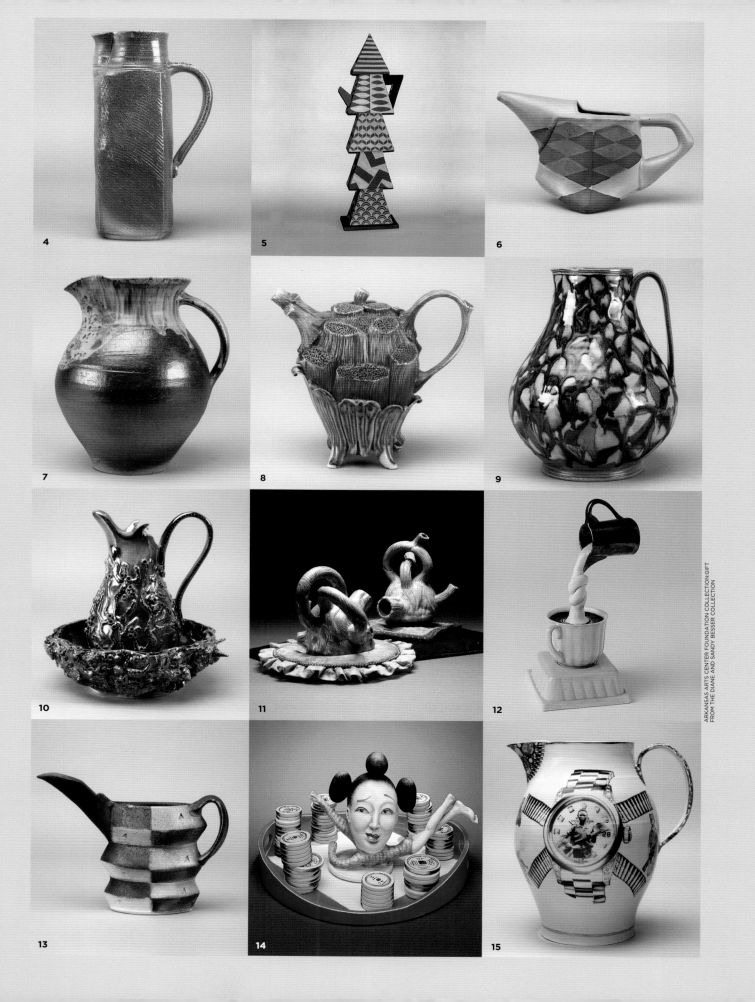

4

5

6

7

8

9

10

11

12

13

14

15

RIGHT

**RON NAGLE, *UNTITLED CUP (R/LANTERN)*, 1995.**

In this work the artist questions the definitions of *function* and *display* by displaying a functional ceramic cup in a presentation box. The cup can be taken out of its "container" and used, then replaced. The box also serves as a framing device, further confounding the definition by implying that the boxed cup is framed art. And, because of its rich and ordered color composition, when the cup is stored in its box, it echoes the formalism of a color field painting.

BELOW RIGHT

**BEAN FINNERAN, 2-TONE YELLOW RING, 2003, CERAMIC.**

Finneran, whose studio is situated overlooking the tidal marshes of San Francisco Bay, uses thousands of hand-rolled clay coils, which she calls "curves," to assemble sculptures that abstractly depict the marsh grasses that surround her studio. Held together solely by stacking and tension, Finneran has become a master at arranging these curves into structures that evoke the organic growth patterns found in nature.

LEFT

**RICHARD SHAW, *CHINA COVE*, 2000, CERAMIC.**
A West Coast ceramic sculptor, Shaw also rose to prominence during the highly charged decade of the 1960s. He is best known for producing intimate trompe l'oeil compositions, such as this, which re-create in clay what seem to be ordinary objects that are removed from their usual contexts and invested with magic and enigmatic meanings.

RIGHT
**CARY ESSER,** *CAMPSIS RADICANS* **TILES, 1998, TERRACOTTA.**

OPPOSITE
**TONY HEPBURN,** *KOREA GATE PROJECT,* **2006, CERAMIC.**

Artists who use clay sculpturally have also embraced ceramic's potential to serve as architectural structure and/or ornament. Hepburn's commissioned work for the Clayarch Gimhae Museum in Korea underscores the intersection between ceramic art and architecture. Similarly, Esser's large-scale tile installations are the result of her investigations of the decorative languages deployed in architectural ornamental structures.

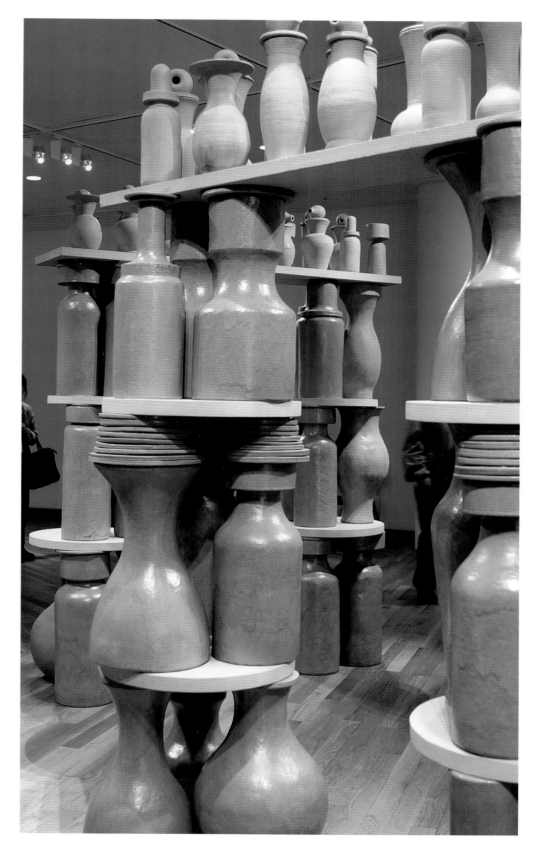

FOLLOWING PAGE

TOP LEFT
**LAURA ANDRESON, DOUBLE GOURD BOTTLE, 1974, PORCELAIN.**

TOP RIGHT
**JOHN GLICK, WALL MANTEL WITH EWER, VESSEL, AND PEARS, 1994, STONEWARE.**

BOTTOM LEFT
**GERTRUD AND OTTO NATZLER, *TALL DOUBLE-CURVED BOTTLE WITH LIP*, 1963.**

BOTTOM RIGHT
**RALPH BACERRA, *UNTITLED CLOUD VESSEL*, 1997.**
Bacerra is a master of ceramic form and glaze decoration, having developed a high-keyed, sophisticated language of surface embellishment. In this series of "cloud vessels," Bacerra looks to Asia for inspiration, appropriating the cloud motif from ancient Chinese scroll paintings and reproducing the famed celadon glaze developed by Chinese potters centuries ago.

Representing the next generation, Jeff Oestreich took inspiration from ordinary farm equipment in his native Minnesota, incorporating and exaggerating the form of a watering can for his pitchers (see "Pitcher Perfect: A Survey of Serving Pieces," page 222). Milk buckets, oil cans, and the ubiquitous silos and grain bins have offered ideas for others exploring the vessel form.

This aesthetic vision soon expanded beyond the Midwest to potters elsewhere in America who felt a kinship with the history of functional pottery traditions from Europe, the Middle East, and Asia. Gertrud and Otto Natzler, who emigrated from Vienna to America in 1938, carried with them their craft skills in pottery as well as their memories of the sleek, elegant shapes of European ceramics and the richness and sophistication of the glazes. They collaborated on their vessels: Gertrud threw superb, delicate, and elegant thin-walled forms, and Otto made and applied new and amazing glazes, most resulting in astonishing surface effects. Soon after settling in Southern California, they established a studio and began to create a prodigious output of vessels.

LEFT

JAMES MAKINS, GROUP OF SERVING PIECES, STILL LIFE GROUPING, 2004, CERAMIC.

Similarly, the potter Laura Andreson was entranced by the glazes of Asia. A leader in reviving the art of pottery making in America after it nearly disappeared during the Industrial Revolution, she established in the mid-1930s one of the first academic ceramic programs at UCLA. During a long career, she developed new firing techniques and new clay compositions that resulted in forms and glazes to rival the perfection of the Chinese Song Dynasty. With thousands of students attending her classes over a half century, Andreson shared her historical and technical knowledge, assuring that the next generation would have an appreciation and understanding of ceramic traditions and processes.

Functional potter James Makins has a gestural, more expressive approach to clay than those who fell under the spell of European and Chinese pottery, becoming disciples of its formalism and deep-rooted traditions. Finger ridges, dimples, and a loose attitude toward balance in his vessels give them energy and a sense of movement. Like the vessels of George Ohr more than a hundred years earlier (see page 285), these are forms that push functional ceramics, testing its very definition. Yet they do deliver on their promise of utility, and moreover add dynamism to the hands-on experience of everyday use.

Speaking to the senses of vision and touch, to the patterns and arrangements in nature, to the use of clay whose origins are the earth, all have contributed to a wider aesthetic for an edgier expression within contemporary ware.

OPPOSITE
**ELSA RADY, *STILL LIFE*, CERAMIC VESSELS ON ALUMINUM SHELF.**

# A TISKET, A TASKET: ORIGINS OF BASKET MAKING

★

The cycle of changing seasons prompts all who make baskets to seek out and gather raw materials of reeds, rushes, stalks, horse hair, feathers, grass, or bark. Vine and wood splint, hammered and peeled from green logs, are stripped, shaped, bundled, soaked, and set aside in preparation for long winter hours spent shaping and ornamenting baskets. These are the rhythms that basket makers have followed for centuries.

Making containers to hold things or assist in a work process is but one aspect of basket making. Another is the sheer joy of exploring possibilities open to those who understand how fiber, color, and structure matter. As in all the arts, creative basket makers seek elegance and eloquence in their works. American Indians of the Micmac nation have made porcupine quillwork baskets of dazzling patterns and complexity woven onto birch bark foundations. None of this is actually "useful" in a functional sense of the word. The "use" is a search for refinement or satisfaction like that which the Navajo calls "the beauty way." Members of the Cherokee Nation are masters of the wooden splint baskets that, by their shapes, are instantly recognizable. And even the most utilitarian splint baskets made by Algonquins are brightly patterned with checkerboard colors and

RIGHT

**LISSA HUNTER, *THE PRICE OF BEAUTY*, 2001, BASKETRY AND MIXED MEXIA, 24 x 26 x 4 INCHES.**

The artist explains the concept behind her work by relating this legend of the discovery of silk: "While an Asian empress was seated under a mulberry tree, drinking hot tea, she looked into her cup to see a shimmering, white cocoon which had fallen from the tree floating in the hot beverage. When she reached in to pluck it out, she managed to grasp only the end of the single fiber that winds 'round and 'round to create the cocoon. The moist heat of the tea released the fiber from its sticky substance and the empress reeled off the finest thread she had ever seen.

"Silk, the fiber of emperors and kings, comes from the cocoon of a caterpillar that eats nothing but mulberry leaves. Of course, in the process of producing the beautiful silk thread, mulberry trees are stripped of their leaves, threatening their very lives. The price of beauty can be high."

potato-printed images where the splints intersect. Pomo Indian seed baskets are so tightly twined that no seeds slip through. For ornament, feathers and shells add to an extraordinary sense of design.

Billie Ruth Sudduth is a first-generation basket maker living in the mountains of North Carolina who came to the craft after a "first life" dealing with testing, measurements, and statistics as a school psychologist. That was how she came across the thirteenth-century mathematician Leonardo Fibonacci, who discovered common proportions in spirals throughout nature, whether in seashells like the nautilus, flower petals, or pine cones. (For those not familiar with the sequence, Fibonacci numbers work like this: After two starting values, for example 0 and 1, each number is the sum of the two preceding numbers: 0, 1, 1, 2, 3, 5, 8, 13, 21, 34, 55, 89, 144, 233, 377, 610, 987, 1,597, 2,584, 4,181, 6,765, 10,946, 17,711. . . .)

Drawn to the perfect proportions of Fibonacci numbers, Billie Ruth started creating baskets possessing a rhythmic, naturally flowing design, and released the creativity present in her all along.

Craft artists, like all creative people, typically call on a database of latent experiences, no matter how varied or seemingly insignificant they might be, to be drawn on at some later date. Billie Ruth is currently incorporating chaos theory and fractals into her weaving.

Grand ideas blossom. The stars align in some kind of harmonic convergence. Proof again that we need to be awake to hear opportunity knocking, recognize it for what it is,

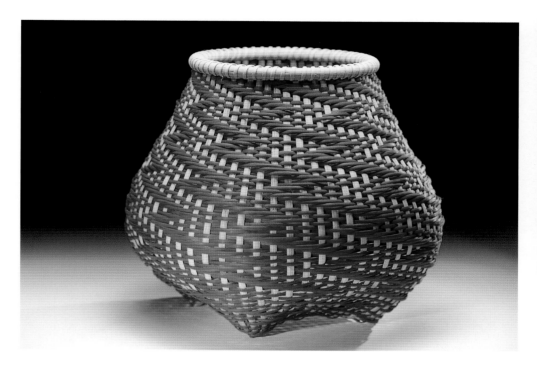

and to not only cope with the change that creativity brings but make the most of its vicissitudes.

Now, in the twenty-first century, basket makers explore the use of an infinite variety of flexible materials from around the world—some natural, some synthetic, and some never before considered in the search to make more expressive structures and capture expressive meanings.

# FROM BURL TO BOWL: THE ART OF TURNED WOOD

★

Turners often say that ancient Egyptians invented the lathe, but there is no evidence to confirm it. The lathe more likely was invented by the ancient Greeks, whose civilization valued human time and energy. A labor- and time-saving tool, it allows material to be quickly shaped into circular forms on a rotating spindle with a sharp cutting blade rather than being rasped round like a stick held by hand. Whoever invented it, turning was a craft long known to those who came to the New World. Some of the first chairs preserved from the Plymouth settlement era are elaborately turned.

The lathe emerged as the creative tool of choice for the studio artists at mid-twentieth century who chose wood as their medium of expression. Paralleling the developments that occurred in ceramics after World War II, wood turning was advanced by a

ABOVE LEFT
**BILLIE RUTH SUDDUTH,**
*FIBONNACI RISING,*
**WALNUT/RED, 2005.**

ABOVE
**JANE SAUER,** *KNOT MAGIC,*
**1991, KNOTTING, WAXED**
**LINEN, AND LINEN,**
**27 x 6 x 4 INCHES.**
Sauer uses the knotted basket to express the power and significance of the practice of knotting, a craft held sacred and believed to be magical by many cultures. Encircling the basket are phrases she has knotted, or woven, that describe various cultural practices and beliefs.

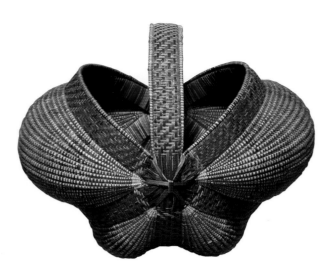

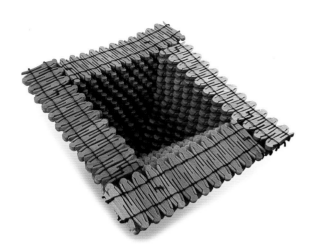

**TREVLE HALEY WOOD,**
*BUTTERFLY BASKET,* **WHITE**
**OAK, 1999.**

In this split oak basket the artist
uses white oak, a traditional
Appalachian material, to create
a basket form that is both
unique in shape and colorful in
its design scheme. Wood's
mastery of basket-making
techniques is evident in the
complex curves and patterns
employed to achieve this
"butterfly" silhouette.

ABOVE RIGHT

**KARYL SISSON,** *BLONDIE (#2*
*OF 4),* **1992, CLOTHESPINS**
**AND WIRE.**

Part of the new generation of
basket makers, Sisson looks to
new materials and forming
methods to make a contempo-
rary statement. Her baskets
present clever plays on tradi-
tion, as Sisson's "weaves"
miniature wood clothespins
and wire to create a basket
construction, displaying an
imaginative use of materials
and techniques.

core group who explored the visual vocabularies of the vessel form and forged new
ground in the medium.

Both Bob Stocksdale of Berkeley, California, and Rude Osolnik of Berea, Kentucky,
were turning wood well before the new studio movement hit its stride in the 1960s.
During World War II, Stocksdale was incarcerated as a conscientious objector. With
both time and access to a lathe at the internment camp, he made bowls, sharpening
his technique and becoming increasingly enamored of the art. In 1946, he moved to
Berkeley, where he and his wife, fiber artist Kay Sekimachi (see pages 255 and 258), set up
studios in their home.

Stocksdale quickly garnered recognition for the purity and clarity of his designs, and
for his use of exotic and richly figured woods that he expertly turned to emphasize the
natural beauty of its graining pattern.

Osolnik acquired his wood-turning skills while majoring in industrial arts at Bradley
University, Peoria, Illinois. Unlike many of the first-generation turners whose quest was
to select the most beautiful piece of wood, Osolnik searched out flawed wood, embracing
its natural defects. By using found or scrap wood—rejected by other turners due to its
imperfections—Osolnik could exploit their inherent organic qualities, such as cracks,
voids, and bark inclusions, creating intriguing, biomorphic, and abstract forms previously
unseen. Possessing the mastery skills of a production turner, Osolnik also produced a line
of highly refined utilitarian pieces, of which his candlesticks are the best known.

Ed Moulthrop, like Stocksdale, was a master of discovering what each tree had
embedded in its trunk. Moulthrop turned his wood bowls in simple shapes with complex
patterns, believing that it was the craftsman's task to reveal the natural beauty of the
grain hidden in the wood. Moulthrop kept secret a special stand of maple trees, the wood
of which were spalted or stained a brilliant red with growth of fungi. He harvested this
distinctive wood for special large-scale turnings, "painting" his monumental vessels with
abstract patterns. His son, Philip, being a key figure in the "new wave" in turning, has

# LOEBER + LOOK: BACK TO THE FUTURE

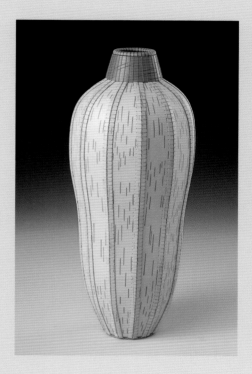

I N the Wisconsin wilds, well north of the million-dollar weekend getaways of Door County, is the "Northwoods," home to husband-and-wife craft artists Ken Loeber and Dona Look and stands of birch, cedar, and basswood.

Which works out well, because Dona is a basket maker (as well as a jeweler with Ken) and draws on the fallen trees that appear from under snowdrifts every spring, continuing a centuries-old American Indian tradition. Her baskets aren't the kind one might use for feeding animals or carrying laundry. They're as light as gossamer, referencing classic pottery and nature. Her tools couldn't be simpler: needle, thread, scissors, and a knife. "We would make button holes on our clothing by hand, as a child," Dona remembers. "And I still use that stitch today sewing pieces of bark. One of my grandmothers crocheted even when she was blind; she could feel the thread and knew exactly what she was doing by touch."

Over the years Dona has been making baskets from bark that Ken has helped harvest. They also collaborated on fine silver and gold jewelry in geometric and organic shapes, but all that changed several years ago, when Ken suffered a stroke that left his right side paralyzed and made speech difficult. It was an event that challenged their creativity and communication—and tested the adage "Necessity is the mother of invention."

Before the stroke, Ken's career as a jeweler was as accomplished and successful as Dona's, including an NEA grant and the artistic excellence award from the American Craft Council. His jewelry evolved from his training as a sculptor; his necklaces and brooches turn sculptural forms into small, wearable objects noted for their light weight and comfort while worn.

Ken has since learned to adapt to working with one hand. Still brimming with creativity and imagination, he constructs and solders his fine metal forms using jigs and clamps he's specially devised.

ABOVE LEFT Dona Look, *Basket #2000–1,* 2000, white birch and silk thread.

ABOVE RIGHT Ken Loeber, *Rose Brooch,* 2006, sterling silver and 18-karat gold, forged and fabricated.

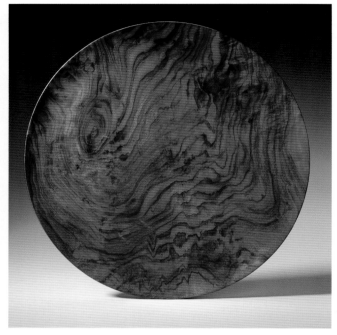

been instrumental in charting different courses. His innovative "mosaic" technique—suspending wood segments in a resin base—produces highly patterned surfaces never before possible. Such innovations have advanced the wood-turning field by adding complexity and extending the visual vocabulary.

Mark Lindquist is the son of an established wood turner—Mel Lindquist—and his works are much admired for their classicism. In the early 1970s, Lindquist made a quantum leap, through the study of Japanese art, particularly ceramic forms, in the art of turning. The younger Lindquist's use of a chain saw and lathe together for shaping wood ruptured the quiet sensuousness of traditional turning, producing roughly marked and abstracted shapes that were daringly direct and bold. This marked a stunning departure in the discipline, liberating wood turners from the tyranny of the lathe and the smoothly turned and symmetrical works it produced.

David Ellsworth also revolutionized the craft by creating a series of "bent" tools that make it possible to produce thin-walled hollow forms, like those thrown on the potter's wheel. Trained as a sculptor, Ellsworth's previous experience with clay led him to "consider the intimate power of the vessel form," and started him on a search for the essential mysteries to be discovered on interiors unseen, a process he refers to as "blind turning."[1] Such investigations and innovations of technique, of material, and of concept—the channeling of ideas through the medium—have laid the foundation of the studio wood-turning movement on which future craftspeople will build and broaden.

ABOVE LEFT
**FRANK E. CUMMINGS III,**
*CAROUSEL-AGE OF*
*AWARENESS,* 1995.
Part of his "Jeweled Fantasy in Wood Collection," this is one of the largest and most complex turned and carved vessels the artist has ever created. A master craftsman accomplished in the arts of jewelry, wood sculpture, and furniture, Cummings creates each artwork to communicate and confront.

ABOVE RIGHT
**BOB STOCKSDALE,** *TRAY,* 1970,
**BLACK WALNUT.**

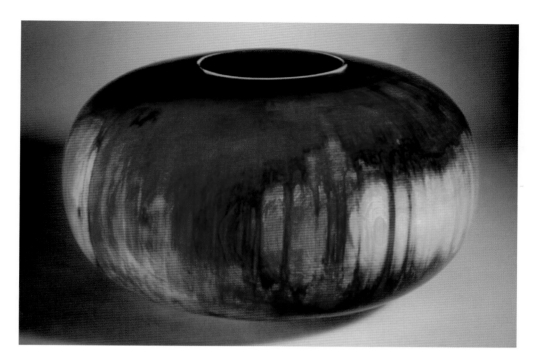

**ED MOULTHROP SUPER-ELLIPSOID, 1978, TULIPWOOD.**

**PHILIP C. MOULTHROP,**
**_MOSAIC BOWL,_ 1994, WHITE**
**PINE CROSS SECTIONS,**
**EPOXY, AND SAWDUST.**
Philip, like his father, Ed, works
in turning classic shapes, but
explores new, individualistic
directions in surface decoration.
One such exploration has
resulted in the "mosaic" vessels,
a series of bowls featuring an
inventive layering technique
that creates striking graphic
effects.

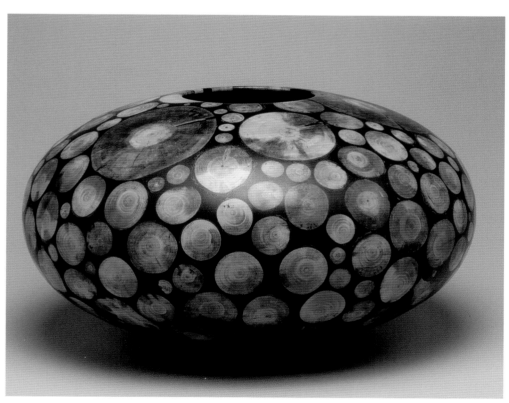

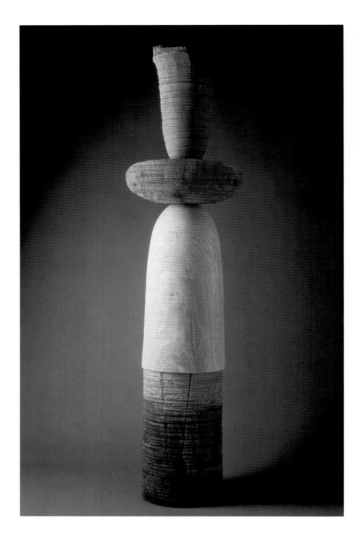

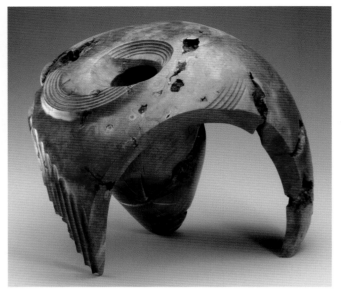

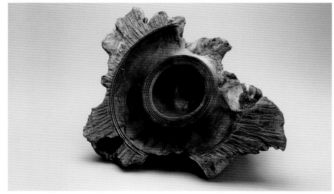

TOP LEFT
MARK LINDQUIST, *SILENT WIT-NESS #1, OPPENHEIMER,* 1983, WALNUT, PECAN, AND ELM.

TOP RIGHT
STONEY LAMAR, *FIREBIRD,* FROM THE "DANCE AND MOVEMENT" SERIES, 1989, CHERRY BURL.

MIDDLE
ROBYN HORN, *NATURAL EDGE GEODE,* 1988, REDWOOD BURL.

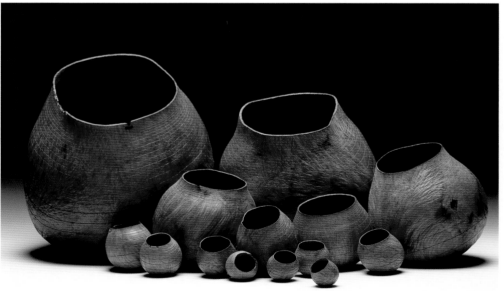

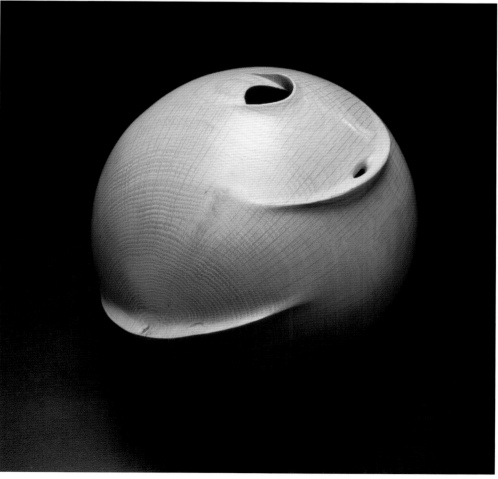

OPPOSITE, BOTTOM
**CHRISTIAN BURCHARD,**
*BASKETS,* **2004.**
Burchard turns thin-walled vessels from wood burls while the wood is still green (wet), causing them to crinkle and warp as they dry, with each vessel warping differently depending on its size. Arranged in groupings, these vessels make a dynamic composition of animated forms frozen in motion.

ABOVE LEFT
**MICHELLE HOLZAPFEL,**
*CUSHIONED BOWL,* **1998,**
**FIDDLEBACK SUGAR MAPLE.**
Turning is the beginning or the "canvas" on which Holzapfel carves fantastic imagery. She sees the vessel form as "capable of shifting its shape while brimming with meanings. It contains narratives, allusions, and characters. The tension between idea and material, mind and body is our human inheritance. The act of making things is a reconciliation of passion and reason, harnessing them in tanden for the process of creation."

LEFT
**DAVID ELLSWORTH,** *MO'S*
*DELIGHT,* **1993.**

# WHARTON ESHERICK, FOUNDING FATHER OF STUDIO FURNITURE

"**W**HARTON Esherick's designs were too personal to establish a style," notes Mansfield Bascom, curator of the Wharton Esherick Museum, "and he wouldn't have wanted that anyway." But he pioneered the way for future generations of artists working in wood to create and market their own, original designs.

Esherick trained as a painter at the Pennsylvania Academy of the Fine Arts from 1908 to 1910. In 1922, he was asked to illustrate *Rhymes of Early Jungle Folk,* a children's book on evolution, a hot topic at the time. With one hundred woodcuts, seventy of which were published, a printmaking career was launched. He began carving organic designs on antique furniture and then making furniture, primarily his unique trestle tables.

In 1940, architect George Howe created a room for the New York World's Fair "America at Home" pavilion, filling the space with works from Esherick's studio. His *Pennsylvania Hillhouse* included the spiral stair, sweeping sofa, leather easy chair, and a new table with five unequal sides, sinuous hickory legs, and a black phenol top (a material intended for large electrical switchboards) with a narrow hickory border. Esherick's exposure should have brought him many commissions, but The World of Tomorrow, as the fair was named, turned out to be World War II, and the public faced issues other than art furniture.

Esherick's 1951 music stand drew attention, but he was never able to find someone who could make it at a price affordable to musicians. He died with a dozen music stands in his shop. Today they fetch high prices at auctions, and an example is part of the permanent collection of the Metropolitan Museum of Art.

After the war he developed a growing clientele who found his work addictive, returning year after year to commission yet another piece. Several began with a chair or a

stool, and ended with entire houses of custom-designed furniture and furnishings.

Through the 1960s, he was busy with commissions for dining tables and sideboards, coffee tables, sofas, desks, cabinets and curvilinear kitchens, salad bowls and servers, trays and cutting boards, and he died with a backlog of work. The most innovative piece in this period was the 1962 spiral library ladder, considered to be one of the finest American furniture designs. His work was featured at the Museum of

Contemporary Crafts with a forty-year retrospective in 1958. His was the only furniture included in the Brooklyn Museum's 1961 *Masters of Contemporary Craft.* When the Smithsonian Institution opened its Renwick Gallery in 1971, a year after his death, Esherick's work occupied the center of the gallery and was surrounded by work of the "second generation"—Wendell Castle, Sam Maloof, Arthur Espenet Carpenter, and George Nakashima.

Carpenter's pieces featured fluid, sculptural profiles that curved through space. The characteristic softened edges and rounded curvaceous forms of his furniture later became known as California Roundover.

Wendell Castle began to make his furniture in 1958 and emphasized his work as sculpture expressed in wood and other materials. Castle has continually challenged convention, experimenting with new techologies and modes of construction, moving freely between styles—from Art Deco to the colorful, playful, and animated forms influenced by vanguard Italian designers.

Esherick considered each commission a challenge for his imagination, working with clients, listening to their descriptions of their needs, and sharing his insights. But he made no drawings and few sketches because he frequently changed his mind as a design developed, and any sketch would involve explanations. Bascom adds, "His customers were always delighted with what they received, although it may have been much different from what they had expected and the price a shock. His work reflected his joy of life, great sense of humor, friendly wit, warm personality, and love for wood."

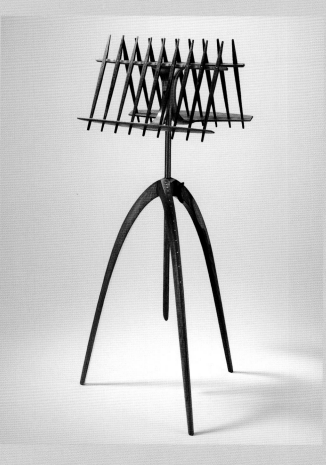

---

**OPPOSITE, RIGHT Esherick's Spiral staircase in his home. Curves and spirals embodied change, according to Esherick, as seen in his spiral staircase.**

**OPPOSITE, LEFT The Esherick Complex.**
Furniture makers from around the world make a pilgrimage to the Esherick compound every year. "An ax was his favorite carving tool," says Paul Eisenhauer, the director of programs at the Wharton Esherick Museum. "The wood told him what to do."

**TOP, RIGHT Esherick's Table and Chairs.**

**BOTTOM, RIGHT Arthur Espenet Carpenter, Music Stand.**

ABOVE
**RUDE OSOLNIK,** *CANDLESTICK SET,* **C. 1952, WALNUT.**

RIGHT
**WILLIAM HUNTER,** *KINETIC GARDEN, 2005,* **COCOBOLO.**
Hunter explores the theme of spirals with his carved turnings of abstracted exotic woods, using the turner's art in a search for pure form, line and space.

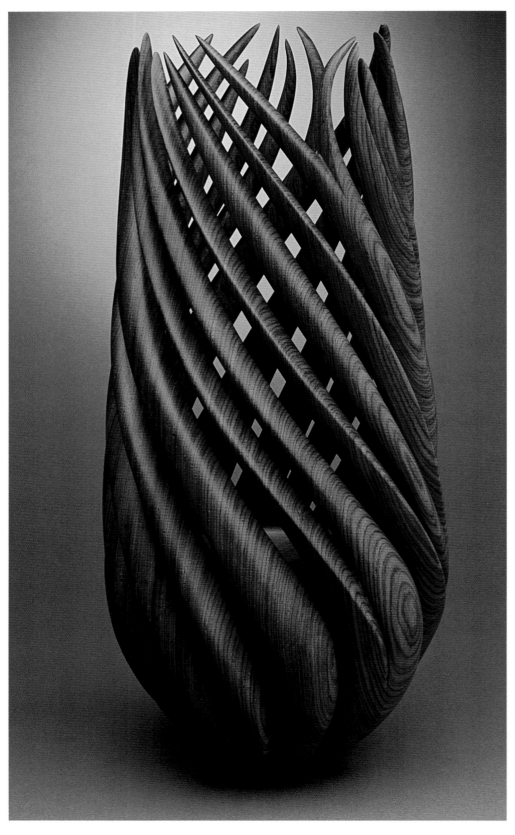

# FEEDING THE FIRE:
## BLACKSMITHING AND FORGED METAL

★

Watching the great physical effort of the blacksmith at the forge and bellows is a memorable experience of rhythms and sounds. With anvil, hammer, and tongs the blacksmith is emblematic of strength and communal usefulness.

C. Carl Jennings was the senior member of the blacksmithing/forged-metal arts community. He lived in Sonoma, California, having moved there from the Midwest with his blacksmith father and grandfather. While he continued a generational craft tradition, he was in the first graduating class at the California College of Arts and Crafts in Oakland. His 1971 forged metal *Gate* consists of lively asymmetrical rectangles hovering in space like the fantasy-constellation compositions of the Spanish painter Joan Miró.

Albert Paley was an MFA jewelry major from the Tyler School of Art in Philadelphia. There he learned to forge metals, at first on a small scale, for jewelry. He also produced skilled, sensitive, preparatory drawings for his work, and has continued this process throughout his career. In 1972, Paley won a competition to make iron gates for the newly renovated Renwick Gallery of the Smithsonian in Washington, D.C. *Portal Gates* features sensuous, curving lines that depict stylized scrolling vines, a prime example of how Paley

BELOW LEFT
TOM JOYCE, RIO GRANDE GATES, INSTALLED AT THE ALBUQUERQUE MUSEUM OF ART, 1997, FORGED IRON AND SALVAGED MATERIALS.

BELOW RIGHT
ALBERT PALEY, *PORTAL GATES,* COMMISSIONED FOR THE RENWICK GALLERY, 1974, FORGED STEEL, BRASS, COPPER, AND BRONZE.

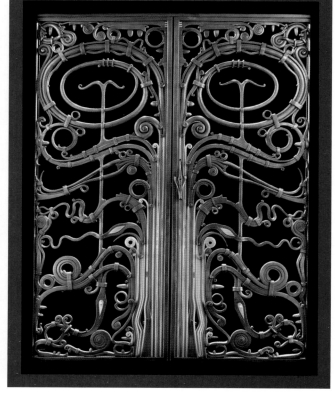

RIGHT
**ALBERT PALEY,** *DRAWING OF PORTAL GATES FOR ST. LOUIS ZOO,* **AND ALBERT PALEY,** *PORTAL GATES OF ST. LOUIS ZOO, ANIMALS ALWAYS,* **INSTALLED, 2006.**

BELOW RIGHT
**C. CARL JENNINGS,** *GATE,* **1971, FORGED AND FABRICATED METAL.**

uses organic design. Paley has become an accomplished master in curvilinear metalworking with designs that are scaled for both domestic and grand architectural environments. His many designs for furniture and lamps demonstrate his agility in coaxing metal into fluid, functional forms suitable for the home. And his more than fifty site-specific works completed over the last thirty years, some of which are monumental, prove him to be an artist of unparalleled range, skill, and vision — the perfect alchemical formula for transforming base metal into masterworks.

In 2003, at age forty-six, blacksmith/craftsman/artist Tom Joyce was awarded a MacArthur Fellowship in recognition of his achievements and to encourage future work. Joyce learned blacksmithing through an apprenticeship in his teens with Peter Wells in El Rito, New Mexico. By age sixteen, he was discovering the magic of reforming found and salvaged metals with fire, anvil, and hammer. He established his own shop in Santa Fe in 1977. His works range widely from functional architectural ironwork, lighting, and vessels to cast and forged iron sculptures that use residual materials left over from industrial manufacturing processes. Throughout his work, Joyce illuminates meaningful inherited history found in materials that have had a prior use. His 1997 *Rio Grande Gates,* installed at the Albuquerque Museum of Art and History, involved community members by having them gather discarded iron refuse from a particularly polluted section of the city's river. The collected materials included oil drums, metal signs, car bodies, fencing, box springs, newspaper dispensers, shopping carts, bicycle parts, and other iron remnants. These objects were heated, folded, and forged into plate-sized billets and fixed onto seventy panels. The panels were riveted together into a patchwork, quiltlike matrix reflecting a selective history of material culture.

BELOW
**DONNA D'AQUINO, *WIRE BRACELET #62*, 1999, STEEL.**

# JEWELRY, THE ART OF PERSONAL ADORNMENT

★

The human body is the gallery or canvas on which jewelry is best displayed and experienced.

Personal adornment can be witnessed on images of humans from prehistoric times, expressed in amazingly diverse ways throughout all cultures across the world.

In the continental United States, there is ample evidence from archaeological sites that well before contact with Europeans, early natives of this country adorned themselves with articulated shells, stones, feathers, headdresses, armbands, breastplates, masks, and bracelets. Other ways of transforming appearance sometimes also included body alterations such as head binding, tooth shaping, or tattooing to "improve" looks or to signal status.

All ornament—whether necklaces, earrings, chin labrets, nose rings, or paint—was part of a personal ensemble that usually included highly articulated clothing of skin and

**CHRISTINA SMITH,** *IN SEARCH OF TERRA INCOGNITO,* 2002, STERLING SILVER.

Smith, a master silversmith and jeweler, uses the tea service as a platform to launch her narratives, personal stories that often center on the domestic sphere and address issues of gender identity. For the artist, the form of the sterling tea service references memories of the women in her life—her mother and grandmother—and the family lore and traditions that were passed down to her over cups of tea. According to Smith, *In Search of Terra Incognito* (In Search of the Unknown Land) is about "finding my place while navigating the foggy landscape of a deteriorating long-term relationship. It is about relying on the traditions of your family and how that can bolster your strength to go in search of the new and the unknown."

**STANLEY LECHTZIN,** *TORQUE 20F,* 1985, ELECTROFORMED SILVER, GILT, PEARLS, AND QUARTZ.

hide, wraps, leggings, foot gear, sashes, belts, hair displays, collars, and hats or head coverings. The modern sense of "costume jewelry" or "commercial jewelry" was unknown to this culture.

Contact with Europeans brought beads, trade cloth, and iron and other metals, as well as forming techniques. Natives were quick to adapt and adopt, and soon became some of the best gunsmiths in the New World. To enhance personal ornamentation, they quickly added on glass trade beads, silver jingles, and cast-and-hammered silver, demonstrating excellent workmanship. To this day skilled American Indian masters from the Navajo, Zuni, Hopi, and Santo Domingo settlements in the Southwest practice jewelry making at an expressively high level. (See Chapter 3: Native Communities—Indigenous Crafts by American Indians.)

The use of jewelry among Colonial settlers can be documented as well, in early portraits showing young children with necklaces of coral beads. Among adult women, more elaborate versions set with garnets, strands of pearl and pearl earrings, and paste or precious gemstones were worn. Miniature portrait paintings, worn as necklaces and bracelets, were highly favored. And both men and women received funeral rings to remember and mourn the deceased from the first settlements in the seventeenth century through the Victorian period.

Such rings and other personal ornaments—stick pins, cuff links, shoe buckles, snuff boxes, chains and fobs, and earrings—were most often made by Colonial silversmiths as part of their normal work. This changed in the nineteenth century with a proliferation of specialized products and labor among manufacturers both in America and abroad.

With it also came the elimination of the traditional dialogue between customer and craftsman. Now, the customer was no longer participatory but merely dependent upon availability of jewelry through commercial manufacturers, catalogs, and sales shops. Indeed, for most Americans today, this is their only connection with jewelry.

# WEATHERVANES: RIDERS OF THE WIND

**W**EATHERVANES have long been a part of the American landscape, sitting atop steeples and cupolas on churches, public buildings, and private homes.

The precursors of weathervanes were the pennants that knights carried during the Middle Ages; the flags bearing their patron's crest or coat of arms were carried into battle and flown atop their castle turrets. Soon metal banners replaced cloth ones.

Richard Miller, former curator of the Abby Aldrich Rockefeller Folk Art Museum, writes of them as community markers, landmarks in their own way:

*Whether depicting barnyard animals in agricultural areas; fish, whales and ships in coastal communities; angels on church steeples; writing quills on libraries and schools; locomotives, automobiles or airplanes; weathervane subjects often mirrored shared values, the foundation of a local economy or acknowledged the novelty of technological developments.*

In 2006, the weathervane, long a practical tool for farmers and fishermen, was recognized for its collectible as well as artistic value. In succeeding auctions seven months apart, two extraordinary examples sold for record prices. In January, a classic mid-nineteenth-century Goddess of Liberty design set a new record of $1 million. In August, a 61-inch-long, three-dimensional locomotive design dating to 1882, which had stood atop the Woonsocket, Rhode Island, train station, broke that record with a price of $1.2 million.

**ABOVE** William Henis, gilt-molded copper painted and sheet-iron "Goddess Liberty Weathervane," Philadelphia, mid-nineteenth century.
This primitive, stocking-capped interpretation of Liberty established the vane as a sought-after American craft object.

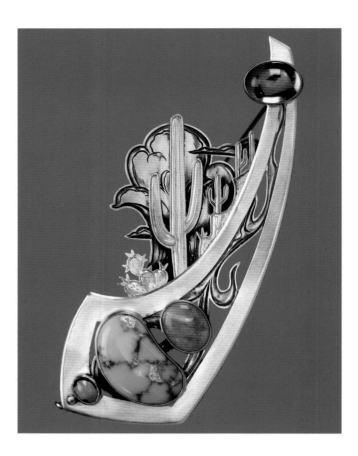

ABOVE

KIT CARSON, *CACTUS CAMP*, 2006.

Craft-jewelry artists follow a serious pursuit of original aesthetic expression, employing new materials and techniques to press forward expressive horizons in the art of human body adornment. Sometimes that involves precious materials and stones; sometimes, not. Sometimes the jewelry is comfortable; sometimes it is barely wearable—or is so challenging to wear that, like medieval armor, the work usually remains unworn and is used as a display object. But this is no shortcoming. Some of the most extraordinary objects ever made and worn by mankind are, by nature, ceremonial, symbolic, or sacred—seen on the body only at special occasions.

The year 1946 marks the beginning of a new era of jewelry making. Starting with an exhibition at New York's Museum of Modern Art, *Modern Jewelry Design* featured artists from the crafts community including Adda Husted-Anderson, Paul Lobel, and Margaret De Patta. Lobel had a studio-shop in Greenwich Village where he sold works constructed of flat sterling sheets without stones. Margaret De Patta produced brooches that drew inspiration from patterns of abstract painters and sculptors—not unlike that found in works by Alexander Calder. Calder's own imaginative jewelry was also featured in this exhibition, as was the work of the American sculptor Jacques Lipschitz. The exhibition set a new course for defining jewelry making. The weaver Anni Albers, together with her student Alex Reed, exceeded all convention with a necklace constructed of paper clips and a sink drain.[2]

Even while the exhibit transformed definitions for new jewelry, there were many important jewelry innovators working in California, unencumbered by rules. These included Merry Renk, Irena Brynner, Peter Macchiarini, Milton Cavagnaro, and Margaret De Patta—all members of the Metal Arts Guild of Northern California, founded in 1951.

In 1968, several important jewelers in the studio craft movement met in Chicago and formed an American guild of contemporary jewelers and metalsmiths, later called the Society of North American Goldsmiths (SNAG). Two years later, this organization mounted the first international conference in St. Paul, Minnesota, featuring an exhibition called *Goldsmith '70*. The organization has been a strong advocate for the field ever since.

One of today's most innovative artists is Stanley Lechtzin. After studying advanced studio work at Cranbrook Academy of Art, he developed an interest in ferrous metals and stainless steel and accepted a teaching position at Philadelphia's Tyler School of Art.

Within five years he began its graduate program in metals, a program that continues

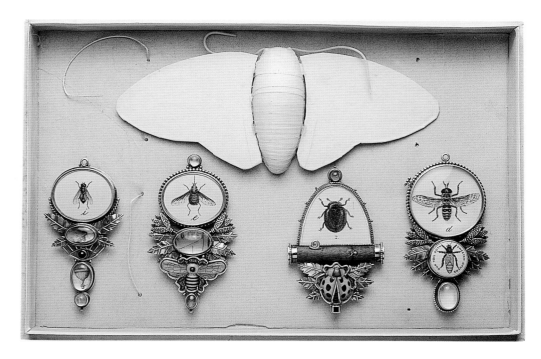

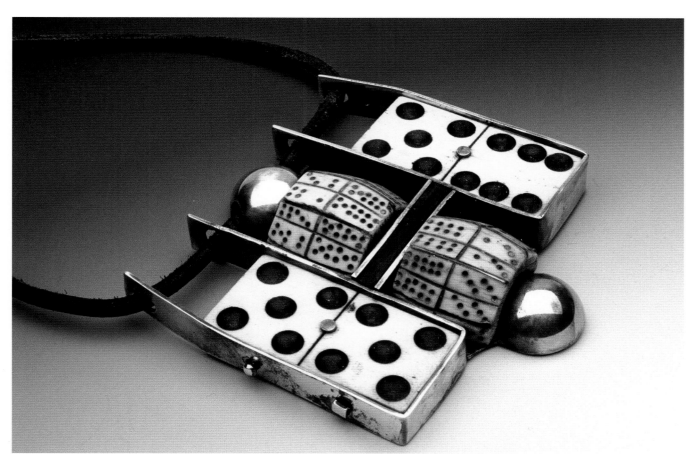

# CROWNING GLORY: CONTEMPORARY TIARAS AND CROWNS

**B**EFITTINGLY, tiaras and crowns sit a "head above" all other forms of jewelry in their close association with royalty, romance, wealth, and high style. The tiara owes its majestic ancestry to ancient Persia where the word was used to describe the bejeweled head ornaments worn by Persian kings, whereas the gold crown, fashioned in the shape of a floral wreath called a diadem, claims Greek heritage. The legend, as relayed through Greek mythology, is that the diadem was conceived by Dionysus, god of wine and revelry; as such, it is an emblem of god-ness, and denotes high rank, power, and position. Perhaps it is from this ancient connotation that the current practice of crowning athletes and beauty contestants derives.

Modern cultures have adapted the diadem into a wedding crown, a foliate wreath, says Geoffrey Munn, author of *Tiaras Past and Present,* "made of leaves and flowers representing the crown of love"—and it has become part of the bridal trousseau. Artist Merry Renk's wedding crown, *James Love Peacock,* with its opals set in gold wire, was made and used for that very purpose.

Some of the distinguishing characteristics of art jewelry are its exploration of visual culture and its expression of personal identity. Tiaras and crowns, invested with historical and cultural significance, prove to be a perfect subject for the contemporary jeweler searching for a grand statement.

Philadelphia jeweler Jan Yager has become a specialist in tiaras that convey both beauty and meaning. *American Tiara: Invasive Species* was included in the exhibition *Tiaras, Past and Present* at London's Victoria & Albert Museum in 2002. In this work, the artist fabricated non-native wildflowers and weeds from gold and silver, impressing into many of the leaves tire-tread patterns, what Yager called "a kind of modern geometry."

Believing in jewelry's "unique power to speak to people," Yager exploited the tiara format to talk about nature's resiliency in spite of urban encroachment—witnessed in the survival of the invasive plants, thereby eloquently framing the struggle of man versus nature.

Today the tiara's royal use has faded as monarchs and consorts throughout the world opt for modern dress.

Nevertheless, the tiara, diadem, and crown in their many incarnations still have a wondrous meaning, imparting to the wearer a sense of empowerment and privilege.

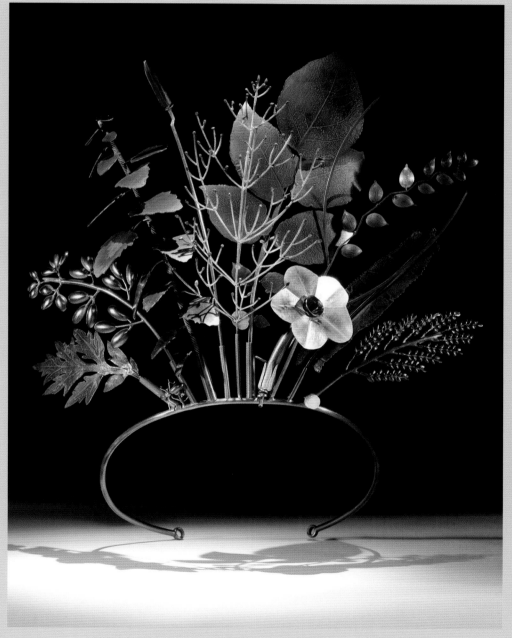

OPPOSITE, TOP Allan Adler, Crowns Commissioned for the Miss Universe and Miss United States of America Pageants, 1953, silver and gold.

OPPOSITE, MIDDLE Merry Renk, *James Love Peacock,* 1981, 14-Karat gold wire and opals.

OPPOSITE, BOTTOM Valerie Mitchell, *Tiara for a Walk on Fourth Street Bridge,* 2005, oxidized sterling silver, pearls, and three tube vessels to hold twigs/flowers.

LEFT Jan Yager, *Tiara of Useful Knowledge,* 2006, gold and silver; views of the tiara assembled and disassembled. The artist was challenged by historical examples of tiaras that are designed with individual pieces of jewelry that can be disassembled from the circlet and worn individually. Yager's tiara is comprised of ten such pieces and is a tour de force of concept and workmanship.

Here she portrays several plant species, each one chosen for its symbolic reference to the disruption, and possible restoration, of nature's balance: a potato leaf recalls the Irish Potato Famine of 1845–50; switchgrass suggests a source of cheap, renewable fuel; and the tobacco leaf warns of the addictive qualities of plants and the exploitative economies that develop to promote them.

to encourage daring and experimentation. Lechtzin himself is a restless explorer who combines magnificent natural and mineral materials with industrial plastics to make lightweight and highly wearable jewelry. Since the late 1980s, Lechtzin has become a frontrunner in using digital CAD/CAM technology (Computer Aided Design/Computer Aided Manufacture) for designing his jewelry. The computer has opened channels of design for Lechtzin as well as enabled him to develop and execute ideas rapidly, quickening his pace to pursue and consider the yet unknown.

Across the country, born on an Arizona ranch, Kit Carson accrued his knowledge by attending various workshops with master engravers and jewelers while studying drawing and sculpture. His Arizona studio is known as the Cactus Camp, so it's not surprising to find the cactus motif as a recurring theme. The power of the accelerating curve that produces, as Carson says, "a mellifluous journey of excitement for the viewer's eye" informs Carson's work. Many of his pieces are richly colored, displaying textured surface inlaid with gorgeous stones. With a name like his, it's a given that his elegant jewelry would be drenched with western imagery, like bronco-riding cowboys, covered wagons, and cattle skulls.

While the western landscape inspires the works of Kit Carson, another western master, Nancy Worden, draws upon reflections on social justice and events from her life. Her 1998 necklace, *Armed and Dangerous,* made of silver, gold, semiprecious stones, bullet casings, acrylic, and money, is her personal response to a horrible ordeal involving cult brainwashing, kidnapping, and victimization of a child. The necklace is Worden's "commentary on how the Christian church has frequently been used as a cover for an agenda of hate and greed."

Such a message is not exactly an expected inspiration for jewelry. Yet social commentary has long been a part of personal adornment. Personal statements in jewelry are often more important than dazzling ornament. This necklace explores how jewelry can function as a highly individualistic record of memories charged with emotions.

Images of a softer, more delicate kind are found in the jewelry made by the husband-and-wife team of David and Roberta Williamson. Working together in Berea, Ohio, Victorian-era illustrations of birds, butterflies, and portraits, set in silver, gold, and bronze, become contemporary cameos that would have looked just as appropriate a century ago.

What makes their work so real (not faux "authentic" or merely "nostalgic") is that a little of their own lives goes into every one of these talismans, combinations of found objects and ephemera, much of which has been passed down in their own families.

Few things give David and Roberta such inordinate pleasure as hearing their customers' own stories about how the pieces remind them of "those special things we remember about our parents, our families, and our friends that we carry with us—safe and secure until that moment the memory comes alive" through them.

The "found object" so characteristic of the Williamsons' work also plays a large part in the jewelry of the Pacific Northwest, where an entire culture promotes the use of alternative materials, incorporating organic and inorganic materials into their work. Two of the Northwest's most recognizable artists are Ramona Solberg and Kiff Slemmons.

Carolyn K. E. Benesh, coeditor of *Ornament,* has likened Solberg's work to a wearable Joseph Cornell box. With Rube Goldberg–like combinations, she had an uncanny eye for taking the offbeat and unusual—buttons, slide rules, beads, pebbles, and her signature dominoes—and transforming them into bold works of fun, wearable art.

Kiff Slemmons draws on historical, cultural, and literary references while redefining decorative and historical traditions. She frequently approaches her works with the spirit of an assemblage painter, throwing into the mix various elements—handcrafted components combined with manipulated found objects—that illustrate private and oftentimes enigmatic narratives (page 283).

Usually seen and appraised in terms of the worth of its materials, their jewelry features objects that have no inherent value, thus challenging the way we view the whole idea of what society has traditionally viewed as both personal adornment and portable wealth.

## TEXTILE ARTS: THE WEAVER'S TALE

★

The textile arts predate written or historic records. Weaving evolved, on all continents, along with animal domestication and agriculture, by shearing sheep and the like and utilizing the strands of fiber-rich plants such as flax and cotton, and in Asia, silk. Gathering and processing these fibers by traditional means was labor intensive and time consuming,

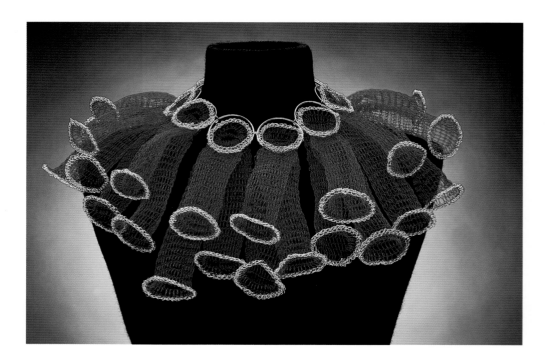

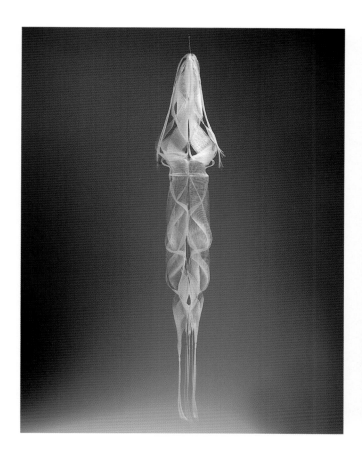

as was, and is, weaving. The back-and-forth action of the shuttle's throw encourages con-templation and an enhanced design. Life and thoughts are physically embedded in the works of the fiber artist. No wonder that the loom and its weavers explore and express human mysteries in parables and metaphors about life.

From the earliest times of settlement in America, trade cloth—a roughly woven woolen fabric, sometimes brightly colored and made in England—was imported to the New World and traded for beaver skins with American Indians who had not known such wondrous stuff as this flexible and comfortable fabric.

Because of the time and effort required in colonial days to process fiber and weave cloth, products of the loom were among the most expensive goods listed in early American-estate inventories.

Considering the high production costs, entrepreneurs soon looked for ways to make textiles in mills and factories using giant mechanized looms. The old arts of weaving never died out, however, and during the studio crafts period of the late twentieth century, they were taken to a new level of artistry by a group of key figures who made a conscious attempt to add to the visual language of the field.

Lenore Tawney traveled to Mexico and then returned to Chicago to study with the sculptor Alexander Archipenko. After some years in Paris, other parts of Europe, and

# ARCTIC EXPRESSIONS: THE STORYTELLING JEWELRY OF DENISE WALLACE

**T**HE jewelry of Denise Wallace can be appreciated as exquisitely crafted objects of art, as a window into the culture of the Arctic people, and as visual stories with the major motif of transformation. Denise is a master storyteller who narrates with silver, gold, fossil ivory, and colored stones rather than words.

Combining their respective expertise in metalwork and lapidary, Denise, a Chugach (Eskimo) Aleut, and her non-Native husband and partner, Sam, create contemporary wearable art. Its complex designs are drawn primarily from Denise's northern Native traditions, symbolism, and stories as well as from their personal experiences.

As with other Native North American cultures, a larger universal order and its reflective iconography link the Eskimo and Aleut cosmos to its regalia and stories, all of the elements blending into an artistic assembly. The Arctic

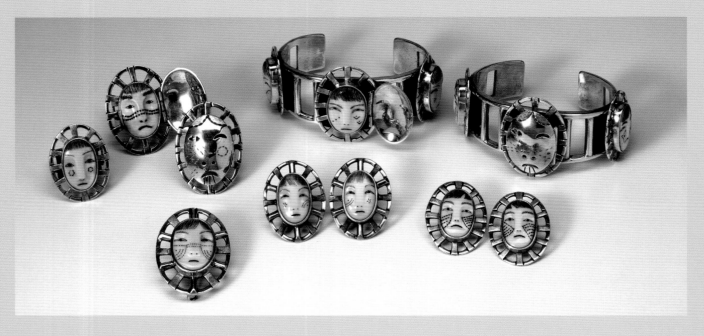

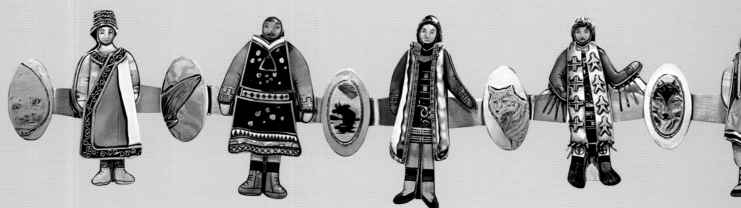

universe is conceived as a web of interconnections between sky and land, natural phenomena and humanity. The cosmos is divided into three layers: sky world, earth world, and underworld, each with its own pantheon of creatures, spirits, and opposing forces. Humanity's role is to identify and mediate between the opposing forces in order to maintain harmony and the balance of life, a concept expressed in stories, ritual, daily life, and the arts.

Lois Dubin, in *Arctic Transformations: The Jewelry of Denise and Samuel Wallace,* points out, "Context, contained in both the physical and spiritual worlds of the Arctic peoples, is very important in the Wallaces' work since it provides a wealth of literal and metaphorical images for their very fertile imaginations." A view shared throughout the Arctic is that all living creatures contain a *yua* ("its double"), which is capable of taking on different forms. Arctic stories refer to a time when humans could transform themselves into animals, and animals into humans, while maintaining their original *yuas,* or spirits. Traditional Arctic clothing and adornment accentuated this ambiguity.

This possibility of transformation is also expressed in the Wallaces' jewelry: Hinged doors open to reveal surprises, stories are contained within stories, faces peek from behind masks, humans and animals transform into one another. Furthermore, the pieces themselves transform from a belt component to a pin or pendant while a small pendant emerges from a larger pendant, and pendants become earrings.

What truly distinguishes Denise and Sam Wallace's art is a sense of life and animation. Their ability to combine comple-mentary motifs within a single object of jewelry creates a dynamism that imbues their work with movement and expression and therefore with life. Evoking the spirit of the finest traditional Arctic carvings, the Wallaces' intimately scaled work communicates a monumental life force.

---

**OPPOSITE, ABOVE** "Woman in the Moon" jewelry of sterling silver and fossil ivory showing the various pieces with opened and closed doors, revealing the carved ivory masks hidden underneath the closed silver doors.

**BELOW** Denise and Samuel Wallace, *Crossroads of Continents Belt,* 1990, sterling silver, fossil ivory, 14-Karat gold, turquoise, chrysoprase, silicated chrysocolla, lapis lazuli, sugilite, coral.
This belt was inspired by the 1990 Smithsonian exhibition, *Crossroads of Continents: Cultures of Siberia and Alaska.* Five of the human figures represent indigenous Siberian people groups (Nanai, Koryak, Even, Yukaghir, and Chuckchi), and five represent Alaskan Native peoples (Alaskan Eskimo, Aleut, Koniag Eskimo, Athapaskan, and Tlingit). Northern wildlife species adorn the ten oval medallions connecting the figures. The *Crossroads of Continents Belt* is the single most important of the sixteen major belts the Wallaces made, a signature of their work. *The Crossroads of Continents Belt* took them about 2,500 hours to complete.

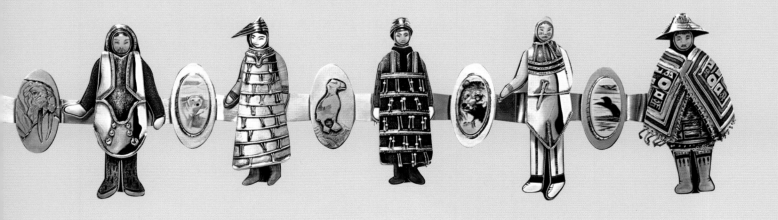

Africa, she returned to the U.S. and began tapestry weaving at Penland. Her 1963 *Fountain of Word and Water* has the solemn appearance of a ritual object with an imposing height of 162 inches. On close inspection several features reference a vertical loom that holds a weaving. The opening split in the center reveals weft fibers hanging, braided and knotted on bars, as if the weaver had left her work to return later in order to add something more. The weaving is left open—even like that of contemporary art and life.[3]

Contrasted to the totemic appearance of Tawney's weaving, the work of Claire Zeisler stands free of any wall attachment, as is evident in *Private Affair II* (1986). An imposing sculptural composition, it consists of an impressive spill of red cotton and rayon, braided, knotted, and wrapped in varied dimensions and techniques to enhance the dynamics of the fabric. Zeisler celebrated the opulence of the fiber, and the sheer beauty of the material dominates the smaller, finely wrought elements of the fall. Like Tawney, Zeisler studied with Archipenko, as well as Lázló Moholy-Nagy, one of the most adventurous sculptors/painters of the period. Her fiber works are informed by African and early Peruvian tribal art, American Indian baskets, and the painters Joan Miró and Pablo Picasso. There are no ambiguities here; like the "movement" of fiber from wall and loom to free-wheeling, freely woven sculpture, it is assertive, confident, and commands (and rewards) attention.[4]

Arline M. Fisch's works, like her *Pink and Silver Circles* (2005), are made for human ornament—as sculptured jewelry, or often as a body covering or piece of clothing, which is, after all, the natural domain of fiber. Fisch incorporates different materials and textile processes: knitting, plaiting, and weaving. The artist manipulates silver wire and other unusual materials like fiber shaping itself to the human body, like a modern-day chainmail: tactile and animated with the body's movement. Drawing from ancient civilizations such as Egyptian, Greek, Etruscan, and Pre-Columbian, she weaves the ideas extracted from past cultures with contemporary concerns to create layers of visual meaning.

Kay Sekimachi of Berkeley, California, pioneered hybrid forms—part structured material, part fluid abstraction. The artist's free-standing *Amiyose V* (1968), woven of monofilament (think fishing line), was a breakthrough work joining existing traditions while simultaneously challenging and overthrowing them. We find netlike structures that remind Sekimachi of jellyfish, and in which others perceive a woman's form. These weavings enclose and define space with quiet grace, leaving ambiguous interior/exterior relationships in ways that recall theater scrims, revealing and obscuring, reflecting and reshaping.

As with many media, today's weavers seek out materials previously unheard of, or considered impossible to work with.

# ART TO WEAR VS. READY-TO-WEAR

★

In discussing the role of the unsung craft artist in European high fashion, Harold Koda, curator of the Metropolitan Museum of Art's costume collection, uses the phrase *les petits mains*—literally, little hands:

> *the fleets of anonymous seamstresses, appliqué experts, and embroiderers whose (now vanished?) skills in applying individual sequins, or ostrich feathers, silk flowers, hand-knotting, or other tiny gew-gaws, enabled celebrated fashion designers such as Chanel, Balenciaga, and Dior to achieve the lavish detail and swoon-inducing effects of their haute couture garments.*

BELOW

ANNA LISA HEDSTROM, COAT, 2005, DIGITALLY PRINTED POLYESTER BASED ON ARASHI DYED FABRIC.

As Janet Abrams, director of the University of Minnesota Design Institute, notes, here craft was "associated with the cumulative efforts of many nameless individuals—craftspeople whose skills buttress hallowed reputations."

Whether it be high fashion or street fashion, craft artists have played an important role. With 1967's Summer of Love in San Francisco's Haight-Ashbury neighborhood, the hippie movement was in full bloom, a counterculture that was at once political, social, and artistic. Thousands of so-called flower children returned home from that particular summer vacation bringing new styles, ideas, attitudes, and behaviors.

Many of today's finest craft practitioners trace their genesis as craft artists to this era. Alumni of communes and cooperatives in remote parts of America, they can often still be found there, experiencing the land a half century later.

As part of the movement, artwear became an important vehicle for craft artists. Macramé, knitting, weaving, and crocheting all came of age. The first incarnation of this movement was the streetwear particularly prevalent in New York City and the San Francisco Bay Area. Clothing styles ranged from mod miniskirts to psychedelia-adorned vintage and ethnic garments. K. Lee Manuel painted leather and suede garments and wove together feather collars that were almost ceremonial in feeling.

Gaza Bowen's shoes featured vibrant colors and unusual patterns using the cultural symbolism of the shoe as a platform from which to lampoon both fashion and issues of feminism, sexuality, and greed. Faith Porter employed 12,700 vintage mother-of-pearl buttons to make a four-piece movable kinetic sculpture that purports to "hold the universal pearl of wisdom, creating order out of chaos." And Janet Lipkin combined a cornucopia of colors, materials, and textures in her apparel in a way that would influence a generation of clothing designers.

Each designer, in her own way, reflected the colorful flamboyance that marked the Bay Area's style. Their common thread: What mattered was the expression of one's inner self, explicitly and honestly. Their fashion was the anticouture, a counter to the clothes

**FAITH PORTER,** *THE CLOUD MAKER,* **1976.**

The artist refers to this piece as a "kinetic sculpture"—an ensemble of headpiece, cloak, pectoral, and boots—because when activated by the spinning movements of the wearer, it "becomes a refractive and reflective mass of light."

OPPOSITE

**JANET LIPKIN,** *UNTITLED,* **C. 1972, MIXED MEDIA OF WOOL, YARNS, AND CERAMIC ORNAMENT.**

This coat was commissioned by artist Garry Knox Bennett for his wife, Sylvia, and to personalize the gift, Lipkin crocheted mementoes given to her by Sylvia into the design.

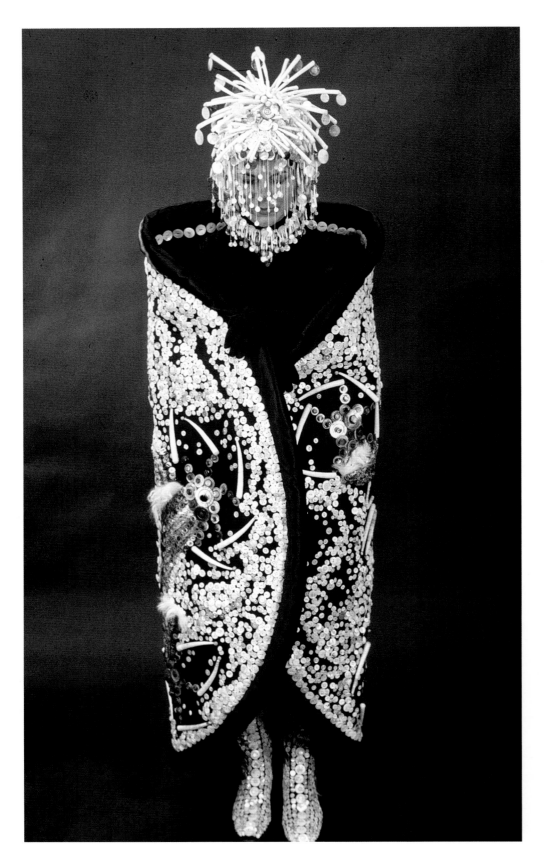

glamorized by the photographs of Richard Avedon and worn by fashion models in *Vogue* (and by Jacqueline Kennedy in the White House).

As the hippie scene faded, Japanese *arashi shibori,* a more sophisticated cousin of Woodstock-era tie-dyeing, changed the face of wearable art forever. By crinkling, twisting, and knotting fabrics before dyeing (also known as resist-dyeing), *shibori* ("storm" in Japanese, because its patterns look so much like driving rain) expanded artistic possibilities. One of its leading practitioners in America is Anna Lisa Hedstrom. On a visit to Japan in 1983, she met that country's last master dyer, Reicchi Suzuki, and collected samples from him. With Suzuki's death in 1989, the production of these textiles — and the formulas he used — died with him. As a result, Hedstrom had to continue the *shibori* tradition by reconstructing the process without any documentation — just her samples. The atmosphere of experimentation and discovery integral to the entire textile arts explosion suited her well, and she started using silks, instead of the traditional kimono cotton, and employed stitching techniques generally used only in shaping and trimming garments. This was followed by other inventive techniques, including laminating and airbrushing her materials.

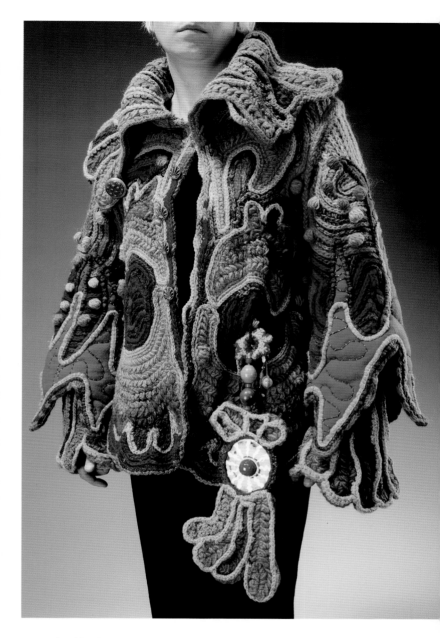

As an example of craft's spirit of renewal, Hedstrom relishes the fact that *shibori,* given up for dead in Japan, was appropriated and reinvented by American artists, giving it an imaginative future.

Even though a reaction to couture, artwear, despite its own studied look and feel, at first still smelled of fashion. What was missing was a vibrant independence — something that would finally take hold in the 1980s and 1990s. Today, a unity of art, design, and craft are invested in a single garment. One article of clothing may take weeks or even months to complete. The best pieces crackle with an unbridled energy, excitement, and passion that make the observer stop — and even gasp. The head, the heart, the hand, and the eye are overwhelmed by the visual and tactile.

Contributing to this is the fact that a vast majority of today's craft artists are university trained and have added theory and conceptualization to their work. As a result, artwear created today carries with it not only a sense of beauty and style, but more often than not, a sense of purpose. It is art coupled with ideas. And the work succeeds on so many levels because of it.

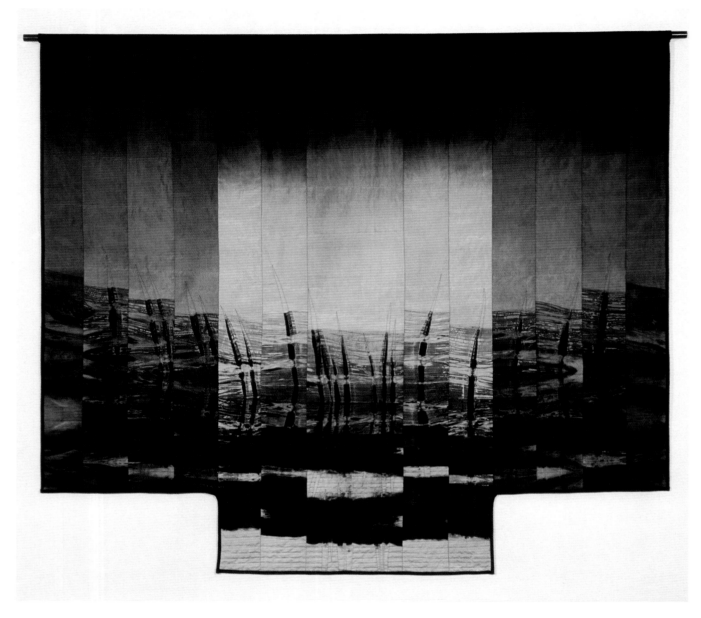

ABOVE
**JUDITH CONTENT,** *RAIN SHADOW*, **2005, SILK.**
The Japanese method of *shibori* dyeing is uniquely adapted by American artist Judith Content to produce this silk wall hanging. This new application of a traditional Asian technique demon- strates the cross-pollination of ideas and processes among craft artists.

OPPOSITE
**TIM HARDING,** *KOI KIMONO*, **1996, SILK.**

## AN EQUAL OPPORTUNITY

The author and artist Nancy Aiken explains what is a basic truth about studio craft, and the doors it has opened to everybody who wishes to avail themselves of its possibilities. Recognizing its underlying egalitarianism, she tells us that,

> *Art can be made by any of us. It need not result in museum-quality work; it can be only an elaboration of an ordinary object: . . . fashion rather than a simple covering to keep warm, decorating rather than a room with furniture. We can all dance, sing, and doodle; some just do these better than others.*[5]

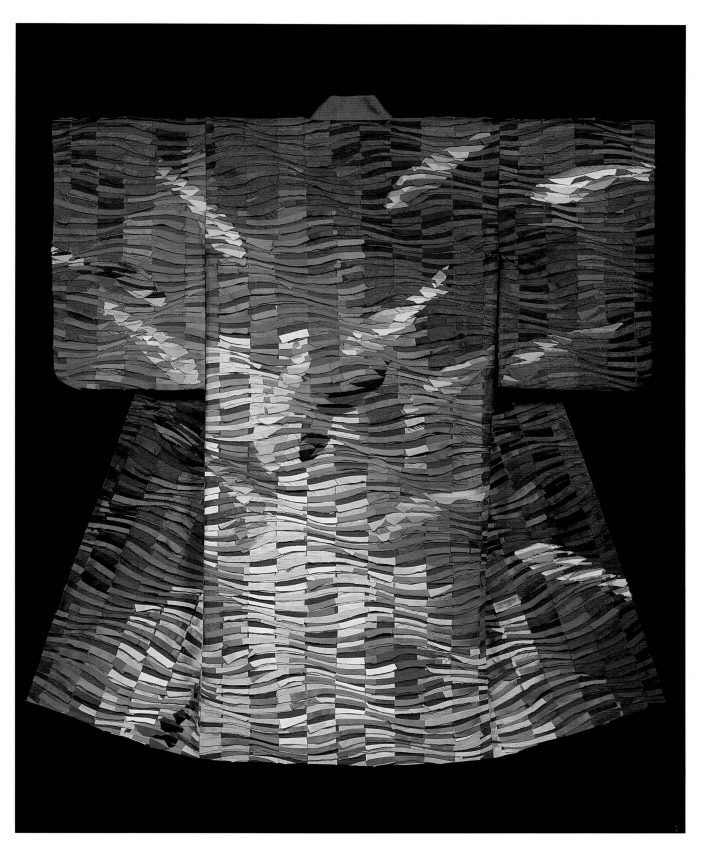

# TAKE YOUR SEAT: A JOURNEY THROUGH AMERICAN FURNITURE

**W**ELCOME to this virtual gallery of chairs made in America. You are invited to rest here and contemplate the journey of American craft. Like the larger area of craft, this community of chairs includes the familiar and unfamiliar, the sometimes useful and the sometimes provocative—all offered up for your consideration and delight.

A chair is the embodiment of the human form, with its legs, seat, arms, and back arranged to receive the body. Moreover, chairs represent the design form with which human bodies have the most intensive interaction. Integral are the practical considerations of utility, durability, and comfort; overlaid are the multiple contexts of the chair's aesthetic content and its role as a cultural document.

## THE PRE-MODERN ERA

In the early days of America, the chair was a seating unit and an index of authority. The Pilgrim Edward Winslow's family chair, made c. 1650, was among the first pieces of American furniture to be illustrated and published, depicted here in this woodcut from the 1841 book printed in Boston *Chronicles of the Pilgrim Fathers of the Colony of Plymouth 1620–1625*. Its sturdy and authoritarian air—evoked by solid oak construction of frame-and-panel joinery, and its imposing, thronelike design—bespeak its no-nonsense utility and importance.

One hundred years later, a chair's authority was established not by grandness of scale but by the dictates of fashion and elite taste. Such high-style chairs as the magnificently wrought Rococo style *Side Chair* from Philadelphia

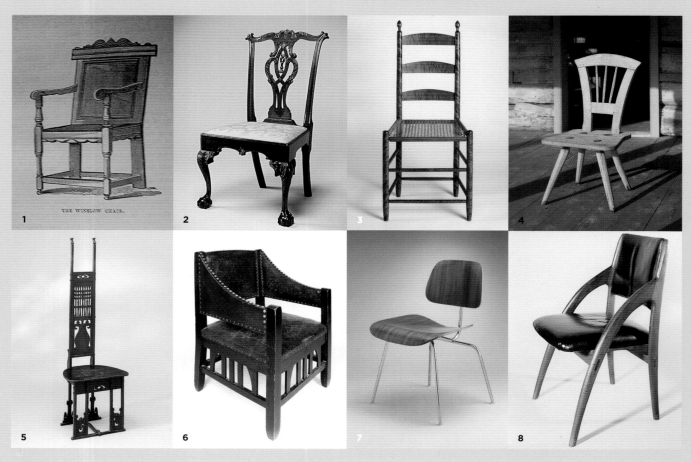

1

2

3

4

5

6

7

8

(c. 1760–80) were intended to impress. This *Side Chair* commanded visual attention, delighting the eye with its curvilinear profile and intricate carving.

In the nineteenth century, chairs could be as rough-hewn as the Texas-German, splat-backed side chair from Cat Springs, Texas (c. 1860), its seat and back literally whacked from a trunk of a tree, or as gracefully refined as the Shaker side chair (c. 1840s) constructed with precision-turned legs and posts, stretchers, and slats.

As noted, these early chairs had to carry a symbolic load: Along with their practical use they functioned as emblems of status and design preferences, grand or modest, stylish or straight-forward. One could say they cast a longer shadow than their silhouette, throwing into high relief their owner's societal position and taste.

Adhering to Arts and Crafts guidelines, the unique, handcrafted chair in the late 1880s needed to be more than just a functioning seat and status indicator; it required to be a visual statement of principles and a repository of values.

Hall Chair (c. 1900) by the Charles Rohlfs Workshop and Armchair (c. 1910) by the Roycrofters Furniture Shop exemplify the movement's ideals framed in this quotidian household object. Usually constructed of native white oak, quarter-sawn to expose the grain pattern, these chairs celebrate the use and beauty of natural, indigenous materials.

## MODERNISM TAKES HOLD

The potency of Arts and Crafts waned as a style and movement in the 1920s—and was virtually extinguished by 1930. Two new movements were on the rise—the studio furniture movement and Modernism—existing on parallel temporal planes but emerging from different constructs.

Modernism was foremost a movement based on theory rather than style and process, but its philosophy of "good design" had direct application to architecture and the applied arts. In the field of furniture, the movement was based on the industrial designer who drew furniture on a drafting board (or created prototypes).

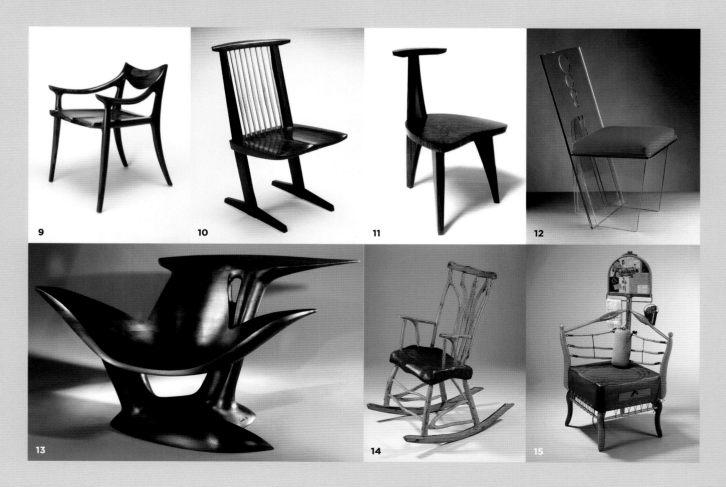

9       10       11       12

13       14       15

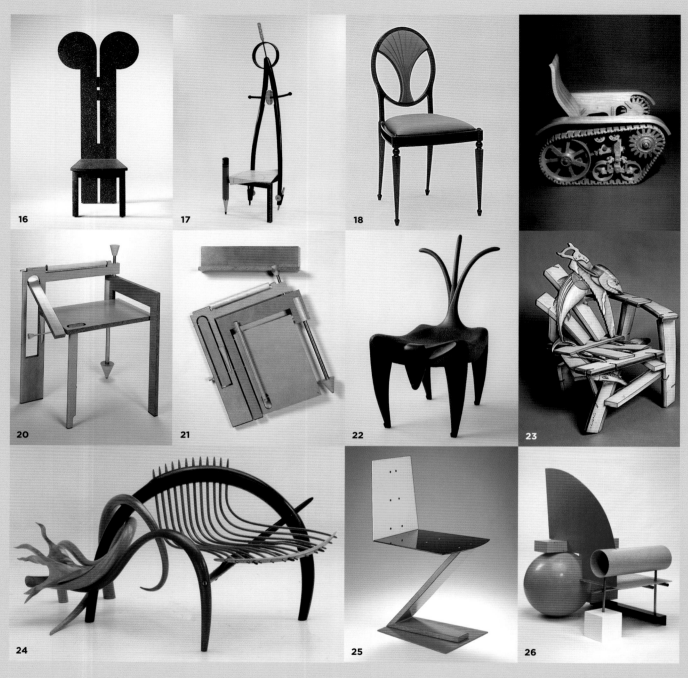

These chairs were structurally intended for viable mass production and were made from manufactured materials. The innovative use of new technologies developed by the defense and aerospace industry was also characteristic. The aspiration of the modernist furniture designer was the "machine aesthetic"—designing industrial-looking, aerodynamic forms made of chromed steel, extruded aluminum, molded plastic, and laminated plywood.

As industrial manufacturing removed the hand of the maker from the process, it caused a break in the continuity of craft traditions. Eclectic revivals were featured by manufacturers, but by the 1930s Modernism was becoming a leading-edge design cannon; and those who did not heed its call were marginalized within a decade. A few visionary artists, however, refused to embrace the machine aesthetic.

These pioneers were heir to Arts and Crafts ideals:

independent craft artists working in their studios, often alone and isolated. They sustained the reverence for natural materials and the process of handcrafting. In so doing, they collectively gave birth to the studio furniture movement in the 1940s and created the bridge that allowed craftsmanship to survive in modern, industrialized American society as it evolved in the twentieth century.

## THE RISE OF THE STUDIO FURNITURE MOVEMENT

The studio furniture movement was based on the individual who worked alone, or with apprentices, in his or her studio to design and handcraft unique or limited-production furniture from natural materials.

Leaders of the movement included Wharton Esherick, the first to forge the path. Esherick was quickly followed by George Nakashima and Sam Maloof, each a woodworker and furniture maker devoted to his craft, each possessing a frontier spirit that urged the pursuit of the road less traveled and an outcome that might be less highly regarded. They were committed to making each piece individually in their workshops from nonindustrial materials according to the time-honored methods of hand workmanship. Besides setting them apart from Modernism, this commitment was part of an alternative way of living and working, one now referred to as the Craftsman Lifestyle.

The three chairs featured in this "Chair Gallery" by Esherick, Nakashima, and Maloof stand as a visual record of their uncompromising vision and resolute craftsmanship. Their handcrafted chairs are functional, fluid sculptural forms articulated in solid wood—each an example of flawless perfection achieved through modest means and minimal production methods. Several generations of studio furniture artists have succeeded these founding figures, evidence that personal and expressive workmanship have an appreciative audience.

## POSTMODERNISM SUPPLANTS MODERNISM

In the 1970s, a swing of the cultural pendulum shifted the aesthetic focus to Postmodernism, which calls for inclusion of diverse aesthetic values, reclaiming premodern history as a source of cultural inspiration, and championing pluralism—the acceptance of other historical and cultural perspectives that had been marginalized during Modernism's reign.

Postmodernism opened the floodgates of style, and change inundated every corner of furniture design. Suddenly craftsmen were presented with usable aesthetic alternatives: Their handcrafted furniture could now be freely expressive and metaphorical, conceptual and playful, abstract, absurd, and even minimally functional. They were liberated to create hybrid forms that conjoined natural and synthetic materials and handmade components with manufactured elements.

Many contemporary studio-furniture makers have chosen the ordinary chair as the ideal form in which to explore their ideas. As this gallery of traditional and unconventional chairs shows, the "new" studio craftsman has answered the call to create diverse and intriguing pieces. These provocative chairs test the relationship of form and function and exploit the intricate connections between art, architecture, craft, and design. You are invited to be the judge—to compare and contrast. Take a seat, take a moment, contemplate, and consider.

1. **Pilgrim Edward Winslow's Chair, c. 1650.**
2. **Philadelphia Side Chair, c. 1760-1780.**
3. **Side Chair, Shaker Community, Mount Lebanon, New York, c. 1850.**
4. **Texas-German Splat-backed Side Chair, c. 1860.**
5. **Hall chair, Charles Rohlfs Workshop, c. 1900.**
6. **Roycrofters Furniture Shop, Armchair, c. 1910.**
7. **Charles and Rae Eames, DCM (Dining Chair Metal), 1960.**
8. **Wharton Esherick, S-K Chair, 1942.**
9. **Sam Maloof, Side Chair, 1975.**
10. **George Nakashima, Conoid Chair, 1961.**
11. **Mira Nakashima Yarnall, Concordia Chair, 2003.**
12. **Charles Hollis Jones, Wisteria Chair, 1968.**
13. **Wendell Castle, Dead Eye, 2006.**
14. **John Coonan, Untitled Rocking Chair, 1981.**
15. **Tommy Simpson, Boxing Chair, 1987.**
16. **Wendy Maruyama, Mickey Mackintosh chair, 1988.**
17. **Alphonse Mattia, Architect's Valet Chair, 1989.**
18. **Kristina Madsen, Side Chair, 1989.**
19. **Tom Eckert, Tank Chair, 1980.**
20. **Thomas Loeser, Folding Chair (opened), 1988.**
21. **Thomas Loeser, Folding Chair (folded), 1988.**
22. **Judy Kensley McKie, Wagging Dog Chair, 2006.**
23. **John Cederquist, Sashimi Side Chair, 1997.**
24. **Michael Cooper, Woody, 2005.**
25. **Garry Knox Bennett, GR #13, 2003.**
26. **Peter Shire, Bellaire Chair, 2006.**

# Shaping Craft in an American Framework

WITH THEIR MINDS, hearts, and hands, the men and women who made the works displayed in this book have transformed nature's raw substances into expressive objects that are artistically innovative, astonishing, refreshing, and vital. They stand on the shoulders of generations of craftsmen before them.

American crafts are embedded in American history, an essential part of which is the incredible story of large-scale industrialization: factory systems, mass labor, and astonishing wealth concentrated in the owners of such enterprises. The fiber arts provide a useful example.

The impulse to make increasingly refined fabric and to lower its production cost inexorably led to the development of mills and factories. Because of a shortage of labor in the New World, industrialization—which multiplies the output of every worker—quickly found a place here, with accelerated developments in the eighteenth and nineteenth centuries. The first commercially successful cotton-spinning mill with a fully mechanized power system was Slater Mill in Pawtucket, Rhode Island.

Established around 1790 by Samuel Slater and Moses Brown, it exponentially increased America's production of thread, yarn, and cloth. It is worth noting that

OPPOSITE

**GREAT ROSE WINDOW, CATHEDRAL CHURCH OF ST. JOHN THE DIVINE, NEW YORK, NY.**
Arts and Crafts ideals are well represented by the Connick Stained Glass Studios of Boston. After the demise of its founder, Charles J. Connick, the Connick Studio was managed as a neo-medieval guild of fellow workmen, under the leadership of Orin Skinner. This enterprise worked effectively, producing immense works of stained glass (as a team), the results of which appeared as if created by a single mind and hand.

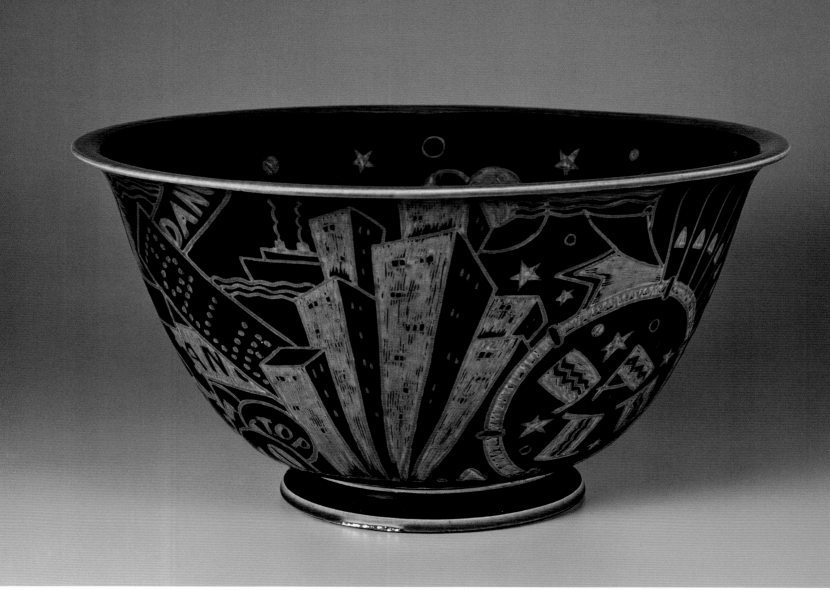

ABOVE

**VICKTOR SCHRECKENGOST, JAZZ BOWL, C. 1930, BLUE-GLAZED EARTHENWARE.** Combining the skills of an artist/craftsman with those of an industrial designer, Vicktor Schreckengost created amazing works that were adapted to commercial production. His range of works included commercial lighting fixtures, tricycles and bicycles, and earthenware sculpture, the most famous being the blue-glazed "Jazz Bowl" of about 1930 made by the Cowan Pottery Company of Ohio.

the patterns of early mill machinery were usually made by woodworkers, and then converted by founders to iron or brass. Most of the parts of the textile mechanisms (Arkwright carding and spinning machines) were made of turned wood—just as were the parts of spinning wheels and earlier weaving devices.

The Slater Mill is often cited as the birthplace of the American Industrial Revolution. Textile industries flourished throughout much of New England, with larger mills built at falls on rivers in Lowell and Lawrence, Massachusetts, and in Manchester, New Hampshire. In an ongoing cascade over the life of America, that revolution—and the invention of new and better labor-saving tools—led to the production of various kinds of goods more quickly and efficiently than the human hand alone could manage.

New industries gradually eliminated the need for small, independent craft shops to supply a quickly growing population. Unfortunately, those who gained factory employment soon discovered that they were hired as unskilled labor: human machines tending the machines of mass production. While there were economic gains for some, workers suf-

fered loss of self-esteem, exploitation, and poverty. In a particular egregious example, children were hired at the Slater Mill for less than a dollar per day and required to produce 14 pounds of finished yarn daily or they would be sent to the "whipping room" for correction.

## THE BEDROCK OF AMERICAN CRAFT

★

Reacting to such social evils, both here and abroad, were social reforms that gave birth to the Arts and Crafts movement—the philosophical bedrock for craft artists in England, the Continent, and America.[1]

The same spirit of personal expression informed a slightly earlier phase of artistic reform known as the Aesthetic Movement, illustrated in the United States by the stunning works of the artists Louis Comfort Tiffany and John LaFarge. Both drew inspiration from the arts of the Far East. Both were painters as well as innovators in stained glass and other arts of design. Tiffany was also an early advocate for creative reform of artistic production and founded Laurelton Hall on Long Island, New York, as a summer retreat for artists and craftspeople.

Ironically, two Americans who were perhaps the most vocal and public proponents of Arts and Crafts displayed a decidedly ambivalent attitude toward industrialization. Gustav Stickley used "factory" steel-woven webbing for supporting cushion upholstery in his furniture rather than more craftsmanlike hand-tied linen webbing. In similar fashion, Elbert Hubbard, of the Roycrofters community, produced his numerous books on paper made of wood pulp processed on a continuous-belt, paper-manufacturing system that essentially eclipsed the craft of hand-processed papermaking. He even instituted a time clock for his employees. Stickley and Hubbard were both entrepreneurs who knew that art was also a business.

The historical trajectory of the Arts and Crafts beliefs reached out to education through vocational schools like Boston's North Bennet Street Industrial School, founded by Mrs. Quincy A. Shaw in 1885 for manual training in traditional crafts. In colonial times, the neighborhood had been home to craftsmen such as Paul Revere and the weathervane maker Deacon Shem Drowne. Today the educational and charitable school flourishes—and has dropped *Industrial* from its original name to reflect its revised mission.

The widespread engagement of institutions and craftsmen with Arts and Crafts across America, from the 1880s into the 1940s, has been well documented in several major art museum exhibitions, catalogues, and books. This record is a testament to the vigor and diversity of artists who worked in crafts media and their American patrons. Their collective beliefs about the virtue of workmanship form spiritual substrata of memory and appreciation that spread across the continent.

# THE MACHINE MADE VERSUS THE HANDCRAFTED

★

In the first half of the twentieth century, mass industry advanced with highly mechanized and streamlined designs. The leading edge of this new era was the Paris exposition of 1925 (the *Exposition Internationale des Arts Décoratifs et Industriels Modernes*), from which the term *art deco* derives.

The most radical objects in this display, furniture made of industrial materials and machined surfaces, came from Germany. Such innovative ideas slowly seeped into the American imagination and provided prototypes for the modern.

The Great Depression swept away many supporters of the Arts and Crafts movement. Unemployment meant that labor for factories was cheap; further, few patrons could afford to buy handcrafted works, which took significant time to fabricate. Over the years, mass production of household goods and devices provided many Americans incredible freedom and leisure time.

At the other end of the craft spectrum of practice, a simpler but in some ways equally complex America has persisted. This "other America" consists of a "Nation of Nations" spread across the land, reflecting the popular, provincial, ethnic, vernacular, and folk traditions long established by immigrants from many lands. Even some American Indians

RIGHT
Although the World's Fair of Chicago in 1933 featured the newest in technology and design, it also included "The Carolina Cabin." The year after the Chicago exposition, students attending the summer session at Penland School of Handcrafts raised funds to build a log structure there called the "Edward F. Worst Craft House," named after the volunteer summer teacher at Penland (1928–1946). A substantial dorm with several classrooms[2]—it is shown here during construction of the log framing.

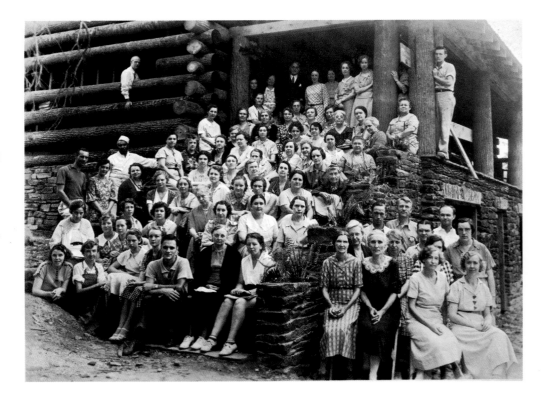

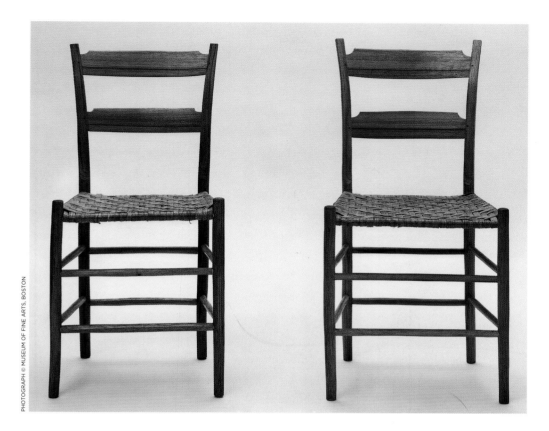

PHOTOGRAPH © MUSEUM OF FINE ARTS, BOSTON

LEFT

**CHAIRS, RICHARD "DICK" POYNAR (LEFT) AND JOHN ALEXANDER (RIGHT).**

Poynor was a free black slave who established a highly productive shop in nineteenth-century Williamson County, Tennessee. There he and his son made mule-eared, slat-back chairs out of green wood, pinned together with wooden pegs without glue and bottomed with woven white oak splints. Poynor's chairs were sturdy and highly regarded in their day and are eagerly collected by antiquarians today.[3] Similar chair-making traditions are continued by Alexander in Baltimore, Maryland, where he advocates and exalts the beauty of working green wood to make a chair from a tree.

LEFT

**PORTRAIT OF MARY JACKSON AND HER HUSBAND, STONEY, AT MARY'S BOOTH, SMITH-SONIAN CRAFT SHOW, APRIL 2006.**

Mary Jackson of South Carolina is a contemporary basket maker who learned her craft—how to harvest seagrass and elegantly shape it—from her mother and grandmother. Beyond its utility, her basket making is an eloquent art form expressing her personal muse. Moreover, it sustains a three hundred-year-old tradition that can be traced to the Ivory Coast of Africa.

SHAPING CRAFT IN AN AMERICAN FRAMEWORK   273

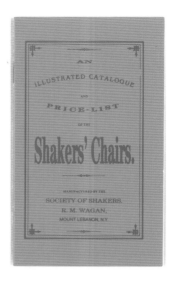

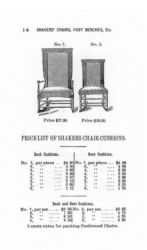

were, in the beginning, immigrants, crossing the Aleutian land bridge from Asia into North America. People of many and various heritages and beliefs—Amish, Mennonite, Moravian, Zoar, Norwegian, Texas Germans, Mormons, Italians, Chinese, Japanese, Hispanic, Africans, Latino, Hawaiian, Puerto Rican, folks from Slavic and Near Eastern nations, among others, followed. They sustain vital sources of culture that continue to produce distinctive crafts. Craft artists and artisans in America are deemed important partners within the whole society, whether that society is utopian, religious, or simply small town.

Thus, in the early years of the last century, America was still blessed with abundant tradition-bound, small country shops and cottage industries, especially beyond the fringes of large urban centers, where fashion dictates taste. For example, in Pittsburgh, large-scale industrial steel may have been king, but downstream on the Monongahela River in Pennsylvania and West Virginia, practical stoneware potters continued to turn and fire their salt-glaze kilns. Master glassblowers and engravers were making traditional stemware goblets in factories, but on off-hours were given considerable freedom to express themselves. Wives of underpaid craftsmen and factory workers saved rags to weave into rag runners to sell in weekend markets.

Rural crafts endure for many reasons—not the least of which is that, like folk or western music, they preserve memories and recall bygone times. These objects also offer evidence of their makers' pride in achievement. Those who acquire rural crafts for use (or collect them as art) enjoy personally knowing the artist who made them. Typically, folk or popular crafts offer both maker and user sensory pleasure associated with natural or organic materials. Also, personal pride of workmanship usually produces works of beauty and durability.

In Appalachia and in the American South, handmade crafts were particularly strong because people often could not afford to purchase products of large-scale industry. "Make-do" became a way of life, leading to original and highly personal expressions.

## THE POSTWAR YEARS: A NEW FUSION

★

With the war years of the 1940s, the Arts and Crafts aesthetic drifted toward a state of gentle slumber, and machine-made products dominated U.S. culture. The romance of large-scale manufacturing had captured the imagination of urban America. Consumer

# ASILOMAR AND THE BIRTH OF STUDIO CRAFT

**I**N MANY RESPECTS, the new studio crafts movement was born in 1957 at the Asilomar Conference Grounds in Pacific Grove, California. This seminal conference sponsored by the American Craft Council brought together studio craftsmen who had never met and in many cases were unaware of one another's works. Here, for example, California's Sam Maloof met Pennsylvania's Wharton Esherick, who led discussions with other wood craftsmen. The 450 attendees constituted a who's who of craft artists, educators, and designers, from both the old and the new traditions. Beyond its vital exchanges and bonding experiences, the conference was an affirmation of the significance of craft.

One of the participants, Jean Delius, a woodworker and educator from New York State, assembled another seminal conference in March 1966 at Niagara Falls, New York. This conference, entitled "The Role of the Crafts in Education," sponsored by the State University of New York College at Buffalo, also featured an exhibition of works made by many of the participants. Now, more than forty years later, the participants' position papers and the record of the final report remain vital.[4] The ideas reflect the best thinking of leading craft artists of that era, some of whom, such as Mary Caroline Richards and Fran Merritt, are now gone, but fortunately, not forgotten.

Amazingly, many conference participants expressed the belief that contemporary crafts were irrelevant to contemporary society or, at best, were backward looking and a romantic folly in an environment largely shaped by designers working for industrial production. If the same questions were framed today, views might be substantially different. In part, this is because Americans have come to recognize the inadequacy of Modernism and its related large-scale industrialization. Practitioners of art and of craft have long predicted the negative consequences of the brave new world that modern industrialization created. The artist/craftsman represents, rather, a union of the material and the spiritual and a reassertion of the human and the creative.

**ABOVE LEFT Cover of Asilomar Conference Report.**

**ABOVE RIGHT Inside page of Asilomar Report featuring quotes from several of the participants.**

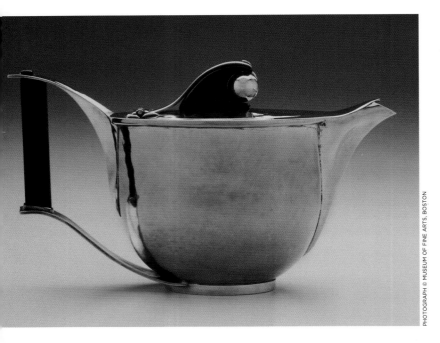

ABOVE

**MARGARET CRAVER, *TEAPOT*, C. 1936, SILVER AND GABON EBONY.**

Metalsmith Margaret Craver was one of the key figures who kept alive the traditional methods of silversmithing during the 1930s and 1940s. Because large-scale industrial silver manufacturers adopted expedient methods for shaping silver such as lathe turning, the art of hand-wrought silversmithing fell into eclipse. Craver made considerable efforts to learn and maintain the skills and knowledge of hand-forging and -raising, and planishing hollowware vessels in sterling silver. She was among the few practitioners who, after World War II, sustained the art, joy, and mystery of hand-wrought silversmithing.

goods and new machines for transport (autos, trains, and planes) were encased in shapes that suggested speed and motion. *Design* became the mantra, manifesting the separation of those who shaped or made things from those who specialized in conceptualizing prototype models or made drawings for factory production.

Yet not everyone in these decades accepted a mechanistic view of the future that kept design in a separate intellectual silo. Many artist-craftsmen-designers who were born shortly after the turn of the century drew inspiration from the Arts and Crafts credo and pioneered new realms to become admired senior leaders of the studio crafts movement that became the hallmark of the late twentieth century—and continues to this day.

Central to the new studio crafts movement is the realization that craft no longer needs to serve utilitarian ends. Studio crafts became tied to contemplation, touch, and communion. While the studio crafts movement focused on the handcrafted, it also adapted to new materials and technologies, many the outcome of industrialization. The postwar years of the late 1940s and 1950s offered abundant material supplies from war surplus. Factories manufacturing aluminum, Plexiglas, and plywood, for example, needed to find new uses or markets for their products. New tools for shaping wood and other materials for making crafted objects also evolved.

Today, those artists who make the bold commitment to work in craft media do so because of a passion for the expressive potentials of the materials they use. They also understand the risks involved. Unlike the manufacturers whose products are standardized and market tested, the craft artist often works in isolation with a field of unknown possibilities. Irregularities in materials, idea changes that take place in the process of shaping works, and uncertainty about outcome or patronage are all part of risk-taking ventures in the arts. Whether they become turners, blacksmiths, jewelry makers, potters, furniture makers, glass workers, metalsmiths, or weavers—whatever—they share a common bond as artists who welcome risks. They fashion personally expressive works, and thereby make art.[5]

An important function of crafts today is to reground us in the real and material world. This is not a mere luxury—it is a necessity.[6] Remembering that people are more than tools of mass production, society needs to rethink what it means to be human and how individuals relate to one another and to their environment. Thoughtful studio craftsmen, working within the worlds of material and spirit, offer useful and important answers to these seminal questions for the new age.

—JONATHAN LEO FAIRBANKS, *Fellow AIC (Hon.)*

# Epilogue: A Past That Is a Prologue

*If there is a name I would like to copyright, it is "craftsman." It is a name that places a tremendous responsibility on those who claim it. And believe me, in our world and in our time, we are deeply in need of the values which come under the head of "craftsmanship."*
—CHARLES EAMES, American Renaissance man

ART IS DEFINED BY MOVEMENTS, but craft defines life. Craft gives substance to who we were, what we've done, and how we've changed. It is how we do things. Craft is a living archive of our lifestyle and the value we put on our heritage.

Fact is, each of us, in his or her own way, has had a craft experience. Sometimes it's an object passed down that links us to our forebears. Perhaps it's the quilt our mothers bundled us up in on a cold winter's night. The antique rocking horse we climbed on to ride off into the sunset. Or the subtle reminder of the basket that sits on the counter, holding house keys and letters to be answered. In these ways, and so many more, our oldest, newest—but fondest—memories are tied collectively, inexorably to craft.

Craft is our "stuff"—repositories of our culture. Beyond fabrics, wood, and metal, craft is composed of the values and beliefs of those who created it, purchased it, and then preserved or discarded it. It is used and collected in homes across America—from your house to the White House.

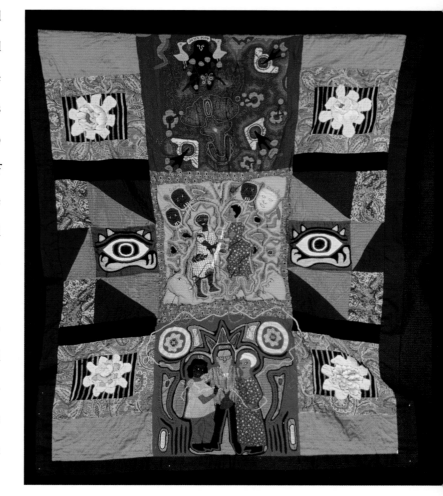

American craft is democratic. It is broad enough to accommodate anyone who makes something or appreciates the handmade. The writer and jeweler Bruce Metcalf believes "the uniqueness of the handmade is an analogy to one's own individuality; the craft object stands for one's singularity in a world of mass production."

# A JOURNEY WITHOUT END

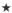

Is it because of America's role as the melting pot—not possessing a single, dominating craft style—that craft here is uniquely exciting, compelling, and extraordinary to the eye, the touch, and the imagination?

Without doubt, our pluralistic society has rendered the American craft tradition the most complex and rich in the world, typified by boundless designs, styles, and energy. Precisely because we have been so free to ignore the old definitions and limitations of the possible, American craft has opened so many eyes to the impossible.

Looking at a handcrafted object these days, whether it's from the twenty-first century

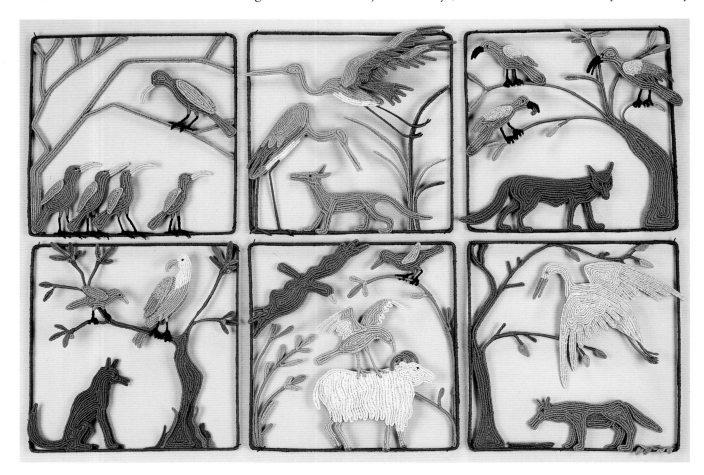

# VENUES FOR HANDMADE OBJECTS

**T**HE mission statements of America's craft organizations—the galleries, museums, and educational programs—vary. But together they are our keepers of the flame, living archives and repositories that inspire us, educate us, and provide enjoyment in the experience. They ensure that craft artists are able to sustain themselves and that their skills are kept alive for generations that follow.

We visit museums and attend exhibitions to see how American crafts (and American craft artists) have evolved from strictly utilitarian origins to those reflecting our ever-evolving tastes, styles, and sensibilities. They are the storehouses of our psyche and our creativity

We see exhibitions of artists, often local or regional, with limited exposure, whose work has been surprisingly prescient, demonstrating exciting new ways of interpreting and, sometimes, reinventing familiar objects. They bear witness to creativity put to practical use. We find ourselves riding a mobius ring of ideas, seeing the beginnings of the present in the past and the richness of the past in the present.

The first recorded exhibition that focused on finely executed craft objects was held in Boston in 1897, sponsored by the Society of Arts and Crafts. It featured about one hundred artists and craftsmen and showcased objects in all the craft media. Their second show, two years later, included more than three thousand objects, reflecting rapid growth in the craft commnunity and interest in their work. Numerous regional and national shows followed.

But in 1969 an extraordinary exhibition brought to the national (and international) stage a new movement called studio craft, in which artists went beyond the utilitarian to create works based solely on aesthetic lines. The exhibit is called, succinctly, *Objects: USA.*

Sponsored by S. C. Johnson & Son, Inc. (maker of Johnson's Wax and other household products), the exhibition gave Americans and the world the opportunity to examine a vital cross section of the works being created by artists working in craft media. *Objects: USA* opened at the Smithsonian Institution and traveled over five years to museums throughout the United States and Europe.

With 300 objects made by 267 craft artists, visitors to the *Objects: USA* exhibition could experience visual and concep-

tual themes. Some were made from new synthetic and plastic materials, reflecting the interaction between design, technology, and crafts. The show also shook up the definition of *craft* and examined the tie between craft and national identity by demonstrating that the objects made in this country resonated with the values of individualism, risk taking, and experimentation.

In his curatorial proposal for *Objects: USA,* Manhattan art dealer Lee Nordress stated that "crafts represent a refinement of the objects with which we are confronted daily, [and] their appeal stretches from the most sophisticated to the most rustic of audiences." He had "little doubt but that the appeal of these objects will be instantaneous and widespread . . . Everyone from the country storekeeper who whittles a toy by his pot-bellied stove to the Park Avenue dowager who dabbles with ceramics will be interested in seeing a new concept—and beautifully executed—of a spoon, a chair, a necklace, a bottle, a room divider."

Indeed, scores of institutions in towns and cities everywhere see an exhibition of our objects to be a natural extension of American art and culture.

---

**BELOW** Wayne Higby, *Seclusion Lake,* 1982; Stoneware, Raku fired. Among the works in *Objects: USA* was a raku-fired vessel by Wayne Higby. Throughout his career, Higby has explored the potentials of raku firing—as well as other techniques—and has refined pictorial compositions, particularly abstracted canyon landscapes, the "subject" depicted on this large vessel.

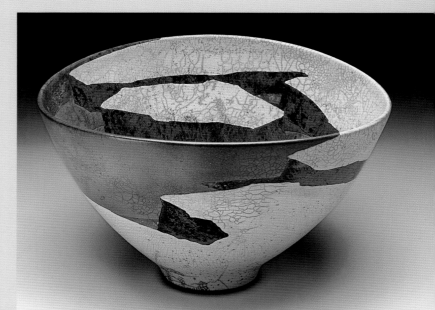

**MATTHEW METZ, A PAIR OF VESSELS, 2006, STONEWARE.**
Metz's functional vessels feature carved surfaces that draw on diverse, centuries-old sources ranging from Early American pots, quilts, and folk art to Asian and European ceramics traditions. "My functional pots add another dimension, I hope, to the user's everyday life," Metz states.

or much, much earlier, we are more likely to see first its art and its beauty . . . and then the intended function and use. Clearly, craft has very much evolved from the everyday to its acceptance as an important art form.

Throughout our history, sometimes against all odds, this very special artistic expression has endured, a constant in our lives. Now, in today's point-and-click, drag-and-drop Digital Age, as our civilization becomes more mechanized, standardized, and computerized, the handmade has taken on new meaning, becoming what we value as special and appreciate the most. As the theorist and futurist Marshall McLuhan anticipated in the mid-60s, "In the future the role of the craftsman will be more important than ever before."

As with much of what he predicted, this, too, resonates with us. As humble objects from our past and present—a belt, a bowl, a basket—have been elevated by the duality of their art and their utility, the artist's personal creativity and intellectual curiosity have gained in respect and appreciation.

Truth is, the beauty of the former would be impossible without the strength of the latter.

# LIVING A LIFE OF PERSONAL POSSIBILITY

★

In her introduction to *Craftsman Lifestyle: The Gentle Revolution* by Olivia Emery, Eudorah Moore, director of the California Design exhibition series at the former Pasadena Museum of Art, reveals nothing short of a calling— an American Manifesto for individuality, integrity, and singularity. Making craft a vocation, she argues, "is universally a conscious and considered choice. Their career commitment is unregretted. The desire for freedom is ubiquitous, even at material cost. The act of doing supersedes in importance the end result. Art and life are a single fabric."

Unlike the image of the starving artist in his garret, suffering for his art, Moore feels the craft artist "extracts from every moment the joy it offers; whether pleasure in one's work, in visual perceptions, in good food, or in quiet repose."

In short, Moore says, the craftsman's style is one of "participator, not spectator."

# PARTICIPATION BY COMMUNICATION

★

For some craft artists, Moore's "participation" manifests itself in political statements, like the ones their brethren painters and sculptors routinely make.

Richard Notkin, for example, uses the ordinary teapot as a personal vehicle of protest against an unconscionable influence of Big Oil and the poisonous proliferation of nuclear weapons. The precise detail and depth of his design vocabulary enhance the beauty of his pieces.

The AIDS Memorial Quilt, for example, started in 1987 by Cleve Jones and a group of volunteers in San Francisco, is the largest ongoing community arts project in the world. In the 1980s, many people who died of AIDS-related causes did not have funerals because funeral homes and cemeteries—fearing contamination—refused to handle their bodies. With no memorial service or grave site for their loved ones, the quilt was, for many survivors, the only opportunity to remember and give substance to the lives of those who died. There are more than forty thousand 3 × 6-foot panels, each the size of a human grave. They are extraordinarily poignant remembrances from the heart that include photos, favorite sayings, or pieces of clothing, using patchwork, appliqué, embroidery, fabric painting, collage, spray paint, and needlepoint.

BELOW

**RICHARD NOTKIN,** *TWENTIETH CENTURY SOLUTIONS TEA POT: NOBODY KNOWS WHY,* **2006, YIXING SERIES, STONEWARE.**
Richard Notkin's father was an immigration lawyer specializing in Chinese cases, and was often paid with fine historic art pieces. Additionally, many of the family's Chicago neighbors were Holocaust survivors who, according to Notkin, "exhorted [them] to be activists." Notkin's fascination with the precision and detail of the art, coupled with this ingrained social activism, has had an extraordinary influence on his work.

Yet another example of political statement is Judy Chicago's feminist celebration *The Dinner Party*. An homage to women's history, created between 1974 and 1979, it takes the form of a large triangular table with symbolic ceramic plates representing thirty-nine famous feminist "guests of honor." It is on permanent exhibit at New York's Brooklyn Museum.

## "WHEREVER YOU GO, THERE YOU ARE"

—JON KABAT-ZINN

★

Today more and more museums, in cities of all sizes, are dedicated to showcasing our substantial heritage of craft. And why not? We are enamored of objects. Blockbuster exhibits (and their accompanying gift shops) focus on the personal objects of czars and czarinas or of Egyptian child kings, for example. We are enthralled with the things they held important in their daily lives and how these crafted pieces compare and contrast to our own.

Institutions like the Barnes Foundation in Pennsylvania place craft at total parity with the finest works of the world's art, displaying them side-by-side without distinction or discrimination. Founded as a school in 1922, the building's "wall ensembles" were intended to illustrate the visual elements and aesthetic traditions that Albert Barnes felt were present in all art forms across periods and cultures. Henri Matisse hailed the foundation as the only sane place in America to view art.

Scores of museums, from the Mint Museums of Art and Craft + Design in Charlotte, North Carolina, to the new Bellevue (Washington) Arts Museum celebrate regional artists and actively promote craft's future through extensive schedules of workshops that

RIGHT

**ANNA BELLE KAUFMAN AND FRIENDS, *ZACK*, AIDS QUILT PANEL, 1988, COTTON AND ACRYLIC PAINT.**

Zachary Jacob Fried loved trains, and drew this special one "for [his] Momma." He was five and a half when he died.

BELOW

**CLIFF LEE, C. 2005.**

Cliff Lee was a brain surgeon when he took his first pottery workshop. Intrigued by the detail possible in the craft, he abandoned his practice to become a full-time ceramist. His works are highly sought after for their incredible thinness and exquisite glazes.

# HANDS ACROSS TIME

CRAFT artists are guided by their hands: complex tools of bone, sinew, and nerve endings that can rotate 270 degrees, flip up and down 150 degrees, and freely rock from side to side. With its fully opposable thumb, the hand can grasp and grip with a power and precision unknown to any other species. Craft artists' hands have shaped their development—their ability to know things, to feel things, to talk about things. And most importantly, to use their heads.

**Kiff Slemmons, *Hands of the Heroes Project*, 1987–1991, silver, aluminum, brass, copper, acrylic, shell, wood, and found objects, approximately 3¼ × 2½ inches.**

The hand has been at the center of craft since its very beginnings. By taking the universal shape found in art since prehistory, Kiff Slemmons embellished them with historical, cultural, and literary references and symbology. A total of sixteen famous figures in science, art, politics, and cultural history are represented in this showcase of thought-provoking art. Here is a selection from the project.

1. Colette
2. Emily Dickinson
3. Marie Curie
4. Harry Houdini
5. Glenn Gould
6. Satchel Paige
7. Joseph Cornell
8. Dr. Martin Luther King, Jr.
9. Don Quixote

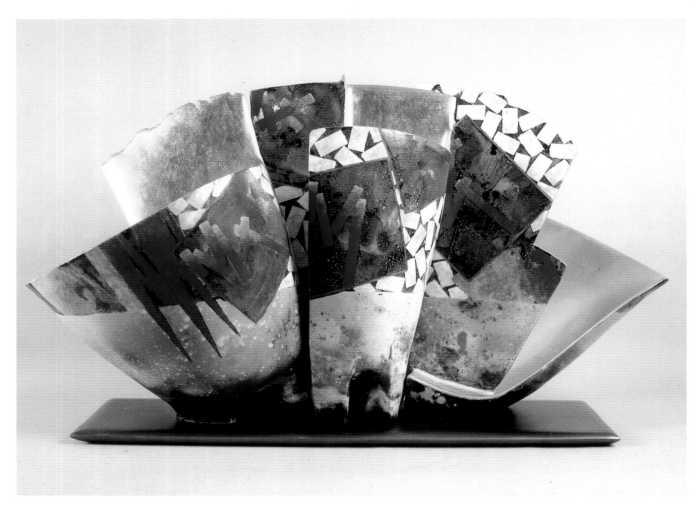

are hands-on fun for adults—and more tellingly, children. (Find a place near your home by exploring the "Museums That Show Craft, Design, and Decorative Arts" section in the back of this book.)

Following the model of Renaissance arts patrons, today's governments and corporations (our contemporary Medicis) as well as individuals of means are commissioning objects that enrich public spaces and private homes. Their support translates into greater opportunities for craft to survive and flourish, and offers further incentive for the artists themselves to constantly experiment with new techniques and technologies.

Other groups, like the Smithsonian's Renwick Alliance and the Women's Committee of the Philadelphia Museum of Art play an important role. Through their sponsorship of premier craft sales, they generate funds that promote collecting; in the case of the Women's Committee, the money raised goes directly into purchasing craft objects for the museum.

As with all art, a burgeoning community of collectors forms the backbone of support for craft artists. Some buy a few pieces. Many, after their first bowl, basket, or special

LEFT

**GEORGE OHR POT GREEN AND RED WITH HANDLES, C. 1900, CERAMIC.**

This "pot" is an excellent example of Ohr's iconic work as described by art historian Robert A. Ellison: "For a few brief years, from 1895–1910, George Ohr's altered, wheel-thrown pots gave critics, connoisseurs and just plain folks across the United States— a glimpse of the future . . . he used specific gestures of twisting, folding, indenting, ruffling, lobing, crinkling and off-centering. In a sense, he destroyed good pots in his quest for nontraditional form." ("George Ohr and the Altered Pot," American Craft, *August/ September 2006, pp. 50–51 and 61.*)

piece of jewelry or handmade fashion, find collecting addictive. They seek out galleries and craft shows like those sponsored by the American Craft Council, the Smithsonian, and the Philadelphia Museum of Art, to see new work by established artists and discover new artists who are just beginning to make their marks.

Like a bridge that spans the river of time, craft is wide enough and strong enough to support the studied classicism of a Paul Revere, the wild abandon of a George Ohr, and the form's very redefinition/reinvention by artists who continually stretch the limits of their materials/media. With exposure to the world, and greater global access, who can say where the next great reimagining of craft will come from?

If today's craft artists are any indication, it is a rich heritage that we can expect to be perpetuated as far as the eye can see and in ways the other senses can only imagine.

★ ★ ★

# Notes

**PART 1: COMMUNITIES OF CULTURE**

1. Corzo, Miguel Angel. "Craft in America Symposium Tapes, May 18th, 2002," page 24.

**CHAPTER 1: RELIGIOUS COMMUNITIES AND THE HONORING OF THE HANDMADE**

1. According to Jerry Grant, the exact "founding" of the Shakers cannot be known for certain. The closest date for the establishment of the first Shaker community in America is when the Shakers "brought the community into gospel order at Mount Lebanon in 1787." Written statement provided by Jerry Grant, Director of Archives, Shaker Museum and Library, Old Chatham, New York; August 17, 2006.

2. June Sprigg and David Larkin, *Shaker: Life, Work, and Art* (Boston: Houghton Mifflin Company, 1987). "Put your hands to work" quote on page 110, and "get down on your knees" quote on page 115.

3. Sister Marguerite Frost, "The Prose and the Poetry of Shakerism" in *The Shakers: Their Arts & Crafts* (Philadelphia Museum Bulletin, Spring 1962), p. 70.

4. Written statement by Jerry Grant, Director of Archives, Shaker Museum and Library, Old Chatham, New York, August 17, 2006.

5. Sprigg and Larkin, *Shaker: Life, Work, and Art,* p. 134.

6. Sharon Duane Koomler, *Shaker Style: Form, Function, and Furniture* (London: PRC Publishing, 2000), pp. 130–148.

7. June Spring, *By Shaker Hands* (New York: Alfred A. Knopf, Inc., 1973), p. 3.

8. Sprigg and Larkin, *Shaker: Life, Work, and Art,* p. 134.

9. Bertha M. H. Shambaugh, *Amana: The Community of True Inspiration* (a Penfield Press facsimile of the 1908 publication of the same name, published by Joan Liffring-Zug, State Historical Society of Iowa, 1988, p. 57.

10. Marjorie K. Albers and Peter Hoehnle, *Amana Style: Furniture, Arts, Crafts, Architecture & Gardens,* a partial reprint of Albers's *The Amana People and Their Furniture* (Iowa: Iowa State University Press, 1990), pp. 9–10; and Shambaugh, *Amana,* pp. 27–30, 57–59, 69, 72–78, 83.

11. Shambaugh, *Amana,* p. 78.

12. Ibid., pp. 34–35, 44–72, 133.

13. Ibid., pp. 45–117.

14. Ibid., pp. 73–79.

15. Ibid., pp. 105–10.

16. Shambaugh, *Amana,* p. 79.

17. John Fleming and Hugh Honour, *Dictionary of the Decorative Arts* (New York, Hagerstown, San Francisco, London: Harper & Row, 1977), p. 143.

18. Roderick Kiracofe and Mary Elizabeth Johnson, *The American Quilt: A History of Cloth and Comfort 1750–1950* (New York: Clarkson Potter, 1993), pp. 35–36.

19. Albers and Hoehnle, *Amana Style,* pp. 110–12.

20. www.amana.com.

21. Albers and Hoehnle, *Amana Style,* p. 129.

22. Emma Jones Lapsansky and Anne A. Verplanck, *Quaker Aesthetics: Reflections on Quaker Ethic in American Design and Consumption* (Philadelphia: University of Pennsylvania Press, 2003), p. 15.

23. Kiracofe and Johnson, *The American Quilt,* p. 181.

24. Stephen Henkin, "A Stitch in Time: Lancaster County Quilts" in *The World & I* (July 1, 2000).

25. Robert Shaw, *America's Traditional Crafts* (Hong Kong: Hugh Lauter Associates, 1993), p. 18.

26. Lapsansky and Verplanck, *Quaker Aesthetics,* p. 248.

27. "Sunshine and Shadow: Nineteenth-Century Mennonite Quilts," exhibition text provided by Carolyn Ducey, Curator of Collections, International Quilt Study Center, University of Nebraska, 1997.

28. Ibid., and see also Stephen Henkin, "A Stitch in Time."

29. Henkin, "A Stitch in Time."

30. Shaw, *America's Traditional Crafts,* p. 18.

31. "Mennonites and Their Quilts: A World of Sunshine and Shadow."

32. Shaw, *America's Traditional Crafts,* p. 20.

33. Daniel McCauley, *Decorative Arts of the Amish of Lancaster County* (Intercourse, Penn.: Good Books, 1988), pp. 16–18. See also Patricia T. Herr, "Lancaster Amish Quilts: 1869–1996: Are Amish Quilting Traditions Dying or Simply Evolving?" in *Fiberarts* 23 (January/February 1997), pp. 37–41.

34. "The Collector's Eye: Amish Quilts from the International Quilt Study Center Collections." Online Gallery Guide, http://www.quiltstudy.org/search/index.html.

35. Shaw, *America's Traditional Crafts,* pp. 22–23.

**CHAPTER 2: THE ARTS AND CRAFTS MOVEMENT IN AMERICA, 1890–1930**

1. William Morris, "The Lesser Arts of Life" in Garth Clark, *Ceramic Art: Comment and Review 1882–1977: An Anthology of Writings on Modern Ceramic Art* (New York: E. P. Dutton, 1978), p. 7.

2. Eileen Boris, " 'Dreams of Brotherhood and Beauty': The Social Ideas of the Arts and Crafts Movement" in Wendy Kaplan, ed., *"The Art That Is Life": The Arts & Crafts Movement in America, 1875–1920* (Boston: Little, Brown and Company, and the Museum of Fine Arts, Boston, 1987), p. 210.

3. Ibid., p. 212.

4. For an understanding of William Morris's principles and ideals, from which these maxims are drawn, see Mary Morris, ed., *The Collected Works of William Morris,* vol. 24 (London: Longman's, 1910–1915).

5. Gustav Stickley, "Critical Correspondence," *The Craftsman* 4 (April 1903), pp. 58–59.

6. Gustav Stickley, "The Use and Abuse of Machinery, and Its Relation to the Arts and Crafts," in Barry Sanders, ed., *The Craftsman: An Anthology* (Santa Barbara and Salt Lake City: Peregrine Smith, 1978), pp. 186–90.

7. Stickley's first house plan was in the California Mission style and included elevations, renderings, floor plans, and detailed recommendations for the interior. "Craftsman House Series of 1904, Number One," *The Craftsman* 5, no. 4 (January 1904), pp. 399–404. Succeeding issues offered Craftsman-style homes to suit many tastes, lot sizes, and geographic areas. Four of its best-known designs were included in the magazine's final issue: "Four Popular Craftsman Houses: Numbers 55, 152, 79, and 96," *The Craftsman* 31, no. 3 (December 1916), pp. 301–304.

8. Clara Driscoll, head of the Women's Glass Cutting Department, and her colleagues were the subject of a 2007 exhibition at the New-York Historical Society entitled *Clara Driscoll and the Tiffany Girls: The Women of Tiffany Studios.*

9. John Balzar, "An Eye and Heart for Detail," *Los Angeles Times,* June 5, 2003, pp.F1 and F10–11.

## CHAPTER 6: CALIFORNIA COLLEGE OF THE ARTS

1. Wendy Kaplan, ed. *"The Art That Is Life": The Arts and Crafts Movement in America, 1875–1920* (Boston: Little, Brown and Company and the Museum of Fine Arts, Boston, 1987), p. 321.

2. CAA offers a detailed timeline of the college's history, including its former name changes over the last 100 years, on its website, www.cca.edu.

3. See Kaplan's *"The Art That Is Life,"* page 321 and Kenneth R. Trapp, *et al, The Arts and Crafts Movement in California, Living the Good Life* (New York and London: Abbeville Press, 1993), pp. 143 and 283, which give more details about the founding faculty.

4. Kaplan, *"The Art That Is Life,"* p. 302.

5. See Kaplan's *"The Art That Is Life,"* page 321 for more detailed information on the Pan-Pacific display, which exhibited Meyer's students' designs. Kaplan illustrates an oak print chest and wall cabinet designed by Margery Wheelock on page 322.

6. *Viola Frey: Memory Assembled,* a documentary film produced by David Bransten for Bay Package Productions in association with Rena Bransten Gallery, San Francisco, California, 2006.

7. Per former Oakland Museum of California Curator of Decorative Arts Suzanne Baizerman.

8. From a statement that Jean Cacicedo made for the Asia Pacific Applied Arts Forum at the University of California, Davis.

9. See Rebecca Niederlander's essay "Better Living Through Tea" in J. Lauria et al., *Color and Fire: Defining Moments in Studio Ceramics, 1950–2000* (New York: Rizzoli in association with the Los Angeles County Museum of Art, 2000), p. 210.

## CHAPTER 9: BLACK MOUNTAIN COLLEGE

1. Harris, Mary Emma, *The Arts at Black Mountain College* (Cambridge: MIT Press, 1988), pp. 2–7.

2. Ibid., p.4.

3. Ibid., p. 52.

4. Ibid., p. 53.

5. Kentgens-Craig, Margret. *The Bauhaus and America, First Contacts 1919–1936* (Cambridge, Massachusetts and London, England: MIT Press, 1999), p. 95.

6. Harris, Mary Emma, *The Arts at Black Mountain College* (Cambridge: MIT Press, 1988), p. 9.

7. Janet Kardon, *Craft in the Machine Age: The History of Twentieth-Century American Craft, 1920–1945* (New York: American Craft Museum, 1995), p. 65

8. Magdalena Droste, *Bauhaus 1919–1933* (Bauhaus-Archiv Museum für Gestaltung, Berlin, Benedikt Taschen Verlag GmbH, 1998), p. 34.

9. "Black Mountain College Project: A Brief History: 1930s, 1940s, 1950s," www.bmcproject.org and "BMC: A Radical Vision," www.blackmountaincollege.org.

10. "Black Mountain College Project: A Brief History: 1930s, 1940s, 1950s," www.bmcproject.org.

11. Herbert Bayer, Walter Gropius and Ise Gropius, eds., *Bauhaus 1919–1928* (The Museum of Modern Art, New York, 1938 and 1975), p. 23–26.

12. Harris, Mary Emma, *The Arts at Black Mountain College* (Cambridge: MIT Press, 1988), pp. 20, 24, 86.

13. Kirkham, Pat, ed. *Women Designers in the USA, 1900–2000: Diversity and Difference* (Bard Graduate Center for Studies in the Decorative Arts, New York, by Yale University Press, New Haven and London, 2000), p. 151.

14. Harris, Mary Emma, *The Arts at Black Mountain College* (Cambridge: MIT Press, 1988), p. 24.

15. Ibid., p. 132.

16. Ibid., p. 188.

17. Trapp, *Skilled Work,* American Craft in the Renwick Gallery, p. 31.

18. Harris, Mary Emma, *The Arts at Black Mountain College* (Cambridge: MIT Press, 1988), p. 191.

19. Ibid., pp. 191, 231–234.

20. Garth Clark. *American Potters: The Work of Twenty Modern Masters* (New York: Watson-Guptill Publication, 1981), p. 20.

21. Ibid., p. 20.

22. Harris, Mary Emma, *The Arts at Black Mountain College* (Cambridge: MIT Press, 1988), p. 245.

## CHAPTER 11: THE NEW STUDIO CRAFTS MOVEMENT

1. Quoted from the artist's website, www.ellsworthstudios.com/david/schoolwood.html.

2. Susan Grant Lewin, *One of a Kind American Art Jewelry Today* (New York: Harry N. Abrams, 1994), pp. 33–34.

3. Suzanne Ramljak, "Necessary Luxuries: On the Value of Crafts in Crafting a Legacy" in *Crafting a Legacy: Contemporary American Crafts in the Philadelphia Museum of Art* (Philadelphia: Philadelphia Museum of Art, 2002), p. 95.

4. Ibid., p.57.

5. Nancy Aiken, *The Biological Origins of Art* (Westport and London: Praeger, 1998), p. 174.

## CHAPTER 12: SHAPING CRAFT IN AN AMERICAN FRAMEWORK

1. American Arts and Crafts exhibition catalogs include *The Arts and Crafts Movement in America,* Princeton University, 1972; *In Pursuit of Beauty/Americans and the Aesthetic Movement,* The Metropolitan

Museum of Art and Rizzoli, New York, 1987; *"The Art That Is Life:"*
*The Arts & Crafts Movement in America, 1875–1920,* The Museum of
Fine Arts, Boston, 1987; *Minnesota 1900/Art and Life on the Upper*
*Mississippi/1890–1915,* University of Delaware Press, Newark, 1994;
*The Ideal Home/1900–1920/The History of Twentieth-Century American*
*Craft,* Harry N. Abrams, New York, 1993.
2. Olivia Mahoney, *Edward F. Worst/Craftsman and Educator* (Chicago:
Chicago Historical Society, 1985).
3. Ric Warwick, "Richard 'Dick' Poynor" in *Art of Tennessee*
(Nashville, Tenn.: Frist Center for the Visual Arts, 2003), pp. 90–91.

4. The Conference report, edited by R.C. Wilson, *The Role of the*
*Crafts in Education,* was published by the U.S. Department of Health,
Education, and Welfare, June 1969.
5. David Pye, *The Nature and Art of Workmanship* (London:
Cambridge University Press, 1968).
6. Suzanne Ramljak, "Necessary Luxuries: On the Value of Crafts in
Crafting a Legacy" in *Crafting a Legacy: Contemporary American Crafts*
*in the Philadelphia Museum of Art,* pp. 22–26.

# Selected Bibliography

Baker, Malcolm, Brenda Richardson, et al. *A Grand Design: The Art of the*
*Victoria and Albert Museum.* New York: Harry N. Abrams and the
Baltimore Museum of Art, 1997.

Clark, Garth. *American Ceramics: 1876 to the Present.* New York: Abbeville
Press, 2003.

Connick, Charles J. *Adventures in Light and Color.* New York: Random
House, 1937.

Csikszentmihalyi, Mihaly. *Flow: The Psychology of Optimal Experience.*
New York: Simon & Schuster, 1991.

Dale, Julie Schafler. *Art to Wear.* New York: Abbeville Press, 1986.

Dubin, Lois Sherr, and Kiyoshi Tagashi. *North American Indian Jewelry*
*and Adornment.* New York: Harry N. Abrams, 1999.

Eaton, Allen H. *Handicrafts of the Southern Highlands,* Dover
Publications, Inc. New York, 1973. The Dover edition first published
in 1973 is an unabridged replication of the work originally published
in 1937 by Russell Sage Foundation, New York.

Greenhalgh, Paul, ed. *The Persistence of Craft: The Applied Arts Today.*
London: A & C Black; New Brunswick, N.J.: Rutgers University
Press, 2002.

Herman, Lloyd E. *American Glass: Masters of the Art.* Seattle: University
of Washington Press, 1999.

Herman, Lloyd E. *Art That Works: The Decorative Arts of the Eighties,*
*Crafted in America.* Seattle: University of Washington Press, 1990.

Illian, Clary, and Charles Metzger. *A Potter's Workbook.* Iowa City:
University of Iowa Press, 1999.

Kardon, Janet, ed. *Craft in the Machine Age: The History of Twentieth-*
*Century American Craft 1920–1945.* New York: Harry N. Abrams in
association with the American Craft Museum, 1995.

Kardon, Janet, ed. *The Ideal Home, 1900–1920: The History of Twentieth-*
*Century American Craft.* New York: Harry N. Abrams in association
with the American Craft Museum, 1993.

Kardon, Janet, ed. *Revivals, Diverse Traditions 1920–1945: The History of*
*Twentieth-Century American Craft.* New York: Harry N. Abrams in
association with the American Craft Museum, 1994.

Levin, Elaine. *The History of American Ceramics.* New York: Harry N.
Abrams, 1988.

Liu, Robert K. *Collectible Beads: A Universal Aesthetic.* San Marcos, Calif.:
Ornament, Inc., 1995.

Lucie-Smith, Edward. *Furniture: A Concise History.* London: Thames and
Hudson, 1999.

Lucie-Smith, Edward. *Story of Craft: History of the Craftsman's Role in*
*Society.* Oxford: Phaidon Press, 1981.

Madarasz, Anne. *Glass, Shattering Notions.* Pittsburgh: Historical Society
of Western Pennsylvania, 1998.

Manhart, Marcia. *The Eloquent Object: The Evolution of American Art in*
*Craft Media Since 1945.* Seattle: University of Washington Press, 1987.

Miller, R. Craig. *Modern Design in the Metropolitan Museum of Art, 1890–*
*1990.* New York: Harry N. Abrams with Metropolitan Museum of
Art, 1990.

Monroe, Michael W., and Barbaralee Diamonstein. *The White House*
*Collection of American Crafts.* New York: Harry N. Abrams, 1995.

Needleman, Carla. *The Work of Craft: An Inquiry into the Nature of Crafts*
*and Craftsmanship.* Tokyo: Kodansha International, 1993.

Nordness, Lee. *Objects: USA.* New York: Viking Press, 1970.

Olivarez, Jennifer Komar. *Progressive Design in the Midwest.*
Minneapolis: Minneapolis Institute of Arts, 2000 (distributed by the
University of Minnesota Press).

Pye, David. *The Nature and Art of Workmanship.* London, New York, and
Melbourne: Cambridge University Press, 1968.

Shaw, Robert. *America's Traditional Crafts.* Hong Kong: Hugh Lauter
Levin Associates, 1993.

Simpson, Tommy, Lisa Hammel and William Bennett Seitz. *Hand and*
*Home: The Homes of American Craftsmen.* Boston: Bullfinch Press, 1994.

Smith, Paul J. *Craft Today: Poetry of the Physical.* New York: American
Craft Museum, 1986.

Trapp, Kenneth R., and Howard Risatti. *Skilled Work, American Craft in*
*the Renwick Gallery.* Washington, D.C.: Renwick Gallery, National
Museum of American Art, Smithsonian Institution, and Smithsonian
Institution Press, 1998.

## INTRODUCTION: THE EVOLUTION OF AMERICAN CRAFTS

Anderson, Clay, Andy Leon Harney, and Tom Melham. *The Craftsman in*
*America.* Washington, D.C.: National Geographic Society, 1975.

Clayton, Virginia Tuttle, Elizabeth Stillinger, Erika Doss, and Deborah
Chotner. *Drawing on America's Past: Folk Art, Modernism, and the Index*

*of American Design*. Chapel Hill: University of North Carolina Press, 2002.

Diamonstein, Barbaralee. *Handmade in America: Conversations with Fourteen Craftmasters*. New York: Harry N. Abrams, 1983.

## CHAPTER 1: RELIGIOUS COMMUNITIES AND THE HONORING OF THE HANDMADE

Arnett, William and Paul Arnett, eds. *The Quilts of Gee's Bend*. Atlanta: Tinwood Books, 2002.

Fleming, John, and Hugh Honour. *Dictionary of the Decorative Arts*. New York, Hagerstown, San Francisco, London: Harper & Row, 1977.

Good, Phyllis Pellman. *Quilts from Two Valleys: Amish Quilts from the Big Valley and Mennonite Quilts from the Shenandoah Valley*. Intercourse, Penn.: Good Books, 1999.

Gordon, Beverly. *Shaker Textile Arts*. Lebanon, N.H.: University Press of New England, 1980.

Kiracofe, Roderick, and Mary Elizabeth Johnson. *The American Quilt: A History of Cloth and Comfort 1750–1950*. New York: Clarkson Potter, 1993.

Koomler, Sharon Duane. *Shaker Style: Form, Function, and Furniture*. London: PRC Publishing, 2000.

Kraybill, Donald B., Patricia T. Herr, and Jonathan Holstein. *A Quiet Spirit: Amish Quilts from the Collection of Cindy Tietze and Stuart Hodosh*. Los Angeles, Calif.: UCLA Fowler Museum of Cultural History, 1996.

Lapsansky, Emma Jones, and Anne A. Verplanck. *Quaker Aesthetics: Reflections on Quaker Ethic in American Design and Consumption*. Philadelphia: University of Pennsylvania Press, 2003.

McCauley, Daniel. *Decorative Arts of the Amish of Lancaster County*. Intercourse, Penn.: Good Books, 1988.

Muller, Charles R., and Timothy D. Rieman. *The Shaker Chair*. Atglen, Penn.: Schiffer Publishing, 2003.

Nicoll, Jessica Fleming. *A Mirror to Show Thy Friends to Thee: Delaware Valley Signature Quilts, 1840–1855*. Winterthur Program in Early American Culture Thesis, 1989, library.winterthur.org.

Shambaugh, Bertha M. H. *Amana: The Community of True Inspiration*. A Penfield Press facsimile of the 1908 publication of the same name, published by Joan Liffring-Zug, State Historical Society of Iowa, 1988.

Shaw, Robert. *America's Traditional Crafts*. Hong Kong: Hugh Lauter Associates, 1993.

Sprigg, June. *Shaker Design*. New York: W. W. Norton in association with Whitney Museum of American Art, 1986.

Sprigg, June, and David Larkin. *Shaker: Life, Work, and Art*. Boston: Houghton Mifflin Company, 1987.

## CHAPTER 2: THE ARTS AND CRAFTS MOVEMENT IN AMERICA, 1890-1930

Anderson, Timothy, Eudorah M. Moore, and Robert W. Winter. *California Design, 1910*. Salt Lake City: Peregrine Smith Books, 1989.

Baizerman, Suzanne Lynn Downey, and John Toki. *Fired by Ideals: Arequipa Pottery and the Arts & Crafts Movement*. San Francisco: Pomegranate, 2000.

Burke, Doreen Bolger, et al. *In Pursuit of Beauty: Americans and the Aesthetic Movement*. New York: Rizzoli and the Metropolitan Museum of Art, 1987.

Clark, Robert Judson, ed. *The Arts and Crafts Movement in America 1876–1916*. Princeton, N.J.: Princeton University Press, 1972.

Crawford, Alan. *C. R. Ashbee, Architect, Designer & Romantic Socialist*. New Haven and London: Yale University Press, 1985.

Emery, Olivia H. *Craftsman Lifestyle: The Gentle Revolution*. Pasadena: California Design Publications, 1978.

Goss, Peter L., and Kenneth R. Trapp. *The Bungalow Lifestyle and the Arts & Crafts Movement in the Intermountain West*. Salt Lake City: Utah Museum of Fine Arts, University of Utah, 1995.

Kaplan, Wendy, ed. *The Arts & Crafts Movement in Europe & America: Design for the Modern World*. London: Thames & Hudson, 2004.

Kaplan, Wendy, et al. *"The Art That Is Life": The Arts & Crafts Movement in America, 1875–1920*. Boston: Little, Brown and Company and the Museum of Fine Arts, Boston, 1987.

Livingstone, Karen, and Linda Parry, eds. *International Arts and Crafts*. London: V&A Publications, 2005.

Meyer, Marilee Boyd, et al. *Inspiring Reform, Boston's Arts and Crafts Movement*. Wellesley, Mass.: Davis Museum and Cultural Center, 1997.

Morris, William. *Signs of Change: Seven Lectures*. London, New York, and Bombay: Longmans, Green, and Co., 1903.

Shay, Felix. *Elbert Hubbard of East Aurora*. New York: Wm. H. Wise, 1926.

Trapp, Kenneth R., et al. *The Arts and Crafts Movement in California, Living the Good Life*. New York: Abbeville Press in association with the Oakland Museum, 1993.

Watkins, Laura Woodside. *Early New England Potters and Their Wares*. Cambridge, Mass.: Harvard University Press, 1950.

## CHAPTER 3: NATIVE COMMUNITIES—INDIGENOUS CRAFTS BY AMERICAN INDIANS

### American Indian Titles

Chalker, Kari, ed. *Totems to Turquoise: Native North American Jewelry Arts of the Northwest and Southwest*. New York: Harry N. Abrams, 2004.

Cohodas, Marvin. *Basket Weavers for the California Curio Trade: Elizabeth and Louise Hickox*. Tucson: University of Arizona Press, 1997.

Dillingham, Rick. *Fourteen Families in Pueblo Pottery*. Albuquerque: University of New Mexico Press, 1994.

Dubin, Lois Sherr. *Arctic Transformations: The Jewelry of Denise and Samuel Wallace*. Westport, Conn.: Easton Studio Press/Theodore Dubin Foundation, 2005.

Jacka, Jerry D. *Beyond Tradition: Contemporary Indian Art and Its Evolution*. Flagstaff, Ariz.: Northland Publications, 1988.

McFadden, David Revere, and Ellen Napiura Taubman, eds. *Changing Hands: Art Without Reservation, 1: Contemporary Native American Art from the Southwest*. New York: American Craft Museum, in association with St. Martin's Press, 2002.

Schlick, Mary Dodds. *Columbia River Basketry: Gift of the Ancestors, Gift of the Earth*. Seattle: University of Washington Press, 1994.

Trimble, Stephen. *Talking with the Clay: The Art of Pueblo Pottery*. Santa Fe: School of American Research Press, 1987.

Whitaker, Kathleen. *Southwest Textiles: Weavings of the Navajo and Pueblo.* Seattle: University of Washington Press, 2002.

## Hispanic Southwest Titles

Pierce, Donna, and Marta Weigle. *Spanish New Mexico: The Spanish Colonial Arts Society Collection, Volume 2: Hispanic Arts in the Twentieth Century.* Santa Fe: Museum of New Mexico Press, 1996.

Rosenak, Chuck and Jan, eds. *The Saint Makers: Contemporary Santeras Y Santeros.* Flagstaff, Ariz.: Northland Publishing, 1998.

## CHAPTER 4: COMMUNITIES OF HERITAGE—SOUTHERN CONTRIBUTIONS

Baldwin, Cinda K. *Great and Noble Jar: Traditional Stoneware of South Carolina.* Athens: University of Georgia Press, 1993.

Burrison, John A. *Brothers in Clay: The Story of Georgia Folk Pottery.* Athens: University of Georgia Press, 1983.

Crosby, David. *Quilts and Quiltings in Claiborne County: Tradition and Change in a Rural Southern County.* Port Gibson, Miss.: Mississippi Cultural Crossroads, 1999.

Eaton, Allen H. *Handicrafts of New England.* New York: Harper & Row, 1969.

Eaton, Allen H. *Handicrafts of the Southern Highlands.* 1937. New York: Dover Publications, 1973 reprint.

Horton, Laurel, and Lynn Robertson Myers. *Social Fabric: South Carolina's Traditional Quilts.* Columbia: McKissick Museum, University of South Carolina Press, nd.

Koverman, Jill Beute, ed. *"I Made This Jar…" The Life and Works of the Enslaved African-American Potter, Dave.* Columbia: McKissick Museum, University of South Carolina Press, 1998.

Mack, Charles R. *Talking with the Turners: Conversations with Southern Folk Potters.* Columbia: University of South Carolina Press, 2006.

*Making Faces: Southern Face Vessels from 1840–1980.* Columbia: McKissick Museum, University of South Carolina Press, 2000.

Rosengarten, Dale. *Row Upon Row: Sea Grass Baskets of the South Carolina Lowcountry.* Columbia: McKissick Museum, University of South Carolina Press, 1986.

Severn, Jill, ed. *New Ways for Old Jugs: Tradition and Innovation at the Jugtown Pottery.* Columbia: McKissick Museum, University of South Carolina Press, 1994.

Sweezy, Nancy. *Raised in Clay: The Southern Pottery Tradition.* Washington, D.C.: Smithsonian Institution Press, 1984.

Vlach, John Michael. *The Afro-American Tradition in the Decorative Arts.* Cleveland: Cleveland Museum of Art, 1979.

Vlach, John Michael. *Charleston Blacksmith: The Work of Philip Simmons.* Columbia: University of South Carolina Press, 1992.

## CHAPTER 5: RHODE ISLAND SCHOOL OF DESIGN (RISD)

Frid, Tage. *Tage Frid Teaches Woodworking.* Newtown, Conn: Taunton Press, 1979.

Rose, Augustus F. (Augustus Foster). *Copper Work: A Text Book for Teachers and Students in the Manual Arts.* Worcester, Mass.: Davis Press, 1906. The book was reprinted in eight editions.

*Views: RISD Fall 2002.* Providence, R.I.: Rhode Island School of Design, 2002.

## CHAPTER 6: CALIFORNIA COLLEGE OF THE ARTS

Bray, Hazel V. *The Tapestries of Trude Guermonprez,* exhibition catalog. Oakland, Cal.: Oakland Museum, 1982.

Lauria, Jo, et al. *Color and Fire: Defining Moments in Studio Ceramics, 1950–2000.* New York: Rizzoli in association with the Los Angeles County Museum of Art, 2000.

*Ripples: Marguerite Wildenhain and Her Pond Farm Students,* exhibition held at the Robert V. Fullerton Art Museum, California State University, San Bernardino.

## CHAPTER 7: THE CRANBROOK VISION

*Arts and Crafts in Detroit 1906–1976: The Movement, The Society, The School.* Detroit: Detroit Institute of Arts, 1976.

Christ-Janer, Albert. *Eliel Saarinen: Finnish-American Architect and Educator.* Chicago: University of Chicago Press, 1979. rev. ed.

*Design in America: The Cranbrook Vision, 1925–1950.* New York: Harry N. Abrams in association with the Detroit Institute of Arts and the Metropolitan Museum of Art, 1983.

Eckert, Kathryn Bishop. *The Campus Guide: Cranbrook.* New York: Princeton Architectural Press, 2001.

## CHAPTER 8: SCHOOL FOR AMERICAN CRAFTS, ROCHESTER INSTITUTE OF TECHNOLOGY

Norton, Lisa. "A History of the School for American Craftsmen," *Metalsmith* 5 no. 1 (Winter 1985).

"The School for American Craftsmen," *Craft Horizons* 4 no. 10 (August 1945).

## CHAPTER 9: BLACK MOUNTAIN COLLEGE

Clark, Garth. *American Potters: The Work of Twenty Modern Masters.* New York: Watson-Guptill Publications, 1981.

Droste, Magdalena. *Bauhaus 1919–1933.* Kohl, Germany: Taschen Publishers, 2002 reprint.

Harris, Mary Emma. *The Arts at Black Mountain College.* Cambridge, Mass.: MIT Press, 1988

Kircham, Pat, ed. *Women Designers in the USA, 1900–2000: Diversity and Difference,* exhibition catalog. New York: Bard Graduate Center for Studies in the Decorative Arts, Design and Culture, 2001.

## CHAPTER 10: CRAFT SCHOOLS AND RESIDENCY PROGRAMS

Morgan, Lucy, with LeGette Blythe. *Gift From the Hills: Miss Lucy Morgan's Story of her Unique Penland School.* Chapel Hill: University of North Carolina Press, 1971.

Penland School of Crafts. *The Nature of Craft and the Penland Experience.* Asheville: Lark Books, 2004.

## CHAPTER 11: THE NEW STUDIO CRAFTS MOVEMENT

Adams, Henry, et al., *Edris Eckhardt: Visionary and Innovator in American Studio Ceramics and Glass.* Cleveland: Cleveland Artists Foundation, 2006.

Adamson, Jeremy. *The Furniture of Sam Maloof.* New York: W. W. Norton in association with the Smithsonian American Art Museum, 2001.

*Art in Craft Media: The Haystack Tradition* (catalog). Deer Isle, Maine: Haystack Mountain School of Crafts, 1981.

Beeley, Glenn Johnson. *Handicrafts for Everywoman.* Salt Lake City: National Women's Relief Society, 1935.

Bennett, Garry Knox, et al. *Made in Oakland: The Furniture of Garry Knox Bennett.* New York: American Craft Museum, 2001.

Bunting, Banbridge. *John Gaw Meem, Southwestern Architect.* Albuquerque: University of New Mexico Press, 1983.

Burgard, Timothy. *The Art of Craft: Contemporary Works from the Saxe Collection.* Boston: Bulfinch Press in association with the Fine Arts Museums of San Francisco, 1999.

Clark, Garth, and Tony Cunha. *The Artful Teapot.* New York: Watson-Guptill Publications, 2001.

Cooke, Edward S., Jr. *New American Furniture: The Second Generation of Studio Furnituremakers.* Boston: Museum of Fine Arts, Boston, 1989.

Cooke, Edward S., Jr.; Gerald W. R. Ward, and Kelly H. L'Ecuyer with the assistance of Pat Warner. *The Maker's Hand: American Studio Furniture, 1940–1990.* Boston: Museum of Fine Arts, Boston, 2003.

Cooke, Edward S., Jr; and Glenn Adamson. *Woodturning in North America Since 1930.* New Haven: Yale University Art Gallery, 2003.

Current, Karen, and William R. Current. *Greene & Green Architects in the Residential Style.* Fort Worth, Tex.: Amon Carter Museum of Western Art, 1974.

Dietz, Ulysses Grant. *Great Pots: Contemporary Ceramics from Function to Fantasy.* Madison, Wis.: Guild Publishing in association with the Newark Museum, Newark, N.J., 2003.

Dubin, Lois Sherr. *Arctic Transformations, the Jewelry of Denise & Samuel Wallace.* Westport, Conn.: Easton Studio Press/Theodore Dubin Foundation, 2005.

Fairbanks, Jonathan L., and Kenworth W. Moffett. *Directions in Contemporary American Ceramics.* Boston: Museum of Fine Arts, Boston, 1984.

Fairbanks, Jonathan L., Pat Warner, et al. *Glass Today by American Studio Artists.* Boston: Museum of Fine Arts, Boston, 1997.

Frid, Tage. *Frid Teaches Woodworking—Book 1—Joinery.* Newtown, Conn.: Taunton Press, 1979.

Game, Amanda, and Elizabeth Goring. *Jewellery Moves: Ornament for the Twenty-first Century.* Edinburgh: National Museums of Scotland, 2002.

Herman, Lloyd E., and Matthew Kangas, with an introduction by John Perreault. *Tales and Traditions: Storytelling in Twentieth-Century American Craft.* St. Louis: Craft Alliance, Saint Louis, 1993 (distributed by University of Washington Press, Seattle and London).

Herman, Lloyd E., with Gretchen Keyworth. *Trash Formations East.* Brockton, Mass.: Fuller Craft Museum, 2005.

Kangas, Matthew. *Craft and Concept: The Rematerialization of the Art Object.* New York: Midmarch Arts Press, 2006.

Kelsey, John, and Rick Mastelli, eds. *Furniture Studio: The Heart of the Functional Arts.* Free Union, Va.: Furniture Society, 1999.

Larsen, Jack Lenor. *Jack Lenor Larsen—A Weaver's Memoir.* Kenmore, N.Y.: Merrill Press, 1998.

Lewin, Susan Grant. *One of a Kind: American Art Jewelry Today.* New York: Harry N. Abrams, 1994.

Little, Carol. *Discovery: Fifty Years of Craft Experience at Haystack Mountain School of Crafts.* Orono: University of Maine at Orono Press, 2004.

Littleton, Harvey. *Glassblowing: A Search for Form.* New York: Van Nostrand, Reinhold, 1971.

Maloof, Sam, Jonathan Pollock, and Jonathan Fairbanks. *Sam Maloof: Woodworker.* New York: Kodansha America, 1989.

Mazloomi, Carolyn, Faith Ringold, and Cuesta Ray Benberry. *Spirits of the Cloth.* New York: Clarkson Potter, 1998.

McFadden, David Revere, et al. *Dual Vision: The Simona and Jerome Chazen Collection.* New York: Museum of Arts & Design, 2005.

Meilach, Dona Z. *The Contemporary Blacksmith.* Atglen, Penn.: Schiffer Publishing, 2000.

Meilach, Dona Z. *Wood Art Today: Furniture, Vessels, Sculpture.* Atglen, Penn.: Schiffer Publishing, 2004.

Merritt, Francis. *In Celebration of Francis Merritt, 1913–2000.* Deer Isle, Maine: Haystack Mountain School of Crafts, 2001.

Nakashima, George. *The Soul of a Tree: A Woodworker's Reflections.* New York: Kodansha America, 1988.

Nakashima, Mira. *Nature Form and Spirit, The Life and Legacy of George Nakashima.* New York: Harry N. Abrams, 2003.

Oldknow, Tina. *Einar and Jamex De La Torre: Intersecting Time and Place.* Corning: Museum of Glass, 2005.

Oldknow, Tina. *Pilchuck: A Glass School.* Seattle: Pilchuck Glass School in association with the University of Washington Press, 1996.

Ramljak, Suzanne, and Darrel Sewell. *Crafting a Legacy: Contemporary American Crafts in the Philadelphia Museum of Art.* Philadelphia: Philadelphia Museum of Art, 2002.

Richards, Mary Caroline. *Centering in Pottery, Poetry, and the Person.* Middletown, Conn.: Wesleyan University Press, 1962.

Simpson, Tommy. *Two Looks to Home: The Art of Tommy Simpson.* Boston: Little, Brown, 1999.

Smith, Paul, ed. *Objects for Use: Handmade by Design.* New York: Harry N. Abrams in association with the American Craft Museum, 2001.

Southworth, Susan, and Michael Southworth. *Ornamental Iron.* Boston, Mass.: David R. Godine, 1973.

Stone, Michael A. *Contemporary American Woodworkers.* Salt Lake City: Peregrine Smith, 1986.

Taragin, Davira S., Edward S. Cooke, Jr., and Joseph Giovannini. *Furniture by Wendell Castle.* New York: Hudson Hills Press in association with the Founders Society, Detroit Institute of Arts, 1989.

Wilson, R. C. *The Role of the Crafts in Education.* Washington, D.C.: U.S. Department of Health, Education and Welfare, Office of Education, Bureau of Research, 1969.

## CHAPTER 12: SHAPING CRAFT IN AN AMERICAN FRAMEWORK

Clark, Robert Judson, ed. *The Arts and Crafts Movement in America.* Princeton, N.J.: Princeton University Press, 1972.

Kentgens-Craig, Margaret. *The Bauhaus and America, First Contacts 1919–1936.* Boston: MIT Press, 2001.

Pye, David. *Wood Carver and Turner.* Bath, England: Crafts Council, 1986.

# Craft Centers and Schools

## ALABAMA

THE UNIVERSITY OF ALABAMA
Tuscaloosa, AL
art.ua.edu

UNIVERSITY OF ALABAMA
AT BIRMINGHAM
South Birmingham, AL
www.uab.edu/art/index.html

UNIVERSITY OF MONTEVALLO
Montevallo, AL
www.montevallo.edu/art

THE UNIVERSITY OF NORTH
ALABAMA
Florence, AL
www2.una.edu/art

## ALASKA

UNIVERSITY OF ALASKA
ANCHORAGE
Anchorage, AK
art.uaa.alaska.edu

UNIVERSITY OF ALASKA FAIRBANKS
Fairbanks, AK
www.uaf.edu/art

## ARIZONA

ARIZONA COMMISSION ON THE ARTS
Phoenix, AZ
www.azarts.gov

ARIZONA STATE UNIVERSITY
School of Art
Herberger College of Fine Arts
Tempe, AZ
art.asu.edu

CREATIVE ARTS OF CHANDLER
Chandler, AZ
(480) 855-9809

## ARKANSAS

UNIVERSITY OF ARKANSAS
Fayetteville, AR
art.uark.edu

UNIVERSITY OF ARKANSAS AT
LITTLE ROCK
Little Rock, AR
ualr.edu/art

UNIVERSITY OF CENTRAL
ARKANSAS
Conway, AR
www.uca.edu/cfac/art

## CALIFORNIA

CALIFORNIA COLLEGE OF THE ARTS
San Francisco/Oakland
San Francisco, CA

Oakland, CA
www.cca.edu

CLAY STUDIO
San Francisco, CA
www.theclaystudio.com

GEMOLOGICAL INSTITUTE OF
AMERICA
Carlsbad, CA
www.gia.edu

INSTITUTE OF MOSAIC ART
Oakland, CA
www.instituteofmosaicart.com

LOS ANGELES MUNICIPAL ART
GALLERY- BARNSDALL ART PARK
Los Angeles, CA
www.barnsdallartpark.com

PUBLIC GLASS
San Francisco, CA
www.publicglass.org

SAN JOSE STATE UNIVERSITY
San Jose, CA
ad.sjsu.edu

SAN FRANCISCO STATE UNIVERSITY
San Francisco, CA
www.sfsu.edu/~artdept

SCRIPPS COLLEGE
Claremont, CA
www.scrippscollege.edu

UNIVERSITY OF CALIFORNIA
AT DAVIS
Davis, CA
art.ucdavis.edu

UNIVERSITY OF CALIFORNIA
AT LOS ANGELES (UCLA)
Los Angeles, CA
www.arts.ucla.edu

UNIVERSITY OF SOUTHERN
CALIFORNIA
Los Angeles, CA
finearts.usc.edu

## COLORADO

ANDERSON RANCH ARTS CENTER
Snowmass Village, CO
www.andersonranch.org

## CONNECTICUT

BROOKFIELD CRAFT CENTER
Brookfield, CT
www.brookfieldcraftcenter.org

FARMINGTON VALLEY ARTS CENTER
Avon, CT
www.fvac.net

GUILFORD ART CENTER
Guilford, CT
www.handcraftcenter.org

## DELAWARE

DELAWARE COLLEGE OF ART
AND DESIGN
Wilmington, DE
www.dcad.edu

## DISTRICT OF COLUMBIA

CORCORAN COLLEGE OF ART &
DESIGN
Washington, DC
www.corcoran.edu

HOWARD UNIVERSITY
Washington, DC
www.coas.howard.edu/art

## FLORIDA

COLSON SCHOOL OF ART
Sarasota, FL
(941) 366-2662

RINGLING SCHOOL OF ART
AND DESIGN
Sarasota, FL
www.ringling.edu

## GEORGIA

SAVANNAH COLLEGE OF ART
AND DESIGN
Savannah, GA
www.scad.edu

## HAWAII

HUI NO'EAU VISUAL ARTS CENTER
Makawao, Maui, HI
www.huinoeau.com

UNIVERSITY OF HAWAII
Honolulu, HI
www.hawaii.edu/art

## IDAHO

UNIVERSITY OF IDAHO
Moscow, ID
www.uidaho.edu/artdesign

## ILLINOIS

NORTHWESTERN UNIVERSITY
Artica Studios, Norris University
Center
Evanston, IL
www.norris.northwestern.edu

SCHOOL OF THE ART INSTITUTE
OF CHICAGO
Chicago, IL
www.saic.edu

## INDIANA

INDIANA UNIVERSITY
Henry Radford Hope School of
Fine Arts
Bloomington, IN
www.fa.indiana.edu

INDIANAPOLIS ART CENTER
Indianapolis, IN
www.indplsartcenter.org

## IOWA

UNIVERSITY OF NORTHERN IOWA
Cedar Falls, IA
www.uni.edu/artdept

## KANSAS

UNIVERSITY OF KANSAS
Lawrence, KS
arts.ky.edu

THE WICHITA CENTER FOR THE ARTS
Wichita, KS
www.wcfta.com

## KENTUCKY

BEREA COLLEGE
Berea, KY
www.berea.edu

THE KENTUCKY SCHOOL OF CRAFT
Hindman, KY
www.hazard.kctcs.edu

## LOUISIANA

TULANE UNIVERSITY
Newcomb Art Department
New Orleans, LA
www.tulane.edu/~art

## MAINE

HAYSTACK MOUNTAIN SCHOOL
OF CRAFTS
Deer Isle, ME
www.haystack-mtn.org

WATERSHED CENTER FOR THE
CERAMICS ARTS
Newcastle, ME
www.watershedceramics.org

## MARYLAND

CHESTER RIVER CRAFT AND ART
SCHOOLS
Chestertown, MD
(410) 778-5954

## MASSACHUSETTS

CAPE COD SCHOOL OF
BLACKSMITHING
Orleans, MA
(508) 240-7661

CLASSICAL BLACKSMITHING
SCHOOL OF BOSTON
Lynn, MA
www.hammersmithstudio.com/class/
classinfo.html

FULLER CRAFT MUSEUM
Brockton, MA
www.fullercraft.org

IS 183, ART SCHOOL OF THE
BERKSHIRES
Stockbridge, MA
www.is183.org

NORTH BENNET STREET SCHOOL
Boston, MA
www.nbss.org

SNOW FARM: THE NEW ENGLAND
CRAFT PROGRAM
Williamsburg, MA
www.snowfarm.org

WORCESTER CENTER FOR CRAFTS
Worcester, MA
www.worcestercraftcenter.org

## MICHIGAN

COLLEGE FOR CREATIVE STUDIES
Detroit, MI
www.ccscad.edu

CRANBROOK ACADEMY OF ART
Bloomfield Hills, MI
www.cranbrookart.edu

PEWABIC POTTERY
Detroit, MI
www.pewabic.com

UNIVERSITY OF MICHIGAN
School of Art and Design
Ann Arbor, MI
www.art-design.umich.edu

## MINNESOTA

MINNEAPOLIS COLLEGE OF ART
AND DESIGN
Minneapolis, MN
www.mcad.edu

UNIVERSITY OF MINNESOTA
Minneapolis, MN
artdept.umn.edu

## MISSISSIPPI

MISSISSIPPI CULTURAL CROSSROADS
Port Gibson, MS
www.msculturalcrossroads.org

## MISSOURI

CRAFT ALLIANCE
Universal City, MO
www.craftalliance.org

KANSAS CITY ART INSTITUTE
Kansas City, MO
www.kcai.edu

## MONTANA

ARCHIE BRAY FOUNDATION
FOR THE CERAMIC ARTS
Helena, MT
www.archiebray.org

MONTANA STATE UNIVERSITY-
BILLINGS
Billings, MT
www.msubillings.edu/art

THE UNIVERSITY OF MONTANA
Missoula, MT
www.umt.edu/art

## NEBRASKA

UNIVERSITY OF NEBRASKA, LINCOLN
International Quilt Study Center
Department of Textiles, Clothing
and Design
Lincoln, NE
www.quiltstudy.org

**HEIKKI SEPPÄ,** *SEEING YOU WITH THE*
*LIGHT THROUGH THE HYPERBOLIC*
*PARABOLOID,* 1983, STERLING SILVER.

## NEVADA

WESTERN FOLKLIFE CENTER
Elko, NV
www.westernfolklife.org

## NEW HAMPSHIRE

DARTMOUTH COLLEGE
Hanover, NH
www.dartmouth.edu/~sart

NEW HAMPSHIRE INSTITUTE OF ART
Manchester, NH
www.nhia.edu

## NEW JERSEY

AMERICAN WOODCARVING SCHOOL
Wayne, NJ
www.americanwoodcarving.com

THE ART SCHOOL AT OLD CHURCH
Demarest, NJ
www.occcartschool.org

PETERS VALLEY CRAFT EDUCATION
CENTER
Leyton, NJ
www.pvcrafts.org

WHEATON ARTS AND CULTURAL
CENTER
Millville, NJ
www.wheatonarts.org

## NEW MEXICO

TAOS ART SCHOOL
Taos, NM
taosartschool.org

TURLEY FORGE BLACKSMITHING
SCHOOL
Santa Fe, NM
www.turleyforge.com

## NEW YORK

ALFRED UNIVERSITY
Alfred, NY
art.alfred.edu

92ND STREET Y
New York, NY
www.92y.org

FASHION INSTITUTE OF
TECHNOLOGY
New York, NY
www.fitnyc.edu

GREENWICH HOUSE POTTERY
New York, NY
www.greenwichhousepottery.org

NEW YORK SCHOOL OF INTERIOR
DESIGN
New York, NY
www.nysid.edu

ROCHESTER FOLK ART GUILD
Middlesex, NY
www.rfag.org

ROCHESTER INSTITUTE OF
TECHNOLOGY SCHOOL FOR
AMERICAN CRAFTS
Rochester, NY
cias.rit.edu/crafts

URBAN GLASS
Brooklyn, NY
urbanglass.org

WOMEN'S STUDIO WORKSHOP
Rosendale, NY
www.wsworkshop.org

## NORTH CAROLINA

JOHN C. CAMPBELL FOLK SCHOOL
Brasstown, NC
www.folkschool.com

PENLAND SCHOOL OF CRAFTS
Penland, NC
www.penland.org

SOUTHERN HIGHLAND CRAFT GUILD
Asheville, NC
www.southernhighlandguild.org

## NORTH DAKOTA

UNIVERSITY OF NORTH DAKOTA
Grand Forks, ND
www.und.edu/dept/art

## OHIO

THE CLEVELAND INSTITUTE OF ART
Cleveland, OH
www.cia.edu

## OKLAHOMA

CITY ARTS CENTER AT FAIR PARK
Oklahoma City, OK
www.cityartscenter.org

## OREGON

AMERICAN JEWELERS INSTITUTE
Portland, OR
www.jewelersacademy.com

OREGON COLLEGE OF ART
AND CRAFT
Portland, OR
www.ocac.edu

## PENNSYLVANIA

FABRIC WORKSHOP AND MUSEUM
Philadelphia, PA
www.fabricworkshop.org

GRIST MILL CRAFT SCHOOL
New Britain, PA
www.handworks.com/gristml.html

PITTSBURGH CENTER FOR THE ARTS
Pittsburgh, PA
www.pittsburgharts.org/school

TOUCHSTONE CENTER FOR CRAFTS
Farmington, PA
www.touchstonecrafts.com

TEMPLE UNIVERSITY
Tyler School of Art
Elkins, PA
www.temple.edu/tyler

UNIVERSITY OF THE ARTS
Philadelphia, PA
www.uarts.edu

## RHODE ISLAND

RHODE ISLAND SCHOOL OF DESIGN
Providence, RI
www.risd.edu

## SOUTH CAROLINA

CLEMSON UNIVERSITY
Clemson, SC
www.clemson.edu/caah/art

COLUMBIA COLLEGE
Columbia, SC
www.columbiacollegesc.edu

UNIVERSITY OF SOUTH CAROLINA
Columbia, SC
www.cas.sc.edu/art

## SOUTH DAKOTA

UNIVERSITY OF SOUTH DAKOTA
Vermillion, SD
www.usd.edu/cfa/Art

## TENNESSEE

APPALACHIAN CENTER FOR CRAFT
Smithville, TN
www.tntech.edu/craftcenter

ARROWMONT SCHOOL OF ARTS
AND CRAFTS
Gaitlinburg, TN
www.arrowmont.org

DOLLYWOOD CRAFT PRESERVATION
SCHOOL
Pigeon Forge, TN
www.dollywood.com

## TEXAS

CRAFT GUILD OF DALLAS
Dallas, TX
www.craftguildofdallas.com

SOUTHWEST SCHOOL OF ART
AND CRAFT
San Antonio, TX
www.swschool.org

## UTAH

UTAH STATE UNIVERSITY
Logan, UT
www.art.usu.edu

## VERMONT

FLETCHER FARM SCHOOL FOR
THE ARTS AND CRAFTS
Ludlow, VT
www.fletcherfarm.com

SHELBURNE ART CENTER
Shelburne, VT
www.shelburneartcenter.org

VERMONT STATE CRAFT CENTER-
FROG HOLLOW
Burlington, VT
Middlebury, VT
Manchester, VT
www.froghollow.org

## VIRGINIA

SPRINGWATER FIBER WORKSHOP
Alexandria, VA
www.springwaterfiber.org

VIRGINIA COMMONWEALTH
UNIVERSITY
Richmond, VA
www.vcu.edu/arts

## WASHINGTON

CLAYSPACE ON PUGET SOUND
Suswuamish, WA
(360) 598-3688

COUPEVILLE ARTS CENTER
Coupeville, WA
www.coupevillearts.org

THE NORTHWEST SCHOOL OF
WOODEN BOATBUILDING
Port Townsend, WA
www.nwboatschool.org

PILCHUCK GLASS SCHOOL
Seattle, WA
www.pilchuck.com

PRATT FINE ARTS CENTER
Seattle, WA
www.pratt.org

UNIVERSITY OF WASHINGTON
Seattle, WA
art.washington.edu

## WEST VIRGINIA

CEDAR LAKES CRAFT CENTER
Ripley, WV
www.cedarlakes.com/craftscenter.htm

## WISCONSIN

UNIVERSITY OF WISCONSIN
Madison, WI
art.wisc.edu

## WYOMING

CASPER COLLEGE
Casper, WY
www.caspercollege.edu

# Museums That Show Crafts, Design, and Decorative Arts

## ALABAMA

BIRMINGHAM MUSEUM OF ART
Birmingham, AL
www.artsbma.org

HUNTSVILLE MUSEUM OF ART
Huntsville, AL
www.hsvmuseum.org

MONTGOMERY MUSEUM OF FINE
ARTS
Montgomery, AL
www.fineartsmuseum.com

## ALASKA

ANCHORAGE MUSEUM AT
RASMUSON CENTER
Anchorage, AK
www.anchoragemuseum.org

## ARIZONA

HEARD MUSEUM
Phoenix, AZ
www.heard.org

PHOENIX ART MUSEUM
Phoenix, AZ
www.phxart.org

## ARKANSAS

ARKANSAS ARTS CENTER
Little Rock, AR
www.arkarts.com

## CALIFORNIA

AMERICAN MUSEUM OF
CERAMIC ART
Pomona, CA
www.ceramicmuseum.org

CALIFORNIA AFRICAN
AMERICAN MUSEUM
Los Angeles, CA
www.caamuseum.org

CRAFT AND FOLK ART MUSEUM
Los Angeles, CA
www.cafam.org

DE YOUNG MUSEUM
San Francisco, CA
www.thinker.org/deyoung

THE GAMBLE HOUSE
Pasadena, CA
www.gamblehouse.org

LOS ANGELES COUNTY MUSEUM
OF ART
Los Angeles, CA
www.lacma.org

LONG BEACH MUSEUM OF ART
Long Beach, CA
www.lbma.org

MINGEI INTERNATIONAL MUSEUM
San Diego, CA
www.mingei.org

MUSEUM OF CRAFT AND FOLK ART
San Francisco, CA
www.mocfa.org

PALM SPRINGS ART MUSEUM
Palm Springs, CA
www.psmuseum.org

RUTH CHANDLER WILLIAMSON
GALLERY AT SCRIPPS COLLEGE
Claremont, CA
www.scrippscollege.edu/dept/gallery

SAN FRANCISCO MUSEUM OF
CRAFT + DESIGN
San Francisco, CA
www.sfmcd.com

SAN JOSE MUSEUM OF ART
San Jose, CA
www.sjmusart.org

SAN JOSE MUSEUM OF
QUILTS & TEXTILES
San Jose, CA
www.sjquiltmuseum.org

SANTA BARBARA MUSEUM OF ART
Santa Barbara, CA
www.sbmuseart.org

SANTA BARBARA MUSEUM OF
NATURAL HISTORY
Santa Barbara, CA
www.sbnature.org

## COLORADO

BOULDER MUSEUM OF
CONTEMPORARY ART
Boulder, CO
www.bmoca.org

DENVER ART MUSEUM
Denver, CO
www.denverartmuseum.org

## CONNECTICUT

YALE UNIVERSITY ART GALLERY
New Haven, CT
artgallery.yale.edu

## DELAWARE

DELAWARE ART MUSEUM
Wilmington, DE
www.delart.org

WINTERTHUR MUSEUM AND
COUNTRY ESTATE
Winterthur, DE
www.winterthur.org

## DISTRICT OF COLUMBIA

NATIONAL MUSEUM OF THE
AMERICAN INDIAN
Washington, DC
www.nmai.si.edu

SMITHSONIAN AMERICAN ART
MUSEUM- RENWICK GALLERY
Washington, DC
www.americanart.si.edu/renwick

THE TEXTILE MUSEUM
Washington, DC
www.textilemuseum.org

## FLORIDA

CHARLES HOSMER MORSE MUSEUM
OF AMERICAN ART
Winter Park, FL
www.morsemuseum.org

LOWE ART MUSEUM, UNIVERSITY OF
MIAMI
Coral Gables, FL
www.miami.edu/lowe

TAMPA MUSEUM OF ART
Tampa, FL
www.tampagov.net/dept_Museum

WOLFSONIAN—FLORIDA
INTERNATIONAL UNIVERSITY
Miami Beach, FL
wolfsonian.fiu.edu

## GEORGIA

GEORGIA MUSEUM OF ART
Athens, GA
www.uga.edu/gamuseum

HIGH MUSEUM OF ART
Atlanta, GA
www.high.org

## HAWAII

BISHOP MUSEUM
Honolulu, HI
www.bishopmuseum.org

THE CONTEMPORARY MUSEUM,
HONOLULU
Honolulu, HI
www.tcmhi.org

## IDAHO

BOISE ART MUSEUM
Boise, ID
www.boiseartmuseum.org

## ILLINOIS

THE ART INSTITUTE OF CHICAGO
Chicago, IL
www.artic.edu/aic

## INDIANA

INDIANAPOLIS MUSEUM OF ART
Indianapolis, IN
www.ima-art.org

## IOWA

CEDAR RAPIDS MUSEUM OF ART
Cedar Rapids, IO
www.crma.org

UNIVERSITY OF IOWA MUSEUM
OF ART
Iowa City, IO
www.uiowa.edu/uima

## KENTUCKY

KENTUCKY MUSEUM OF ART AND
CRAFT
Louisville, KY
www.kentuckyarts.org

## LOUISIANA

NEW ORLEANS MUSEUM OF ART
New Orleans, LA
www.noma.org

## MAINE

COLBY COLLEGE MUSEUM OF ART
Waterville, ME
www.colby.edu/academics_cs/museum
_of_art

FARNSWORTH ART MUSEUM
Rockland, ME
www.farnsworthmuseum.org

PORTLAND MUSEUM OF ART
Portland, ME
www.portlandmuseum.org

## MARYLAND

BALTIMORE MUSEUM OF ART
Baltimore, MD
artbma.org

THE WALTERS ART MUSEUM
Baltimore, MD
www.thewalters.org

## MASSACHUSETTS

AMERICAN TEXTILE HISTORY
MUSEUM
Lowell, MA
www.athm.org

THE ART COMPLEX MUSEUM
Duxbury, MA
www.artcomplex.org

FULLER CRAFT MUSEUM
Brockton, MA
www.fullercraft.org

MUSEUM OF FINE ARTS, BOSTON
Boston, MA
www.mfa.org

PEABODY ESSEX MUSEUM
Salem, MA
www.pem.org

## MICHIGAN

CRANBROOK ART MUSEUM
Bloomfield Hills, MI
www.cranbrookart.edu/museum

THE DETROIT INSTITUTE OF ARTS
Detroit, MI
www.dia.org

THE HENRY FORD MUSEUM AND
GREENFIELD VILLAGE
Dearborn, MI
www.hfmgv.org

## MINNESOTA

MINNEAPOLIS INSTITUTE OF ARTS
Minneapolis, MN
www.artsmia.org

TEXTILE CENTER
Minneapolis, MN
www.textilecentermn.org

## MISSISSIPPI

MISSISSIPPI MUSEUM OF ART
Jackson, MS
www.msmuseumart.org

OHR O'KEEFE MUSEUM OF ART
Biloxi, MS
www.georgeohr.org

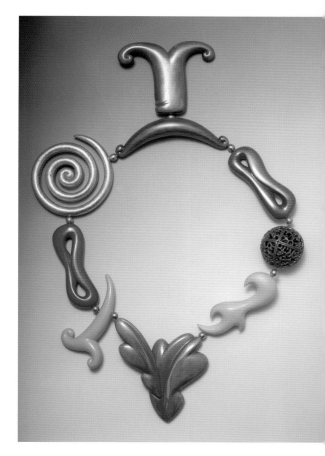

BRUCE METCALF, *LIPS AND LEAVES,* 2002,
PAINTED MAPLE, HOLLYWOOD, COPPER
ELECTROFORM, GOLD-PLATED BRASS,
23K GOLD LEAF.

WARREN MACKENZIE, VASE, C. 2002,
STONEWARE.

## MISSOURI

THE NELSON-ATKINS MUSEUM
OF ART
Kansas City, MO
www.nelson-atkins.org

SAINT LOUIS ART MUSEUM
Saint Louis, MO
www.stlouis.art.museum

## MONTANA

HOLTER MUSEUM OF ART
Helena, MT
www.holtermuseum.org

MISSOULA ART MUSEUM
Missoula, MT
www.missoulaartmuseum.org

## NEBRASKA

INTERNATIONAL QUILT STUDY
CENTER, UNIVERSITY OF NEBRASKA,
LINCOLN
Lincoln, NE
www.quiltstudy.org

## NEVADA

NEVADA MUSEUM OF ART
Reno, NV
www.nevadaart.org

## NEW HAMPSHIRE

ENFIELD SHAKER MUSEUM
Enfield, NH
www.shakermuseum.org

## NEW JERSEY

THE NEWARK MUSEUM
Newark, NJ
www.newarkmuseum.org

THE STICKLEY MUSEUM AT
CRAFTSMAN FARMS
Morris Plains, NJ
www.stickleymuseum.org

## NEW MEXICO

MUSEUM OF FINE ARTS/
NEW MEXICO
Santa Fe, NM
www.mfasantafe.org

MUSEUM OF INTERNATIONAL
FOLK ART
Santa Fe, NM
www.internationalfolkart.org

## NEW YORK

AMERICAN FOLK ART MUSEUM
New York, NY
www.folkartmuseum.org

AMERICAN MUSEUM OF NATURAL
HISTORY
New York, NY
www.amnh.org

BROOKLYN MUSEUM
Brooklyn, NY
www.brooklynmuseum.org

COOPER-HEWITT NATIONAL
DESIGN MUSEUM
New York, NY
ndm.si.edu

CORNING MUSEUM OF GLASS
Corning, NY
www.cmog.org

ELBERT HUBBARD ROYCROFT
MUSEUM
East Aurora, NY
www.roycrofter.com/museum.htm

EVERSON MUSEUM OF ART
Syracuse, NY
www.everson.org

THE JEWISH MUSEUM
New York, NY
www.jewishmuseum.org

THE METROPOLITAN MUSEUM
OF ART
New York, NY
www.metmuseum.org

THE MUSEUM OF ARTS AND DESIGN
New York, NY
www.madmuseum.org

THE MUSEUM OF MODERN ART
New York, NY
www.moma.org

NATIONAL MUSEUM OF THE
AMERICAN INDIAN- THE GUSTAV
HEYE CENTER
New York, NY
www.nmai.si.edu

SCHEIN-JOSEPH INTERNATIONAL
MUSEUM OF CERAMIC ART
Alfred, NY
ceramicsmuseum.alfred.edu

SHAKER MUSEUM AND LIBRARY
Old Chatham, NY
shakermuseumandlibrary.org

## NORTH CAROLINA

MINT MUSEUM OF CRAFT + DESIGN
Charlotte, NC
www.themintmuseums.org

NORTH CAROLINA MUSEUM OF ART
Raleigh, NC
www.ncartmuseum.org

## NORTH DAKOTA

PLAINS ART MUSEUM
Fargo, ND
www.plainsart.org

## OHIO

CINCINNATI ART MUSEUM
Cincinnati, OH
www.cincinnatiartmuseum.org

## OKLAHOMA

NATIONAL COWBOY & WESTERN
HERITAGE MUSEUM
Oklahoma, OK
www.nationalcowboymuseum.org

OKLAHOMA CITY MUSEUM OF ART
Oklahoma City, OK
www.okcmva.org

PHILBROOK MUSEUM OF ART
Tulsa, OK
www.philbrook.org

## OREGON

JOHN SCHNITZER MUSEUM OF ART
Eugene, OR
uoma.uoregon.edu

MUSEUM OF CONTEMPORARY
CRAFT
Portland, OR
www.contemporarycrafts.org

TIMBERLINE LODGE
Timberline, OR
www.timberlinelodge.com

## PENNSYLVANIA

THE BARNES FOUNDATION
Merion, PA
www.barnesfoundation.org

PHILADELPHIA MUSEUM OF ART
Philadelphia, PA
www.philamuseum.org

WHARTON ESHERICK MUSEUM
Malvern, PA
www.levins.com/esherick.html

## RHODE ISLAND

NEWPORT ART MUSEUM
Newport, RI
www.newportartmuseum.com

RHODE ISLAND SCHOOL OF DESIGN
MUSEUM
Providence, RI
www.risd.edu/museum.cfm

## SOUTH CAROLINA

McKISSICK MUSEUM
Columbia, SC
www.cas.sc.edu/mcks

## SOUTH DAKOTA

SOUTH DAKOTA ART MUSEUM
Brookings, SD
www.southdakotaartmuseum.com

## TENNESSEE

METAL MUSEUM
Memphis, TN
www.metalmuseum.org

## TEXAS

HOUSTON CENTER FOR
CONTEMPORARY CRAFT
Houston, TX
www.crafthouston.org

## UTAH

NORA ECCLES HARRISON MUSEUM
OF ART
Logan, UT
www.usu.edu/artmuseum

UTAH MUSEUM OF FINE ARTS
Salt Lake City, UT
www.umfa.utah.edu

## VERMONT

SHELBURNE MUSEUM
Shelburne, VT
www.shelburnemuseum.org

## VIRGINIA

ABBY ALDRICH ROCKEFELLER FOLK
ART MUSEUM- COLONIAL
WILLIAMSBURG
Williamsburg, VA
www.history.org/History/museums/
abby_art.cfm

CHRYSLER MUSEUM OF ART
Norfolk, VA
www.chrysler.org

DEWITT WALLACE DECORATIVE
ARTS MUSEUM
Williamsburg, VA
www.history.org/History/museums/
dewitt_gallery.cfm

VIRGINIA MUSEUM OF FINE ARTS
Richmond, VA
www.vmfa.state.va.us

WEST VIRGINIA MUSEUM OF
AMERICAN GLASS
Weston, WV
wvmag.bglances.com

## WASHINGTON

BELLEVUE ARTS MUSEUM
Bellevue, WA
www.bellevuearts.org

MUSEUM OF GLASS
Tacoma, WA
www.museumofglass.org

TACOMA ART MUSEUM
Tacoma, WA
www.tacomaartmuseum.org

## WEST VIRGINIA

HUNTINGTON MUSEUM OF ART
Huntington, WV
www.hmoa.org

## WISCONSIN

JOHN MICHAEL KOHLER ARTS
CENTER
Sheboygan, WI
www.jmkac.org

MILWAUKEE ART MUSEUM
Milwaukee, WI
www.mam.org

RACINE ART MUSEUM
Racine, WI
www.ramart.org

## WYOMING

UNIVERSITY OF WYOMING ART
MUSEUM
Laramie, WY
www.uwyo.edu/artmuseum

# Acknowledgments

*Craft in America: Celebrating Two Centuries of Artists and Objects* has been a heroic effort by scholars, writers, artists, and craft lovers. I must first thank President Jimmy Carter, the author of this book's prologue, for taking time from his schedule to share his thoughts about craft's importance to our country.

Collaboration has been the essence of my work with lead authors Jo Lauria and Steve Fenton.

Jo bravely accepted the invitation to write this book despite impossible deadlines and the task's enormity. Her scholarly approach begins to answer the questions associated with this little-understood art form. Her collaboration with editors and our contributing writers helped to define, shape, and guide, the book's content. The story of craft is told from many perspectives, but in Jo's hands, it is presented as a fluid stream of ideas, with the clarity of a unified voice. From Jo, I've learned to be tireless, tolerant, and focused, and to enjoy life as we hurry through it.

Steve Fenton has been with the *Craft in America* project from the beginning, helping to make the history and appreciation of crafts accessible. His skill in translating big ideas into understandable yet profound prose makes this book interesting *and* educational. I am extremely grateful for Steve's willingness, fortitude, and insight.

We are also indebted to Jonathan Fairbanks for his wisdom. He was instrumental in giving seasoned advice and expert counsel, acting as the book's art history consultant.

I would also like to thank our contributing authors. All accomplished scholars in their fields, they greatly enriched the book with their sensitivity, generosity, and expertise.

Many specialists contributed their knowledge: Lois Dubin, Mansfield Bascom, Suzanne Baizerman, Scarlet Cheng, Elaine Levin, and Namita Wiggers.

Our independent editor Jacqueline Tasch overcame challenging obstacles at every turn with assurance and adeptness. Fine editorial advice of text submitted by Jonathan Fairbanks was provided by Gerald W. R. Ward, The Katharine Lane Weems Senior Curator of Decorative Arts and Sculpture, Art of the Americas, Museum of Fine Arts, Boston. And a thankful bow to Kathryn Gallagher, who helped with text formatting and style consistency.

Further, I thank those who contributed their photography: Jennifer Gerardi, Jane Feldman, Robert Liu, Rachel Gehlhar, Lloyd Solly, Doug Hill, Gene Sasse, Bob Hunsicker, Michael Freeman and wife Neyla, Steve Uzzell, Cynthia Sears, M. Lee Fatherree, and Kiyoshi Togashi.

Additional images were provided by Patty Crosby, Mississippi Cultural Crossroads; Robin Dreyer, Penland School of Crafts; Cris Paschild and Karin Higa, the Japanese American National Museum; Roberta Frey Gilboe, Cranbrook Art Museum; Leslie S. Edwards, Cranbrook Archives and Cultural Properties; Marjie Gowdy and Trish Lawrence, Ohr–O'Keefe Museum of Art; Linny Adamson, Timberline Lodge; Sarah B. Munro; Jerry Grant, and Sharon Duane Koomler, Shaker Museum and Library; Pewabic Pottery; The Archie Bray Foundation; Jayne Stokes, Melody Ennis, and Melissa Buchanan, Rhode Island School of Design Museum; Paul Kotula, Paul Kotula Projects; Allyn Kaye, Asilomar State Beach and Conference Grounds; Elizabeth Cameron, Paley Studios, Ltd.; Ken Clark, Chihuly Studios; Kaye Spilker, and Cheryle Robertson, Los Angeles County Museum of Art; Albert LeCoff, the Wood Turning Center; Sylvia and Garry Knox Bennett; Seb Hamamjian, San Francisco Museum of Craft + Design; Frank Lloyd, Frank Lloyd Gallery; Gerry Ward and Erin M. A. Schleigh the Boston Museum of Fine Arts;

OPPOSITE **BETTY WOODMAN**, *HOUSE OF THE SOUTH*, 1996, CERAMIC, 173 × 273 × 9½ INCHES

Terri K. Bryson, Mingei International Museum; Sandra Wiskari, The Metropolitan Museum of Art; Anne Gochenour, and Eileen Turan, Arkansas Arts Center; Steven L. Grafe, National Cowboy & Western Heritage Museum; Cynthia von Nusbaum, Hancock Shaker Village, Jennifer Engelkemier, Amana Heritage Society; Laurence Loewy and Jamie Thompson, CMG Worldwide; Lisa Chemery and Amber Howell, Craft in America production; Susan Newsom, Tacoma Museum of Glass; David Shuford, American Craft Council Library; Jill Koverman, McKissick Museum, The University of South Carolina; North Carolina Department of Cultural Resources; Stacey Zwald Hegarty, Oakland Museum of California; Roz Bock of Sam Maloof Woodworking; Mira Nakashima of Nakashima Studio; and the United States Postal Service (for the Gee's Bend Stamps).

Donna Ropp, project manager for Craft in America, Inc., oversaw the countless details related to this book and coordinated the efforts of our researchers: Maile Pingel, Kaitlyn Collier, Scarlet Cheng, Allison Zimmer, Denise Kang, Sandi Williams, and Ruth Oglesby. Special thanks are also due the volunteers who performed the innumerable tasks that a book requires: Rachel Gehlhar, Judy Hing, Laura Hofberg, Janice Jordan, Nikki Lewis, and Francesca Rollins.

Susan Grode, of Katten, Muchin, Rosenman, gets my appreciation for serving double-duty: being a good friend as well as signing on to provide legal advice as our pro-bono counsel. Dighton Spooner must be credited for his early work on the negotiations with Random House.

And, finally, thanks go to Shaye Areheart for introducing us to all the people at Clarkson Potter who were responsible for shepherding this extensive project through to completion: Lauren Shakely, publisher; Doris Cooper, editorial director; Adrienne Jozwick, editorial assistant; and especially Maggie Hinders, senior designer. Together, their efforts have helped to bring a beautiful book to fruition—one that will give pleasure to the reader and does justice to the subject.

Fortunately, many have believed in the project just as passionately as I have, and have combined encouragement with invaluable financial support: Helen and Peter Bing, L. L. Brownrigg, Cathleen Collins, Corinna Cotsen, Lillian and Jon Lovelace, Diane Maler, Cynthia Sears and Frank Buxton, the Public Broadcasting Service (PBS), the Corporation for Public Broadcasting (CPB), the National Endowment for the Arts (NEA), the Independent Television Service (ITVS), the Stolaroff Foundation, the Windgate Charitable Foundation, the Klorfine Foundation, the Greenberg Foundation, and many others. To them I express my sincere gratitude—and the promise that the CRAFT IN AMERICA project will continue in its mission to increase awareness of craft and craft artists.

★

CRAFT IN AMERICA had its genesis in a 2002 symposium of scholars, curators, writers, artists, and filmmakers who care deeply about the handmade. They included Jacoba Atlas, James Bassler, Cathleen Collins, Miguel Angel Corzo, Anthony Cortese, Mihalyi Csikszentmihalyi, Patrick Ela, Shan Emanuelli, Steve Fenton, Janet Ginsberg, Dale Gluckman, Beverly Gordon, Barbara Hamaker, David Haugland, Jo Lauria, Nikki Lewis, Elaine Levin, Robert K. Liu, Bruce Metcalf, Stephen Poster, Tia Pulitzer, Howard Risatti, Cynthia Lovelace Sears, Dan Seeger, Kenneth Trapp, Roz Tunis, and Hidde Van Duym. Additional advice has been given by many scholars and artists as CRAFT IN AMERICA further evolved. Special thanks are due to Carolyn Benesh, Lani Lattin Duke, Steven L. Grafe, Anne Gould Hauberg, Lloyd Herman, Sarah Monroe, Eudorah Moore, and Paul Smith.

In the end it is the artists' work that is this book's true substance, and if it has helped the reader to better appreciate these objects that are all around us—and too often taken for granted—then this book has succeeded. This book is intended to complement and accompany a nationally touring exhibition and a three-part television series. We extend our sincere thanks to all the lenders who gen-

erously agreed to loan their personal and institutional treasures.

My involvement in craft began formally in 1969 when Toshi Seeger taught me how to throw pots; but it really began as a child when my mother, Madeline, taught me how to work with my hands; and my father, Gabriel, introduced me to the treasures that abound in this country. I dedicate my work on *Craft in America* to these mentors and to my children, Rachael and Noah Reitman, who have encouraged my efforts in every way.

—CAROL SAUVION

I want to thank my family—Mike, Alex, and Mackenzie Fargo—who have endured neglect in silence and have persevered with patience and grace during the protracted period required to work on this manuscript. They can now take comfort in the knowledge that the long absence of attention has come to an end, and that a meaningful book, worthy of their esteem, is the result.

—JO LAURIA

Thank you to my wife, Jackie Mirabel, who supported my decision to do this book, although it meant many hours would be spent staring at a computer screen. Dinners went cold. Vacations went by the wayside. Her acceptance, good humor, and smiling countenance made the blinking cursor easier to face. A shout out to Bill Haney, Gail Zeltman, Elliot Ravetz, and Dan Becker for their insights, wisdom, and direction; John Nieman for reminding me how much pleasure comes from writing; and Avi Barbasch, Ward Cunningham-Rundles, Jeffrey Olin, and Jamie Aisenberg, who, quite literally, kept me going.

—STEVE FENTON

Contributing Writers to CRAFT IN AMERICA: CELEBRATING TWO CENTURIES OF ARTISTS AND OBJECTS:

MARK COIR
Director of Cranbrook Archives and Cultural Properties
[Chapter 7]

JONATHAN LEO FAIRBANKS
Fellow AIC (Hon.)
The Katharine Lane Weems Curator of American
Decorative Arts and Sculpture Emeritus,
Museum of Fine Arts, Boston
[Chapters 11 and 12; art history consultant]

JEANNINE FALINO
Independent curator and consultant,
American decorative arts, sculpture, and painting
[Chapter 2, 5, and 8]

STEVEN L. GRAFE, PH.D.
Curator of American Indian Art
National Cowboy & Western Heritage Museum
[Chapter 3]

JILL BEUTE KOVERMAN
Curator of Collections, McKissick Museum
[Chapter 4]

MAILE PINGEL
Independent researcher and writer
[Chapters 6 and 9]

EMILY ZAIDEN
Independent researcher and writer
[Chapter 11]

# Credits

Cover: George and Mira Nakashima, *Conoid Bench,* designed 1961. Courtesy Mira Nakashima and Bob Hunsicker of Pharos Studios, George Erml Photograph.

2: Roseline Delisle. Susan Einstein Photograph.

6: Caleb Siemon, *Banded Low Bowl,* 2006. Doug Hill Photograph.

8: Jimmy Carter, Shaker Style Bench. Museum of Design, Atlanta, Bart Kasten Photograph.

10: John Jordan, *Black Textured Jar,* 1993, box elder. Arkansas Arts Center Foundation Collection, Gift of John and Robyn Horn, 1996.023.003.

12: June Schwarz, *No. 834,* vessel, 1981. Forrest L. Merrill Collection, M. Lee Fatherree Photograph.

13: Michael Frimkess, *Visit to Club W.O.S.E.K.,* stoneware. Courtesy of the Artist.

14: Nathan Jackson (Tlingit), Tlingit Mask, c. 1995. © AlaskaStock.com, Chris Arend Photograph.

15: *Glass in the Glory Hole,* Pilchuck Glass School. Courtesy of Pilchuck Glass School.
John Vaughn Economaki, *Vaughn Street Dessert Cart,* 1985. Courtesy of Museum of Contemporary Craft (Formerly Contemporary Crafts Gallery), Dan Kvitka Photograph.

16: James and Einar de la Torre, *Italian Style,* 2006. Doug Hill Photograph.

17: Carroll Barnes, *Paul Bunyan,* 1938. Collection of Cranbrook Art Museum, Bloomfield Hills, Michigan, Gift of the Artist (CAM 1981.58).

18: C. F. Martin & Co., *George Nakashima Commemorative Butterfly Guitar,* 1990. Courtesy of C.F. Martin & Co., Inc.

19: Lucy Morgan in Weaving Cabin at Penland School of Crafts, c. 1935. North Carolina Collection, University of North Carolina Library, Chapel Hill, Bayard Wooten Photograph.

20: Mary Chase Perry Stratton at Cranbrook, 1916. Courtesy of Pewabic Pottery, Detroit, MI and Copyright Cranbrook Archives, Bloomfield Hills, Michigan, (POL2.114.2).
*Rainbow Fountain,* Cranbrook, 1916, restored 2003. Copyright Cranbrook Archives, Bloomfield Hills, Michigan.
Newcomb Pottery, Joseph Meyer (d. 1931), Vase, 1900–10, New Orleans Louisiana, United States, Decorated by Marie de Hoa LeBlanc, glazed earthenware, 11½ x 6½ x 6½ inches. Museum of Fine Arts, Boston, Laurie Chrichton Memorial Fund, 1980.226, Photograph © 2007 Museum of Fine Arts, Boston.

21: Adelaide Alsop Robineau, *Scarab Vase,* 1911. Everson Museum of Art, Syracuse, NY, Museum Purchase, 30.4.78a-c.

22: MoMA's 1941 exhibit, "Indian Art of the United States." Museum of Modern Art, New York, NY, U.S.A., Digital Image © The Museum of Modern Art and Licensed by SCALA/Art Resource, NY

23: Ansel Adams, *Catholic Church,* Manzanar Relocation Center, California, 1943. Gift of Ansel Adams, Library of Congress Prints and Photographs Division Washington, DC, Manzanar War Relocation Center photographs, number LC-DGI-pprsp00333 DLC.

24: Bird Pins, Various camps. Bird Pins, c. 1942–1945, Japanese American National Museum.

25: Gees Bend Stamps Issued by the United States Postal Service. Quilts of Gee's Bend Stamp Series © 2006 United States Postal Service. All rights reserved. Used with Permission.

26: Philip Simmons, *Detail of Walkway Gate.* Courtesy Philip Simmons Foundation, Steve Uzzell Photograph.

28: John Townsend, Chest of Drawers, 1765, Mahogany, white pine, chestnut, tulip, poplar, 34½ x 37½ x 30¾ inches. The Metropolitan Museum of Art, Rogers Fund, 1927 (27.57.1) Photograph © 1984 The Metropolitan Museum of Art.
Paul Revere Jr., *Sons of Liberty Bowl,* 1768, silver. Museum of Fine Arts, Boston. Museum purchase with funds donated by contribution, and Francis Bartlett Fund, 49.45, Photograph © Museum of Fine Arts, Boston.

30: Thomas Hart Benton, State House Murals, WPA. Missouri State Archives. Art © T. H. Benton and R. P. Benton Testamentary Trusts/UMB Bank Trustee/Licensed by VAGA, New York, NY.

31: Sue Allan, *Blue Gentian,* 1986, hand screen-printed poster. Courtesy of Sue Allen (Original design courtesy Friends of Timberline, Archives).

Dining room of Timberline Lodge, Mt. Hood, Oregon. Friends of Timberline, Archives.
Exterior of Timberline Lodge, Mt. Hood, Oregon. Friends of Timberline, Archives.
Needleworkers hired through the Works Progress Administration at Timberline Lodge, c. 1937, Mt. Hood, Oregon. Friends of Timberline, Archives.

32: German Puzzle Jug, Yolande Delasser, watercolor, graphite, and gouache on paperboard, Index of American Design, ca. 1938. Index of American Design, Image © 2006 Board of Trustees, National Gallery of Art, Washington, 1943.8.7500.(NYC-CER-86)/IA.
Western Style Crazy Quilt, Charlotte Winter, watercolor, graphite, and gouache on paperboard, Index of American Design, ca. 1938. Index of American Design, Image © 2006 Board of Trustees, National Gallery of Art, Washington, 1943.8.2754.(NYC-TE-181)/IA.

33: Aileen Osborne Webb, November, 1956. Courtesy of American Craft Council Library and Archives.
Shaker furniture and objects (tools). Courtesy of Shaker Museum and Library, Old Chatham and New Lebanon, New York; Jane Feldman Photograph.

34: Alice Mumford Culin, *The New York World's Fair,* 1937, The Trylon and the Perisphere, Offset Lithograph poster. Library of Congress, Printed Ephemera Collection; Portfolio 133, Folder 30, reproduction number P&P, LC-USZCA-4856.

35: Raymond Loewy, *S-1 Locomotive,* Rendering, 1979. Courtesy of Laurence Loewy and CMG Worldwide.

36: Paul Bunyan in Clay, at the Oregon Ceramic Studio now the Museum of Contemporary Craft, Portland, Oregon. Courtesy of Museum of Contemporary Craft (Formerly Contemporary Crafts Gallery).
Glen Lukens, Yellow Crackle-glazed Bowl. Courtesy of Museum of Contemporary Craft (Formerly Contemporary Crafts Gallery), Dan Kvitka Photograph.

37: Edwin and Mary Goldsmith Scheier, Bowl, 1951. Collection of Cranbrook Art Museum, Bloomfield Hills, Michigan,

Museum Purchase with funds from The Cranbrook Foundation, (CAM 1951.9); Courtesy of Cranbrook Art Museum, R. H. Hensleigh and Tim Thayer Photograph, © Edwin and Mary Scheier.

38: "!", Kathleen Gray, 2001. Chris Brown Photography.

39: The Shakers at a Spiritualist Camp Meeting, ca. 1880. Courtesy of Shaker Museum and Library, Old Chatham and New Lebanon, New York; F. Crosier Photograph.

42: Oval Boxes. Michael Freeman Photography.

44: The Round Stone Barn, Hancock Shaker Village. Courtesy of Hancock Shaker Village, Jane Feldman Photograph.
Laundry/Machine Shop, Hancock Shaker Village. Courtesy of Hancock Shaker Village, Jane Feldman Photograph.
Farming Tools, 1850–1920. Courtesy of Shaker Museum and Library, Old Chatham and New Lebanon, New York; Jane Feldman Photograph.

45: Gift Drawing, "From Mother Ann to Amy Reed, January 7, 1848," drawn by Sarah Bates, Church Family, Mount Lebanon, New York. Courtesy of Shaker Museum and Library, Old Chatham and New Lebanon, New York.

46: David Gurney, Tree of Life, 2006. Doug Hill Photograph.

47: Chair Store, South Family, Mount Lebanon Shaker Village. Courtesy of Shaker Museum and Library, Old Chatham and New Lebanon, New York.
Chair Catalog, South Family, Mount Lebanon Shaker Village, ca. 1876. Courtesy of Shaker Museum and Library, Old Chatham and New Lebanon, New York.
Rocking Chairs "Product Line," Mount Lebanon, ca. 1880. Courtesy of Shaker Museum and Library, Old Chatham and New Lebanon, New York.

48: Side Chair Hung on a Peg Rail. Courtesy of Hancock Shaker Village, Jane Feldman Photograph.

49: Wheelchair, Watervliet, New York, ca. 1820–1830. Courtesy of Shaker Museum and Library, Old Chatham and New Lebanon, New York.
Side Chair, Mount Lebanon, New York, ca. 1850. Courtesy of Shaker Museum and Library, Old Chatham and New Lebanon, New York.

50: Jon Brooks, Ladderback Chair, 1996. Courtesy of San Francisco Museum of Craft and Design, The Bennett Collection, M. Lee Fatherree Photograph.

51: Ladder, Mount Lebanon, New York, ca. 1870. Courtesy of Shaker Museum and Library, Old Chatham and New Lebanon, New York; Jane Feldman Photograph.
Leon Rasmeier, Old Rocker, 2001. Museum of Art, Rhode Island School of Design, Gift of Leon Rasmeier, Erik Gould Photograph.
Gary Knox Bennett, Ladderback. Courtesy of San Francisco Museum of Craft and Design, The Bennett Collection, M. Lee Fatherree Photograph.

52: Dona Look, Basket, 2006. Courtesy of the Artist, Susan Einstein Photograph.
Pharmaceutical Workshop, Hancock Shaker Village. Michael Freeman Photography.

53: Cooper-ware from a variety of Eastern Shaker communities, 1830–1875. Courtesy of Shaker Museum and Library, Old Chatham and New Lebanon, New York; Jane Feldman Photograph.

54: Long Dress and Bonnets, 19th Century. Michael Freeman Photography.

55: Sisters, the South Family from Watervliet, New York, ca. 1890. Courtesy of Shaker Museum and Library, Old Chatham and New Lebanon, New York, Unknown Photographer.
"Oblong (Poplar) Work Box," Mount Lebanon, New York, ca. 1915. Courtesy of Shaker Museum and Library, Old Chatham and New Lebanon, New York.

56: Cloak, ca. late 19th century. Courtesy of Shaker Museum and Library, Old Chatham and New Lebanon, New York.
Exhibit of typical furnishings of a post Civil War Mount Lebanon, New York, Shaker "Retiring Room." Courtesy of Shaker Museum and Library, Old Chatham and New Lebanon, New York; Jane Feldman Photograph.

57: Sisters of South Union Settlement, Kentucky, woven silk kerchiefs. Michael Freeman Photography.
Randall Darwall, Scarves and Shawls, Detail, Hand-woven silk, 2006. Jennifer Gerardi Photograph.

59: Meeting House Bench, Enfield, New Hampshire, ca. 1845. Courtesy of Shaker Museum and Library, Old Chatham and New Lebanon, New York.
George Nakashima, Spindle-back Bench, Settee, designed 1960. Philadelphia Museum of Art: Gift of the Philadelphia Commercial Museum (also known as the Philadelphia Civic Center Museum, 2004, (2001-111-2).
George and Mira Nakashima, Conoid Bench, designed 1961. Courtesy Mira Nakashima and Bob Hunsicker of

Pharos Studios, George Erml Photograph.

60: Meeting House, Lower Alloways Creek, New Jersey, 1756. Bernard L. Herman Photograph.

61: Handcrafted Objects and Hand Sewn Clothing, Amana. Courtesy of the Amana Heritage Society, J. Rich Photograph.
Meeting House, Homestead Village, Amana. Courtesy of the Amana Heritage Society.

62: The Knitting Lesson, Amana, 1898. Courtesy of the Amana Heritage Society, Private Collection, Bertha Shambaugh Photograph.
Liebesmahl (communion) Sunday in Amana, 1894. Courtesy of the Amana Heritage Society, Friedrich Oehl, Sr. Photograph.

63: Amana Crafts Revival. Courtesy of the Amana Heritage Society.

65: Quaker Plain Dress, Winterthur Museum, Delaware. Courtesy Winterthur Museum, Gift of Eleanor A. Murphey in honor of Henry H. and Maria M. Albertson.

66: Anna (Huber) Good (1876–1969), Lancaster County, PA. Joanne Hess Siegrist Photograph.

67: Charlotte Gillingham, Cotton with block-and-roller-printed cotton, silk appliqué and pieces work, silk with silk embroidery, intersecting diagonal quilting; drawings, inscriptions, and signatures in ink. Philadelphia Museum of Art: Gift of the five grand-daughters of Samuel Padgett Hancock: Mrs. Levis Lloyd Mann, Mrs. H. Maxwell Langdon, Mrs. George K. Helbert.

68: Eagle Quilt, Pennsylvania, ca. 1870–1890. International Quilt Study Center, University of Nebraska-Lincoln, 1997.007.0460.
Mary Allen, Memorial Quilt (detail), 1841–1847, pieced and appliquéd, embroidered, and quilted cotton, 89 x 117 inches. Los Angeles County Museum of Art, Gift of Mr. and Mrs. Laurence A. Ferris, M.87.175, Photograph © 2006 Museum Associates/LACMA.

69: Crazy Stars Quilt, Lebanon County, Pennsylvania, ca. 1890–1910. International Quilt Study Center, University of Nebraska-Lincoln, 1997.007.0658.
Log Cabin Quilt, Lancaster County, Pennsylvania, ca. 1880–1900. International Quilt Study Center, University of Nebraska-Lincoln, 1997.007.0691.

70: Flowers and Grapes Quilt, Pennsylvania, ca. 1860–1880. International Quilt Study Center, University of Nebraska-Lincoln, 1997.007.0378.
Amish Women at an Auction, Elkhart-LaGrange Counties, Indiana, 1981–1984.
Susan Einstein Photograph.

71: Center Diamond Quilt, Lancaster County, Pennsylvania, ca. 1920–1940. International Quilt Study Center, University of Nebraska-Lincoln, 1997.007.0071.

72: Public Auction, Elkhart-LaGrange Counties, Indiana, 1981–1984.
Susan Einstein Photograph.

73: Bars Quilt, Lancaster County, Pennsylvania, ca. 1890–1910. International Quilt Study Center, University of Nebraska-Lincoln, 1997.003.0013.
Tumbling Blocks Quilt, Wayne County, Ohio, ca. 1975. International Quilt Study Center, University of Nebraska-Lincoln, 1997.007.0512.

74: Baskets Quilt, Midwest, ca. 1930–1950. International Quilt Study Center, University of Nebraska-Lincoln, 1997.007.0010.

75: Michael James, *Interference Effect: (Betrayed) Lover's Knot #2*, 2005, 52 x 160 inches. Larry Gawel Photograph.

76: Arturo Alonzo Sandoval, *Skyscape No. 1,* 1979. Tim Collins Photograph.

77: Wendy Huhn, *Eat, Sleep, Work, Play,* 2005. David Loveall Photography, Inc. Eugene, Oregon.

78: Rookwood Pottery, Charles (Carl) Schmidt, Vase with Black Irises, 1911, earthenware, 13 inches. Los Angeles County Museum of Art, Gift of Max and Ellen Palevsky, AC1995.250.35, Photograph © 2006 Museum Associates/LACMA.

80: C. R. Ashbee, Cover of *An Endeavor Towards the Teaching of John Ruskin and William Morris,* 1891. Courtesy Special Collections, Arizona State University Libraries.

82: "A Corner in the Hull House Labor Museum," illustrated in *The Chautauquan,* May 1903. Jane Addams Memorial Collection (JAMC neg. 475) Special Collections Department, University Library, University of Illinois at Chicago.

83: Mayflower Embroidered Centerpiece by the Deerfield Society of Blue and White Needlework, ca. 1896–1906. Photo © 2004 Pocumtuck Valley Memorial Association, Memorial Hall Museum, Deerfield, Massachusetts.

84: Elbert Hubbard, Founder of the Roycroft Community. Print Collection, Miriam and Ira D. Wallach Division of Art, Prints and Photographs, The New York Public Library, Astor, Lenox and Tilden Foundations.
Roycrofts, Chair. Courtesy Boice Lydell, Thomas Loonan Photograph.

85: Roycrofts, Coffee Cup and Saucer, 1910–1920, Manufactured by Buffalo Pottery for the Roycrofter Inn featuring the Roycroft Symbol, Earthenware. Los Angeles County Museum of Art, Gift of Jordan-Volpe Gallery, New York, NY. M.84.118.3a-b, Photograph © Museum Associates/LACMA.

86: Craftsman House, Living Room, Designed by Gustav Stickley and Craftsman Workshops, 1910–1913. The Craftsman Farms Foundation, Parsippany, New Jersey; Ray Stubblebine Photograph.

87: Bow Arm Morris Chair, original design ca. 1910, by Leopold Stickley. Photograph courtesy of L. & J. G. Stickley, Inc. Manlius, NY.

88: Byrdcliffe Arts and Crafts Colony. The Winterthur Library: Joseph Downs Collection of Manuscripts and Printed Ephemera, Matt Ferrari Photograph, Herbert F. Johnson Museum of Art Cornell University.

89: Byrdcliffe Arts and Crafts Colony, American, Linen Press, Made in: Woodstock, New York, ca. 1904. Oak, tulip poplar, brass; 55 x 41 x 18¾ inches. The Metropolitan Museum of Art, Purchase, Friends of the American Wing Fund, and Mr. and Mrs. Mark Willcox, Jr. Gift 1991 (1991.311.1), Photograph © 1992 The Metropolitan Museum of Art.

90: Rose Valley, Worker House, 1960. Courtesy of the Rose Valley Museum and Historical Society, Moylan, PA.

91: Rose Valley Community Furniture Shop Artisans, Gothic Hall Chair. Courtesy Morris Mather Potter, Rick Echelmeyer Photograph.
A House Book, 1906, Robert Wilson Hyde, Suede and brass cover, suede flyleaves, parchment, woven rag paper, and ink. Los Angeles County Museum of Art, Gift of Max Palevsky in honor of the museum's twenty-fifth anniversary, M.89.151.31, Photograph © Museum Associates/LACMA.

92: Made by Tiffany Glass and Decorating Company 1892–1902, American, Vase, Designed by Louis Comfort Tiffany (1848–1933), Made in: Corona, New York, 1893-96. Favrile glass; 14⅛ x 11½

inches. The Metropolitan Museum of Art, Gift of H. O. Havemeyer, 1896 (96.17.10), Photograph © 1991 The Metropolitan Museum of Art.

94: Maria Longworth Nichols, Rookwood Pottery Founder. Cincinnati Museum Center, Cincinnati Historical Society Library.
Rookwood Decorators, 1900. Cincinnati Museum Center, Cincinnati Historical Society Library.

95: Arthur Stone, Pair of Altar Vases, 1915. Collection of Pomfret School, Pomfret, Connecticut; Geoffrey R. Stein Photograph.

96: Arequipa Pottery, attributed to Frederick Hurten Rhead, Vase, ca. 1912, glazed earthenware, 13 x 10 inches. Collection of the Oakland Museum of California, Gift of the Estate of Pheobe H. Brown (A91.9.1).

97: Karen Koblitz, *Arts and Crafts Still Life #2,* 1994. Susan Einstein Photograph.
Randy Stromsoe, Santa Rosa Coffeepot, 2002. Courtesy of the Artist, Ron Bez Photograph.

98: Tiffany Tea Set, ca. 1878, by Tiffany & Company, silver, brass, copper, and gold. Los Angeles County Museum of Art, Decorative Arts Council Acquisition Fund, M.85.10a-c, Photograph © 2006 Museum Associates/LACMA.
Youth, Painting by Arthur and Lucia Mathews, ca. 1917. Collection of the Oakland Museum of Art, Gift of the Concours d'Antiques, the Art Guild, (A66.196.24), M. Lee Fatherree Photograph.

99: Detail of the Stairs in the David B. Gamble House, Pasadena, California, 1907-09. Ognan Borissou Photograph.
Robert Blacker House, Pasadena, California, 1907. Greene and Greene Archives, The Gamble House, University of Southern California, The Randell L. Makinson Archive, Leroy Hulbert Photograph.

100: Sam Maloof's House, San Bernardino, California. Gene Sasse Photography.

101: Sam Maloof, Double Rocker, 2006. Gene Sasse Photography.
Sam Maloof, Spiral Staircase, recycled shipping crates. Gene Sasse Photography.

102: Spokane, Man's Beaded Vest, ca. 1920. Courtesy Lee and Lois Miner Collection, Ed Muno Photograph.

104: Mesa Verde Black-on-White Kiva Jar, ca. 1200–1300 C.E. Courtesy Mesa Verde National Park, Steve Grafe Photograph.

105: Western Apache (Arizona), Polychrome Basketry Olla, ca. 1890s. Robert K. Lui/Ornament Photograph and assisted by Karen Williamson.

106: Nettie Jackson (Klikitat), Coiled Cedar Root Basket, 1984. Doug Hill Photograph, Mary Dodds Schlick Collection.

107: Slockish Family Huckleberry Picking near Mt. Adams, Washington, 1935. USDA Forest Service, Gifford Pinchot National Forest, Used With Permission, Ray M. Filloon Photograph.
Pat Courtney Gold (Wasco/Tlingit), *Honor the Wasco Weaver of the 1805 Basket Collected by Lewis and Clark,* 2003. © Tacoma Art Museum, Richard Nicol Photograph.

108: Elizabeth Hickox (Karuk), 1913. Huntington Library, Art Collections and Botanical Gardens.

109: Louisa Keyser (Washoe), "Degikup" Basket, ca. 1918. Gift of Clark Field, 1942.14.1909 © The Philbrook Museum of Art, Tulsa, Oklahoma.

110: Hohokam Culture (Arizona), Mosaic Frog Pendant, ca. 1200–1450 C.E. Robert K. Liu/Ornament Photograph.
Carl Clark (Navajo), Dancing Yeis Bracelet, 2005. Mike Waddell Photograph.
Martine Lovato (Santo Domingo Pueblo), *Doorway to Chaco Canyon Necklace and Earrings,* 2004. Lollie Pritchett Collection.

111: Doris Shippentower (Yakama/Umatilla/ Navajo), Woman's Beaded Hat, 1998. Collection of Dr. and Mrs. Robert B. Pamplin, Jr., Ed Muno Photograph.

112: Preston Singletary (Tlingit), *Killer Whale Hat,* 2004. Russell Johnson Photograph.

114: Maria Martinez and Popovi Da (San Ildefonso Pueblo), Plate with Avanyu Design, circa 1960. Fred Jones Jr. Museum of Art, The University of Oklahoma, Norman; Gift of Dr. and Mrs. R.E. Mansfield, 2003.
Nampeyo (Hopi-Tewa), Sikyatki Revival Polychrome Olla, c. 1903. © Copyright 2000 Steven L. Grafe.

115: Diego Romero (Cochiti), *Lynching,* 2004, earthenware, 5 x 11 x 11 inches. The Garth Clark and Mark Del Vecchio Collection.
Richard Zane Smith (Wyandotte), *Bury My Heart at Auschwitz,* 1995. Anonymous gift in memory of Eunice and Charles Frank; © The Philbrook Museum of Art, Tulsa, Oklahoma.

116: Jesse Monongya (Hopi/Navajo), Hummingbird Bracelet, 2005. Mike Waddell Photograph.

117: Al Qöyawayma (Hopi), *Square Tower,* 1998. Museum Purchase, The Martin and Ruth Ann Fate, Native American Art Acquisition Fund, 2003.1 © The Philbrook Museum of Art, Tulsa, Oklahoma.

118: Teri Greeves (Kiowa), *Prayer Blanket,* 2006. Courtesy Thirteen Moons Gallery, Santa Fe, NM, James Hart Photograph.

119: Ella Henderson (Navajo), Woven Rug, 2001. National Cowboy and Western Heritage Museum, Oklahoma City, OK; Catalog # 2004327, Ed Muno Photograph.

120: David Sengel, Nightbirds, 1996. Arkansas Arts Center Foundation Collection: Purchased with a gift from the Vineyard in the Park, 1997.048.

123: Scene on public square, Edgefield, S.C. (Postcards edge. Co. 33). Courtesy of South Caroliniana Library, University of South Carolina, Columbia, SC.

124: David Drake, *Food Storage "Monday" Jar,* 1857. All rights reserved McKissick Museum, The University of South Carolina, 1997.39.00.03.

125: Jonathan Green, *Sir Dave,* 1998. © Jonathan Green, Collection of Kevin and Mary Ann Donohue, Tim Stamm Photograph.

126: Jacques and Juliana Busbee, dining with Ben Owen, ca. 1940. McKissick Museum, The University of South Carolina, and Courtesy Pam and Vernon Owens.

127: Salt-glazed stoneware churn, Jugtown, North Carolina, 2006. Jugtown Pottery, Travis Owens Photograph.

129: Lanier Meaders, *Double Face Jug*; and Brown Family Potters, *Devil Jug.* Doug Hill Photograph.
Unknown enslaved potter attributed to Thomas Davies factory, Stoneware Face Vessel, Edgefield District, SC, ca. 1860. All rights reserved McKissick Museum, The University of South Carolina, 1998.37.120.02.

130: Mark Hewitt, *Large Planter: Flaming Triangles,* 2004. Private Collection, Jason Dowdle Photograph.

132: *Friendship Quilt,* Edgefield and Laurens Districts, South Carolina, 1857. All rights reserved McKissick Museum, The University of South Carolina, 1992.07.00.01.

133: Hystercine Rankin, *Memories of Hystercine Rankin,* Claiborne County, Mississippi, 1991. Courtesy of Mississippi Cultural Crossroads, Rachel Gehlhar Photograph.

134: Loraine Harrington, *Pants Legs Quilt,* c. 1992. Courtesy of Mississippi Cultural Crossroads.

135: Geraldine Nash, *Geraldine's String,* 1999, 76 x 84 inches. Courtesy of Mississippi Cultural Crossroads, Rachel Gehlhar Photograph.

136: Woven Cherokee baskets in traditional materials and patterns from the mid-1970's. Courtesy of Eudorah M. Moore, Richard Gross Photograph.

137: Jason Reid, Chairmaker, Blairsville, GA, c. 1930. Berea College, Used with special permission from the Berea College Art Department, Berea, KY, Doris Ulmann Reprint.

138: Shadrack Mace, Slipper chair, Western North Carolina, ca. 1950. Courtesy of Mountain Heritage Center, Western Carolina University, Cullowhee, NC.

141: Therman Statom, Artist, at Penland School of Crafts, 1995. Courtesy of Penland School of Crafts, Ann Hawthorne Photograph.

144: John Dunnigan, *Vestigial Bonheur du Jour,* 2000. Collection of Museum of Art, Rhode Island School of Design.

146: Randy Darwall, Portrait, 2006. Jennifer Gerardi Photograph.

147: John Eric Riis, *Greed,* Jacket, 2006. Courtesy Thirteen Moons Gallery, Sante Fe, NM.
John Eric Riis, *Greed,* Jacket, 2006, detail. Courtesy Thirteen Moons Gallery, Sante Fe, NM.

148: Louis Mueller, *The Price of Immortality,* Necklace, 1989. Museum of Art, Rhode Island School of Design, 1996.62.3, Photograph taken for hire.
John Prip, *Dimension,* Tea and Coffee Service, c. 1960. Museum of Art, Rhode Island School of Design; Elizabeth T. and Dorothy N. Casey Fund, 1999.15, Erik Gould Photograph.

149: Marie Zimmermann, Three Vessels, Painted Copper, c. early 1920's. Svartvik Metalworks, David Cole Photograph.

150: Rosanne Somerson, *Tall Black Chair,* 1990. Museum of Art, Rhode Island School of Design; Museum Purchase with funds from the National Endowment for the Arts, 1991.006; Erik Gould Photograph.

151: Dale Chihuly, Pilchuck Baskets, blown glass. © 2006 by Chihuly, ® Inc. All rights reserved; Edward Claycomb Photograph.

152: Lia Cook, *Traces: Intent,* 2002. Don Tuttle Photography.

155: Trude Guermonprez, Untitled Space Hanging, c. 1965. Collection of the Oakland Museum of California, Gift of Eric and Sylvia Elsesser, A89.1.

157: Viola Frey, Waterman and Untitled. Artists' Legacy Foundation, Used with permission; Susan Einstein Photograph. Art © Artists' Legacy Foundation / Licensed by VAGA, New York, NY.

159: Candace Kling, *Candy Sampler: Crème de la Crème,* 1998. John Bagley Photograph.

161: Robert Brady, *Loyal Subject.* Michael Scott Photograph.
Robert Arneson, *Smorgie-Bob, The Chef,* 1971. Art © Estate of Robert Arneson, Licensed by VAGA, New York, NY.

162: Jack Lenor Larsen, *Magnum,* designed 1970. Collection of Cranbrook Art Museum, Bloomfield Hills, Michigan, Museum Purchase with Funds from the Wetsman Foundation (CAM 2000.5); Courtesy of Cranbrook Art Museum, R. H. Hensleigh and Tim Thayer Photograph.

165: Thomas Hastings, Gate, 1915. Gift of George G. Booth, Photograph © 1999 Detroit Institute of Arts.
Oscar Bruno Bach, Arts and Crafts Clock, 1926–27. Copyright Cranbrook Archives, Bloomfield Hills, Michigan, (#2301).

166: Hand-colored image of the West Terrace and West Wing of Cranbrook House, ca. 1920. Copyright Cranbrook Archives, Bloomfield Hills, Michigan, (E388).

167: Edward Burne-Jones (designer) and Walter Taylor, John Martin, and Robert Ellis (weavers), *David Instructing Solomon in the Building of the Temple,* 1902–03. Copyright Cranbrook Archives, Bloomfield Hills, Michigan, (JK300).

168: Eliel Saarinen, Aerial perspective of Cranbrook School, 1926 pencil on paper. Copyright Cranbrook Archives, Bloomfield Hills, Michigan, (#2302).

169: Cranbrook's architecture and art. Copyright Cranbrook Archives, Bloomfield Hills, Michigan, (AA1057-1).

170: Studio Loja Saarinen brochure logo from the cover of a studio brochure, ca. 1932. Copyright Cranbrook Archives, Bloomfield Hills, Michigan, (#1990-08).
Studio Loja Saarinen weavers with a rug woven for a Kingswood School reception room, ca. 1931. Copyright Cranbrook Archives, Bloomfield Hills, Michigan, (#4266).

171: Arthur Nevill Kirk, *Triptych,* 1940. Collection of the Cranbrook Art Museum, Bloomfield Hills, Michigan, Gift of George Gough Booth and Ellen Scripps Booth through The Cranbrook Foundation (CAM 1940.69); Courtesy of Cranbrook Art Museum, © Estate of Arthur Nevill Kirk, R. H. Hensleigh and Tim Thayer Photograph.

172: Hiromi Oda, Woven Textile, Detail. Doug Hill Photograph.

173: Gerhardt Knodel, *Guardians of the New Day,* 1987, Cotton, linen, Mylar, 42 x 93 x 6 inches. Courtesy of Gerhardt Knodel, R.H Hensleigh Photograph.

174: Loja Saarinen (designer) and Valborg Nordquist Smalley (weaver), *Rug No. 1,* 1928. Collection of Cranbrook Art Museum, Bloomfield Hills, Michigan (CAM 1955.4); Courtesy of Ronald S. Swanson and Cranbrook Art Museum, R. H. Hensleigh Photograph.

175: Eliel and Loja Saarinen (designers) and Loja Saarinen and Valborg Nordquist Smalley (weavers), *Rug No. 2,* 1928–29. Collection of Cranbrook Art Museum, Bloomfield Hills, Michigan (CAM 1955.3), Photography © The Detroit Institute of Arts, Detroit Michigan, Dirk Bakker Photograph.

176: Eero Saarinen and Charles and Ray Eames, Haskelite corporation (plywood shells), Marli Ehrman (upholstery designer), and Heywood-Wakefield Company (Upholsterer), 32½ x 18 x 18 inches. © 2006 EAMES OFFICE LLC (www.eamesoffice.com), and Copyright Cranbrook Archives, Bloomfield Hills, Michigan, and Courtesy of Ronald S. Swanson.

177: Eliel Saarinen, "A Room for a Lady." Copyright Cranbrook Archives, Bloomfield Hills, Michigan, (#2758), and Courtesy of Ronald S. Swanson.

178: Maija Grotell with one of her vases, 1947. Copyright Cranbrook Archives, Bloomfield Hills, Michigan, (#6513).
Maija Grotell, Vase, before 1943. Collection of the Cranbrook Art Museum, Bloomfield Hills, Michigan, Gift of George Gough Booth and Ellen Scripps Booth through The Cranbrook Foundation (CAM 1943.13), R. H. Hensleigh and Tim Thayer Photograph, Courtesy of Cranbrook Art Museum.
Marianne Strengell, Robert Sailors and other students in the Cranbrook Academy of Art Weaving Studio, 1944. Copyright Cranbrook Archives, Bloomfield Hills, Michigan, (#6513).

179: Marianne Strengell in her studio at Cranbrook, ca. 1956. Copyright Cranbrook Archives, Bloomfield Hills, Michigan, (#1991-07).

Students working in the Ceramics Studio of the Cranbrook Academy of Art, 1944. Copyright Cranbrook Archives, Bloomfield Hills, Michigan, (#6656).

180: Harry Bertoia, Coffee and Tea Service, 1940. R. H. Hensleigh Photograph, Courtesy of Cranbrook Art Museum; © 2007 Estate of Harry Bertoia/ Artists Rights Society (ARS), New York, NY.
Chunghi Choo, Decanter, 1980. Collection of the Cranbrook Art Museum, Bloomfield Hills, Michigan, Gift of Dr. Charles H. Read, (CAM 1982.64); Courtesy of Cranbrook Art Museum, R. H. Hensleigh and Tim Thayer Photograph.

181: Gary S. Griffin, Scale Model, Entrance Gates, Cranbrook Academy of Art, 2001. Courtesy of Gary S. Griffin and copyright Cranbrook Archives, Bloomfield Hills, Michigan (#2006-07).
Myra Mimlitsch-Gray, Candelabrum, *Seven Fragments,* 2002–03. Collection of Cranbrook Art Museum, Bloomfield Hills, Michigan, Cranbrook Centennial Acquisition, Museum Purchase with funds from George Gough Booth and Ellen Scripps Booth by exchange (CAM 2003.6); Courtesy of Cranbrook Art Museum, R. H. Hensleigh and Tim Thayer Photograph.

182: Charles (Ed) Rossbach, *Ceremonial Vessel with Shells,* 1991. Collection of the Cranbrook Art Museum, Bloomfield Hills, Michigan, Gift of Linda and Allan Ross and Arlene and Richard Selik (CAM 1992.5); Courtesy of Cranbrook Art Museum, R. H. Hensleigh and Tim Thayer Photograph.
Richard DeVore, Vessel, 1981. Ceramic. 15 x 13 x 8.6 inches. Collection of the Cranbrook Art Museum, Bloomfield Hills, Michigan, Gift of Kempf Hogan in honor of the Helen Kyes Family (CAM 1986.7); Courtesy of Cranbrook Art Museum, R. H. Hensleigh and Tim Thayer Photograph.

185: Tage Frid, Stool with three legs, 1982, walnut, 30 x 19¾ inches. Museum of Art, Rhode Island School of Design; Gift of the Rhode Island School of Design, Class of 1982.
Wendell Castle, Music Stand. Courtesy of Wendell Castle Studio, Dirk Bakker Photograph.

186: Albert Paley, *Brooch (#68-3),* 1968. Boardman Family Collection, Courtesy of Paley Studios LTD.
William Frederick, Pair of Vases, Silver, 1994–1995, H. 12 in.; diam. 6½ inches. Courtesy of John and Lordes Mark and

William Frederick, Anthony Cuñha Photograph.

187: Jere Osgood, Summer '99 Shell Desk, 1999. Museum of Art, Rhode Island School of Design: Helen M. Danforth Acquisition Fund, 1999.30, Erik Gould Photograph.

188: Julia Galloway, Ceramic Pitcher. Doug Hill Photograph.

191: Front Porch, Robert E. Lee Hall. Courtesy of the North Carolina Department of Cultural Resources; BMC Collection, Photographs, Folder 275.1, Photographer unknown.

192: Josef Albers Drawing Class, Black Mountain College, c. 1939-40 (l-r) Harriet Englehardt, Lisa Jalowetz (squatting), Bela Martin (light t-shirt), Joseph Albers, Robert De Niro, Martha McMillan, Eunice Shifris, Claude Stoller. Courtesy of the North Carolina State Archives, Black Mountain College Papers, Photographs, Faculty Photographs.

193: Dining Hall, Lake Eden, c. 1950. Courtesy of the North Carolina Office of Archives and History, Raleigh, NC.

194: Anni Albers with unidentified student, c. 1937. Courtesy Josef Breitenbach Archive, The Josef Breitenbach Trust, New York.

195: Anni Albers, *Ancient Writing.* © 2007 The Josef and Anni Albers Foundation/Artists Rights Society (ARS), New York, NY.

196: Robert Turner, Jar, 1997. Collection Dr. Myron and Joyce Laban, Tim Thayer Photograph.

197: Karen Karnes, *Lidded Vessel,* 1988. Mingei International Museum Collection.

198: Marguerite Wildenhain, Bowl, 1956, stoneware. Scripps College, Claremont, CA. Gift of Mr. and Mrs. Fred Marer.

200: Woven textile, Penland School of Crafts, 2006. Courtesy of Penland School of Crafts, Jennifer Gerardi Photograph.
Garry Knox Bennett and Wendell Castle with a student at Penland at Penland School of Crafts. Courtesy of Penland School of Crafts, Dana Moore Photograph.
Kurt Weiser painting a ceramic vessel in his studio at Penland School of Crafts. Courtesy of Penland School of Crafts, Robin Dreyer Photograph.
Lucy Morgan and Howard (Toni) Ford with the Travelog, which took Penland products to the 1933 Chicago World's Fair. Courtesy of Penland School of Crafts, Bayard Wooten Photograph.
Artist in Residence, Shoko Teruyama,

carving clay at Penland School of Crafts, 2006. Courtesy of Penland School of Crafts, Jennifer Gerardi Photograph.
Metalworker, Gertie Schrattenthaler, Penland School of Crafts. Courtesy of Penland School of Crafts, Robin Dreyer Photograph.
A basket making class, Penland School of Crafts, 1930's. Courtesy of Penland School of Crafts, North Carolina Collection, University of North Carolina Library, Chapel Hill, Bayard Wooten Photograph.
Jim Bassler in his studio at Penland. Courtesy of Penland School of Crafts, Photographer Unknown.

202: Penland School of Crafts, 2006. Courtesy of Penland School of Crafts, Jennifer Gerardi Photograph.
Rufus Morgan Cabin, Penland School of Crafts, 1937 or earlier. Courtesy of Penland School of Crafts, Photographer Unknown.
Edward Worst and Lucy Morgan, Morgan Hall, Penland School of Crafts, c. 1934. Courtesy Penland School of Crafts and John Freas; North Carolina Office of Archives and History, Raleigh, NC., Bayard Wooten Photograph.

203: Michigan Room, Lily Loom House, Penland School of Crafts, 1950s. Courtesy of Penland School of Crafts, Larry Stevens Photograph.

204: Penland School of Crafts, *Iron Studio Gate,* 2000. Courtesy of Penland School of Crafts, David Ramsey Photograph.

205: Artist in Residence, Vivian Beer, with a chair she designed while at Penland School of Crafts, 2006. Courtesy of Penland School of Crafts, Jennifer Gerardi Photograph.
Bead Artist, David Chatt, Penland School of Crafts, 2006. Courtesy of Penland School of Crafts, Jennifer Gerardi Photograph.

206: Sarah Jaeger, c. 2005. George Lano Photograph.
Akio Takamori, Gemini Vases, 1990 (diptych). Courtesy Frank Lloyd Gallery, Anthony Cuñha Photograph.
Archie Bray Foundation, Arches. Carol Sauvion Photograph.

207: Richard Marquis, *Teapot Goblets,* 1991–94. Smithsonian American Art Museum, Washington, DC/Art Resource, NY.

210: Dante Marioni, Colored Vessel Display, 2006. Courtesy of Dante Marioni, Roger Schreiber Photograph.

212: Adrian Saxe, 2004. Lloyd Solly Photograph.

Nikki Lewis, 2004. Lloyd Solly Photograph.

213: Edris Eckhardt, Eve. Courtesy The New Bedford Museum of Glass, New Bedford, MA.
Frederick Carder, Vase. Philadelphia Museum of Art: Gift in memory of Eugene Sussel by his wife Charlene Sussel, 1991.98.68, Graydon Wood Photograph.

214: Joey Kirkpatrick and Flora C. Mace, *By Means and Measure,* 2002. Courtesy of Joey Kirkpatrick and Flora C. Mace, Robert Vinnedge Photograph.

215: William Morris, *Canopic Jar, Doe.* Courtesy of William Morris Studio, Robert Vinnedge Photograph.

216: Susan Stinsmuehlen-Amend, *Wedding Checklist,* 2005, kiln fired glass with wood supports (14 panes). Courtesy of Susan Stinsmuehlen-Amend, Kim Stephenson Photograph.
Anne Gould Hauberg, 2006. Cynthia Lovelace Sears Photograph.

217: Marvin Lipofsky, *IGS VI, 1997-99 #11,* 2000. M. Lee Fatherree Photograph.

218: Paul Stankard, *Swarming Honeybee Orb,* 2005. Schaible Photography.

219: Harvey Littleton, Penland School of Crafts. Courtesy Penland School of Crafts, Photographer Unknown.
Mark Peiser, *Moon and Palms on Blue,* 1979. Ann Hawthorne Photograph.

220: Toshiko Takaezu, *Sakura I,* 2002 and *Sakura II,* 2002. JANM, Gift of the Artist, Japanese American National Museum (2005.167.1 & 2); Courtesy of Philadelphia Museum of Art, Graydon Wood Photograph.

221" Peter Voulkos, working on a more than three-foot "stack." Courtesy of the Voulkos & Co. Catalogue Project.
Peter Voulkos, Stacked Pot, 1975. Scripps College, Claremont, CA. Gift of Mr. and Mrs. Fred Maurer, and Courtesy of the Voulkos & Co. Catalogue Project.

221: Rudy Autio, *Chocolate,* 2006. Courtesy of Rudy Autio, Chris Autio Photograph.

222: Heidi Loewen, Pitcher. Doug Hill Photograph.
Anna Silver, Pitcher. Rachel Gehlhar Photograph.
Cindy Kolodziejski, *String of Pearls,* 1999. Anthony Cuñha Photograph.

223: Cynthia Bringle, Pitcher. Doug Hill Photograph.
Kazuko Matthews, *Stacked Teapot,* 48 x 12 x 7 inches. © 1999 Kazuko Matthews, Used with Permission, P.T. Dunn Photograph.

Marc Digeros, Pitcher, terra cotta. Doug Hill Photograph.

Tinya Seeger, Pitcher. Doug Hill Photograph.

Bonnie Seeman, Teapot. Doug Hill Photograph.

Linda Sikora, Pitcher. Doug Hill Photograph.

Nikki Lewis, Pitcher and Bowl. Doug Hill Photograph.

Phyllis Green, *Conversation,* 2005. Collection of Sonny and Gloria Kamm, Ave Pildas Photograph.

David Furman, *It's Knot for Me to Say,* 1980, clay, 8¾ x 4¼ x 4 inches. Arkansas Art Center Foundation Collection: Gift from the Diane and Sandy Besser Collection, 1987.043.005.

Jeff Oestreich. Doug Hill Photograph.

Patti Warashina, *Ka-Ching,* Tea set. Robert Vinnedge Photograph.

Michelle Erikson, Pitcher. Doug Hill Photograph.

224: Ron Nagle, *Untitled Cup (R/Lantern),* 1995. Courtesy Frank Lloyd Gallery, Anthony Cuñha Photograph.

Bean Finneran, *2 Hue Yellow Ring,* 2003, ceramic. Courtesy of John Michael Kohler Arts Center, Jeffrey Machtig Photograph.

225: Richard Shaw, *China Cove,* 2000. Courtesy Frank Lloyd Gallery, Charles Kennard Photograph.

227: Tony Hepburn, Korea Gate Project, 2006. Courtesy of the Artist, Anton Reijnders Photograph.

Cary Esser, Campsis Radicans, 1998. Seth Tice-Lewis Photograph.

228: Gertrud and Otto Natzler, Tall Double-Curved Bottle with Lip, 1963. Courtesy of Cranbrook Art Museum, R. H. Hensleigh and Tim Thayer Photograph.

Ralph Bacerra, Untitled Cloud Vessel, 1997. Courtesy Frank Lloyd Gallery, Anthony Cuñha Photograph.

Laura Andreson, Bottle, *Double Gourd,* 1974. Collection, Mingei International Museum Gift of Roy Leeper and Gaylord Hall.

John Glick, *Wall Mantle with Ewer, Vessel, and Pears,* 1994. Elanor Wilson Photograph.

229: James Makins, *Still Life Grouping,* 2004. Lauren Jordan Photograph.

230: Elsa Rady, *Still Life,* 1989. Brian Forrest Photograph, Courtesy Craig Krull Gallery.

232: Lissa Hunter, *The Price of Beauty,* 2005. K. B. Pilcher Photograph.

233: Billie Ruth Sudduth, Fibonacci Rising, walnut/red, 2005 Paul Jeremias Photograph.

Karyl Sisson. Lloyd Solly Photograph.

234: Trevle Haley Wood, *Butterfly Basket,* 1999, White oak. Tennessee State Museum Collection, Bill La Fevor Photograph.

Jane Sauer, *Knotted Magic,* 1991. Sara and David Lieberman Collection, Wendy McEahern Photograph.

235: Dona Look, *Basket #2000-1,* white birch and silk thread. Susan Einstein Photograph.

Ken Loeber, *Rose Brooch,* Sterling silver + 18K gold. Ralph Gabriner Photograph.

236: Frank Cummings III, *Carousel-Age of Awareness,* 1995, walnut, ebony, rubellites, 18 karat-gold, and pearls, 16¾ x 12 inches. Courtesy of the Artist, Frank Cummings Photograph.

Bob Stocksdale, Tray, 1970, walnut. Forrest L. Merrill Collection, M. Lee Fatherree Photograph.

237: Ed Moulthrop, *Super-Ellipsoid,* 1978, tulipwood. High Museum of Art, Atlanta, Georgia, Gift of the Junior Committee of the Members Guild, 1978.1000.19; Courtesy of the Research Library and Archives of the Wood Turning Center, Philadelphia, PA.

Philip C. Moulthrop, *Mosaic Bowl,* 1994. Yale University Art Gallery, Gift of Ruth and David Waterbury, B.A. 1958, in honor of Patricia E. Kane, 2000.93.1; Courtesy the Research Library and Archives of the Wood Turning Center, Philadelphia, PA., John Carlano Photograph.

238: Mark Lindquist, *Silent Witness #1, Oppenheimer,* 1983, walnut, pecan, and elm. Collection of Margaret A. Pennington, Paul Avis Photograph.

Stoney LaMar, *Firebird,* 1989, cherry burl. Owned by Yale University Art Gallery, Gift of Robyn and John Horn; Courtesy the Research Library and Archives of the Wood Turning Center, Philadelphia, PA., John Carlano Photograph.

Robin Horn, *Natural Edged Geode,* 1988. Owned by Yale University Art Gallery, A partial gift of Robyn and John Horn and partial purchase funded by Ruth and David Waterbury, B.A. 1958.2000.55.1; Courtesy the Research Library and Archives of the Wood Turning Center, Philadelphia, PA., John Carlano Photograph.

Christian Burchard, *Baskets,* 2004. Rob Jaffe Ashland Photograph.

239: Michelle Holzapfel, *Cushioned Bowl,* 1998. Collection of Wendy Evans Joseph, David Holzapfel Photograph.

David Ellsworth, Mo's Delight, 1993. Arkansas Arts Center Foundation Collection: Gift of John and Robyn Horn. 2004.001.016.

240: Wharton Esherick, Spiral Stair. M. Bascon Photograph.

Wharton Esherick, Studio. M. Bascon Photograph. Argillite

241: Wharton Esherick, Table and Chairs. Collection of Jack Lenor Larsen, Leonard Nones Photograph.

Arthur Espenet Carpenter, Music Stand, c. 1962. Forrest L. Merrill Collection, M. Lee Fatherree Photograph.

242: Rude Osolnik, Candlestick Set, 1952, walnut. Mobile Museum of Art, Museum purchase with funds from John B. Waterman by exchange, P1998.04.01-.02-.03.

William Hunter, Kinetic Garden, 2005. Courtesy of the Artist, William Shaffer Photograph.

243: Albert Paley, *Portal Gates* commissioned for the Renwick Gallery, 1974, forged steel, brass, copper, and bronze. Courtesy of Paley Studios LTD, Bruce Miller Photograph.

Tom Joyce, *Rio Grande Gates,* 1997, Albuquerque. Courtesy of the Artist, Nick Merrick Photograph.

244: Albert Paley, Drawing of *Portal Gates for St. Louis Zoo.* Courtesy of Paley Studios LTD, Bruce Miller Photograph.

Albert Paley, *Portal Gates for St. Louis Zoo.* Courtesy of Paley Studios LTD, Bruce Miller Photograph.

C. Carl Jennings, Gate, 1971. Forrest L. Merrill Collection, M. Lee Fatherree Photograph.

245: Donna D'Aquino, *Wire Bracelet #62,* 1999, steel. Courtesy of Museum of Contemporary Craft (Formerly Contemporary Crafts Gallery), Dan Kvitka Photograph.

246: Christina Smith, *In Search of Terra Incognito,* tea service, 2002. Anthony Cuñha Photograph.

Stanley Lechtzin, *Torque Necklace.* Courtesy of the Artist, Stanley Lechtzin Photograph.

247: William Henis, *Goddess Liberty Weathervane,* Gilt-molded copper painted. © Copyright 2007 Christie's Images Ltd. All rights reserved.

248: Kit Carson, *Cactus Camp,* 2006. Doug Hill Photograph.

249: Dave & Roberta Williamson, *Insect Collection,* 2004. Collection of the Artists.

Ramona Solberg, *Necklace with Dominos,* 1989. Courtesy Robert K. Liu/ Ornament, Robert K. Liu Photograph.

250: Allan Adler, Crowns, 1953, silver and gold. Doug Hill Photograph.

Merry Renk, *James Love Peacock,*

Wedding Crown, 1981. Courtesy Mieko Hogan, Doug Hill Photograph.
Valerie Mitchell, *Tiara.* Mark Johann Photograph.

251: Jan Yager, Tiara of Useful Knowledge, 2006. Courtesy of the Artist, Jack Ramsdale Photograph.
Jan Yager, Tiara of Useful Knowledge, 2006 (in parts). Courtesy of the Artist, Jack Ramsdale Photograph.

252: Nancy Worden, *Armed and Dangerous,* 1998. Boardman Family Collection, Courtesy of Nancy Worden, Rex Rystedt Photograph.
Pencil Brothers, Ken Cory and Lesley LePere, *8-Ball,* wall hanging, 1977. Courtesy of Leslie W. LePere, Lynn Thompson Photograph.

253: Lenore Tawney, *Fountain of Word and Water,* 1963. Philadelphia Museum of Art: Gift of the Women's Committee of the Philadelphia Museum of Art, 1994, 1994.23.1.
Claire Zeisler, *Private Affair II,* 1986. Courtesy of Rhonda Hoffman Gallery and Estate of Claire Zeisler, 1987.49.2.

254: Arline M. Fisch, Pink and Silver Circles, 2005. Courtesy of the Artist, William Gullette Photograph.

255: Kay Sekimachi, Amiyose V, 1968. Collection of the Artist, M. Lee Fatherree Photograph.
Joy Stocksdale, Wall hanging, silk, 2005. Joy Stocksdale Photograph.

256: Denise and Samuel Wallace, *Woman in the Moon.* © Photography by Kiyoshi Togashi.
Denise and Samuel Wallace, *Crossroads of Continents Belt,* 1990. © Photography by Kiyoshi Togashi.

258: Jean Cacicedo, *Rain Coat #1,* 1999. Barry Shapiro Photograph.

259: Anna Lisa Hedstrom, Coat, 2005. Elaine Keenan Photograph.

260: Faith Porter, *The Cloud Maker,* 1976. Jay Ahrend Photograph.

261: Janet Lipkin, Untitled, c. 1972, mixed media, wool, yarns and ceramic ornament. The Bennett Collection, M. Lee Fatherree Photograph.

262: Judith Content, *Rain Shadow,* 2005. James Dewrance Photograph.

263: Tim Harding, Koi Kimono, 1996, silk. Courtesy of the Artist.

264: Pilgrim Edward Winslow's Family Chair, c. 1650.
From Boston, Chronicles of the Pilgrim Fathers of the Colony of Plymouth, 1620–1625, and Courtesy of Jonathan Fairbanks.
Side Chair, c. 1760-1780. Courtesy of the Diplomatic Reception Rooms, U.S. Department of State, Washington, DC,

Will Brown Photograph.
Side Chair, Mount Lebanon, New York, ca. 1830–1850. Courtesy of Shaker Museum and Library, Old Chatham and New Lebanon, New York, Michael Fredericks photograph.
Side Chair, Cat Springs, Texas, ca. 1860. Courtesy of Jonathan Fairbanks.
Charles Rohlfs Workshop, Hall Chair, ca. 1900. Los Angeles County Museum of Art, Gift of Max Palevsky in honor of the museum's twenty-fifth anniversary.
Roycrofters Furniture Shop, armchair, c. 1910. Courtesy Boice Lydell, Thomas Loonan Photograph.
Charles and Ray Eames, DMC, 1960. © 2006 EAMES OFFICE LLC (www.eamesoffice.com).
Wharton Esherick, S-K Chair, 1942. M. Bascom Photograph.

265: Sam Maloof, Side Chair. Gene Sasse Photography.
George Nakashima, *Conoid Chair,* 1961. George Erml Photograph.
Mira Nakashima Yarnall, *Concordia Chair.* Bob Hunsicker Photograph.
Charles Hollis Jones, *Wisteria Chair,* 1968. David Valenzuela Photograph.
Wendell Castle, *Dead Eye,* 2006. Photograph by Lazer, Inc.
John Coonan, Untitled, Rocking Chair. The Bennett Collection, Courtesy of San Francisco Museum of Craft and Design, M. Lee Fatherree Photograph.
Tommy Simpson, *Boxing Chair,* 1987. The Bennett Collection, Courtesy of San Francisco Museum of Craft and Design, M. Lee Fatherree Photograph.

266: Wendy Maruyama, *Mickey Mackintosh Chair,* 1988. The Bennett Collection, Courtesy of San Francisco Museum of Craft and Design, M. Lee Fatherree Photograph.
Alphonse Mattia, *Architects Valet Chair.* Museum of Art, Rhode Island School of Design; Gift of Daphne Fargo through the National Endowment for the Arts Museum Purchase Plan, Del Bogart Photograph.
Kristina Madsen, Side Chair, 1989. Courtesy of the Artist.
Tom Eckert, *Tank Chair.* Arizona State University Photographic Services, and Courtesy of the Artist.
Thomas Loeser, *Folding Chair,* 1988 (open and closed). Museum of Art, Rhode Island School of Design; Museum Purchase with the aid of the National Endowment for the Arts and the Felicia Fund, Erik Gould Photograph.
Judy Kensley McKie, *Wagging Dog Chair,* 1994. Judy McKie Photograph.
John Cederquist, *Sashimi Side Chair,*

1997. M. Lee Fatherree Photograph.
Michael Cooper, *Woody,* 2005. Courtesy of Michael Cooper, Mike Chase Photography.
Garry Knox Bennett, *GR #13 from Rietveld Series,* 2002. The Bennett Collection, M. Lee Fatherree Photograph.
Peter Shire, *Bellaire Chair,* 2006. Doug Hill Photograph.

268: Design for the *Great Rose Window* of the Cathedral Church of St. John the Divine, New York, NY. The Charles J. Connick Stained Glass Foundation, LTD. Newtonville, MA, and Courtesy of Marilyn B. Justice, President.

270: Victor Schreckengost, Punch bowl from the *Jazz Bowl* series, 1931, designed and decorated by Victor Schreckengost and molded by Cowan Pottery Studio, active 1919–1931. Museum of Fine Arts, Boston. Gift of John P. Axelrod, 1990.507, Photograph © Museum of Fine Arts, Boston.

272: The Craft House, Penland School of Crafts, 1935. Courtesy of Penland School of Crafts, Bayard Wootten Photograph.

273: John Alexander, Side Chairs, 1982, hickory. Museum of Fine Art, Boston, Purchased through funds provided by the National Endowment of the Arts, Ethan Allen Inc., and the Robert Lehman Foundation, 1982.624, Photograph © Museum of Fine Arts, Boston.
Mary and Stoney Jackson, Smithsonian Craft Show, 2006. Jennifer Gerardi Photograph.

274: Chair Catalog (cover), South Family, Mount Lebanon Shaker Village, ca. 1876. Courtesy of Shaker Museum and Library, Old Chatham and New Lebanon, New York.
Chair Catalog (interior), South Family, Mount Lebanon Shaker Village, ca. 1876. Courtesy of Shaker Museum and Library, Old Chatham and New Lebanon, New York.

275: *Craft Horizons* (cover), Asilomar conference, 1957. Courtesy of American Craft Council Library and Archives.
*Craft Horizons* (interior), Asilomar conference, 1957. Courtesy of American Craft Council Library and Archives.

276: Margaret Craver, Teapot, c. 1936, silver and Gabon ebony. Museum of Fine Arts, Boston, Gift in memory of Joyce Goldberg with funds provided by Mr. John P. Axelrod, Mr. and Mrs. Sidney Stoneman, Mr. Charles Devens, Mr. and Mrs. Peter S. Lynch, The Seminarians, Mr. James G. Hinkle, Jr., The MFA

Council and Friends, 1988.533,
Photograph © Museum of Fine Arts,
Boston.

277: Joyce J. Scott, *Three Generation Quilt #1,*
1983. Courtesy of the Artist.

278: Carol Eckert, *The Fables,* 2004,
coiled cotton over wire. Courtesy
of Carol Eckert, W. Scott Mitchell
Photograph.

279: Wayne Higby, *Seclusion Lake,* 1982,
stoneware. Courtesy of Wayne Higby,
Steve Myers Photograph.

280: Matthew Metz, Vase and Box, 2005,
hand-thrown, painted, carved and hand
built. Doug Hill Photograph.

281: Richard Notkin, *20th Century Solutions*

*Teapot: Nobody Knows Why,* 2000–06,
Yixing series. Richard Notkin
Photograph.

282: AIDS Quilt, *Zack* (square by Anna
Belle Kaufman), 1988, cotton and
acrylic paint. Courtesy of Anna Belle
Kaufman.
Cliff Lee, c. 2005. Douglas Lee
Photograph.

283: Kiff Slemmons, *Hands of the Heroes
Project,* 1987–1991, Colette, Emily
Dickenson, Madame Curie, Houdini,
Glenn Gould, Satchel Paige, Joseph
Cornell, Martin Luther King Jr.,
Don Quixote. Courtesy of the Artist,
Rod Slemmons Photograph.

284: Bennett Bean, *Master #804,* 2001,
painted earthenware. Bennett Bean
Studio.

285: George Ohr, Handled Vase (red and
green), c. 1900. Ohr O'Keefe Museum
of Art.

294: Heikki Seppa, *Seeing You with the Light
Through the Hyperbolic Paraboloid,* 1983,
sterling silver. Cynthia Lovelace Sears
Collection, Rachel Gehlhar Photograph.

297: Bruce Metcalf, *Lips and Leaves,* 2002.
Collection of the Artist.

298: Warren Mackenzie, Tall Vase. Lauren
Jordan Photograph.

300: Betty Woodman, View of Installation.
Courtesy of Max Protech Gallery.

★ ★ ★

# Index

Note: Page numbers in *italics* refer to illustrations.

## A

Abrams, Janet, 259
*Abstract Design in American Quilts*
    (Holstein), 73
Adams, Ansel, *23*
Addams, Jane, 83
Adler, Allan, 250, *250*
Aesthetic Movement, 271
African-American quilts, *25*, 25–27, *134*,
    134–135, *135*
AIDS Memorial Quilt, 281, *282*
Albers, Anni, 191, 194, *194*, *195*, 196, 248
Albers, Joseph, 191–192, *192*, 193, 194,
    196
Alexander, John, *273*
Algonquin basketry, 231–232
Allen, Mary, *68*
Allen, Sue, *31*
Amana Colonies, 61–64
Amana Refrigeration, 64
America House, 33
American Craft Council, 33, *33*, 275
American Craft Museum. *See* Museum of
    Arts and Design (New York City)
American Indians, 22–23, 103–119
    basketry, *105*, *106*, 106–107, *107*, *136*, 137,
        231–232
    beadwork, *102*, *110*, *111*, 113, *118*
    communal artistic style, 104
    contemporary artists, *111*, *112*, *115*, *116*,
        *117*, 119, *119*
    craft and community, 41
    glass, *112*, 113
    influence of geography, 108
    jewelry, 245–246, *256*, 256–257, *257*
    pottery, 113–115, *117*, 122, 219
    Santa Fe Indian Market, 116, 118
    textiles, 110–111
    war masks (Tlingit Indians), 13–14, *14*

Amish
    beliefs, 60, 61
    quilts, 64–65, 70–75
Anabaptists, 60
Ancestral Puebloan (Anasazi) culture,
    104, *104*, 108
Andreson, Laura, *228*, 231
*The Apotheosis of the Toiler* (Robineau), *21*,
    22
Appalachian furniture, 137–139
Appalachian Industrial School, 201
appliqué, 69–70, *70*
Archie Bray Foundation for the Ceramic
    Arts, 206
"Arctic Expressions: The Storytelling
    Jewelry of Denise Wallace," 256–257
Arequipa Pottery, 95–97, *96*
*Armed and Dangerous* (Worden), 252,
    *252*
Arneson, Robert, 159–160, *161*, 220
Arrowmont School of Arts and Crafts,
    19
Arts and Crafts movement, 40–41,
    79–101, 271
    Asian and Japanese influence, 98, *98*,
        99
    Booth, George Gough, 164–165
    Byrdcliffe, *88*, 88–90
    legacy of, 97, *97*, 100–101
    Rookwood Pottery, 94, *94*
    Rose Valley, 90, *90*, 91
    Roycroft Community, 84–85
    Stickley furniture, 85–87
    tenets of, 80–82
    Tiffany glass, *92*, 93–94
artwear, 259, 261
Ashbee, Charles Robert, *79*, 82–83
Asian and Japanese influence, 98, *98*, 99
"Asilomar and the Birth of Studio Craft,"
    275
Associated Artists, 93
Atlas, Gustina, 134
Autio, Rudy, 220, *221*

## B

Bacerra, Ralph, *228*
Bach, Oscar Bruno, *165*
Barber, Edwin Atlee, 128
Barnes, Carroll, *17*
Barnes Foundation, *282*
Bascom, Mansfield, 240, 241
basketry
    Amana Colonies, 62–63, *63*
    American Indians, *105*, *106*, 106–107,
        *107*, *136*, 231–232
    Eckert, Carol, *278*
    Garret, John, *234*
    Gold, Pat Courtney, *107*
    Hickox, Elizabeth, *108*
    Jackson, Mary, *273*
    Jackson, Nettie, *106*
    Klikitat legend, 106–107
    Look, Donna, *52*, 235, *235*
    new studio crafts movement,
        231–233
    at Penland, *200*
    Shakers, *52*, 55, *55*
    Sisson, Karyl, *234*
    South Carolina, 136–137
    Sudduth, Billie Ruth, 137, 232, *233*
    Wood, Trevle Haley, *234*
Bassler, Jim, *200*
Batchelder, Ernest A., 83
Bauhaus, 191, 194–195, 199
beadwork, *110*, *111*, 113, *118*, *205*, 217
Bean, Bennett, *284*
Beer, Vivian, *205*
Benesh, Carolyn K. E., 254
Bennett, Garry Knox, 50, *51*, *200*, 266
Benton, Thomas Hart, *30*
Berea College, 19, 131–132
Bertoia, Harry, 179, *180*
Bertoni, Christina, 149
Black Mountain College, 189–199
    Albers, Joseph, 191–192, *192*, 193, 194,
        196
    founder, John Andrew Rice, 189–193

pottery and ceramics, 196–199, 220
    weaving, 194, *194*, *195*, 196
blacksmithing, 243–245
    in Charleston, 26, *26*
    Simmons, Philip, *26*
blacksmithing and forged metal, 243–245
    Jennings, C. Carl, 243, *244*
    Joyce, Tom, *243*, 245
    Paley, Albert, 243, *243*, *244*, 245
blacksmithing and metal forging
    at Penland, *204*
*Blonde* (Garret, Sisson), *234*
Booth, George Gough, 163–170, 175
Booth, Henry, 168–169
Bowen, Gaza, 259
Boynton, Linda, 66
Brady, Robert, 160, *161*
Bray, Archie, 206
Brigham, William, 148
Bringle, Cynthia, *223*
Brooks, Jon, 50, *50*
Brooks, Van Wyck, 30, 32
Brown, Bill, 204–205
Brown Family Potters, *129*
Bucher, Amy, *69*
Buffalo Pottery, *85*
Burchard, Christian, *238*
Burke, Constance, 32
Burne-Jones, Edward, *166*
Burnett, John C., 170
Busbee, Jacques and Juliana, 126, *126*, 131
Bush, Lawrence, 149
*Butterfly Basket* (Wood), *234*
*By Means and Measure* (Kirkpatrick,
    Mace), *214*
Byrdcliffe Art Colony, 83, *88*, *88*–90

**C**

C. F. Martin Company, 17, *18*
Cacicedo, Jean Williams, 158, *258*
Calder, Alexander, 248
calico, *62*, 63
California College of the Arts, 153–161
*Candelabrum, Seven Fragments*
    (Mimilitsch-Gray), *181*, 182
Carder, Frederick C., 213, *213*
Carpenter, Arthur Espenet, 241
Carson, Kit, *248*, 252

Carter, Jimmy, *8*, 8–10
Castle, Wendell, 185, *185*, *200*, 241, *265*
Catawba pottery, 122
Cederquist, John, *266*
Center for Art and Public Life, 160
*Centering in Pottery, Poetry and the Person*
    (Richards), 219–220
ceramics. *See* pottery and ceramics
*Ceremonial Vessel with Shells* (Rossbach),
    179, *182*
Chandler, Thomas, 128
Charles Rohlfs Workshop, *264*, 265
Chatt, David, *205*
Cherokee nation, 122, *136*, 137, 231
Chicago, Judy, 282
Chihuly, Dale, *151*, *215*, 216
Choo, Chunghi, *180*
Christensen, Hans, 186
Clark, Carl, *110*
Cohn, Abe and Amy, 108
Cole families, 130
Coleman, Minnie Sue, *25*
collectors, 284–285
Collier, John, 23
Colonial era, 29
communal artistic style, 104
community and craft, 40–41
Connick Stained Glass Studios, *268*
Content, Judith, *262*
Cook, Lia, *152*, 158
Coolidge, Mary Hill, 36
Coonan, John, *265*
Cooper, Michael, *266*
cooperware (pails), *53*
*Copper Work* (Rose), 148
Corning Glass Works, 213, 215
Cory, Ken, *252*
craft centers and schools, 142–143,
    292–295
crafting *vs.* craft, 34–35
Craft Revival, 29
*The Craftsman*, 85, 86
Craftsman Farms, *86*, 87
Craftsman homes, 86
Craftsman Workshops, 86
Craig, Burlon, 126
Cranbrook Community, 163–182
    architecture (Eliel Saarinen), *168*, *169*,
        173–174, 175, 177, *177*, 179

clock, *165*
    designing and building, 166, *166*, *168*,
        168–169
    founder, George Gough Booth,
        163–170
    goals, 169
    metalworking, 170, *171*, 174, 179, *181*,
        182, *182*
    pottery and ceramics, 178, 179, *179*,
        *182*
    weaving, 170, *170*, 172–175, *178*, 179
Craver, Margaret, 276
*The Crossroads of Continents Belt* (Wallace
    and Wallace), 256–257
crowns, 250–251
Csikszentmihalyi, Mihaly, *16*
Culin, Alice Mumford, *34*
Cummings, Frank E., *236*

**D**

D'Aquino, Donna, *245*
Dartmouth College, 183–184
Darwall, Randall, *57*, *146*
Dave the Potter. *See* Drake, David
de Kooning, William, 193
Delasser, Yolande, *32*
Delisle, Rosaline, *2*
Delius, Jean, 275
De Patta, Margaret, 248
Detroit Society of Arts and Crafts, 165
DeVore, Richard, 179, 182, *182*
Dewey, John, 82
D'Harnoncourt, René, 23
diadems, 250
Digeros, Marc, *223*
Dissanayake, Ellen, 14
Drake, David, 26, 123, 124–125, *125*
Dubin, Lois, 257
Dunnigan, John, *144*, 149

**E**

Eames, Charles, 34, *176*, 177, 267, 277
Eames, Rae, 34, 267
Eaton, Allen, 126
Eaton, Charles Frederick, 91
Eckert, Carol, *278*
Eckert, Tom, *266*

Eckhardt, Edris, 213, *213*
Economaki, John Vaughn, *15*
Edgefield potteries, 26, *123*, 123–126, 128, *129*
Edward F. Caldwell and Company, 165, *165*
Eiseley, Loren, 13
Ellsworth, David, 236, *239*
*An Endeavor Towards the Teaching of John Ruskin and William Morris* (Ashbee), *79*
Erickson, Michelle, *223*
Eschmann, Jean, *170*
Esherick, Wharton, *240*, 240–241, *241*, *264*, 267
Esser, Cary, *227*

**F**

*The Fables* (Eckert), *278*
face jugs, 126, 128, *129*
Fairbanks, Jonathan, 208–209
favrile glass, *93*, *93*
fiber artists, 75–76
Fibonacci numbers, 232
Finneran, Bean, *224*
Fisch, Arline, *254*, 258
flow, 16
Foerstner, George, 64
Ford, Howard (Toni), *200*
*Fountain of Word and Water* (Tawney), *253*, 258
Fred Harvey Company, 117–118
Frey, Viola, 156, *157*, 221
Frid, Tage, 149, 185, *185*
Frimkess, Michael, *13*
Fuller, Buckminster, 199
Furman, David, *223*
furniture
    Alexander, John, *273*
    Appalachian, 137–139
    Bennett, Garry Knox, *50*, *51*, *200*, 266
    Brooks, Jon, *50*, *50*
    Byrdcliffe, *89*
    Carpenter, Arthur Espenet, 241
    Carter, Jimmy, *8*
    Castle, Wendell, *185*, *185*, 200, 241, *265*
    Dunnigan, John, *144*, 149
    Eames, Charles, 34, *176*, 177, 267, 277
    Eames, Rae, 34, 267

Economaki, John Vaughn, *15*
Esherick, Wharton, *240*, 240–241, *241*, *264*, 267
Frid, Tage, 149, 185, *185*
Mace, Shadrack, *138*
Maloof, Sam, 100–101, *265*, 267
Maruyama, Wendy, *266*
Nakashima, George, 58, *59*, 241, *265*, 267
Osgood, Jere, 185, *187*
Poynar, Richard "Dick," *273*
Rasmeier, Leon, 50, *51*
Reid, Jason, *137*
Rhode Island School of Design, 149, *150*
Rose Valley, 90, *91*
Roycroft, *84*
Saarinen, Eero, *176*, 177
School for American Crafts (RIT), *185*, 185–186, *187*
Shaker influence, 49–52, *50*, *51*, *52*, 58, *59*
Shakers, *33*, 47–49, *59*, 274
Somerson, Rosanne, 149, *150*
Stickley, Gustav, 29, 85–87, 271
Stickley, Leopold, 87, *87*
studio furniture movement, 240–241, 267
"Take Your Seat: A Journey Through American Furniture," 264–267
Townsend, John, 28, *28*

**G**

Galloway, Julia, 186, *188*
Gee's Bend quilts, 25, 27
geography, influence of, 108, 121–122
*Gerneration Quilt 1* (Scott), *277*
GI Bill of Rights, 27, 193–194
Gillingham, Charlotte, *67*
glass, 213–219
    California College of the Arts, 158
    Carder, Frederick C., 213, *213*
    Chihuly, Dale, *151*, 215, 216
    Connick Stained Glass Studios, *268*
    Eckhardt, Edris, 213, *213*
    Gray, Katherine, *38*
    Kirkpatrick, Joey, *214*
    Labino, Dominick, 215–216
    Lipofsky, Marvin, 153, 158, 217, *217*

Littleton, Harvey K., 215–217, 219
Mace, Flora C., *214*
Marioni, Dante, *210*
Marquis, Richard, *207*
Peiser, Mark, *219*
Penland, *219*
Pilchuck Glass School, *15*, 214–216
Rhode Island School of Design, 151
School for American Crafts (RIT), 188
Siemon, Caleb, *6*
Singletary, Preston, *112*
Stankford, Paul, *218*, 219
Stinsmuehlen-Amend, Susan, *216*
studio glass movement, 207, 213–219
Tiffany, Louis Comfort, *92*, 93–94, 271
Torre, Einar and James de la, *16*
Glick, John, *228*
Goddess Liberty weathervane, 247, *247*
Gold, Pat Courtney, *107*
golden mean, 137
Good, Anna (Huber), *66*
Gothic style, *91*
Gray, Katherine, *38*
Great Depression, 30, 31, 36, 272
*Greed Jacket* (Riis), *147*
Green, Jonathan, *125*
Green, Phyllis, *223*
Greene, Henry Mather and Charles Sumner, 98, *99*
Greeves, Teri, *118*
Griffin, Gary S., *181*
Grotell, Maija, *178*, 179
*Guardians of the New Day* (Knodel), *173*
Guermonprez, Trude, 153, *155*, 156, 196
Guild and School of Handicraft, 82–83
guitars, 17, *18*
Gurney, David, *46*

**H**

Hamada, Shoji, 198, 221
Hancock Shaker Village, *44*
*Handicrafts of the Southern Highlands* (Eaton), 126
*Hands of the Heroes Project* (Slemmons), *283*
Harding, Tim, *263*
Harrington, Loraine, *134*
Harris, Mary Emma, 199
Hastings, Thomas, 165, *165*

Hauberg, Anne and John, 216, *216*
Hedstrom, Anna Lisa, 259, 261
Henderson, Ella, *119*
Henis, William, *247*
Hepburn, Tony, *226*
Herman, Sam, 217
Hewett, Edgar Lee, 114, 117
Hewitt, Mark, *130*
Hickox, Elizabeth, *108*
Higby, Wayne, *279*
hippie movement, 259
Hiromi Oda, *173*
Hirsch, Richard, 186
Holcomb, Jan, *149*
Holstein, Jonathan, 73
Holzapfel, Michelle, *239*
Horn, Robyn, *238*
Howard, Japeth, *204*
Howe, George, 240
Hubbard, Elbert, 83–85, *84*, 271
Hughes, Robert, 28
Huhn, Wendy, 76, *77*
Hull House, *82*, 83
Hunter, William, *242*
Husted-Anderson, Adda, 248
Hyde, Robert Wilson, 91

**I**

immigration, 29, 38, 41, 44, 61–62,
    190–191, 229, 272, 274
*Index of American Design*, 30, 32, *32*
Indiana quilts, 72–73, *73*, *74–75*
Indian Arts and Crafts Act (1990), 116
Indian Arts and Crafts Board, 23
industrialization, 33–34, 79–82, 269–271,
    275
*In Search of Terra Incognito* (Smith), *246*
Inspirationists (Amana Colonies),
    60–64
Institute of American Indian Arts,
    118

**J**

Jackson, Dan, 185
Jackson, Inez Slockish, *107*
Jackson, Mary, *273*
Jackson, Nathan, *14*

Jackson, Nettie, *106*
Jaeger, Sarah, *206*
James, Alice, *204*
James, Michael, 75, 76
Japanese Americans, 23, *23–24*, *24*
Japanese and Asian influence, 98, *98*, *99*,
    198–199
Jazz Bowl (Schrechengost), 270
Jennings, C. Carl, 243, *244*
jewelry, 245–246, 248–254
    Adler, Allan, 250, *250*
    American Indians, 108, 110, 110–111,
        *111*, 245–246, 256, 256–257, *257*
    Carson, Kit, 248, *252*
    Clark, Carl, *110*
    "Crowning Glory: Contemporary
        Tiaras and Crowns," 250–251
    D'Aquino, Donna, *245*
    Lechtzin, Stanley, 246, 248, *252*
    Loeber, Ken, 235, *235*
    Lovato, Martine, *110*
    Metcalf, Bruce, 209, 278, *297*
    Mitchell, Valerie, *250*
    Montongya, Jesse, *116*
    Renk, Merry, 250, *250*
    Slemmons, Kiff, 253–254, *283*
    Smith, Christina, *246*
    Solberg, Ramona, 249, 253–254
    Wallace, Denise and Sam, *256*, 256–257,
        *257*
    Williamson, David and Roberta, *249*,
        *253*
    Worden, Nancy, 252, *252*
    Yager, Jan, 250, *250*
Jones, Charles Hollis, *265*
Jones, Cleve, 281
Jordan, John, *10*
Joyce, Tom, *243*, 245
Jugtown Pottery, 126, *126*, *127*, 131

**K**

Kabotie, Fred, *22*
Karnes, Karen, 197, *197*
Kaufman, Anna Belle, *282*
Keam, Thomas, 114, *114*, 117
Keyser, Louisa, *109*
Keyser, William, 185
Kirk, Arthur Nevill, 170, *171*, 174

Kirkpatrick, Joey, *214*
kiva jars, *104*
Klikitat baskets, *106*, 106–107, *107*
Kling, Candace, *159*, 160
Knodel, Gerhardt, 172–173, *173*
knotting, *233*
Koblitz, Karen, *97*
Kolodziejski, Cindy, *222*

**L**

Labino, Dominick, 215–216
ladder-back chairs, *47*, *48*, 49, *49*, 50, *50*,
    *51*, 137, 138
Lamar, Stoney, *237*, 238
Larsen, Jack Lenor, *162*, 172, 179
lathes, 233
Leach, Bernard, 198, 221
LeBlanc, Marie De Hoa, *20*
Lechtzin, Stanley, *246*, 248, 252
Lee, Cliff, *282*
Le Pere, Lesley, *252*
Lewis, Nikki, *212*, 223
Lewis and Clark, 107, 113
Lindquist, Mark, *236*, 238
Lindsay, Bertha, 45
Lipkin, Janet, 259, *261*
Lipofsky, Marvin, 153, 158, *217*, 217
Littleton, Harvey K., 215–217, *219*
Lobel, Paul, 248
Locke, Alain, 26
Loeber, Ken, 235, *235*
Loeser, Thomas, *266*
Loewen, Heidi, *222*
Loewy, Raymond, 35, *35*
Look, Donna, *52*, 235, *235*
Lovato, Martine, *110*
Lower Alloways Creek, *60*
Lukens, Glen, 36, *36*

**M**

Mace, Flora C., *214*
Mace, Shadrack, *138*
Mackenzie, Warren, 198, 221, *298*
Madsen, Kristina, *266*
Makins, James, *229*, 231
Maloof, Sam, 100–101, *265*, 267
Marioni, Dante, *210*

Marquis, Richard, *207*

Martin, Christian Frederick, 17

Martinez, Maria and Julian, 114, *114*, 117

Maruyama, Wendy, *266*

mass production, 34

Mathews, Arthur and Lucia, *98*, 154

Matthews, Kazako, *223*

Mattia, Alphonse, *266*

McCall, Jane Byrd, 88

McKie, Judy Kensley, *266*

McLuhan, Marshall, 280

Meaders, Cheever, 126

Meaders, Lanier, 126, 128, *129*

Mennonites, 64–65, *66*, 66–70, *68*, *69*, *70*

Merton Abbey, *166*

Metal Arts Guild of Northern California, 248

metalworking. *See also* blacksmithing and forged metal; silversmithing
  at Cranbrook, *181*
  Griffin, Gary S., *181*
  Hastings, Thomas, and Edward F. Caldwell and Company, 165, *165*
  at Rhode Island School of Design, 146, 148
  Schwartz, June, *12*
  Zimmermann, Marie, *149*

Metcalf, Bruce, 209, 278, *297*

Metz, Christian, 61

Metz, Matthew, *280*

Meyer, Frederick, 154–155

Meyer, Joseph, *20*

Micmac nation, 231

Mies van der Rohe, Ludwig, 38

Miles, Lewis, 123, 124

Miller, Ellen, 83

Miller, Richard, 247

Milles, Carl, *169*

Mimilitsch-Gray, Myra, *181*, 182

Mission furniture, 86

Missouri legislature mural, *30*

Mitchell, Valerie, *250*

modernism, 265–267, 275

*Modern Jewelry Design* exhibition (Museum of Modern Art), 247

Mondale, Joan, 9

Montongya, Jesse, *116*

Mooney, Lottie, *25*

Moore, Eudorah M., 100, 281

Moravian pottery, 122–123

Morgan, Lucy, *19*, 36, 201, *202*, 203–204, 205

Morgan, Rufus, 201

Morris, William (Arts and Crafts movement), 79–82

Morris, William (glass), *215*

Morris chair, *87*

Morris & Co., 82

Morton, Philip, 185

mosaic vessels, *237*

Motherwell, Robert, 193

Moulthrop, Ed, 234

Moulthrop, Philip, 234, 236, *237*

Mueller, Louis, 148, *148*

Munn, Geoffrey, 250

Museum of Arts and Design (New York City), 32–33

Museum of Contemporary Crafts (Portland), 36, *36*

museums and craft, 282, 284–285

museums (crafts, design, and decorative arts), 296–299

**N**

Nagle, Ron, *224*

Nakashima, George, *18*, 58, *59*, 241, *265*, 267

Nakashima, Mira. *See* Yarnall, Mira Nakashima

Nampeyo, 114, *114*

Nash, Arthur J., 93

Nash, Geraldine, *135*

National Endowment for the Arts, 140

National Museum of the American Indian, 23

Natzler, Gertrud and Otto, *228*, 229

needlework, *31*, *83*

Newcomb Pottery, 20, *20*

New Hampshire Craftsmen, 36

*The New Negro* (Locke), 26

new studio crafts movement, 208, 211–212, 276
  Asilomar, 275
  basketry, 231–233
  blacksmithing and forged metal, 243–245
  furniture, 240–241

glass, 213–219
  jewelry, 245–254, 256–257, 258–262
  pottery and ceramics, 219–231
  textile arts, 254–255
  wood turning, 233–239, 242

New York World's Fair (1939), 34

Nichols, Maria Longworth, 94, *94*

Nicholson, Grace, 108

Nordress, Lee, 279

North Bennet Street School, 271

Notkin, Richard, 281, *281*

**O**

*Objects: USA*, 279

Oda, Hiromi, 172, *172*

Oestreich, Jeff, *223*, 229

Ohio quilts, *73*, 74–75

Ohr, George, *285*

Oregon Ceramic Studio, 36, *36*

Osgood, Jere, 185, *187*

Osolnik, Rude, 234, *242*

Owen, Ben, *126*, 131

Owen, Ben, III, 131

Owens, Pam and Vernon, *127*, 131

**P**

Pacific Northwest jewelry, 253–254

pails (cooperware), *53*

Paley, Albert, 186, *186*, 243, *243*, *244*, 245

Panama-Pacific International Exposition, 96-97, 155

Paris exposition (1925), 272

Pasteur, Louis, 15

*Paul Bunyan* (Barnes), 17

Peacock Vase (Tiffany), *92*

Pearson, Ronald Hayes, 185

Peiser, Mark, *219*

Pencil Brothers, *252*

Penland School of Crafts, *19*, *19*, 139, *141*, 201–205, *219*, 272

Penn Normal, Industrial, and Agricultural School, 136

Pennsylvania quilts, *69*, *71*, *72*–74, *73*

Perkins, Dorothy Wilson, 149

Perkins, Lyle, 149

Pettway, Jessie T., *25*

Pettway, Loretta, *25*

Pewabic Pottery, 20, 22, *22*
Philadelphia Side Chair, *264*, 264–265
*The Philistine*, 84, 85
Pilchuck Glass School, *15*, 214, 215, 216
Pilgrim Edward Winslow's family chair, 264, *264*
Pirsig, Robert, 16
political statements and craft, 281–282
Pomo Indian baskets, 232
Pond Farm pottery, 155–156
Popovi Da, *114*
*Portal Gates,* Renwick Gallery (Paley), 243, *243*, 245
Porter, Faith, 259, *260*
Portland Arts and Crafts Society, 36
post-modernism, 267
pottery and ceramics, 219–231
    American Indians, 113–115, 117, 122, 219
    Andreson, Laura, *228*, 231
    Archie Bray Foundation for the Ceramic Arts, 206
    Arequipa Pottery, 95–97, *96*
    Arneson, Robert, 159–160, *161*, 220
    Autio, Rudy, 220, *221*
    Bacerra, Ralph, *228*
    Bean, Bennett, *284*
    Black Mountain College, 196–199, 220
    Brady, Robert, 160, *161*
    Buffalo Pottery, *85*
    California College of the Arts, 155–156, *157*, 158, 159–160
    Cranbrook, *178*, 179, *179*, *182*
    Delisle, Rosaline, *2*
    DeVore, Richard, 179, 182, *182*
    Drake, David (Dave the Slave), 26, 123, 124–125, *125*
    Edgefield potteries, 26, *123*, 123–126, 128, *129*
    Esser, Cary, *227*
    face jugs, 126, *127*, 128
    Finneran, Bean, *224*
    Frey, Viola, 156, *157*, 221
    Frimkess, Michael, *13*
    Galloway, Julia, 186, *188*
    Glick, John, *228*
    Grotell, Maija, *178*, 179
    Hepburn, Tony, *226*
    Hewitt, Mark, *130*
    Higby, Wayne, *279*

Jaeger, Sarah, *206*
Karnes, Karen, 197, *197*
Koblitz, Karen, *97*
Lee, Cliff, *282*
Lukens, Glen, 36, *36*
Mackenzie, Warren, 198, 221, *298*
Makins, James, *229*, 231
Martinez, Maria and Julian, 114, *114*, 117
Meaders, Lanier, 126, 128, *129*
Metz, Matthew, *280*
Nagle, Ron, *224*
Nampeyo, 114, *114*
Natzler, Gertrud and Otto, *228*, 229
Newcomb Pottery, 20, *20*
Oestreich, Jeff, *223*, 229
Ohr, George, *285*
Pewabic Pottery, 20, 22, *22*
Pitcher Perfect: A Survey of Serving Pieces, 221–222
Qöyawayma, Al, *117*
Rhode Island School of Design, 149
Robineau, Adelaide Alsop, *21*, 22
Romero, Diego, *115*
Rookwood Pottery, 79, 94, *94*
Rossbach, Charles (Ed), 179, *182*
Scheier, Edwin and Mary, *36*
Schreckengost, Vicktor, *270*
Shaw, Richard, *225*
Smith, Richard Zane, *115*
Takaezu, Toshiko, 220, *220*
Takamori, Akio, *206*
Teruyama, Shoko, *200*
Turner, Robert, *196*, 196–197, 219–220
Voulkos, Peter, 153, 159, 198, 199, 220, *221*
Weiser, Kurt, *200*
Wildenhain, Marguerite, 155–156, 197–198, *198*
Woodman, Betty, *300*
Powers, Harriet, 135–136
Poynar, Richard "Dick," *273*
Price, Will, 90
Prip, John (Jack), 148, *148*, 185
*Private Affair II* (Zeisler), *253*, 258
Prown, Jules, 209
Public Works of Art Project, 30
Punahou High School glass program, 217

**Q**
Qöyawayma, Al, *117*
Quakers, 60, *60*, 61, 64–65, *65*, 66–70, *68*
Qualla Arts and Crafts Mutual, 122, 136
Quigley, Robin, 148
quilting
    African-American, 25, 25–27, *134*, 134–136, *135*
    AIDS Memorial Quilt, 281, *282*
    Allen, Mary, *68*
    Amish, 64–65, 70–75
    appliqué, *70*
    Bucher, Amy, *69*
    contemporary, 75–77
    Gee's Bend quilts, 25, 27
    Gillingham, Charlotte, *67*
    Good, Anna (Huber), *66*
    Harrington, Loraine, *134*
    Huhn, Wendy, 76, *77*
    James, Michael, *75*, 76
    Kaufman, Anna Belle, *282*
    Mississippi Cultural Crossroads, 132, 134–135
    Nash, Geraldine, *135*
    Quakers and Mennonites, 64–67
    Rankin, Hystercine, *133*, 134, 136
    Sandoval, Arturo Alonzo, 76, *77*
    Scott, Joyce, *277*
    South Carolina, *132*

**R**
Rady, Elsa, *230*
Rankin, Hystercine, *133*, 134, 136
Rasmeier, Leon, 50, *51*
Rauschenberg, Robert, 199
Reid, Jason, *137*
Renk, Merry, 250, *250*
Revere, Paul, 28, *28*
Rhead, Frederick Hürton, *96*, 96–97
Rhode Island School of Design (RISD), 145–152
Rice, Jacqueline, 149
Rice, John Andrew, 189–193
Richards, Mary Caroline, 219–220
Riis, John Eric, *147*
*Rio Grande Gates,* Albuquerque Museum of Art and History (Joyce), *243*, 245
Risatti, Howard, 15

RISD. *See* Rhode Island School of Design (RISD)
Robineau, Adelaide Alsop, *21, 22*
Rochester Institute of Technology. *See* School for American Crafts (Rochester Institute of Technology)
Rogers, Michael, 188
Rollins College, 189–190
Romero, Diego, *115*
Rookwood Pottery, *79.94*, 94
Roosevelt, Eleanor, 22, 29–30
Rose, Augustus, 146, 148
Rose Valley Arts and Crafts Colony, 90, *90, 91*
Rossbach, Charles (Ed), 179, *182*
Roycroft Community, 84–85
Roycrofters Furniture Shop, *264, 265*
Ruskin, John, 79–82

## S

S. C. Johnson and Sons, Inc., 279
Saarinen, Eero, *176, 177*
Saarinen, Eliel, *168, 169*, 173–174, *175*, 177, *177*, 179
Saarinen, Loja, *169, 170, 171, 172, 174, 175*
Sailors, Robert, *178*, 179
Sandoval, Arturo Alonzo, 76, *77*
Sandwich Home Industries, 36
Santa Fe Indian Market, 116, 118
Santa Fe Indian School, 118
Sauer, Jane, *233*
Saxe, Adrian, *212*
*Scarab Vase* (Robineau), *21, 22*
Schapiro, Meyer, *104*
Scheier, Edwin and Mary, *36*
Schmidt, Charles (Carl), *79*
School for American Crafts (Rochester Institute of Technology), 36, 183–188
schools of craft, 142–143, 292–295
Schrattenthaler, Gertie, *200*
Schreckengost, Vicktor, *270*
Schulman, Norman, 149
Schwartz, June, *12*
Scott, Joyce, *277*
Scripps, James Edmund, 164
Sears, Sarah Choate, 36
*Seclusion Lake* (Higby), *279*
Seeger, Tiyna, *223*

Seeman, Bonnie, *223*
Sekimachi, Kay, 234, *255*, 258
Sengal, David, *120*
Seppä, Heikki, *294*
Shaker influence, 49–52
    Bennett, Gary Knox, *51*
    Brooks, Jon, *50*
    Darwall, Randall, *57*
    Gurney, David, *46, 47*
    Look, Donna, *52*
    Nakashima, George, 58, *59*
    Rasmeier, Leon, *51*
Shakers, *39*, 43–60
    beliefs, 45–46, 56, 60
    buildings, *44*
    founder, Mother Ann, 43–44, 45
    furniture, *33*, 47–49, *59*, 274
    gift drawing, *45*
    textiles, *54, 55, 55–56, 56, 57*
    tools, *44*
    utilitarian containers, *42, 52, 52, 53, 55, 55*
Shaw, Josephine Hartwell, 148
Shaw, Mrs. Quincy A., 271
Shaw, Richard, *225*
Shaw, Robert, 75
Sheerer, Mary Given, 20
*shibori*, 261, *262*
Shippentower, Doris, *111*
Shire, Peter, *266*
Siemon, Caleb, *6*
Sikora, Linda, *223*
Sikyatki Revival, 114
silk, legend of the discovery of, 232
Silver, Anna, *222*
silversmithing, 28, *28*
    Bertoia, Harry, 179, *180*
    Choo, Chunghi, *180*
    Cranbrook, 179, 182, *182*
    Craver, Margaret, *276*
    Kirk, Arthur Nevill, 170, *171*, 174
    Mimilitsch-Gray, Myra, *181, 182*
    Mueller, Louis, 148, *148*
    Navajo, *110*
    Paley, Albert, 186, *186*
    Prip, John (Jack), 148, *148*, 185
    Revere, Paul, 28, *28*
    Rhode Island School of Design, 148, *149*
    School for American Crafts (RIT), 186, *186*, 188

Seppä, Heikki, *294*
Stone, Arthur, 95, *95*
Stromsoe, Randy, *97*
Tiffany & Co., *98*
Simmons, Philip, *26*
Simpson, Tommy, *265*
Singletary, Preston, *112*
Sisson, Karyl, *234*
Skinner, Orin, *269*
Slater Mill, 269–270
Slemmons, Kiff, 253, 254, *283*
Slockish, Minnie Marie, *107*
Smalley, Valborg Nordquist, *174, 175*
Smith, Christina, *246*
Smith, Margery Hoffman, *31*
Smith, Richard Zane, *115*
Society of Arts and Crafts (Boston), 36, 83, 279
Society of Blue and White (Massachusetts), 83
Society of North American Goldsmiths, 248
Solberg, Ramona, *249*, 253–254
Somerson, Rosanne, 149, *150*
"Sons of Liberty Bowl" (Revere), *28*
Southern craft heritage, 121–140
    American Indians, 122–131
    basketry, 136–137
    furniture, 137–139
    influence of geography, 121–122
    pottery, 122–131
    schools, 139
    textiles, 131–136
South Union Settlement, *57*
Southwestern Association for Indian Arts (SWAIA), 116
Stankford, Paul, *218*, 219
Statom, Therman, *141*
Stickley, Audi & Company, 87
Stickley, Gustav, 29, 85–87, 271
Stickley, Leopold, 87, *87*
Stinsmuehlen-Amend, Susan, *216*
Stocksdale, Bob, 234, *236*
Stocksdale, Joy, 160, *255*
Stone, Arthur, 95, *95*
Stratton, Mary Chase Perry, 20, *20*, 22
Strengell, Marianne, *172, 178*, 179, *179*
Stromsoe, Randy, *97*

studio craft, 208. *See also* new studio
    crafts movement
Sudduth, Billie Ruth, 137, 232, *233*

**T**

Takaezu, Toshiko, 220, *220*
Takamori, Akio, *206*
"Take Your Seat: A Journey Through
    American Furniture," 264–267
Tawney, Lenore, *253, 255*, 258
Temple, Byron, 221
Teruyama, Shoko, *200*
Texas-German spat-backed chair, *264,*
    265
textile arts. *See also* quilting
    Albers, Anni, 191, 194, *194, 195,*
      196
    Amana Colonies, *62*, 63
    American Indians, 110–111
    Bassler, Jim, *200*
    Berea College (Kentucky), 131–132
    Black Mountain College, 194, *194, 195,*
      196
    Bowen, Gaza, 259
    Cacicedo, Jean Williams, 158, *258*
    California College of the Arts, 158, *159*
    Content, Judith, *262*
    Cook, Lia, *152*, 158
    Cory, Ken, *252*
    Cranbrook, 170, *173*, 179
    Cranbrook Community, 170, *170,*
      172–175, *178*, 179
    Darwall, Randall, *57, 146*
    Fisch, Arline, *254*, 258
    Guermonprez, Trude, 153, *155*, 156, 196
    Harding, Tim, *263*
    Hedstrom, Anna Lisa, 259, 261
    Henderson, Ella, *119*
    itinerant weavers, 19
    Kling, Candace, *159*, 160
    Knodel, Gerhardt, 172–173, *173*
    knotting, *233*
    Larsen, Jack Lenor, *162*, 172, 179
    Le Pere, Lesley, *252*
    Lipkin, Janet, 259, *261*
    needlework, *31, 83*
    Oda, Hiromi, 172, *172*
    Penland, 19, *19*, 201, 203, *203*

Porter, Faith, 259, *260*
Rhode Island School of Design, 146
Riis, John Eric, *147*
Rossbach, Charles (Ed), 179, *182*
Saarinen, Loja, *169*, 170, *171*, 172, *174, 175*
Shakers, *54, 55*, 55–56, *56, 57*
*shibori*, 261, *262*
Smalley, Valborg Nordquist, *174, 175*
Strengell, Marianne, 172, *178*, 179, *179*
studio crafts period, 255, 258
Tawney, Lenore, *253, 255*, 258
trade cloth, 255
Zeisler, Claire, *253*, 258
Thomas Davies Brickwork, 128, *129*
tiaras, 250–251
Tiffany, Louis Comfort, *92*, 93–94, 271
Tiffany & Co., *98*
Timberline Lodge (Oregon), 31, *31*
Torre, Einar and James de la, *16*
Townsend, John, 28, *28*
trade cloth, 255
Trapp, Ken, 16
Turner, Robert, *196*, 196–197, 219–220
*Twentieth Century Solutions Tea Pot: Nobody
    Knows Why* (Notkin), 281, *281*
Tyler School of Art, 248, 252

**U**

Urban Glass, 217

**V**

Val-Kill, 29–30
Voulkos, Peter, 153, 159, 198, 199, 220, *221*

**W**

Walker, Edna, *89*
Wallace, Denise and Sam, *256*, 256–257, *257*
war masks, 13–14, *14*
Warren, H. Langford, 83
Wattis Institute for Contemporary Arts,
    160
weathervanes, 245, *247, 247*
weaving. *See* textile arts
Webb, Aileen Osborn, 32–33, *33*, 36, 183
Weinrib, David, 197

Weiser, Kurt, *200*
Western Apache, *105*
Whitehead, Ralph Radcliffe, 88
White House Collection of American
    Crafts, 9–10
Whiting, Margaret, 83
Whitman, Sarah Wyman, 36
Wildenhain, Frans, 185
Wildenhain, Marguerite, 155–156,
    197–198, *198*
Williamson, David and Roberta, *249*, 253
Winter, Charlotte, *32*
"Women as Leaders in American Craft,"
    36–37
Woodman, Betty, *300*
Woodstock Byrdcliffe Guild, 90
wood turning, 233–234, 236, *236–239*, 242
    Burchard, Christian, *238*
    Cummings, Frank E., *236*
    Ellsworth, David, 236, *239*
    Holzapfel, Michelle, *239*
    Horn, Robyn, *238*
    Hunter, William, *242*
    Jordan, John, *10*
    Lamar, Stoney, *237, 238*
    Lindquist, Mark, 236, *238*
    Moulthrop, Ed, 234
    Moulthrop, Philip, 234, 236, *237*
    Osolnik, Rude, 234, *242*
    Sengal, David, *120*
    Stocksdale, Bob, 234, *236*
woodworking
    Barnes, Carroll, *17*
    Jackson, Nathan, *14*
Worden, Nancy, 252, *252*
Works Progress Administration's Federal
    Art Project, 30, 31
Worst, Edward, 202, *203*

**Y**

Yager, Jan, 250, *250*
Yanagi, Soetsu, 198
Yarnall, Mira Nakashima, 58, *265*

**Z**

Zeisler, Claire, *253*, 258
Zimmermann, Marie, 148, *149*